Camille Pissarro

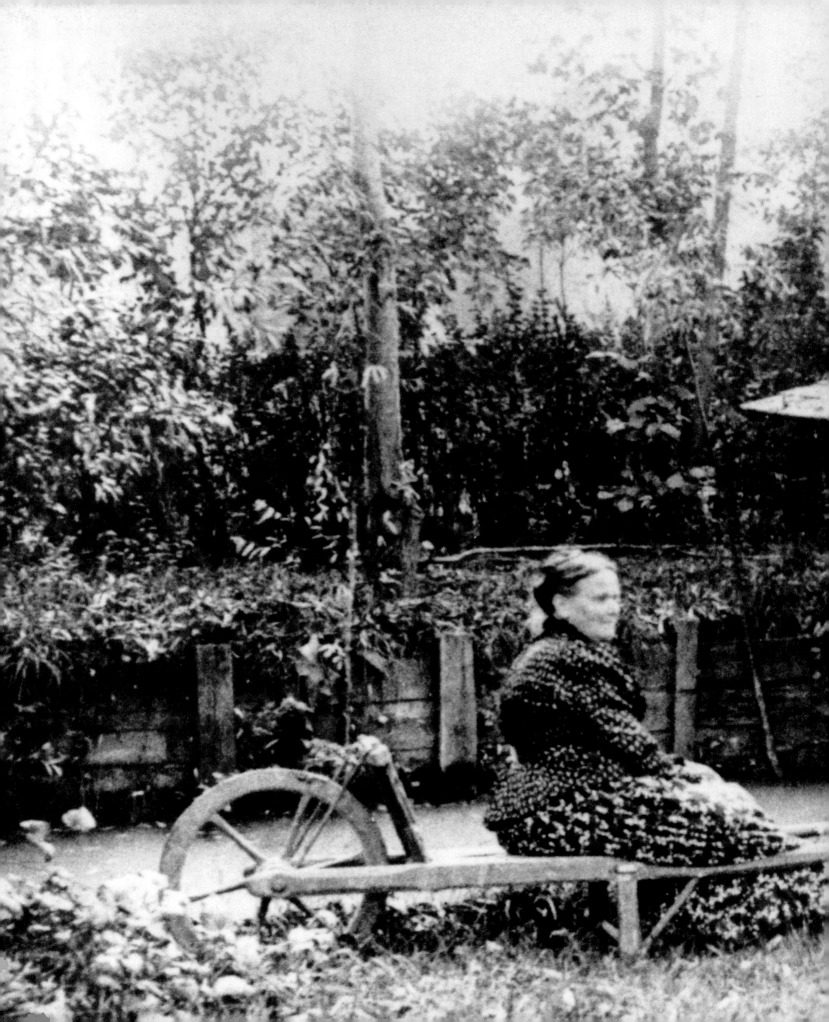

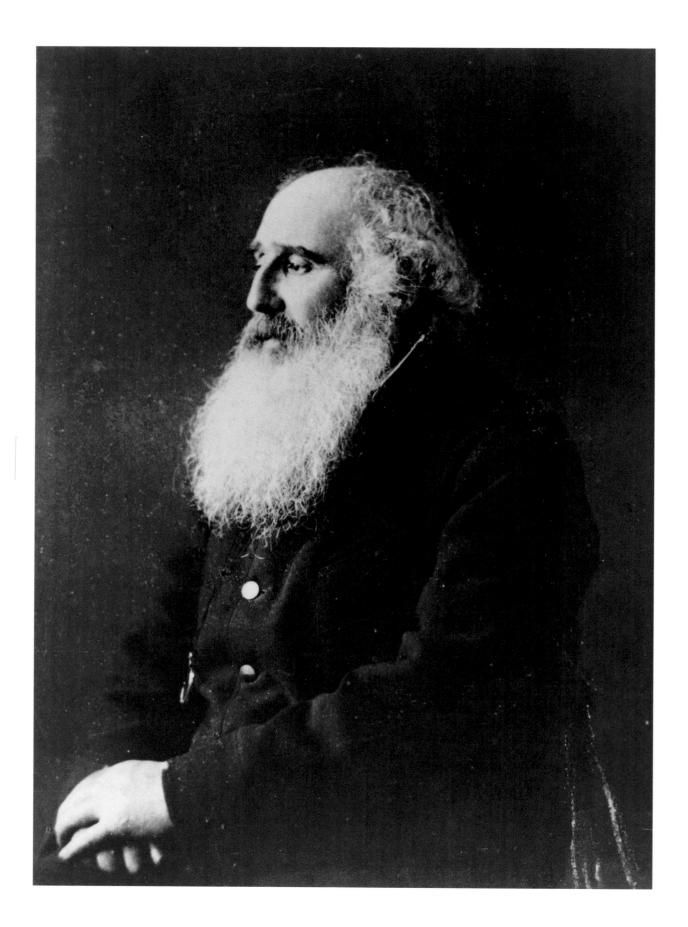

Camille Pissarro

Christoph Becker
Essays by Wolf Eiermann, Ralph Melcher,
Barbara Stern Shapiro

Hatje Cantz Publishers

CONTENTS

CAMILLE PISSARRO 1830–1903 Wolf Eiermann

An Artist's Life

Camille Pissarro was always completely consistent in his work, consistent in the sense that he was continuously questioning and improving what he was doing as an artist. As far as we can tell from the existing catalogues of his œuvre, over two thousand works have survived[1] – paintings, drawings and prints made between 1852 and his death in 1903. Although Pissarro and his family lived in the country, he was no loner, shunning civilisation; on the contrary he had many visitors who valued him as a friend, colleague, teacher, and as an instigator of the exhibitions in Paris which were to go down in history as the legendary Impressionist exhibitions. However, descriptions of him as the "patriarch of Impressionism"[2] can seem too simplistic, and point to the need to look more closely at his position within Impressionism and beyond that in French art as a whole up until 1903. We have chosen to do this here in the form of an illustrated, comparative biography.

Pissarro came from a large, extended family, and if one were even to briefly outline the lives of all his closest relatives – his wife Julie, their eight much-loved children (fig. 1), his three brothers, his half-brothers and half-sisters, one would soon be caught up in a family-saga of several volumes in length. And indeed the wide range of his children's artistic activities would make a fascinating subject; but here we are concerned simply with Camille.

1830

Jacob-Abraham-Camille Pissarro was born on 10 July in Charlotte Amalie, the capital of the St Thomas in the Danish West Indies.
This island, now one of the Virgin Islands and part of the USA, was a free port, and in the

first half of the 19th century flourished as an international centre with thriving trade connections to Europe, South America and the USA.[3] And this proud town was where Camille's father, Frédéric Pissarro, arrived from Bordeaux in 1824, to act as the executor of the will of his uncle, Isaac Petit, who had died in May of that year. There he met his uncle's young widow, Rachel, who already had three small children and was expecting a fourth. Frédéric not only took responsibility for his uncle's business interests and his store, but also stood as father to the children. When Rachel became pregnant again in 1825 and the two declared their intention to marry, the Elders in the Synagogue in Charlotte Amalie objected that they were already too closely related. And when a ceremony was performed privately, the Jewish community refused to recognise its legality; eight years of debate ensued. The Petit family also opposed the marriage. According to Rachel's own inven-

Fig. 1
The family on a haystack in Eragny, c. 1895
Left top to right: Paul, Rodo, Jeanne, Madame Julie Pissarro; left bottom to right: Camille Pissarro, Alice Isaacson, Tommy, 'la Bonne'
Photo: Archive Lionel Pissarro, Paris

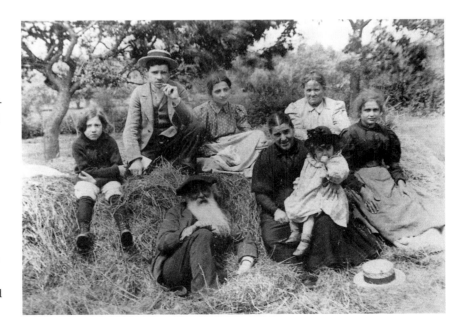

Fig. 2
The Pissarro's store in Charlotte Amalie, St Thomas,
Photo, c. 1930

tory, from her marriage with Isaac Petit, she brought with her the house and the business premises, two slaves and the contents of their clothing store.[4]

1833
After the birth of Frédéric and Rachel's fourth son the Elders of the Synagogue intervened and declared the marriage to be legally binding.
Camille, the third son from this union has two older brothers: Joseph-Gabriel-Félix, who dies young, and the younger Aaron-Gustave; in addition he has two half-brothers, Joseph and Isaac, and two half-sisters, Emma und Delphine, from his mother's first marriage. The family with its many children is comfortably off. Their large, two-storeyed house at 14, Dronnigens Gade, has an eighteen-metre long, stuccoed façade, and an inviting store on the ground floor (fig. 2). Since Frédéric and Rachel are ambitious business-people and successful in their undertakings, the family is able to send Camille to France for his education.

1841
Camille is enrolled in a boarding school near Paris, the Pension Savary. There he spends six years, very close to the home of his grandparents, Joseph and Anne Pissarro.

Camille Pissarro receives his earliest artistic instruction while he is still at school, from a son of the Savary family. While this is perfectly usual in good schools, at Savary it takes

a somewhat unconventional form. Charles Méryon – later to become a printmaker – reported that one piece of advice Camille received was: "Draw from nature during your holidays – as many coconut trees as you can."[5] Another member of the family, the landscape artist Auguste Savary, exhibited in 1824, 1841 and 1859 in the Paris Salon.[6] And it is perhaps surprising that this artist – about whom very little is known[7] – was choosing motifs from the area around Versailles and Pontoise,[8] that is to say, places that were later to feature in Pissarro's own paintings.
This interest in art in the school itself, leads Camille to put so much effort into his drawing that his father has to warn him not to neglect his other subjects.

1847
Camille Pissarro finishes school and returns to St Thomas.

1848–1851
In accordance with his parents' wishes, Pissarro works in his father's business. In view of his school-days and family connections – his grandparents and all his other relatives are in France – it is understandable that, despite living in the Danish West Indies, his thoughts continue to focus on France and French culture.

1851
The frustrating prospect, for Camille, of becoming a book-keeper in his parents' business, is abruptly banished by the arrival of a Danish painter, Fritz Melbye.[9] This young painter – only four years older than Camille – is travelling alone to South America, and just passing through the Danish West Indies. The two become friends, and Pissarro – who has by now come of age – decides to join his fellow-artist, who is planning to travel on to Caracas.

When he leaves for Venuzuela, Pissarro is not intending to pursue a career as an artist. He would have regarded that as running away, "in order to cast off the chains of bourgeois

life".[10] This comment from later on might seem to imply that a bourgeois life and being an artist are mutually exclusive. But that was not necessarily the case, for in the 19th century, painters were, if anything, keen to fit into bourgeois society, so that they might come by wealth and honours, and perhaps even be elevated into the nobility.[11]

Since the publication of Alexander von Humboldt's scientific findings and Johann Moritz Rugendas' pictures of Brazil[12] (*Malerische Reise in Brasilien*, 1835)[13] there had been a demand – also from publishers – for images of landscapes from the Americas.[14] Fritz Melbye later paints a view of the harbour of St Thomas, which is bought by the King of Denmark, and which is also published as a lithograph (fig. 3).[15]

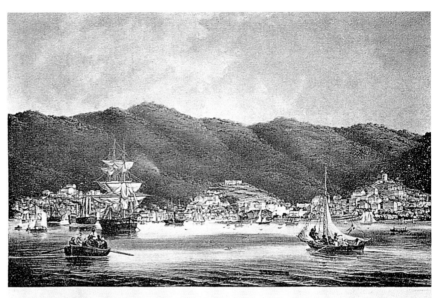

SAINT THOMAS.

1852
On 12 November 1852 Pissarro and Melbye arrive in Venezuela, and stay initially in the port of La Guiara.

Some sketches have survived from 1852, such as the drawing of market women under a large parasol. Pissarro does not draw individual figures, one next to the other, as one might expect of a beginner, but skilfully captures the bustling life of a South American market. His confident handling of this difficult subject matter shows that he must have continued on his own with what he had learnt from the Savarys. His landscapes, however, are rather more cautious; they look more carefully composed, and the figures in them seem to have no more than slightly baroque walk-on parts. The question of a possible pupil-teacher relationship between Melbye and Pissarro is still open to debate; Melbye describes himself as coming from the "school of wild artists".[16]

1854
On 9 August Pissarro returns from Venezuela and once again works in his parents' business. In order to further his training as an artist, he is keen to go to France, but waits until his

brother Alfred has returned from Paris. At this point their mother, Rachel, is in France with Emma and Delphine.

Pissarro paints a picture of the coast of St Thomas, signed and dated "Saint Thomas 12. août 1854".[17] This means that either he completed this very quickly – three days after his return, perhaps on the basis of sketches – or that he dated it after the event. Later on there are other instances where the dates do not always match his various locations, which makes it seem likely that Pissarro worked at some of his paintings for over a year.

1855
Sea-crossing to Paris. Pissarro's half-sister, Emma, marries Phineas Isaacson. Delphine dies on 24 October.[18] Camille lives in Passy near Paris with his mother and Emma, who is expecting a child. His father and his brother-in-law stay in St Thomas. Pissarro rents a studio of his own at 49, rue Notre-Dame-de-Lorette.

Since the upheavals of the 1848 Revolution, Paris has become the capital of the elegant world – and of entertainment. This is not without an effect on the visual culture of the

Fig. 3
Anonymous
Saint Thomas
Dated 1852
Coloured lithograph after a painting from 1851 by Fritz Melbye, 36 x 54 cm
Privately owned

time: The painter Eugène Delacroix[19] comments on a garden party in the Tuileries with coloured lanterns and Bengal lights: "That is beauty to them! An April afternoon leaves them indifferent."[20]

This is the time when the first boulevards in Paris are being laid out by the Prefect Baron Haussmann; they are perfect for the new character that has made his appearance in the town, the flâneur.[21] But the pomp of the new Empire is in stark contrast to the employment conditions and pay of the workers; the average wage is 3 francs per day, i.e., roughly 1,000 francs per annum.[22]

At the World Exhibition in Paris there are 5,000 contemporary paintings and sculptures on show. The paintings are predominantly religious history paintings. Paintings on realistic themes, such as steam locomotives or factories are not regarded as 'high art' and therefore not exhibited.[23] Broadly speaking there is considerable interest in landscape paintings; approximately a quarter of the purchases made by the State (which are so influential on artists' reputations) are of landscape paintings. The State pays between 1,000 and

1,900 francs for these.[24] The number of painters applying to exhibit landscapes in the annual Salon runs into hundreds: this is the competition that the young painter Camille Pissarro is facing.

In his own Pavillon du Réalisme, Gustave Courbet[25] shows large-format paintings of peasants and rural scenes, which promptly provokes the comment that he is "searching in the mud"[26] and, what's more, "...only sovereigns have the right to be painted full-size."[27]

1856

Father Frédéric comes to Paris. In the late summer Pissarro is living and painting in Montmorency.[28] Pissarro meets Anton Melbye[29] – the brother of Fritz – who is a successful maritime artist in Paris; Pissarro paints some skies in Melbye's seascapes.[30] Most probably Pissarro is already in touch with Camille Corot by this time.[31]

During this period Pissarro is studying privately with leading teachers from the Ecole des Beaux-Arts[32] – François-Edouard Picot,[33] Isidore Dagnan,[34] and Henri Lehmann.[35]

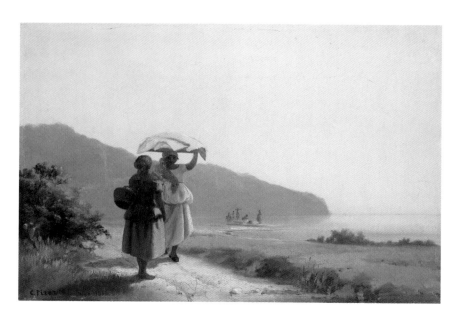

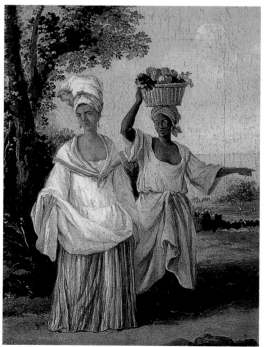

Most of Pissarro's drawings, such as his studies for nudes, portraits and landscapes, which could tell us something about his training, are undated.[36] However, there are several paintings from 1856, five signed with the name "Pizarro". Only one of these depicts a French landscape; the rest still show scenes from the West Indies. In these Pissarro paints expanses of water,[37] by no means a simple motif in view of the highlights and reflections required; but he knew enough about seascapes from the work of the two Melbyes. The painting, *Two Women, Chatting by the Sea, Saint Thomas* (cat. 2) reveals a basic feature of Pissarro's work: his figures are imbued with calm, with joie de vivre, and an air of inner harmony (qualities that are to be an enduring strength in his figures, despite the severe blows that fate inflicts on Pissarro and his family). In this particular case, his chatting women have their own Latin-American panache, and are very much in the local tradition of painters working in the West Indies, such as Augustin Brunias.[38] The vibrant Rococo colours of Brunias' works preserve his female figures from any hint of *tristesse* (fig. 4).[39]

1857

Pissarro spends another summer in Montmorency, from the end of August onwards with the Danish painter David Jacobsen[40] in La Roche-Guyon (Val d'Oise) and Fourges (Eure).[41] His father supports him financially, but writes, expressing the hope that his son's work will start to become profitable.[42] Fritz Melbye, who has been in Paris since the previous autumn, leaves for the United States. Now there are landscape studies in Pissarro's drawing book, depicting motifs from the French landscape: paths, teams of cart-horses, peasants and large haystacks in flat countryside.[43] These point towards Charles-François Daubigny,[44] whose harvest picture[45] exhibited in the Salon of 1852 had a powerful effect on contemporary landscape painters, and who himself was always supportive of Pissarro (fig. 5).

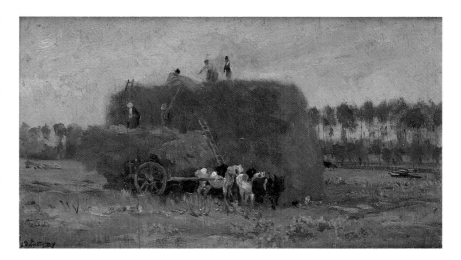

1858

Although the motifs in Pissarro's paintings would seem to point to Montmorency, it does seem that in fact he spent the summer in La Roche-Guyon, where he had already been the previous year.[46]

Pissarro paints a *Picnic* in Montmorency.[47] Auguste Renoir has no choice but to earn a living by painting fans with galant subjects such as the *Embarkation for Cythera* after Jean-Antoine Watteau.[48] The painter Alfred De Dreux[49] paints a park scene, and calls it *Cavaliers and Amazon Pausing by a Lake* (fig. 6), which has precisely what was wanted at the time: *noblesse*. The enthusiastic catalogue-editor at the Louvre even thought he could recognise the features of the young Napoleon III in one of the riders, for "who else could this be other than an imperial Prince?"[50]

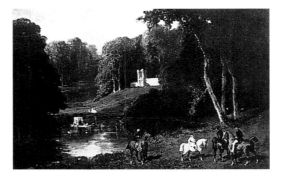

Fig. 5
Charles-François Daubigny
The Haystack
La Meule
c. 1856
Oil on wood, 14.4 x 25.3 cm
Musées de Pontoise

Fig. 6
Alfred De Dreux
Cavaliers and Amazon Pausing by a Lake
Cavaliers et amazone arrêtés au bord d'un lac
c. 1858
Oil on canvas, 43 x 65 cm
Musée du Louvre, Paris

1859

Pissarro draws and paints in Montmorency[51] and in the area around La Roche-Guyon.[52]

His studies of trees show signs of an awareness of recent works by Camille Corot.[53] Pissarro's painting of the *Landscape at Montmorency* becomes the first work he has accepted by the Salon (fig. 7), officially as a pupil of Anton Melbye.[54]

In the life-drawing classes at the Académie Suisse – held in the evening and open to anyone, unlike other classes in other Academies – Pissarro becomes acquainted with Claude Monet.[55]

1860

Pissarro meets Julie Vellay. She comes from a family of vintners in Grancey-sur-Ource, and is employed as a domestic servant in the Pissarro household in Passy. Pissarro falls in love with her, and shares the rest of his life with her. Julie becomes pregnant that same year, but suffers a miscarriage.
1860 also sees the beginning of his friendship with Ludovic Piette,[56] a wealthy amateur painter with an estate in the country. Pissarro visits Lille in July.[57]

1861

During February and March, Piette works temporarily in Pissarro's studio in Paris. In the Académie Suisse Pissarro meets the students Paul Cézanne and Armand Guillaumin.[58] On 16 April he copies a work in the Louvre; it is not known which.

According to Monet, at this time Pissarro is not only painting landscapes, but other motifs too, for instance, a shabby yard in Montmartre.[59] Pissarro submits a painting (title not known) to the Salon, but only to be met by rejection.[60] At a time when acceptance by the Salon was crucial to an artist's survival and career success, this was a major blow to Pissarro, even if the jury, working at top speed, were only fleetingly judging the work and not the artist himself (fig. 8).[61]

1862

Julie takes on some simple tasks in order to help the family's finances. In autumn this is no longer possible because she is pregnant once again.[62]

Monet returns from Algeria and Le Havre and visits the Studio Gleyre in Paris, where Frédéric Bazille, Auguste Renoir and Alfred Sisley are working (The Gleyre Group).

1863

On 20 February Pissarro's son Lucien is born.[63] The artist spends the summer with his family in La Varenne. Cézanne and Emile Zola visit his studio near Montmartre, which he is sharing with David Jacobsen.[64]

Pissarro becomes a member of the 'Société des aquafortistes' (Society of Etchers) which serves as a model for similar organisations founded in 1865 in New York, Boston and Philadelphia. The aim of these societies is to reinvigorate the neglected realm of artists' prints, in the spirit of the 1862 manifesto by Charles Baudelaire, in which he declared that etching was the fashion. There is a market for prints, for instance, as illustrations for journals or books with relatively low print runs.[65] Pissarro makes his first etching.

Fig. 7
Salon de 1859
Exhibitor card belonging to
Camille Pissarro

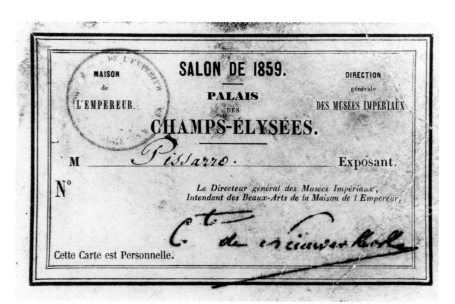

Once again the Salon rejects a painting by him. After numerous protests, Napoleon III agrees to the building of a 'Salon des refusés' because three-fifths of the pictures submitted have been rejected by the jury. The new Salon shows works by Edouard Manet, James Whistler, Paul Cézanne, Armand Guillaumin and three paintings by Pissarro. But the "third-class status" that this gives the paintings is to have dire consequences: Manet's *Déjeuner sur l'herbe* arouses great interest amongst other artists[66] but is derided by the public.[67] The Salon des refusés is slated by the critics: "One used not to be able to imagine what a bad picture is like, now we know."[68] The sheer diversity of the artists involved in the Salon des refusés means that they cannot simply be equated with the avant-garde of the day.

1864

A letter from Piette arrives: Pissarro should come and paint the "green spring" in Montfoucault. Towards the end of the year, Bazille and Monet are sharing a studio in Paris. This becomes a meeting place for Pissarro, Cézanne, Renoir, Sisley and later Courbet as well. In September Pissarro is in Montfoucault.

The Salon jury accepts two paintings (now lost) by Pissarro who officially describes himself as a "pupil of Corot and Anton Melbye".[69]

1865

On 28 January Pissarro's father dies.[70] In family matters Camille's mother comes to depend increasingly on her son Camille, despite the fact that she still has to support him financially and still refuses to accept Julie as his wife. On 18 May Julie gives birth to their second child: Jeanne-Rachel, known as Minette.[71] The family moves to La Varenne-Saint-Maur, 25 kilometres north of Paris.
Pissarro sells very few paintings.
In October he possibly spends some time with the painter Antoine Guillemet,[72] Minette's godfather, in La Roche-Guyon. He frequently meets up with Cézanne and Francisco Oller y Cestero, a painter of the same age from Puerto Rico.[73] At different times, other

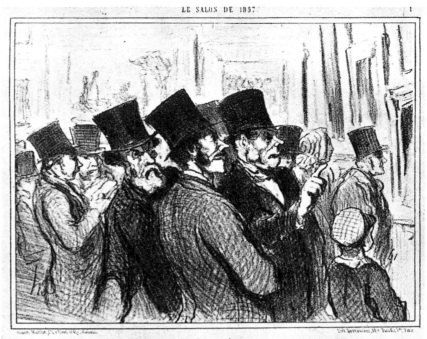

Aspect du salon le jour de l'ouverture, _ rien que de vrais connaisseurs, total soixante mille personnes.

patrons of the Café Guerbois also included the art critic Emile Zola, Louis-Edmond Duranty, Philippe Burty and Zacharie Astruc.[74]
A book on the social purpose of art is published posthumously by Pierre-Joseph Proudhon and is greeted with considerable interest in art circles.[75]

In Paris Pissarro is able to share Guillemet's studio. In the Forest of Fontainebleau he paints together with Renoir und Sisley.
Two pictures are accepted for the Salon: *By the Water* (lost) and *The Marne in Chennevières*; as in the previous year, Pissarro is listed in the catalogue as a pupil of Melbye and Corot. Daubigny's painting, *The Park of St Cloud*, is exhibited, and hung amongst the angels and the saints, but also near to a murder scene (fig. 9). Honoré Daumier draws caricatures of the Salon participants, lampooning the exponents of Naturalism, that is to say, the dissidents and the followers of Courbet – including Pissarro (figs. 10, 11).
Monet does not submit his version of *Déjeuner sur l'herbe* to the Salon.[76] According to his friend Bazille, he is fêted by throngs of Salon

Fig. 8
Honoré Daumier
The Salon of 1857
Le Salon de 1857
"On the day of the opening: . . . only true connoisseurs, sixty thousand people in all"
Lithograph, 2nd state,
19 x 25.2 cm

Thanks to a good word from Daubigny, the jury of the Salon accepts Pissarro's *By the Banks of the Marne, Winter*. Now he is referred to in the catalogue only as a pupil of Melbye.[78] This raises certain questions, because his work is now closer to that of Courbet and Daubigny than to Melbye's seascapes. Zola comments in his review: "Camille Pissarro is an unknown, who most probably no-one will speak of. It is my intention to shake him heartily by the hand before I go. Merci, monsieur, your landscape afforded me a good half hour of repose on my journey through the great Salon desert. . . . By the way, you should be aware that no-one likes you and that people find your pictures too naked, too dark. . . . Austere, serious painting, extreme care taken over the truth and exactitude, a will that is keen and strong."[79] Another example of a painting in dark tones would be the *Square in La Roche-Guyon* (cat. 4) which was also painted in 1866.

painters for his other pictures, and his career as the favourite painter of the upper echelons of society seems secure. Those heaping praise on him include painters such as Léon Bonnat, Alexandre Cabanel, Eugène Fromentin and Alfred Stevens – later to be counted amongst the 'Pompiers', who were known for producing kitsch.

1866

In January Pissarro, Julie, Lucien and Minette move to Pontoise, north of Paris, and take up residence at 1, rue du Fond de l'Ermitage.[77]

1867

Pissarro's paintings are rejected both by the Salon jury and by the committee for the World Exhibition in Paris.

During the World Exhibition Courbet presents his paintings – as before in 1855 – in his

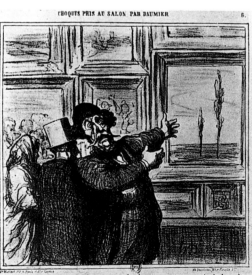

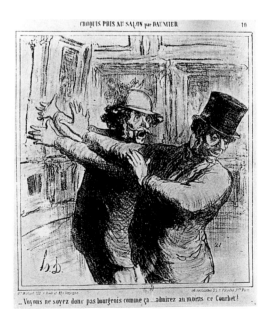

own pavilion. Monet, Bazille and other friends are interested in renting this for future exhibition, but the plan later founders.[80]

1868

Emma Isaacson, Pissarro's half-sister dies in London. He therefore travels to England, where he then stays for a month. His precarious financial situation forces him to paint window blinds with Guillaumin.[81]

In the Salon two of Pissarro's paintings are shown: *The 'Côte du Jallais', Pontoise,* of 1867 (cat. 6) and *L'Hermitage, Pontoise,* c. 1867. While Zola regards Pissarro's paintings as "supremely true", he criticises Monet for being "unable to paint a landscape without putting grandly dressed ladies and gentlemen into it."[82] This is an important comment both with regard to Monet's own concept of truth in nature at the time, and with regard to the inner logic of his paintings (fig. 12). Yet the same comment could also be applied to Pissarro's *Côte du Jallais,* for the two figures are just as much representatives of "fine society". However, unlike Monet, Pissarro almost only ever depicts figures of this kind in pictures that were intended for the Salon or for the later Impressionist exhibitions in Paris. Only about two dozen of his paintings – a mere two percent of his entire output – depict 'comme-il-faut' ladies with summer bonnets, gentlemen in jackets, and well-behaved children playing nicely, out for a walk, in the park, or having a picnic.
In the same year Pissarro also paints *The Maidservant* – a large-format portrait of a gentle soul serving a refreshment in a glass (cat. 7). No other work points so vividly to the difference between Monet and Pissarro's subjects at the time. In artistic terms, it is clear that Pissarro is more daring than his friends when it comes to demonstrating the colour-changes that occur on an object when the light strikes it directly.

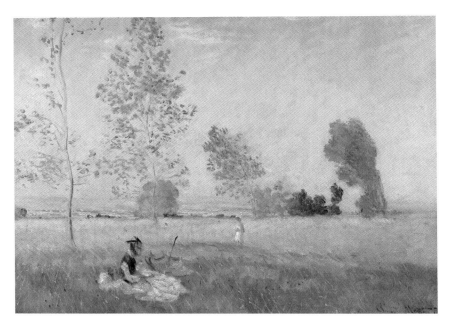

1869

The family leaves Pontoise and moves into a larger house in Louveciennes near Versailles. The 'Maison Retrou' lies on the road that leads from Versailles to Saint Germain, very close to the Marly aqueduct, which used to supply the water for the onetime hermitage of Louis XIV.[83] A merchant (formerly a mason), known as 'Père Martin', buys paintings from Pissarro; he has already done good business with works by Corot and Jongkind. He buys Pissarro's paintings for 40 francs and sells them for between 60 and 80 francs.[84]

Near to Manet's studio, on Thursdays the so-called 'Groupe de Batignolles' (named after a picture by Henri Fantin-Latour) meets in the Café Guerbois: Manet, Degas, Bazille, Guillemet, Fantin-Latour, Pissarro, Monet, Renoir and Cézanne, also the critics Zola, Théodore Duret, Duranty, Armand Silvestre and others. There the discussion often centres on the theory and practice of the light tones needed for 'plein-air painting'.[85] Pissarro becomes friends with Edgar Degas. However, the latter rejects the practice of painting outside which Pissarro, Renoir and Monet are increasingly trying out – for

Fig. 12
Claude Monet
Summer
L'Eté
1874
Oil on canvas, 57 x 80 cm
Staatliche Museen zu Berlin –
Preußischer Kulturbesitz,
Nationalgalerie

instance, on La Grenouillère, an island in the Seine with a bathing place and a rowing club. Crowds of Parisians used to gather there in the pursuit of pleasure, although it was not always of the entirely proper kind. The three friends depict these scenes in their paintings, and the works they produce here are widely regarded as the earliest paintings to implement the tenets of Impressionism. Unfortunately only a small numbers of paintings done by Pissarro in 1869 have survived.[86]

1870

War breaks out between France and its German neighbours. In September the advance of the German troops forces the family to flee to the Piettes in Montfoucault. Pissarro leaves many paintings behind in Louveciennes, including a number of works by Monet who had left them with Pissarro for fear his creditors might impound them.
On 21 October, Adèle-Emma is born, but sadly she dies shortly afterwards on 5 November. Pissarro's mother Rachel flees to London. Camille, Julie, Lucien and Minette follow her, and the family moves into accommodation in the suburb of Norwood.

In the winter of 1869/70, Pissarro and Monet paint the same view of the road in Louveciennes outside Pissarro's house; Monet depicts snow, Pissarro a rainy atmosphere. In spring Monet travels to Trouville. Two paintings by Pissarro (now lost) are accepted by the Salon. The two artists influence each other's work: Pissarro suddenly has a palette of light, purer, brighter colours, reminiscent of Monet's paintings,[87] while Monet temporarily employs the more planar style of Pissarro's landscapes.[88]
Later on in London Pissarro meets the French gallerist Paul Durand-Ruel, who has rented rooms where he is now presenting French artists. He is very interested in Pissarro's work.[89]

1871

On 10 March a letter arrives from a neighbour in Louveciennes with the news that only forty pictures (and some furniture) could be rescued from the German militia. At the end of June Pissarro returns to his plundered house. He later reckons that he has lost 1,500 works.[90]
After eleven years together Camille and Julie marry in Croydon near London: Pissarro's mother – by now back in Paris – has abruptly given her permission.

In London Durand-Ruel informs Pissarro that his friend Monet is also in town. The two visit the galleries there and look at works by John Constable and William Turner. No doubt they also see many other fine works, such as the landscapes by Old Masters, for instance, in the exhibition of the collection of Sir Robert Peel. Meanwhile the Royal Academy chooses not to show works by Pissarro and Monet.[91] Durand-Ruel buys two paintings by Pissarro, and shows the Norwood pictures in his second exhibition beginning on 6 March.[92] From 1 May until September two paintings by Pissarro are on show in the 'First Annual International Exposition', London, South Kensington:[93] *Snow Effect* and *View in Upper Norwood*.[94] Pissarro and Monet also work together in London, as may be seen from Monet's *Hyde Park*, which is very different from his work hitherto, most probably due to Pissarro's influence.[95]
Having returned to France, Pissarro once again paints numerous views of the roads in and around Louveciennes, whose composition (flat horizon, foreshortened middle-ground, roads leading into the distance) may have been influenced by Meindert Hobbema and John Constable (fig. 13), but could equally well have been influenced by similar early works by Corot.[96]
But there are also innovations in the Louveciennes pictures: now there is a logical connection between clouds, light and the (evening) shadows; there is a new coherence – determined by the picture – between the zones given over to the sky and the earth. This was

not generally the case in his earlier land-
scapes, which look rather more contrived and
not as though they have been painted ('plein-
air') after nature.[97] Two works with views of
the road to Louveciennes (cat. 12, 13)
demonstrate – with their new, more sensitive
depiction of light – the progress that Pissarro
has made since his stay in England. Sisley
paints similar views in Louveciennes.

1872

The Pissarros move to Pontoise again, where
they stay until 1882. Cézanne follows with his
partner and their son; they live nearby in
Auvers until early 1874. Dr. Paul Gachet,
physician and art-lover, buys a house in
Auvers; he had treated Pissarro's mother in
the 1860s.[98] Guillaumin also moves into the
neighbourhood. Pissarro's mother Rachel
visits Camille and Julie due to illness. Julie
breeds rabbits in the garden.

Pissarro has his first financial success:
Durand-Ruel puts his faith in the new
painters. For his gallery in the rue Lafitte in
Paris he buys paintings from Pissarro for
5,900 francs (from Monet for 13,200, from
Sisley for 5,350, from Degas for 8,945, from
Manet for 35,000, from Renoir for 500
francs).[99] Durand-Ruel has also managed to
find a niche for Jean-François Millet who has
also repeatedly been rejected by the Salon:
his larger works now make between 15,000
and 20,000 francs.[100] Much to the distress of
the artists, he does not purchase their paint-
ings on a regular basis – sometimes he buys
nothing for years, and then suddenly he buys
in unexpected bulk, no doubt to replenish his
stocks.[101]
In London there is a summer exhibition with
two paintings by Pissarro: *Winter, Upper Nor-
wood* and *Sydenham.*[102]
Pissarro influences Cézanne, who is still
unsure of himself as an artist. As Lucien Pis-
sarro reports, he "walked three kilometres
every day to work with Papa."[103] Cézanne
regards Pissarro's work at the time as more
progressive than that of his other friends.[104]
Together with his fellow-artists, Cézanne and

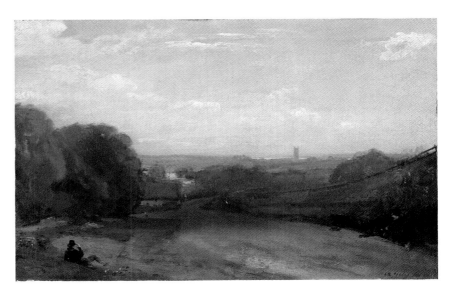

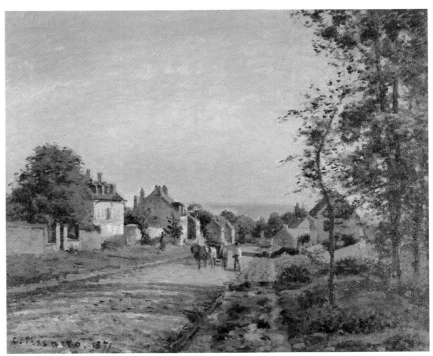

Guillaumin, and also with Dr. Gachet, Pissarro
experiments with etching. All three artists
paint in Dr. Gachet's house. One of the tasks
they set themselves is to paint a still life of
objects belonging to Gachet.[105]
Sisley and Pissarro are both working on the
subject of 'floods'.

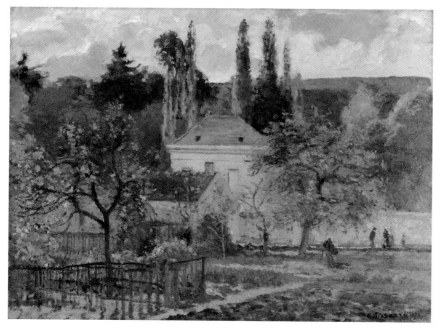

Fig. 14
Claude Monet
Houses in Argenteuil
c. 1873
Oil on canvas, 54 x 73 cm
Staatliche Museen zu Berlin –
Preußischer Kulturbesitz,
Nationalgalerie

1873

Pissarro meets Duret who returned in January from a journey to Japan. Duret soon starts to collect his pictures.[106] In October the Pissarros move into a different house because of the damp and the cold where they are.
Durand-Ruel buys more pictures from Pissarro for 5,300 francs.[107]
There is now public debate on the possibility of an independent exhibition, parallel to the

Salon. Monet, Pissarro, Jongkind, Sisley and others respond on 12 May with a manifesto. In the summer Pissarro works on a constitution for an exhibition society, an artists' co-operative. They are united in their rejection of 'academic' art and of the conditions laid down by the Salon. Together they form a non-academic opposition, as it were. They have neither a name nor a legal charter.[108]

Pissarro seems to have painted outside with Monet in the summer, since there is a contemporaneous version by Pissarro of Monet's flower meadow with three houses (fig. 14).[109] In *Bourgeois House in L'Hermitage, Pontoise*, Pissarro stresses the rural aspects of the scene, particularly drawing the viewer's attention to the rickety garden fence rather than the elegant architecture of the villa further back (cat. 17), for Pissarro is highly sceptical of the use of monumental architecture as a motif. Although he has an aqueduct before his very eyes in Louveciennes (which Sisley painted), it does not feature in his work. Homey views and postcard pictures are of no interest to him.
Duret writes to him saying that he should continue with his own landscape style, without making any concessions to bourgeois tastes nor trying to be like Sisley and Monet, whose work has a touch of the dilettante.[110] Pissarro responds to this by saying that Duret was mistaken about Monet, for the latter's art was founded on precise observation and a new sensitivity – that there was poetry in the harmony of its many colours. To which Duret replies: «I remain convinced that rural landscapes with animals are best suited to your talents. You haven't Sisley's decorative feeling, nor Monet's fanciful eye, but you have what they have not, an intimate and profound feeling for nature and a power of brush, with the result that a beautiful picture by you is something absolutely definitive.» (fig. 15)[111]

1874

On 13 January the business man and art-speculator, Ernest Hoschedé, holds an auction of Impressionist art in the Hôtel Drouot – which

proves to be very successful for Pissarro. Much to everyone's surprise one painting of the landscape by the Oise makes 950 francs.[112]
On 6 April Minette dies at the age of nine. On 24 July, Félix (later known as 'Titi') is born. In mid-August, and again from 20 October, the Pissarros stay with the Piettes in Montfoucault.[113] In London six of Pissarro's paintings are seen in two exhibitions.

Now that Pissarro has a reputation of his own, Duret warns him against a 'special' exhibition, saying he should approach the Salon instead. But Pissarro does not want to abandon his friends.
On 15 April, the first exhibition of the 'Société anonyme des artistes peintres, sculpteurs et graveurs' is held in the boulevard des Capucines, in the studio of the well-known photographer Nadar (fig. 16). The participants besides Pissarro include Eugène Boudin, Félix Bracquemond, Jacques-Emile Brandon, Cézanne, Gustave Colin, Degas, Guillaumin, Gaston Latouche, Stanislas Lépine, Monet, Berthe Morisot, Giuseppe de Nittis, Renoir, Henri Rouart, and Sisley. Pissarro shows six landscapes,[114] including *Hoar Frost* and *Chestnut Trees in Osny*.[115] In four weeks 3,500 visitors come to the exhibition; Pissarro writes to Duret: "The critics are tearing us to bits." On 14 December, the exhibi-

tion is closed due to disastrous financial circumstances. Durand-Ruel, who had also warned against a special exhibition stops buying works, whereas Pissarro had hoped that now he might be able to count on more regular payment.[116] Guillaumin, who supplements his income by working as an unskilled labourer, consoles Pissarro: "Why do you always doubt yourself? It's an illness that you have to get over."[117] The critic Louis Leroy, in a satirical article in *Charivari* on 25 April, mocks the artists as 'Impressionists' – taking the name from Monet's *Impression – soleil levant*. (It should perhaps be noted that the artists now described by art-historians as Impressionists are not simply those who took part in this exhibition and the seven subsequent exhibitions.)
The critic Jules-Antoine Castagnary comments on Pissarro: "He also has a deplorable liking for truck gardens and does not shrink from any presentation of cabbages. . ."[118]
A painting with cabbage fields from 1873, now in the Carmen Thyssen-Bornemisza Collection, may well be that same misunderstood masterpiece that Zola had in mind years later when he wrote: "These decompositions of the light, these horizons where the trees turn blue, while the sky is turning green, but I knew them, these were true Pissarro. . ." (cat. 14).[119]

Fig. p. 12 below

Cat. 17
Bourgeois House in L'Hermitage, Pontoise
Maison bourgeoise à l'Hermitage, Pontoise
1873
Oil on canvas 50.5 x 65.5 cm
Kunstmuseum Sankt Gallen, Sturzeneggersche Gemäldesammlung
PV 227

Cat. 26
L'Hermitage, Pontoise, Snow Effect
L'Hermitage, Pontoise, effet de neige
1874
Oil on canvas, 54 x 64.8 cm
The Fogg Art Museum, Harvard University, Cambridge, Gift of Mr. and Mrs. Joseph Pulitzer jun., 1953.105
PV 240

Fig. 15
Alfred Sisley
Winter in Louveciennes
1876
Oil on canvas, 59.2 x 73 cm
Staatsgalerie Stuttgart

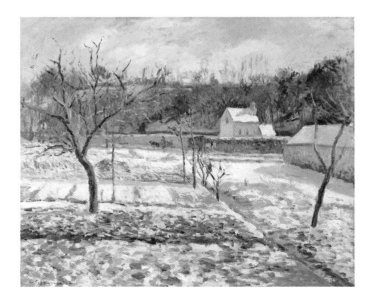

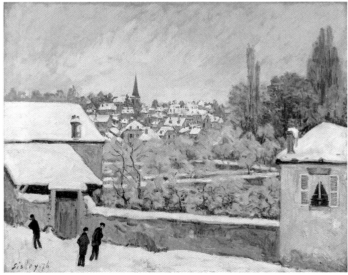

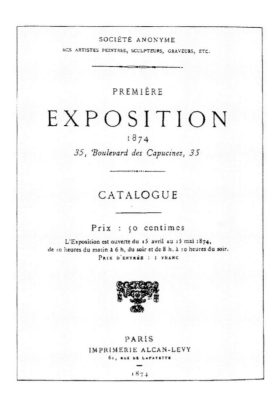

SOCIÉTÉ ANONYME
DES ARTISTES PEINTRES, SCULPTEURS, GRAVEURS, ETC.

PREMIÈRE

EXPOSITION
1874
35, Boulevard des Capucines, 35

CATALOGUE

Prix : 50 centimes

L'Exposition est ouverte du 15 avril au 15 mai 1874,
de 10 heures du matin à 6 h. du soir et de 8 h. à 10 heures du soir.
PRIX D'ENTRÉE : 1 FRANC

PARIS
IMPRIMERIE ALCAN-LEVY
61, RUE DE LAFAYETTE

1874

1875

In the new year the Pissarros are in Mont-foucault, in early February in Pontoise.[124] Cézanne is in Pontoise again from 1875 to 1877.

In March the Impressionists, spurned by the art market, auction a number of works in the Hôtel Drouot, but the works only fetch impossibly low prices.[125] Meanwhile, 400,000 visitors are thronging the 25 rooms of the Paris Salon. Pissarro's works are exhibited in London.[126]

The Paris Opera acquires ceiling-mosaics that consist of myriads of tiny stones, which only form into an image in the eye of the beholder.

Following Duret's friendly advice, Pissarro concentrates on pictures with figures and animals.[127]

L'Hermitage, Pontoise, Snow Effect (cat. 26) clearly shows the influence of Cézanne's palette-knife technique.[128] Years later Pissarro wrote: ". . . he [Cézanne] was influenced by me at Pontoise and I by him".[129] Sisley also paints winter scenes at the same time as his two friends (fig. 15).

It is only against the backdrop of Pissarro's artistic relationship with Cézanne that it is possible to properly understand his *Peasant Untangling Wool* (cat. 24); its emphasis on the

Corot's painting, *Pastorale*,[120] seen in the Salon in 1873 (fig. 17), with its appealing nymphs is closer to public taste, because artists are still supposed to "arrange beautiful scenes".[121] If one compares this to his depiction of a brick factory (fig. 18) from earlier in his career (between 1840 and 1845), then it is evident that in *Pastorale* Corot has yielded once again to the need to produce idealised, picturesque landscapes. In one critic's opinion, this could give the impression that Corot in effect never really got away from (artificially) composed landscapes.[122] Salon painting is seeking gravitas in its subject-matter, and is also turning for inspiration to the chiaroscuro of Baroque painting, all of which could not be more different to the themes and colours of the Impressionists: "Now with the practice of only ever accompanying light with shadow, and only using certain colours in a modulated form, the point had been reached where everything was painted in shadow, and every last, lively gleam of colour had departed from the pictures."[123]

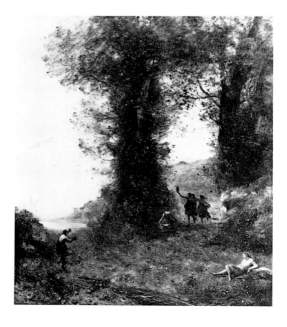

airy texture of the wool, lying on the ground like foam, makes a very clear distinction between itself and the geometric, cuboid shapes in Cézanne's vision of the world.

1876

In spring, Piette is in Pontoise with the Pissarros, and Pissarro goes to Montfoucault in the autumn to return the visit. All year he searches in vain for buyers. He makes an enterprising but unsuccessful attempt to run a lottery in Eugène Murer's patisserie with four paintings as the prizes. Camille thinks of painting ceramics, because they sell more easily.[130]

By now, becoming increasingly used to his lack of success, Pissarro regards Zola as something of an oracle, particularly in view of the latter's criticism of the decisions the Salon jury is currently making: "Any artist who aims to achieve success and sales by placing his faith in the stupidity of the public at large, is no more than a skilled artisan, who would have done better to become a cobbler or a tailor." Elsewhere Zola comments that a certain artist "has gone over to the enemy" (the artist in question is Courbet at the Salon of 1866).[131] Yet gradually 'realist' painting are beginning to have an effect on the Salon artists – the tell-tale sign is the pale light that is finding its way in everywhere, as the somewhat conservative critic Fromentin remarks. Durand-Ruel keeps faith with his painters (fig. 19), and risks an exhibition in his rooms with 19 artists, including Pissarro, Caillebotte, Monet, Morisot, Renoir and Sisley. The critic Albert Wolff in *Le Figaro* reports that "five or six crazy artists, including a woman, have got together here with their works".[132] Accusations of madness in a properly pathological sense were to come up again in 1911 in the battle against Impressionism.[133]

1877

Pissarro, his wife and four children are barely able to get by financially, and occasionally they receive support from relatives. The few pictures that he sells go for an average of 46 francs.[134]

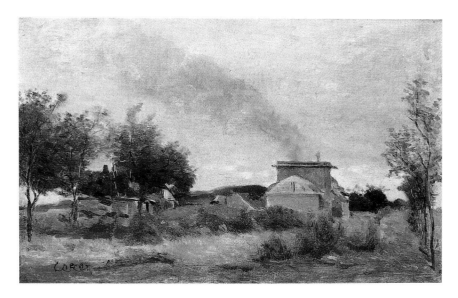

In Paris the third Impressionist exhibition, with 17 participants, takes place in an empty apartment in the first floor of a house in the rue Péletier,[135] financed by Caillebotte. Pissarro shows 22 landscapes in plain, white frames on red plush walls.[136] During the exhibition, the art journal *L'Impressionniste* is published, with a drawing by Pissarro. *Vegetable Garden and Trees in Blossom, Spring, Pontoise* is one of the most interesting works by Pissarro, perhaps by any Impressionist. The main focus is on the fruit trees in front of a hill fringed with houses; but the real subject-matter is the phenomenon of spring: the damp, rainy atmosphere. If one compares the picture with the real landscape, it is still clear to see – despite various changes that have occurred over the years – that Pissarro

Fig. 18
Jean-Baptiste-Camille Corot
The Brickworks
Le Four à briques
c. 1840–1845
Oil on canvas, 21.4 x 32 cm
Staatsgalerie Stuttgart

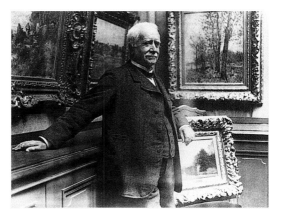

Fig. 19
Paul Durand-Ruel, c. 1910
Photo: Roger-Viollet

has created a denser version of reality. On the painting the hill in the background is higher and closer, and the actual depths of the middle-ground are obscured by the blossoming fruit trees (fig. 20, cat. 31). By contrast, a work by Cézanne (fig. 21), with a comparable motif from Pontoise, is much more tectonic in its composition: the middle-ground is clearly defined by horizontals and verticals, and the distance is not obscured by vegetation.

1878

The family is now virtually on the bread-line. Julie is pregnant once again. April brings the death of Piette, their friend and benefactor in Montfoucault, who had often invited the family to stay on his estate. Out of friendship, the pastrycook Murer buys several small works and commissions portraits of himself and his sister by Pissarro and Renoir. Pissarro had written and told him what a fine portraitist Renoir was.[137]
On 29 November the Pissarro's sixth child, Ludovic-Rodolphe, is born.

In June an auction takes place in the Hôtel Drouot which goes badly for the Impressionists.[138] There is no joint exhibition in Durand-Ruel's rooms during the third World Exhibition in Paris. On the other hand, two of Pissarro's paintings that have been sent to an exhibition in Florence, are sold there.[139]
Pissarro makes some etchings. He remains faithful to his rural motifs and paints a *Pathway at Le Chou, Pontoise* (cat. 33).
Duret publishes a pamphlet with the title *Les Peintres impressionnistes*. He responds boldly to the criticisms of his contemporaries: "Never before has anyone dared to portray so systematically the simple forms of nature, the countryside, the appearance of the fields. Visitors imagined there was something undignified about it. In their opinion art ought to raise itself above ordinary life, floating somewhere in the highest realms, and Pissarro, who had eyes to see the country as it really was, seemed like the consummate peasant to them."[140]

1879

Pissarro offers Murer and Caillebotte five pictures each for 100 francs, so that he can pay his debts. He invites the wealthy stockbroker's agent and amateur painter, Paul Gauguin, to participate in the next exhibition. Gauguin accepts the invitation with pleasure and – most probably on Pissarro's advice – shows one sculpture. In summer Gauguin comes to Pontoise, to paint with Pissarro.[141]

On 10 April the fourth Impressionist exhibition opens at 28, avenue de l'Opéra: the 'Exposition des Artistes Indépendants'. Although 15,400 people come to see the works on show, the profits of 439,50 francs per participant are very meagre. Pissarro shows 38 works, including painted fan designs and pastels.[142]
Renoir shows his works in the official Salon and is richly successful there.
The print *Rain Effect* (cat. 91), despite its affinity to Millet's work, is an outstanding example of Impressionist graphic art. *The Backwoods of L'Hermitage, Pontoise* (cat. 35) shows Pissarro's treatment of vegetation, and is important in terms of the debate surrounding Cézanne's work at this time.

1880

Monet leaves the league of starving independents and, like Renoir, shows his work in the Salon, while his friends (now including Gauguin) are to be found in the fifth Impressionist exhibition at 10, rue des Pyramides (fig. 23).[143]
Together with Mary Cassatt, Pissarro is producing etchings; Degas allow them to use his press. Pissarro is also experimenting with aquatints; for the Impressionist exhibition he underlays his prints with yellow paper and frames them in purple.

1881

Jeanne-Marguerite-Eva, known as Cocotte, is born on 27 August.[144]

Durand-Ruel starts to purchase works once again. The sixth Impressionist exhibition takes place at 35, boulevard des Capucines. Pissarro receives ever-improving reviews; Joris-

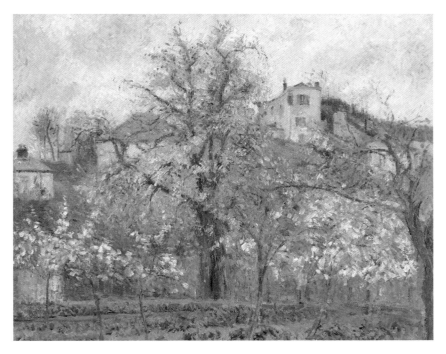

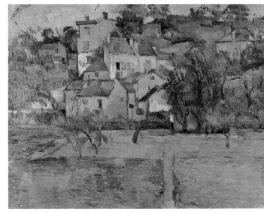

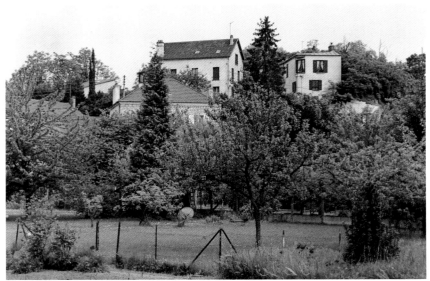

Cat. 31
**Vegetable Garden and Trees
in Blossom, Spring, Pontoise**
Potager et arbres en fleurs,
printemps, Pontoise
1877
Oil on canvas, 65.5 x 81 cm
Musée d'Orsay, Paris, Bequest
from Gustave Caillebotte,
1894, Inv. RF 2733
PV 387

Fig. 20
Gardens in Pontoise
Photo: Wolf Eiermann, 1999

Fig. 21
Paul Cézanne
L'Hermitage, Pontoise,
c. 1875
Oil on canvas, 46.5 x 56 cm
Von der Heydt-Museum,
Wuppertal

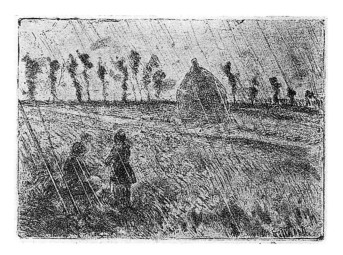
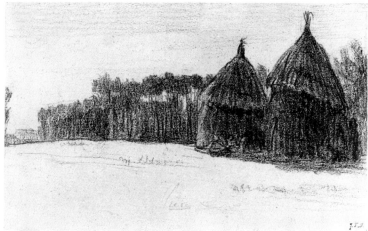

Karl Huysmans credits him with the qualities of a great painter. This is to be Pissarro's most successful Impressionist exhibition.[145]

1882

On 1 February, following falls in the stock market, a major French bank fails. The resulting financial crisis means that Durand-Ruel has little room for manœuvre financially, although business is in fact looking better.[146] The seventh Impressionist exhibition takes place at 251, rue St. Honoré. After much discussion, the following participate: Caillebotte, Gauguin, Guillaumin, Monet, Morisot, Pissarro, Sisley, Victor Vignon and Renoir.[147]

Pissarro is baffled to find himself accused of trying to emulate Millet in his figurative compositions.[148] As far as he is concerned, motivic similarities (figs. 22–25), even to the extent of the replication of anatomical peculiarities,[149] are of little consequence. As he points out a number of times, his application of paint – aiming at "optical mixture" – has nothing to do with Millet's style of painting. Furthermore, the figures in Pissarro's pictures are depicted in their distinctly congenial everyday lives, and are far removed from the obscurely melancholy peasantry of Millet (1814–1875).[150] Probably it is Durand-Ruel, the main dealer for Millet's work, who suggests Pissarro might take up some of Millet's motifs – specifically his pretty peasant girls –

since particularly these themes are selling increasingly well. In 1881, for instance, a painting by Millet is sold for the – in Pissarro's terms – astronomical sum of 160,000 francs.[151] It is also Durand-Ruel who suggests that Pissarro might sell more if he were to turn his hand to fan designs; which Pissarro then does with both diligence and success.[152]

1883

In the autumn Pissarro paints in Rouen and stays at the Hôtel du Dauphin et d'Espagne, which his friend, Murer, has taken over.[153] Pissarro now enters into an extensive correspondence with his son Lucien, an aspiring artist who has moved to London, where he is living with relations. In this exchange of letters one can see both the artistic progress of the son, Lucien, and into the mind of the father, Camille, and what he felt about art. Gauguin is working together with Pissarro, and talks of moving to Rouen with his family.

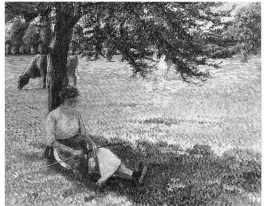

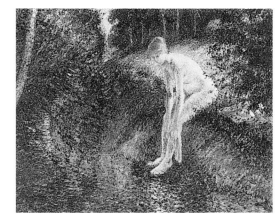

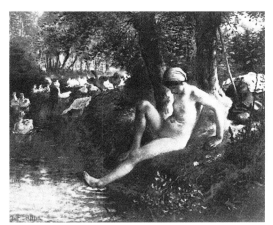

Fig. 24
Camille Pissarro
Cowgirl
1887
Tempera, 54 x 65 cm
Sarah Lee Corporation

Fig. 25
Jean-François Millet
Shepherdess Knitting
Une Bergère tricotante
1858–1860
Oil on wood, 39 x 29 cm
Musée du Louvre, Paris

Fig. 26
Camille Pissarro
Bather in the Wood
La Baigneuse dans le bois
1895
Oil on canvas, 60.3 x 73 cm
The Metropolitan Museum of
Art, New York, Bequest of
Mrs. H. O. Havemeyer, 1929
PV 904

Fig. 27
Jean-François Millet
The Goose Girl
1863
Oil on canvas, 38 x 46.5 cm
Walters Art Gallery, Balti-
more

Works by Pissarro are shown in Boston at the International Exhibition.[154] With a marked lack of success, Durand-Ruel puts on a series of solo exhibitions in Paris for Boudin, Monet, Pissarro (70 works), Renoir and Sisley, in the first floor of a house on the boulevard de la Madeleine.[155] In addition he organises an exhibition in London which Pissarro criticises for the artists selected – it includes work by John Lewis Brown for one.

Struck by a comment from a young painter in Rouen, who sees no point in making studies from nature if no-one appreciates them, Pissarro writes to Lucien: ". . . for an artist should have only his ideal in mind. – He lives poorly, yes, but in his misery one hope sustains him, the hope of finding someone who can understand him; in three out of four cases he finds his man."[156]

He is unbothered by the critic Adolph Menzel's harsh review of the Impressionist exhibition in Berlin. Pissarro plays an active and constructive part in the debate on art and artistic style.[157] The artists involved in these discussions are no longer meeting as the anti-academic opposition; the Impressionist movement has completely put paid to official art – which was already in decline anyway[158] – and can now pursue its debate on its own terms. The discussions themselves, unburdened by supposedly scholarly insights, prepare the theoretical ground for Neo-Impressionism. On 28 February, Pissarro writes to his son Lucien – just twenty, a future artist and keen to learn – that Impressionism "really should be nothing more than a theory of observation."[159]

With the new location come new motifs: now figures and events in the market at Gisors move into the foreground; for Eragny does not have striking landscape features like the steep banks of the Oise in Pontoise or the wide fields to either side of the Seine. No longer do we find houses on hillsides, factories, and rivers in Pissarro's paintings.

He is now also considering working with four-colour lithographs and etchings.

1885

In Guillaumin's studio Pissarro meets Paul Signac, who in turn introduces him to Georges Seurat. The two are the same generation as Lucien and already friends with him.

Signac and Seurat want to find out all there is to know about the question of 'optical mixture' and about how individual pictorial elements go together to form a complete image.

Fig. 28
Camille Pissarro's house in Eragny
Photo: Wolf Eiermann, 1999

1884

The Pissarros move to Eragny-sur-Epte, a hamlet near Gisors. Paul-Emile is born, and there are now eight in the family. On 1 March, Pissarro writes to Lucien: "The house is wonderful and not too dear."[160] It is a comfortable brick house (fig. 28) with a large garden that goes as far as a small stream. In the vegetable garden there is a an outhouse which Pissarro later has extended to create a studio on the first floor (fig. 29). Beyond that the open countryside stretches away with its broad, flat hills. The daily routine is enlivened by the market-days in nearby Gisors, where the children also go to school.

Pissarro regularly reads the socialist journal *Le Prolétaire*.

1886

The last joint Impressionist exhibition is held in Paris in the 'Maison Dorée'. Pissarro becomes acquainted with Octave Mirbeau and Vincent van Gogh. In July he receives a text by Celen Sabbrin, *Science and Philosophy in Art*, which he translates for Signac.[161] Félix Fénéon publishes his pamphlet, *Les Impressionnistes en 1886*, which Pissarro recommends to Durand-Ruel and to the latter's son, who would like to write something about the new movement.[162] Almost all the Neo-Impressionists are interested in 'anarchist' ideas, in particular in the thinking of the émigré Russian prince, Peter Kropotkin, whose philosophy is founded on a "sense of the oneness of human beings with nature, both animate and inanimate."[163] Pissarro later twice pays printing costs of 1,000 francs for the journal, *Les Temps nouveaux*, edited by Jean Grave, to which Kropotkin contibutes.[164]

Durand-Ruel organises an exhibition in the United States with 300 paintings – 40 by Pissarro. He sets off for there in March,[165] and would like to take works by Signac and Seurat as well.[166]

Fig. 29
The studio extension in the garden of Pissarro's house in Eragny
Photo: Wolf Eiermann, 1999

Pissarro's son, Lucien, views Neo-Impressionism – as the new movement is called – not as a departure but as a truer form of Impressionism: "At first the painters, who were later called Impressionists, studied light-phenomena outside, from nature, in accordance with plein-air painting: the deformations and colour changes that objects undergo through the light surrounding them. They freed their palettes of black, that non-colour, shortly afterwards green and brown were banned, they worked with no more than the six colours of the prism, that was the beginning of light colours. Later they took into account the law of complementary colours, which leads completely naturally to the division of the tones themselves."[167]

But the result of this 'division du ton' is seen as a deviation rather than a continuation of the line of Impressionism. Pissarro's changed technique provokes increasing resistance from dealers and art enthusiasts. It leads to differences amongst his friends, too. As a result Renoir, Monet, Sisley and Caillebotte refuse to participate along with Neo-Impressionists in the eighth Impressionist exhibition, although, due to Pissarro's intervention, Signac, Seurat and his son Lucien do take part in the end.[168] Camille writes to the dealer Durand-Ruel that his aim now is to "substitute optical mixture for mixture of pigments. . . . For optical mixture stirs up more intense luminosities than does mixture of pigments." Durand-Ruel is sceptical and does not think much of the style in which this is done. But Pissarro stubbornly holds out against criticism from his own side and heads for confrontation – and not only for artistic reasons. While he declares that "there is something strange about working with points of colour. . . "[169] he also comments that Pointillism will yet frighten the charming bourgeoisie. Contemporaries detect an "anarchist element" in Pissarro's paintings.[170]

1887
Pissarro's Neo-Impressionist style continues to cause criticism. He invites a number of people to buy up the contents of his studio, unsorted and "in the old manner" but no-one

takes up the offer.[171] During several stays in Paris he tries to sell watercolours 'au point' and parts with works by Degas and Antoine-Louis Barye from his own collection. He meets Maximilien Luce and Vincent van Gogh's brother, Théo, who is managing the Galerie Boussod et Valadon. Because of their unending financial difficulties, Julie balks at having to support, not only the four children still at home, but also Lucien, who is already 24 years old. Rather than finding himself good bourgeois employment he is determined, with his father's help, to become an artist. It seems that Camille Pissarro is the epitome of the poor, starving artist – just as Zola would have had it. And in this role he is unswerving in his allegiance to art and his colleagues but perhaps less so to his family, and even less so to the art market. "This is the state we are in: darkness, doubt, quarrels, and with all that one must produce works that will stand up to those of one's contemporaries. One must create art, without which all is lost. So, my dear Lucien, I stiffen myself against the storm and try not to founder. Your mother accuses me of egoism, indifference, nonchalance. I make heroic efforts to preserve my calm so as not to lose the fruit of so much thought and labor."[172] Lucien finds a position as a lithographer.[173]

Pissarro pursues his study of the behaviour of colours. He experiments, for instance, with the colour circle of Michel-Eugène Chevreul, intensifies red/green and orange/blue contrasts; nevertheless he also takes certain liberties with the "scientific rigour" of the subject.[174]

1888
Pissarro manages to sell some paintings to Durand-Ruel and also to Théo van Gogh. Luce and Léo Gausson come to Eragny, in August Pissarro and Luce are together in Lagny.[175] First signs of the eye infection which will trouble him for the rest of his life.[176]

Vincent van Gogh is very taken with Pissarro's comments on the use of colour and in autumn writes from Arles: "Here, under a stronger sun, I have found what Pissarro said

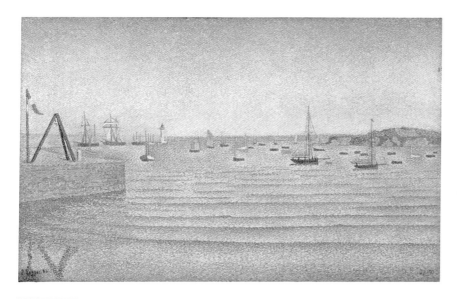

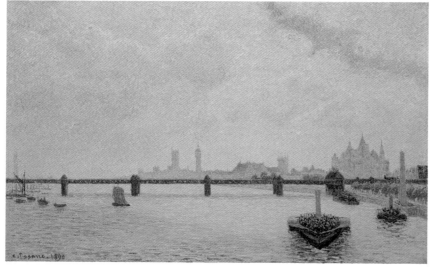

confirmed."[177] He approaches the subject of colour-placement within a picture on both a practical and a theoretical level. Colour in Neo-Impressionist paintings has greater status than hitherto. Yet Pissarro is aware of the dangers of an overly scientific method and expresses his disquiet to Lucien: "I think continually of some way of painting without the dot. I hope to achieve this but I have not been able to solve the problem of dividing the pure tone without harshness. . . . How can one combine the purity and simplicity of the dot with the fullness, suppleness, liberty, spontaneity and freshness of sensation postulated by our impressionist art? This is the

question which preoccupies me. . . "[178] This comment virtually amounts to a rejection of Neo-Impressionism. Nevertheless, a glance at a work by Signac from 1888 – *The Harbour at Portrieux* – shows that in 1890, in his painting *Charing Cross Bridge, London*, Pissarro is still interested in Pointillism (fig. 30, cat. 60). This year also sees the major works, *View from my Window, Eragny* (cat. 48) and *Apple Picking, Eragny-sur-Epte* (cat. 49).
Van Gogh paints landscapes in the style of Pissarro.

1889

On 30 May, Pissarro's mother Rachel dies. Difficulties over her estate instantly ensue.[179] Pissarro recommends Dr. Gachet as a physician for Vincent van Gogh.

Monet marks up another success at the World Exhibition in Paris and, with Théo van Gogh's help, sells a painting for 9,000 francs. Durand-Ruel buys seven paintings from Pissarro for 4,000 francs each.[180] Pissarro exhibits prints in Durand-Ruel's rooms together with members of the 'Peintre-Graveurs'. These include woodcuts by Lucien. For his niece Esther Isaacson in London, with whom he corresponds on the subject of anarchism, Pissarro makes 28 drawings with the title, *Les Turpitudes sociales* (fig. 31), which he then either gives or sends to her in an album.[181]
Lucien is working on a drawing of his father's from the previous year showing a scene with apple pickers (see cat. 49), which he later publishes under his own name as a woodcut.[182] This demonstrates the considerable difficulty involved in attributing certain graphic works either to the father or the son. Yet the signatures on their works indicate that the two wanted there to be a clear distinction between them, even although one may find to one's surprise that there is a Camille Pissarro who remains true to his (Neo-) Impressionist principles in his easel paintings, but when it comes to graphic works – and not only incited by his son – he is always prepared to tread new paths.

1890

Pissarro acquires a hand printing-press, which he uses for experiments, that is to say, he makes individual prints of a number of different versions of the same plate.[183] He becomes a member of the 'Club de l'art social', to which the painter, Luce, also belongs.[184]

The family has an amusing time with the 'in-house' caricatures of the little ones in the family paper, *Guignol*, printed at home. On 5 May Pissarro's brother Alfred dies. Van Gogh hopes that, once he has left the clinic, he can work with Pissarro again, but Pissarro suggests he should go to Dr. Gachet in Auvers. Van Gogh dies there two months later.[185] In May and June Pissarro is in London together with his son Lucien and the painter Luce.[186]

The Administration des Beaux-Arts in Paris buys two etchings from Pissarro.[187] He exhibits works in the Galerie Boussod et Valadon in Paris where the director is Théo van Gogh, and shows prints in the second Peintre-Graveur exhibition in Durand-Ruel's rooms.[188] The exhibition of Japanese art in the Ecole des Beaux-Arts from 25 April until 22 May, organised by Samuel Bing, is extremely successful. 428 illustrated books and 725 individual prints are on show: Pissarro is enthralled.[189] His fan design, *Peasants Planting Pea-Sticks* (cat. 46) shows the influence of Japanese art (fig. 32, 33).[190]

1891

Pissarro is again suffering a painful inflammation of the eye, which forces him to limit the time he spends painting in the open air.

On 29 March, Seurat dies.[191]
Durand-Ruel explains Monet's commercial success by saying that the latter has never aggravated his collectors by adopting different – unpopular – styles. Pissarro, annoyed by the lack of appreciation that greets his Neo-Impressionist works, thinks about working with another dealer. But Durand-Ruel seems to change his mind, and buys works from Pis-

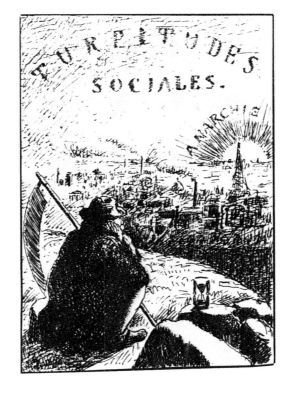

Fig. 31
Camille Pissarro
Les Turpitudes sociales
1889
Drawing, 31.5 x 24.5 cm
Private collection, Daniel
Skira, Geneva

sarro to the value of 23,042 francs; in addition he organises an exhibition of prints by Pissarro and Mary Cassatt.[192]
Pissarro is of the opinion that people will only buy his works when they have cast off what he sees as the constraints of religiosity and mysticism. He is severely critical of the Symbolism now emerging and of Gauguin's current style. When some wrapping paper, painted by his daughter Jeanne-Marguerite, is mistaken for a Symbolist work by him, his account of the episode to Lucien is distinctly cynical. But Lucien opposes his father's "anti-sales" argument and remarks that, however certain works may be classified, a painting that Camille had very recently submitted for an exhibition was not that far removed from the "art nouveau". The view that Pissarro was very much a part of the new direction is shared by the critic Georges Lecomte, and Maurice Denis points out how much the Symbolists owe to the blunt simplification in Pissarro's peasant scenes.[193]

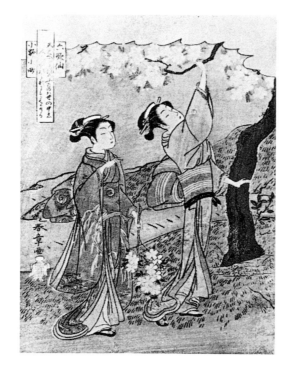
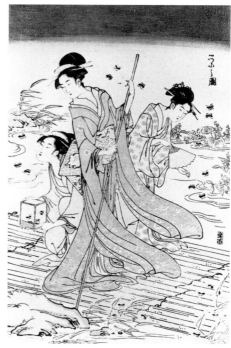

Fig. 32
Shunsho ga
The Poetess Ono no Komachi
1768
Multi-coloured woodcut, 25 x
19 cm
Privately owned

Fig. 33
Eishi zu
Catching Glow Worms
c. 1798
Multi-coloured woodcut, 38.7
x 24 cm
Privately owned

Cat. 46
Peasants Planting Pea-Sticks
Paysannes plantant des rames
1890
Gouache and charcoal on
grey-brown paper,
40.7 x 64.1 cm
(fan design 39 x 60.6 cm)
Ashmolean Museum, Oxford
BL 219

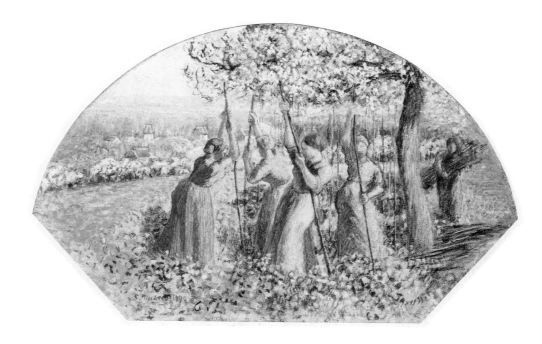

1892

Lucien Pissarro, in London, wants to marry Esther Bensusan. Her father objects to the marriage on grounds of Lucien's lack of independence, both financially and otherwise. Camille Pissarro travels to London, in order to talk Esther's father round. Meanwhile Julie is keen to buy their rented house in Eragny, which is coming up for sale. With help in the shape of a loan from Monet, the family manages to purchase what Julie calls their "fine, bourgeois residence".[194] After Lucien's wedding in London, his brother Georges follows suit, and also marries a relation in London: Esther Isaacson.

Octave Mirbeau's novella *In Heaven* is published. In it there is a painter (Lucien) who sees Camille Pissarro's work as an "imaginary vision". Camille is also aware of the comment by Georges Lecomte, who sees ornamental lines, even arabesques, in Pissarro's most recent works.[195]

From 23 January until 20 February, Durand-Ruel mounts the first retrospective of works by Pissarro. The figurative paintings from his later years demonstrate his own particular synthesis of Impressionism, Divisionism and the abstract, ornamental motifs of the Symbolists and the young Nabis.

Writing in *Le Figaro*, Mirbeau praises Pissarro's increasing mastery of different techniques.[196] Working in the Hôtel Garnier, which is situated opposite the Gare St. Lazare, Pissarro paints his first series of pictures of the Gare St. Lazare.[197]

1893

In August Pissarro becomes a grandfather, but this is overshadowed by the death of the child's mother, Esther, wife of Georges. In October, Lucien and Esther also have a child. Pissarro is suffering again from his eye condition, and has to undergo an operation. In December, Durand-Ruel buys works to the value of 28,600 francs, which greatly eases his financial situation.[198]

Between January and March, Pissarro completes his series of the Gare St. Lazare.[199] Durand-Ruel is again asking for figurative works. Pissarro paints his *Bathers*. The first forgeries begin to emerge.[200]

1894

On 25 June, one day after an anarchist assassinates the French President Carnot, Pissarro, Julie, and Titi set out with Théo van Rysselberghe for Bruges and Knocke-sur-Mer. Pissarro does not return until late October, since he fears reprisals because of his interest in anarchist ideas. But the police do not get wind of his political leanings.[201] Meanwhile, several of his friends are caught up in legal proceedings against alleged anarchists. Pissarro can now only paint in the open for short periods, and sets up a studio indoors in Eragny (fig. 34). He purchases a printing-press, with it he produces series, colour prints and monoprints. He becomes acquainted with Toulouse-Lautrec.

On 21 February, Caillebotte dies, and leaves his collection of Impressionist works to the French State with the stipulation that these are to be kept in the Musée de Luxembourg until the Louvre can take them. This sparks off a lively public row. To quote the director of the Salon, Jean-Léon Gérôme:[202] "Does not his estate contain paintings by Manet, Pissarro and others? I repeat, the fact that the State has accepted such filth is clear evidence of moral decline. These anarchists, these madmen. It is the end of the nation, the end of France." Some professors at the Ecole des Beaux-Arts threaten to resign for they can "no longer teach an art of which the paintings admitted to the Luxembourg violated all the laws."[203]

In the United States, in central and eastern Europe, on the other hand, many artists have already allied themselves to the Impressionist movement. Their works are in ever greater demand, and prices are rising. All of a sudden, collectors are "vying with each other for Impressionist paintings".[204] France now finds itself confronted with works in major exhibi-

tions abroad whose makers do not have official approval in their native land. In Eragny, Pissarro is once again concentrating on atmospheric changes and phenomena: *Hoar Frost, Morning (Snow in Eragny)* is the title of one of his most unusual pictures (cat. 51): apart from anything else, it raises the question of the role that trees play in his work. The series of prints, *The Bathers*, heralds a new development in his art. Pissarro himself describes them as "romantic, printed drawings".[205] The affinity to Degas' late images of women is unmistakable. Pissarro is extending his repertoire as a graphic artist.

Lucien is now printing woodcuts for the English market, and takes the advice of his ever (constructively) critical father. The 'optical mixture', which Camille Pissarro wants to achieve by printing colours over each other, cannot hide the fact that he has by now moved well away from the 'pure Impressionism' of his early graphic works and is now – no doubt influenced by Lucien – making works that are close to the Arts and Crafts movement and even paving the way for Jugendstil.

Fig. 34
Camille Pissarro in his studio in Eragny
Photo: Archive Lionel Pissarro, Paris

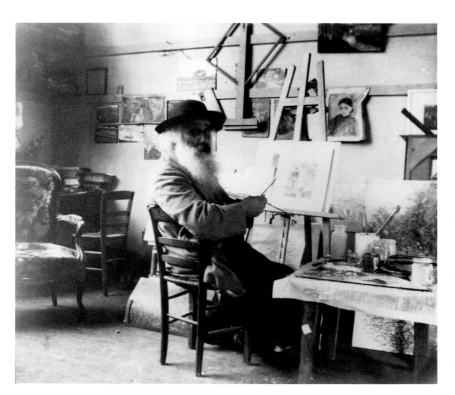

1895

Pissarro makes short visits to Rouen and Paris in April. He encourages his sons' craft skills: Georges and Félix make elaborate boxes for Bing's new gallery, 'L'Art nouveau'. These are displayed (in a room designed by van de Velde) along with the book, *La Reine des poissons*, which was illustrated by Lucien.[206] By now 32 years old, Lucien still turns to his father for advice in art matters. In one letter he comments that he is making little progress with the leafy border to a woodcut that Camille has designed.[207] Pissarro's artist-sons still rely on their 65 year-old father, and he is at times hard put to keep baling them out financially.

In May, Pissarro is much impressed by Monet's series of twenty cathedral pictures at Durand-Ruel's; they create a great deal of interest and receive good reviews.[208]

1896

On 20 January Pissarro travels to Rouen, where he sets up a studio in the Hôtel de Paris. Because of his eye condition he is obliged to paint behind closed windows.[209] So he paints his pictures of Rouen from his hotel room. He in fact does not want to show, *The Roofs of Old Rouen*, which is part of this series, because of possible comparisons with Monet's cathedrals, but he is persuaded to do so by his friend Arsène Alexandre.[210] The pictures of Rouen sell immediately, and Durand-Ruel finances his next trip. He returns to Rouen in September, and takes a room in the Hôtel d'Angleterre, where Monet had also stayed and worked. By 12 November he has finished fifteen pictures, which not only capture the atmosphere of the harbour but also the busy life in the streets and on the quayside. He spends the winter of 1896/97 painting in a hotel in Paris at the place du Havre.

Pissarro now concentrates more than ever before on the atmospheric variations in the look of the city. In Rouen he waits impatiently for the snow, and only continues with

certain pictures when the original conditions – morning mist, for instance – have returned. Despite the success of his cityscapes, his friends and others alike are more interested in discussing Monet's series. With reference to Monet's paintings, Duret comments that – contrary to popular belief – it is much easier to paint a whole variety of motifs in changing conditions, than it is to depict the effect of those conditions on the same subject. "This is a process requiring the greatest sensitivity, and every change is registered with the most alert attention." And, as Duret rightly remarks, the motif itself has no significance in its own right, as in any Impressionist work: "In order to paint landscapes such as these (Monet's *Haystacks*), one must be wholly able to abstract from the subject."[211]

German critics around 1900 describe this process, for instance, as "purely painterly". These series, where the subject has been freed of 'meaning', in effect pave the way for modern painting in the 20th century. The What (the theme) fades into the background compared to the How (the phenomenon). Pissarro's images of churches are not about religion,[212] but about daylight.

1897

Lucien falls ill, and in spring Pissarro travels to London to see him. In Paris he takes a room in the Hôtel de Russie, on the corner of the rue Drouot, with a view of the boulevard Montmartre and the boulevard des Italiens; a series of views of Paris ensues. Lucien, restored to health, comes to Eragny in the summer. On 27 November, Félix dies in London.

Pissarro's street scenes do not only show the momentary "effect" – as he always called it – of the weather and the light on the architecture. Beyond this, he also captures the movement in the streets. His pictures depict the life in the busy metropolis, the relentless traffic, the streaming crowds. Naturally he is not literally painting 'film-stills' – even if they may look like that to us today – yet his series

are closer to film than the documentary photography of one such as Eugène Atget. He tells his eye-specialist that he has no time for an appointment because he is at the window from morning till night, constantly "on the look-out".[213]

1898

From January to April Pissarro sets up camp in Paris in the Hôtel du Louvre. In February, Matisse offers him a studio.[214] In June and July, he and Julie travel to her native Burgundy. In autumn, he is in Rouen again, painting the view from the Hôtel d'Angleterre. He spends October in Amsterdam, where he sees paintings by Rembrandt and others. Finally, in December, he paints his Tuileries series, again from a window.

Pissarro's works are shown together with others in Pittsburgh, USA, in Moscow, Berlin and Munich.[215] The Nationalgalerie in Berlin buys his *Bourgeois House in L'Hermitage, Pontoise* of 1873, which becomes the first of his works to be illustrated in a German newspaper.[216] He makes a colour lithograph for the title page of Kropotkin's socially critical article in *Les Temps nouveaux* showing a man with a hand-plough, which could be based on a woodcut from 1545 by Holbein the Younger.[217]

1899

On 29 January, Sisley dies.[218]

He rents an apartment in Paris, at 201, rue de Rivoli. Setting up his easel in different positions in the apartment, Pissarro paints a total of 71 pictures: his series of the Tuileries, the Louvre and the Seine.[219] Later in the year he travels to Varengeville, following which he goes to Moret to see his son, Georges.

In the works he produces in Eragny, the colour green dominates – an almost overpoweringly intense green. Pissarro trusts increasingly in the luminosity of the colour itself, and reduces the shadows virtually to nothingness. (see *The Gardener, Afternoon Sun, Eragny*, 1899; cat. 54).

1900

Pissarro is in Paris, apart from July when he is in Dieppe and Berneval.

As part of the World Exhibition an international art show is held in the Grand Palais de la Peinture, with a room of Impressionist paintings, organised by Durand-Ruel. This includes works by Degas, Monet, Sisley, Renoir and Pissarro. Pissarro was initially sceptical, but the works on display are of a high standard, and visitors come in large numbers. When the President of the Republic appears at the entrance to the Impressionists' room, the painter Jean-Léon Gérôme bars the entrance, and cries: "Go no farther, Monsieur le Président, France is dishonoured here!"[220]

1901

In spring and late September Pissarro visits his ailing son, Georges, in Moret. In June he makes reconnaissance trips to Dieppe, Lisieux, Villers, Trouville, and Caen. He spends July to September in Dieppe, where he has a view of the church of Saint-Jacques and the market in front of it. He rents a summer house for his family in Berneval. His pictures are suddenly fetching much higher prices; he sells nine paintings for 24,000 francs.[221]

On 27 March in Stuttgart a major exhibition of French artworks opens, including loans from the Musée de Luxembourg and from private collectors, with support from the French President. The Königliches Museum der bildenden Künste – today the Staatsgalerie Stuttgart – under the direction of Konrad Lange, acquires Pissarros *Gardener* from Durand-Ruel.

A critic in Stuttgart agrees with the comment by Léonce Bénédite in the foreword to the exhibition catalogue, when the latter declares that Germany has "shared in" France's art, and the critic adds: "He might even have been so audacious as to say, supped from it for decades . . . for Germany was drowning in brown Piloty sauce."[222] (Karl Theodor von Piloty, who lived in Munich, was one of the leading exponents of history painting in Germany, and always cloaked his subjects in a Rembrandtesque gloom.)

1902

In May Pissarro once again visits Georges. Following this, he spends the summer in Dieppe. Pissarro keeps his Dieppe series back because Durand-Ruel and Bernheim want to hold the prices down.[223] He paints scenes in Moret and harbour views in Dieppe, a total of over sixty paintings.

He advises Francis Picabia.[224]

On 29 September, Emile Zola dies. He was Pissarro's 'own' critic, his best 'promoter'. His public, philosophical words of encouragement legitimised Pissarro's stubborn pursuit of artistic ideals despite the materialism of the world around him, and even despite the financial worries that came with his large family.

1903

In January, Pissarro offers his Dieppe series to other dealers rather than his 'usual' dealer Durand-Ruel. In March, Pissarro is in Paris again, this time in the Hôtel du Quai Voltaire. On 10 May Gauguin dies in Hiva Oa on the Marquesas Islands. In memoires written in 1902, Gauguin describes Pissarro as one of his teachers, whom, unlike all the others, he was glad to recognise.[225] From July to September Pissarro paints in a hotel by the harbour in Le Havre. The museum there buys two paintings from him. An amateur sculptor makes a bust of Pissarro. On 13 November Pissarro dies suddenly in Paris after a short illness. Newspapers all over the world, from New York to Alexandria, publish obituaries of an artist whose importance for the history of painting is only gradually to become clear to the wider public.[226]

English Channel

Dieppe

R. Oise

Le Havre

R. Seine

R. Epte

Rouen

Trouville

Gisors • Eragny

La Roche-Guyon

Pontoise • • Auvers

R. Marne

• Montmorency

Louveciennes •

PARIS

Bougival •

Versailles •

R. Seine

R. Seine

Barbizon •
Fontainebleau •

R. Yonne

R. Loing

District map of Paris

Notes

1 1664 works listed in PV, 194 prints in Delteil
1923, 378 drawings in Brettell/Lloyd 1980, as well as
information on other holdings of drawings.
2 Shikes/Harper 1981 p. 5.
3 Shikes/Harper 1981, p. 17.
4 Shikes/Harper 1981, p. 20.
5 Charles Méryon, 'Notes particulières relatives aux
évènements de ma vie', unpublished manuscript,
Cabinet des Estampes, Bibliothèque Nationale, Paris,
quoted in Shikes/Harper 1981, p. 21.
6 For more on Auguste Savary (born 1799 in
Nantes) see Ulrich Thieme and Felix Becker, *Allge-
meines Lexikon der bildenden Künstler von der Antike bis zur
Gegenwart*, 37 vols, Leipzig 1935, p. 503.
7 It was not possible to locate any paintings by
Savary, nor to establish what his connection might be
to the art-writer Saphary: idem, *L'Ecole éclectique et l'école
française*, Paris 1844, quoted in Cécile Litzenthaler,
L'Ecole des Beaux-Arts du XIX-Siècle, Les Pompiers, Paris
1987, bibliography.
8 Shikes/Harper 1981, p. 22.
9 Fritz Sigfrid Georg Melbye (Helsingør 1826–1896
Shanghai), painter of landscapes and maritime scenes.
10 Letter to Eugène Murer, quoted in: Tabarant
1924, p. 9.
11 Sfeir-Semler 1992, p. 440.
12 Johann Moritz Rugendas (Augsburg 1802–1858
Weilheim/Teck), landscape and genre painter.
13 Johann Moritz Rugendas, *Malerische Reise in
Brasilien*, 4 vols and 1 vol. with 100 lithographed
plates, Mühlhausen and Paris 1835; text in German
and French.
14 The painters Frederic Edwin Church and Cyrus
Field also followed in Humboldt's footsteps in 1853;
see Kenneth W. Maddox, in: exh. cat. *From Canaletto to
Kandinsky. Masterworks from the Carmen Thyssen-Borne-
misza Collection*, Museo Thyssen-Bornemisza, Madrid
1996, p. 122. Melbye later also sold the Danish King a
harbour view of New York; see Benisovich/Dallett
1966, p. 47.
15 Thieme-Becker, Leipzig 1930, p. 353.
16 Jules Laprade, 'Camille Pissarro après des docu-
ments inédits', in: *Beaux Arts*, 17 April 1936, p. 24.
17 PV 4.
18 Bailly-Herzberg, Corr., vol. I, 1980, p. 25;
Shikes/Harper 1981, p. 35: 24 December.
19 Eugène Delacroix (St. Maurice by Paris
1798–1863 Paris), painter, lithographer and etcher.
20 Eugène Delacroix, in: *Journal*, vol. 2, pp. 167f.,
quoted in Shikes/Harper 1981, p. 37.
21 See Smith 1995, chapter 1: 'Manet, Baudelaire
und der Künstler als Flaneur', pp. 33–57.
22 Shikes/Harper 1981, p. 37.
23 As early as 1837 there is already a pictorial broad-
sheet (*Chemin de fer*), illustrated in: exh. cat. *Französi-
sche Bilderbogen des 19. Jahrhunderts. Sammlung Sigrid
Metken, Paris*, ed. by Sigrid Metken, Staatliche Kunst-
halle, Baden-Baden 1972, Novitäten, no. 67. Early ex-
amples of 'industrial' art included the railways by Wil-
liam Turner and Adolph von Menzel (*Die Berlin-Pots-
damer Eisenbahn*, 1847); factories by Karl Blechen (*Das
Walzwerk bei Eberswalde*, c. 1835) and the industrial pano-
rama by George Inness (*The Lackawanna Valley*, 1855).
24 Sfeir-Semler 1992, pp. 320, 408. Her account of
the kind of landscape painting preferred by the offi-
cial buyers is somewhat contradictory, see p. 320:
'topographische Landschaft'.
25 Gustave Courbet (Ornans by Besançon 1819–1877
La Tour de Peilz, Switzerland), leading exponent of
French Realism.
26 Shikes/Harper 1981, pp. 40f..
27 The words of the critic Champfleury writing to
Georges Sand, quoted in: Linda Nicklin, *Realism and
Tradition in Art 1848–1900*, New York 1966, p. 35.
28 PV 10, vol. 2, p. 78.
29 Daniel Hermann Anton Melbye (Copenhagen
1818–1875 Paris). One drawing is illustrated in: exh.
cat. *Zeichnungen aus fünf Jahrhunderten*, Staatsgalerie
Stuttgart, Stuttgart 1999, no. 134, ill. 139.
30 Shikes/Harper 1981, p. 42.
31 Bailly-Herzberg, Corr., vol. I, 1980, p. 26.
32 Shikes/Harper 1981, pp. 43f.
33 François-Eduard Picot (Paris 1786–1868 Paris),
painter of history paintings and portraits, pupil of
Jacques-Louis David.
34 Isidore Dagnan (Marseilles 1794–1873 Paris),
landscape painter.
35 Karl Ernst Rudolf Heinrich Salem Lehmann (Kiel
1814–1882 Paris), painter of history paintings and
portraits, pupil of Jean-Auguste-Dominique Ingres.
36 Brettell/Lloyd 1980, indications of dates often
only in the catalogue text.
37 PV 5, PV 8.
38 Augustin Brunias or Brunais (1730–1796), Italian
landscape painter; in 1752 won the prize of the Accad-
emia di San Luca, Rome, see *Allgemeines
Künstlerlexikon*, vol. 14, Munich 1996, p. 530.
39 Cf. Peter C. Sutton, 'Augustin Brunias, Two
Indian Women Coming from Market', in: exh. cat.
Madrid 1996 (as note 14), pp. 66, 279, ill. 11.
40 David Jacobsen (Copenhagen 1821–1871
Florence), Danish genre painter and sculptor.
41 Exh. cat. Paris 1981, p. 59; Bailly-Herzberg, Corr.,
vol. I, 1980, p. 26.
42 Shikes Harper 1981, p. 46.
43 Brettell/Lloyd 1980, nos 50ff.
44 Charles-François Daubigny (Paris 1817–1878
Auvers-sur-Oise), French landscape painter.
45 *The Harvest*, 135 x 196 cm, Louvre, Paris, illus-
trated in: Madeleine Fidell-Beaufort and Janine Bailly-
Herzberg, *Daubigny*, Paris 1975, ill. 21.
46 Exh. cat. Paris 1981, p. 59.
47 PV 12.
48 Kopplin 1981, p. 105.
49 Alfred De Dreux, also, Dedreux (Paris 1810–1860
Paris), mainly painted riders, horses and dogs.

50 Louis Hautecœur, *La Peinture au Musée du Louvre, Ecole française, XIX. siècle*, Paris undated [after 1912].

51 Exh. cat. Paris 1981, p. 59.

52 PV 13; see Brettell/Lloyd 1980, no. 52.

53 Brettell/Lloyd 1980, nos 52, 59.

54 The little picture of a saddled-up donkey is hardly the *Landscape at Montmorency* shown in the Salon of 1859; this is more likely to be connected with two landscape drawings (held in Oxford) from 1857, which look as though they could have been executed in oils. See Brettell/Lloyd 1980, nos 50f.; on the other hand, see also Julius Meier-Graefe 1904, p. 479; cf. also the *Catalogue sommaire illustré des peintures du musée du Louvre et du musée d'Orsay, Ecole française L–Z,* ed. by Isabelle Compin and Anne Roquebert, Paris 1986, p. 137, R. F. 1943–8.

55 Shikes/Harper 1981, p. 53.

56 Ludovic Piette-Montfoucault (Niort 1826–1877 Paris), landscape painter.

57 Exh. cat. Paris 1981, p. 59.

58 Ibid.

59 Shikes/Harper 1981, p. 54.

60 Duret 1920, p. 36.

61 Sfeir-Semler 1992, pp. 139–141.

62 Exh. cat. Paris 1981, p. 59.

63 Shikes/Harper 1981, p. 57; exh. cat. Paris 1981, p. 59, has the date as 23 Februar 1863.

64 Exh. cat. Paris 1981, p. 59.

65 Jean Leymarie and Michel Melot, *Französische Impressionisten. Das graphische Werk von Manet, Pissarro, Renoir, Cézanne, Sisley,* Munich 1972, pp. 8–10.

66 Jules Breton, *Nos Peintres du Siècle,* Paris 1899, p. 199.

67 Théodore Duret, *Die Impressionisten,* Berlin 1920, p. 36.

68 Sfeir-Semler 1992, p. 138.

69 Shikes/Harper 1981, p. 63; cf. Bailly-Herzberg, Corr., vol. I, 1980, p. 28.

70 Shikes/Harper 1981, p. 68.

71 Exh. cat. Paris 1981, p. 59.

72 Antoine Guillemet (Chantilly 1843–1918 Dordogne), made his debut in the Salon in 1865; a member of the jury from 1880 onwards.

73 Francisco Oller y Cestero (born 1833 in Puerto Rico), pupil of Courbet and Thomas Couture.

74 Bailly-Herzberg 1998, p. 207.

75 Pierre-Joseph Proudhon, *Du Principe de l'art et de sa destination sociale*, Paris 1875.

76 Unlike Manet's version, all the participants in Monet's outdoor repast are fully clothed. Illustrated in: Daniel Wildenstein, *Monet. Vie et œuvre,* vol. 1, Lausanne 1974, no. 63, p. 144.

77 Exh. cat. Paris 1981, p. 59.

78 It seems Corot spoke "severely" to him; see Shikes/Harper 1981, p. 70.

79 Zola 1959, pp. 78f.

80 Bailly-Herzberg, Corr., vol. I, 1980, p. 29.

81 Exh. cat. Paris 1981, p. 59; Shikes/Harper 1981, p. 84.

82 Zola 1959, pp. 135, 130.

83 Exh. cat. Paris 1981, p. 60.

84 Duret 1920, p. 37.

85 Duret 1920, pp. 9f., mentions that in 1870 Fantin-Latour exhibited a picture in the Salon with the title *Atelier in Batignolles*, which shows Manet at his easel, surrounded by his friends Monet, Renoir, Bazille, Zola and Astruc. This was how the group of critics came by the name 'Groupe de Batignolles'.

86 It may well be that amongst the works lost during the Franco-Prussian war in 1870/71 there were also keyworks by Pissarro from La Grenouillère; see also the year 1871 in this biography.

87 Compare Pissarro's painting (PV 96, now in the Bührle Collection) with the painting by Monet from 1867 (Daniel Wildenstein [as note 76], no. 95).

88 Monet's *Voltigeurs de la Garde flânant au bord de l'eau* of 1870 (Daniel Wildenstein [as note 76], no. 149, 1870) is very reminiscent of Pissarro; cf. *Barges on the Seine,* c. 1864 (cat. 3), as well as the later *Port Marly,* 1874 (1872?).

89 Shikes/Harper 1981, p. 90.

90 Shikes/Harper 1981, p. 95; For more details see exh. cat. Paris 1981, p. 60.

91 Rewald 1963, p. 47.

92 Shikes/Harper 1981, pp. 91f.

93 House 1978, p. 637.

94 PV 106, p. 94.

95 In *Hyde Park* Monet banishes colour so completely that it is very reminiscent of *Penge Station, Upper Norwood* by Pissarro. In Duret's words, Pissarro was not yet painting "in full light", but still "rather darkly"; see Duret 1920, p. 4. Statements by contemporaries that Pissarro had removed black, brown-grey and ochre from his palette in 1865 are clearly wrong. For more on this, cf. Barbara Ehrlich White, *Impressionists side by side: their friendships, rivalries, and artistic exchanges,* New York 1996, pp. 110, 116f., ills. pp. 116, 131.

96 Lloyd 1975, p. 725. The difference to the paintings made before their flight to England lies rather in the dispositions of the colours than in the distribution of the pictorial elements.

97 Compare the shadows in his Louveciennes paintings, 1870–1872, illustrated in Pissarro 1993, p. 63, with pictures from Pontoise, c. 1867, ibid., p. 54, above all no. 46, where the evening light on the hill in the background neither fits the dark foreground nor the noon sky.

98 Christopher Gray 'Armand Guillaumin. Leben und Werk', in: exh. cat. *Vom Spiel der Farbe. Armand Guillaumin (1841–1927) – ein vergessener Impressionist,* ed. by Rainer Budde, Wallraf-Richartz-Museum, Cologne 1996, p. 20.

99 Shikes/Harper 1981, pp. 102, 107.

100 Exh. cat. *Jean-François Millet,* Grand Palais, Paris 1975, Chronology, p. 30.

101 Caroline Durand-Ruel Godfroy, 'Paul Durand-Ruel et Alfred Sisley: 1872–1895', in: exh. cat. *Sisley,* Royal Academy of Arts, London, et al., New Haven 1992, Table p. 47.

102 PV 106, vol. 2, p. 94.

103 Shikes/Harper 1981, p. 116.

104 Shikes/Harper 1981, p. 118; according to Duret 1920, p. 39, it was Pissarro who was influenced by Cézanne's glowing colours. This theory is undermined both by Pissarro's spectrum of colours as well as by the style of Cézanne's studio work up to this point, which Duret also mentions.

105 Christopher Gray (as note 98), p. 21.

106 Exh. cat. Paris 1981, p. 60.

107 Shikes/Harper 1981, p. 102.

108 Shikes/Harper 1981, pp. 103–106.

109 PV 221.

110 Bailly-Herzberg, Corr., vol. I, 1980, p. 79, note. 1.

111 Graber 1943, pp. 31–33.

112 Graber 1943, p. 35.

113 Exh. cat. Paris 1981, p. 60.

114 Duret 1920, pp. 14, 39.

115 Shikes/Harper 1981, p. 109.

116 Shikes/Harper 1981 mention hopes of a modest but regular income, pp. 98, 105, 107.

117 Christopher Gray (as note 98), p. 24.

118 Quoted in: Shikes/Harper 1981, pp. 112.

119 Emile Zola, 'Peinture', in: Le Figaro, 2 May 1896, reprinted in: Zola 1959, pp. 265–270.

120 Pastorale, 1873, Glasgow Art Gallery and Museum. Intended for the Salon of 1873, this was originally the Dance of the Nymphs, which Corot gave unfinished to a friend; see France Schoeller and Jean Dieterle, Corot, 2. Supplement, Paris 1956, no. 84.

121 Duret 1920, p. 25.

122 Ernest Chesneau, 'L'Artiste', quoted in: Pierre Miquel, Le Paysage français au XIXième siècle, vol. 2, Maurs-la Joli 1975, p. 57.

123 Duret 1920, p. 2.

124 Exh. cat. Paris 1981, p. 60.

125 Duret 1920, p. 17.

126 PV 106, vol. 2, p. 94.

127 Exh. cat. Paris 1981, p. 60.

128 Shikes/Harper 1981, p. 127.

129 Letter to Lucien on 22 November 1895, in which Pissarro reports on the Cézanne exhibition at Vollard's, quoted in Barbara Ehrlich White, Impressionists side by side: their friendships, rivalries, and artistic exchanges, New York 1996, p. 118.

130 Exh. cat. Paris 1981, p. 60.

131 Zola 1959, p. 54.

132 Duret 1920, pp. 17f.

133 Theodor Alt, Die Herabwertung der deutschen Kunst durch die Parteigänger des Impressionismus, Mannheim 1911, p. 366.

134 Shikes/Harper 1981, p. 141.

135 Duret 1920, p. 18.

136 Shikes/Harper 1981, p. 139.

137 Graber 1943, pp. 49, 53.

138 Letter c. 12 June 1878 to Murer; Bailly-Herzberg, Corr., vol. I, 1980, p. 113.

139 Graber 1943, p. 58, note. 1.

140 Duret 1920, p. 40.

141 Exh. cat. Paris 1981, p. 63.

142 Graber 1943, p. 59.

143 But there is said to have been an exhibition by Claude Monet in the offices of the journal La Vie moderne in the boulevard des Italien; see Duret 1920, p. 22.

144 Exh. cat. Paris 1981, p. 63.

145 Graber 1943, p. 61.

146 Caroline Durand-Ruel Godfroy (as note 101), pp. 48f.

147 Graber 1943, p. 62.

148 For more on this see Pissarro 1993, pp. 156f.; Brettell/Lloyd 1980, pp. 17f.

149 Cf. the crossed legs (?) of Millet's peasant crocheting with those of Pissarro's resting peasant.

150 Linda Nochlin, 'Camille Pissarro. The Unassuming Eye', in: Lloyd 1986, p. 9. In 1887 Pissarro rejects what Millet was doing, but not without mentioning the high prices that the latter's works fetch: letter of 16 May 1887, in: Bailly-Herzberg, Corr., vol. II, 1986, p. 169.

151 In 1872, amongst other things, Durand-Ruel exhibited Millet's Une Bergère assise and L'Angelus. He sold the latter in 1872 for 38,000 francs; the buyer then sold it in 1881 for 160,000 francs, the others were priced at between 12,000 and 15,000 francs. Furthermore Millet's late depictions of shepherdesses came very close to Impressionism; see exh. cat. Jean-François Millet, Grand Palais, Paris 1975, pp. 30, 103, 105, 283f.

152 Kopplin 1981, pp. 104–106.

153 Graber 1943, p. 46, p. 73.

154 Bailly-Herzberg 1998, p. 224.

155 Duret 1920, p. 22; in exh. cat. Paris 1981, p. 63.

156 Pissarro 1943, p. 44.

157 Shikes/Harper 1981, p. 162.

158 Sfeir-Semler 1992, p. 114, notes that the awards ceremony for the Salon medals had been degraded from a state occasion in the Louvre to a much lesser event with the students of the Académie des Beaux-Arts.

159 Pissarro 1943, p. 23.

160 Ibid., p. 58.

161 Exh. cat. Paris 1981, p. 63.

162 Letter of 6 November 1886, in: Bailly-Herzberg, Corr., vol. II, 1986, p. 75.

163 Wilhelm Goerdt, Russische Philosophen, Freiburg 1984, p. 530.

164 Robert L. Herbert and Eugenia W. Herbert, 'Artists and Anarchism', in: Burlington Magazine, 102, 1960, pp. 474, 477.

165 Exh. cat. Paris 1981, p. 63.

166 Letter to Lucien in January 1886, in: Bailly-Herzberg, Corr., vol. II, 1986, p. 15.

167 Lucien Pissarro, 'Talk on Impressionism in Art' (1891), quoted in: Thorold 1993, p. 214.

168 Pissarro 1953, pp. 67f.; Exh. cat. Paris 1981, p. 63; the Neo-Impressionists, on the other hand, are only shown in one separate room.

169 Letter of 30 December 1886, in: Pissarro 1943, p. 86.

170 Smith 1995, pp. 134–142.

171 Exh. cat. Paris 1981, p. 63.

172 Letter of 25 August 1887, in: Pissarro 1943, pp. 117f.

173 Letters of 4 July and 11 August 1887 to Camille, in: Thorold 1993, p. 99.

174 Pissarro 1993, p. 221; Smith 1995, pp. 122–128.

175 Exh. cat. Paris 1981, p. 63.

176 Exh. cat. Dallas 1993, p. XII.

177 Thorold 1992, p. 332.

178 Pissarro 1943, pp. 131–132. Pissarro made a number of experimental pictures, which at least approach the doctrinaire principles of Pointillism (e.g. PV 694, PV 719, PV 723).

179 Exh. cat. Paris 1981, p. 63.

180 Sfeir-Semler 1992, p. 438.

181 Exh. cat. Paris 1981, p. 63.

182 Thorold 1993, p. 235. This excellently presented material raises hopes of further study into the division of labour between father and son.

183 Jean Leymarie and Michel Melot, *Französische Impressionisten. Das graphische Werk*, Munich 1972, p. 22.

184 Robert L. Herbert and Eugenia W. Herbert (as note 164), p. 477; according to exh. cat. Dallas 1993, p. XII, the 'Club de l'Art Social' had already been founded by Tabarant in 1889.

185 Thorold 1992, p. 332.

186 Exh. cat. Paris 1981, p. 64.

187 Shikes/Harper 1981, p. 256.

188 Exh. cat. Dallas 1993, p. XII.

189 Klaus Berger, *Japonismus in der westlichen Malerei 1860–1920*, Munich 1980, p. 188; Bailly-Herzberg, Corr., vol. II, 1986, p. 350.

190 Cf. exh. cat. *Japonisme, Japanese Influence on French Art 1854–1910*, ed. by Gabriel P. Weisberg, The Cleveland Museum of Art, London 1975, no. 145, p. 100; Exh. cat. *Le Japonisme*, Grand Palais, Paris 1988, no. 200 b, p. 207.

191 Exh. cat. Paris 1981, p. 64.

192 Shikes/Harper 1981, pp. 262, 256, 258.

193 Thomson 1982, pp. 19f., 23.

194 Shikes/Harper 1981, p. 263.

195 Shiff 1992, pp. 309f.

196 Shikes/Harper 1981, p. 261.

197 Exh. cat. Dallas 1992, p. XII.

198 Shikes/Harper 1981, p. 269; according to exh. cat. Paris 1981, p. 64, Durand-Ruel makes purchases to the value of 23,600 francs.

199 In December Durand-Ruel makes a further purchase worth 28,600 francs. Pissarro is able to finally pay off all his debts.

200 Exh. cat. Paris 1981, p. 64.

201 Shikes/Harper 1981, pp. 276f.

202 Jean-Léon Gérôme (Vesoul 1824–1904 Paris), painter and sculptor.

203 Shikes/Harper 1981, p. 275.

204 Duret 1920, p. 23.

205 Exh. cat. Bremen 1991, p. 81.

206 Shikes/Harper 1981, p. 288.

207 Border design for *Chloé Washing Daphne by a River*, letter of 26 September 1895, in: Thorold 1993, pp. 423–433.

208 Bailly-Herzberg 1981, nos 321–323, p. 56.

209 Duret 1920, p. 41.

210 Shikes/Harper 1981, pp. 293f.; Bailly-Herzberg 1981, nos 1232f.

211 Théodore Duret, 'Claude Monet und der Impressionismus', in: *Kunst und Künstler*, 2, 1904, pp. 240, 242.

212 Dagmar E. Kronenberger, *Die Kathedrale als Serienmotiv*, Frankfurt am Main 1996, p. 13.

213 Letter of 13 Februar 1897, Hôtel de Russie; cf. exh. cat. Paris 1981, p. 141.

214 Exh. cat. Paris 1981, p. 64.

215 Shikes/Harper 1981, p. 309.

216 *Die Kunst für alle*, 1898, p. 132.

217 Lloyd 1975, p. 725.

218 Exh. cat. Paris 1981, p. 64.

219 Shikes/Harper 1981, p. 309f.

220 Shikes/Harper 1981, p. 310.

221 Exh. cat. Paris 1981, pp. 64f.

222 'Schwäbische Kronik', no. 146, in: *Abendblatt*, 27 March 1901.

223 Exh. cat. Paris 1981, p. 65.

224 Francis Picabia (Paris 1879–1953 Paris).

225 Belinda Thomas, *Gauguin by Himself*, Boston 1995, p. 275.

226 PV 316–318, vol. 2, p. 332.

Camille Pissarro
Study of a Female Peasant Picking Beans
Grey/brown wash over pencil on paper, 14.9 x 19.1 cm
Ashmolean Museum, Oxford
BL 221

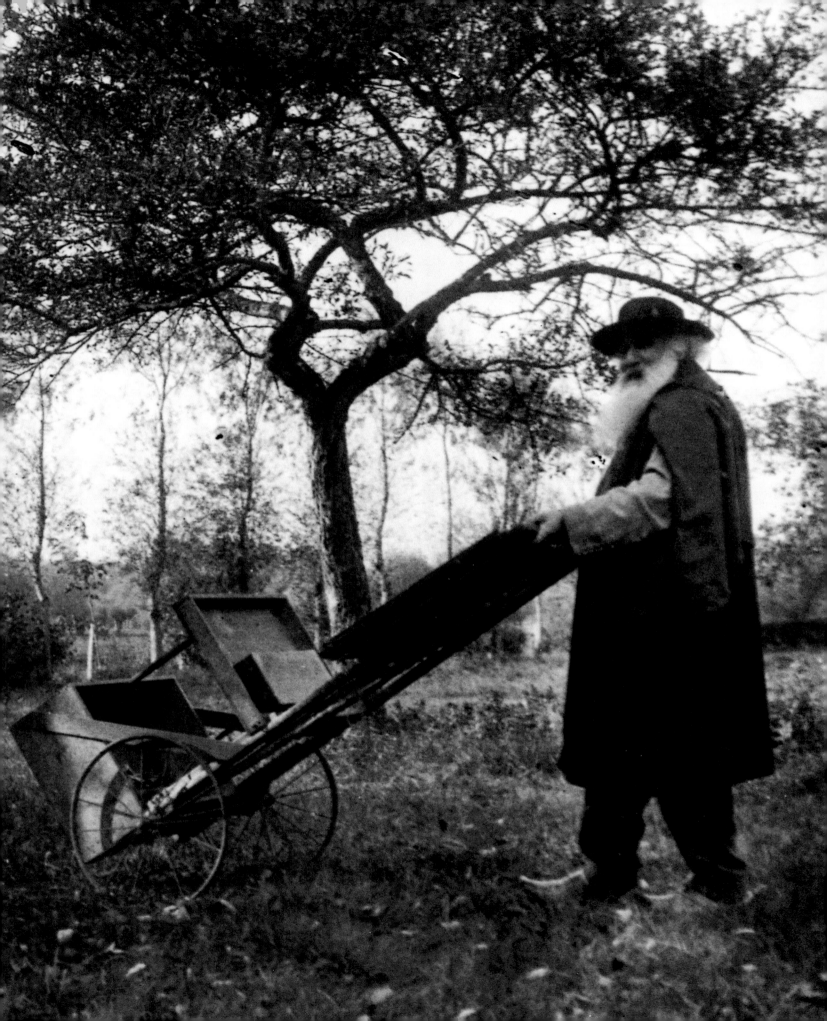

CAMILLE PISSARRO, IMPRESSIONIST ARTIST Christoph Becker

The old man in the garden outside his house was one of the most influential artists of his day. His contemporaries used to refer to him as "Apostle" or "Moses".[1] When he painted the first of his four self-portraits (cat. 1) Camille Pissarro was already 43 years old and not yet a mighty patriarch amongst artists, and by no stretch of the imagination a painter spoilt by success. Modesty, an astute mind and a warm heart were the qualities that the great scholar of Impressionism, John Rewald, saw in Pissarro's portraits – and true enough, the sight of the photograph of him in the garden, a wheelbarrow of garden-soil in front of him, makes it seem as though one could reach out and touch the tranquil existence of an artist in the 19th century. But appearances deceive. It is clear from Pissarro's biography that this man was a tireless worker, an efficient organiser and an outstanding mentor. His œuvre comprises more than two thousand paintings and most probably the same amount of drawings and prints as well as thousands of letters, written over a period of forty years between 1860 and 1903.

Camille Pissarro, the Impressionist: his part in the emergence and evolution of Impressionism can hardly be adequately appreciated. An outward indicator of the role he played is the fact that he, alone, took part in all eight of the legendary Impressionist exhibitions, but it is only by looking at a representative selection of his works that one can begin to acquire a sense of the full range of his expression as an artist.

The following commentary on Pissarro's pictures is divided into four sections. The first presents his early work, by way of selected examples; this is followed in the next by an exploration of Pissarro's path towards Impressionism plus his individual contribution to the movement. The third section addresses his transition from landscapes to genre painting as well as his experiments with Neo–Impressionism. Lastly we examine his cityscapes and review his art as a whole.

I IN NATURE'S SCHOOL 1860–1870

Pissarro's early period is spent on St Thomas, in Caracas and France. His studies take him out into the country, into the area around Paris. He becomes a landscape painter. The first signs of Impressionism.

The first of the four decades spanning Pissarro's career as an artist was shaped by the different places where he lived. Camille Pissarro produced his first works far away from France on St Thomas, the largest of the Virgin Islands, where his parents ran a general store. In 1851, the 21 year-old met the Danish artist

Cat. 1
C. Pissarro, Self-Portrait
Portrait of C. Pissarro
1873
Oil on canvas, 55 x 46.7 cm
Musée d'Orsay, Paris, Gift of
Paul-Emile Pissarro,
RF 2837
PV 200

Fritz Melbye, who saw him drawing at the harbour in Charlotte Amalie, the main town on the island.[2] On 12 November 1852, the two sailed to Caracas, and there Pissarro started to draw scenes from nature. His drawings from that period include numerous landscapes but also genre scenes with the locals. Two large-format drawings – *Wooded Landscape on Saint Thomas*, c. 1854 (cat. 74) and *The Christian Fort in Charlotte Amalie, Saint Thomas*, 1852 (cat. 73), depicting a fort on the harbour front in Charlotte Amalie – reveal that the artist was largely self-taught. When the two friends returned to St Thomas in August 1854, Pissarro had made considerable progress as an artist, and he now started to experiment with oils. He decided to go back to France, in order to pursue a career as an artist. In 1856, a year after his return, he painted *Two Women Chatting by the Sea, Saint Thomas* (cat. 2): a stylish, decorative early work with its golds, browns, and ochres, although conventional in its subject-matter and execution, that is to say, Pissarro was guided in this work by the art that was to be seen in the so-called Salon, the annual official exhibition of French art.

Initially he lived in his parents' apartment in Paris and rented a studio at 54, rue Lamartine, spending the summers in La Roche-Guyon. He mostly painted out in the countryside, in the little towns around Paris and by the rivers. It was here that he painted *Barges on the Seine* c. 1864 (cat. 3), already pointing towards his most important theme – landscape – the red thread that runs throughout his entire œuvre. The scene with the flat lands around La Roche-Guyon takes in the curve of the river with a barge; two more boats, one steam-driven are in the background. The river is not some deserted idyll, it is a place where people work. The steamboat, a modern sign of the times, makes it clear that Pissarro was not locating his landscape in some past era, but was seeing it with contemporary eyes. At the same time, however, he avoided the sheer spectacle of an "industrial landscape" – the central motif is not the modern steamboat but the more old-fashioned barge, which was still in much greater use. Overall the picture has a

matter-of-fact quality, which is typical of many of Pissarro's early works, and which is underpinned by the painterly technique: the paint is applied with a broad spatula, particularly in the area devoted to the sky, and the artist's palette is restricted to greens, browns, blues and white.

In *Square in La Roche-Guyon*, c. 1867 (cat. 4), the houses under a grey sky huddle around a triangular view of the square, which is cut off to the right by the windowless narrow side of a house running the full height of the canvas and creating an impression of oppressive closeness. Clearly Pissarro was interested in the interlocking architecture of gables and roofs, which he then combined, into his own planar composition. The brown and beige, triangular and rectangular planes and the large parallelogram of the roof in the centre are balanced in their composition, and convey the impression of small-town solidity. This painting is an exception in Pissarro's output because in his early period he was really not painting town and city scenes, but used to retreat instead into the open countryside around the towns.

The impasto of the heavy colours applied with a palette knife is typical of the pictures he was painting in the 1860s, generally restricted to browns, greens and blues. At the time Pissarro was experimenting with binding agents and different grounds for individual sections – which ties in with the fact that his artistic output in the 1860s was somewhat sparse and only picked up again noticeably around 1870. This was also the time when his private life took an important new direction. For this was when he met Julie Vellay, who worked as a kitchen maid for his parents. When Julie became pregnant, the middle-class Pissarro family could only see it as a scandal and his parents put up bitter resistance to the situation, because a marriage between the two would mean their son stooping below his class. Undeterred, Camille and Julie stayed together without his parents' blessing. In 1863 Julie gave birth to a son, Lucien, and two years later – the same year that Pissarro's father died – she gave birth to a daughter, Jeanne. The curt

rejection that Julie suffered from Pissarro's mother at least indirectly influenced Pissarro's subsequent life and political attitudes. (His anti-bourgeois attitudes and his supposedly anarchist connections will be discussed at a later point.) Meanwhile Pissarro had been attending the highly respected Académie Suisse in Paris, a private art school, which concentrated mainly on teaching life-drawing and where he had already met Claude Monet and Paul Cézanne in 1860. He struck up a friendship with both artists, which led to their working together in the 1870s.

Pissarro left Paris in 1866, and moved with his partner and their children to Pontoise, where they lived until 1869. He later returned to the little town on the Oise between 1872 and 1883. In those days, the so-called Paris Basin was one large, almost permanently green garden, which above all produced vegetables for the markets in the metropolis. In the 1870s the Parisians developed a positive mania for buying the freshest possible produce, with the result that Pontoise – with a railway station and the perfect, abundant supply of water for cultivating vegetables – became an extremely lively little market town.

The House of Père Gallien, Pontoise, spring 1866 (cat. 5), captures a scene on the outskirts of the town. The main motif is a single fruit-tree, which has just come into leaf; underneath it stands a finely dressed couple. In the centre, behind stone walls, there are a number of several-storeyed houses, loosely grouped together like country villas under the high, grey, cloudy sky. Sparing in its motifs and restrained in its colours, this painting is a select example of painterly skill and, despite its enchanting simplicity, is not without a shimmer of irony. For the elegant couple, trying to find a way across a ploughed field, does not seem to quite fit into the rural idyll of early spring. The picture is redolent with the cultivated boredom of a bourgeois excursion into the country.

The 'Côte du Jallais', Pontoise, 1867 (cat. 6) is one of a number of large-format compositions which were intended for the Salon of 1868 and which show the influence of Charles Daubigny and Gustave Courbet.[3] Particularly the way that the foreground and the path relate to the high, almost horizontal brow of the hill is reminiscent of Gustave Courbet's landscapes around Ornans from the late 1850s. The elements which give the picture its particular character – in Pissarro's case the group of pale houses – are located in the middle-ground.[4] This painting marks a breakthrough on Pissarro's part: the brushwork is powerful, almost impetuous, with the foreground made up of short lines and flecks and the background divided into planes. The play of light and shade is continued in the summer sky, which is executed with great painterly confidence, not unlike a watercolour.[5] Charles Daubigny, whose landscapes Pissarro much admired, made sure that The 'Côte du Jallais' was shown in the Salon of 1868. There the writer and art-critic Emile Zola saw it and commented: "A little valley, a few houses with their roofs just showing at the bottom of a path climbing upwards; then, on the other side, a slope with fields dividing it into bands of green and brown. That's what the modern countryside looks like. One senses that man has been there, tilling the land and cutting it up, giving it a melancholy appearance. And this little valley, this hill are heroic in their simplicity and candour."[6] Zola's judgement is objective. He recognises Pissarro's strengths, his precise observation of nature and his spontaneous grasp on reality, which Zola describes as "truthfulness". Pissarro is acclaimed as a master of the "modern landscape", although it is not clear whether Zola means as its creator or chronicler. But Zola's main point is that Pissarro is above all a modern artist (whose only concern is the truth and to be true to his own conscience) because he is "neither a poet nor a philosopher, simply a naturalist".[7] Thus Pissarro was admitted into the ranks of the most modern movement of the day, the 'Naturalists', whose leading exponents were Gustave Courbet and Camille Corot.[8] The Naturalists, who avoided traditional forms of allegory in their pictures, were not out to edify or entertain their viewers. Pissarro's unadorned portrayals of rural scenes fitted with this attitude

and soon coloured opinions of his character. In the same review of the Salon of 1868 Zola put it as follows: "His originality is deeply human. It is not mere manual skill, falsely transcribing nature. It derives from the very temperament of the painter, from his rigour and gravitas. No paintings have ever seemed to me more masterly in their scope. In them one hears unfathomable voices from the depths of the earth, one senses the powerful life of the trees. The austerity of the horizons, the disdain for extravagance, the complete lack of piquant overtones gives the whole an epic grandeur that is hard to define. This kind of reality goes beyond dreams. The formats are quite small, and yet one has a sense of looking far out into countryside."[9]

The Maidservant of 1867 (cat. 7) perhaps demonstrates most clearly the significance of Corot's art for the young Pissarro, who described himself as a "pupil of Corot's".[10] Clearly the motif, the posture and the relatively small format are all influenced by Corot, but — unlike the cool, silvery tones favoured by the latter — this work uses strongly contrasting colours, applied with broad strokes of the brush, which Pissarro now preferred to the palette knife. This painting has a distinct affinity with an extant photograph from that time, showing Mme Pissarro in the garden being given a glass of punch by a serving maid (fig. 1). The similarity of the pose and the clothing in the photograph and the painting points to a little known aspect of Pissarro artistic praxis. He evidently used photographs, like Degas, to check on certain motifs and bodily postures, indeed it even seems that he sometimes painted from photographs, even if only rarely. The difference between the black and white scene in the photograph – rather stilted because of the long exposure time required – and the gentle charm of the girl in Pissarro's painting, points to a characteristic quality in the artist: Pissarro was able to use the "original" simply as a technical aid. He transformed the objectivity of the photographic image, by taking the external form and using his brush and paint to imbue it with meaning – which one might describe here as stillness and dignity. Perhaps simply copying an original would already have qualified the work as 'Naturalist' in Zola's eyes, but Pissarro's own real allegiance is to the paradigms of the visible. The fact that he ascribed different tasks to painting and to photography, is confirmed by the drawing, *Study of the Artist's Mother with her Maidservant*, 1880–1885 (cat. 79), which is obviously a quick sketch from life. As a rule Pissarro worked on his paintings in a wholly traditional manner, and his works between 1860 and 1870 can properly be described as 'Naturalist'. The principles of Naturalism, "truthfulness" regarding the visible world, and the avoidance of any kind of allegorical excess were to be the foundations for the next stage in Pissarro's development.[11]

Fig. 1
Julie Pissarro in the garden with a maidservant, around 1867
Photograph: Pissarro Family Archive, Paris

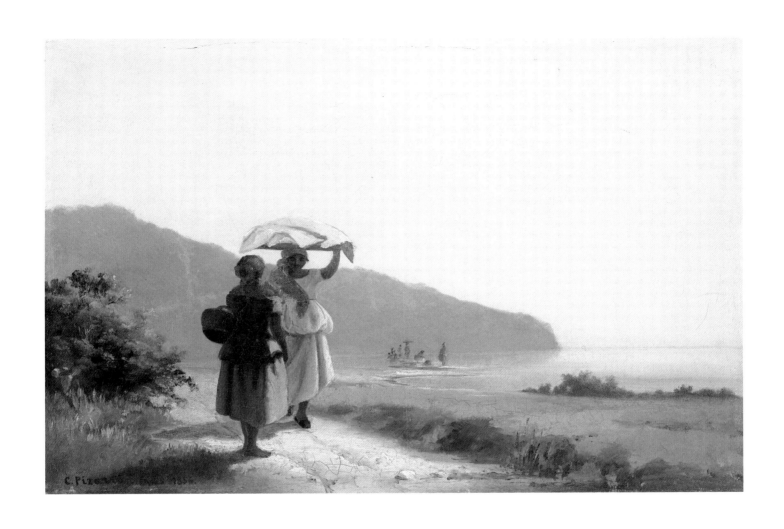

Cat. 2
Two Women, Chatting by
the Sea, Saint Thomas
Deux Femmes causant au
bord de la mer, Saint-Thomas
1856
Oil on canvas, 28 x 41 cm
National Gallery of Art,
Washington, Collection of
Mr. and Mrs. Paul Mellon,
1985.64.30
PV 5

Cat. 3
Barges on the Seine
Péniches sur la Seine
c. 1864
Oil on canvas, 46 x 72 cm
Musée Camille Pissarro,
Pontoise, p. 1980.3
Not listed in PV

Cat. 4
A Square in La Roche-Guyon
Une Place à La Roche-Guyon
c. 1867
Oil on canvas, 50 x 61 cm
Staatliche Museen zu Berlin –
Preußischer Kulturbesitz,
Nationalgalerie Inv. 75-61
PV 49

Cat. 5
The House of Père Gallien,
Pontoise
La Maison du Père Gallien,
Pontoise
1866
Oil on canvas, 40 x 55 cm
Ipswich Borough Council
Museums and Galleries
PV 48

Cat. 6
The 'Côte du Jallais',
Pontoise
La Côte du Jallais, Pontoise
1867
Oil on canvas, 87 x 114.9 cm
The Metropolitan Museum of
Art, New York, Bequest of
William Church Osborn,
1951, 51.30.2
PV 55

Cat. 79
Study of the Artist's Mother
with her Maid
Black chalk on paper,
28.4 x 21.9 cm
Ashmolean Museum, Oxford
BL 152

Cat. 7
The Maidservant
La Bonne
1867
Oil on canvas, 93.6 x 73.7 cm
The Chrysler Museum of Art,
Norfolk, Virginia, Gift of
Walter P. Chrysler, Jr.
PV 53

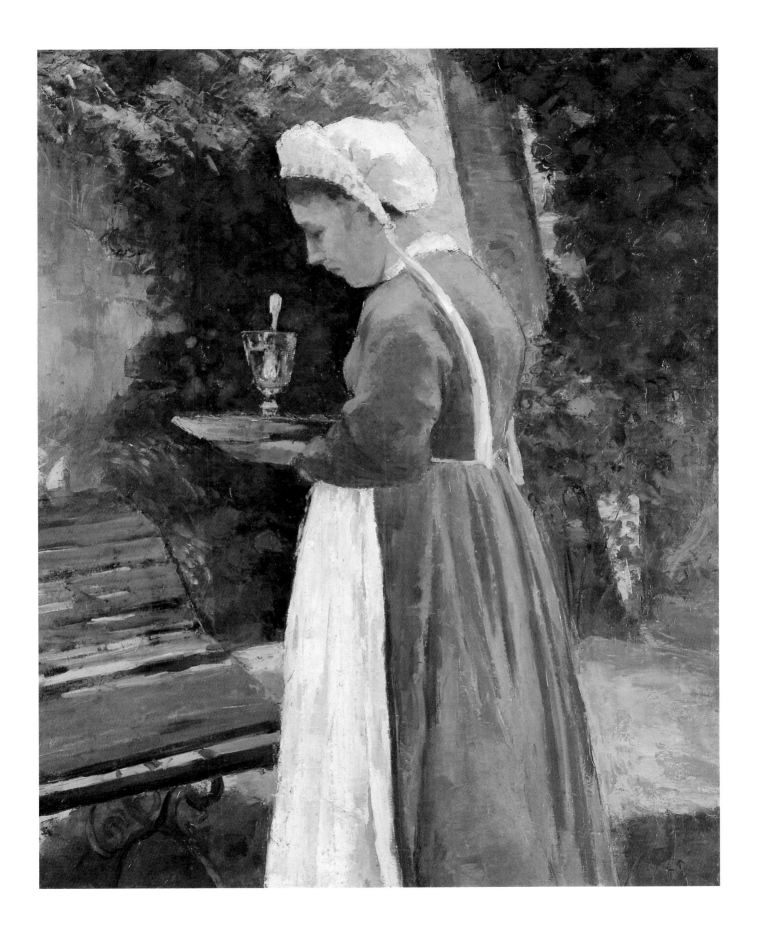

II THE IMPRESSIONIST MOVEMENT 1870–1880

In the 1870s, Pissarro – together with Claude Monet and Paul Cézanne – is a member of the avant-garde and plays a decisive part in the emergence of Impressionism. He mainly works in Pontoise, but also in Gisors, Montfoucault and London.

The 1870s saw a period of change in Pissarro's life, above all as a consequence of major political events in Europe. The Franco-Prussian War forced him to move a number of times, including a period of exile in England. Having spent a considerable time in Pontoise, in spring 1869 he moved with his family to Louveciennes, and in autumn 1870, they moved to Montfoucault, in order to escape the advancing German troops. In winter of the same year the Pissarros fled to England, where they found a temporary home near London. In July 1871, two years after they had left Louveciennes, they returned there once more. During this restless time Pissarro's artistic output by no means stagnated; on the contrary, he began to distance himself from his Naturalist beginnings and to change his style, initially almost imperceptibly. The decade 1870 to 1880 saw very few new themes in painting but it did produce an astonishingly wide range of styles and techniques; most importantly it saw the breakthrough of Impressionism, with Pissarro as a major player in the process. The central theme in his art was still the landscape. In brief, his stations during the 1870s were Louveciennes (1870 until 1872), interrupted by a period of exile in London (1871), and then a longer period in Pontoise (1872 until 1882).

Louveciennes and London 1870/71

Chestnut Trees in Louveciennes, Spring, 1870 (cat. 8) shows the local park, filled with the freshness of an early spring day. The sun is just out of the picture, and the trees cast long shadows across the grass. Oddly enough, the tree-trunks are pale although they are not facing the sun, while the figures seem to be caught in sunlight from the upper left. Perhaps these observations go to show that this painting – like a number of others with similar small discrepancies – were painted partly in the studio and partly in the open air. At the time Pissarro was working on the various effects of sunlight, shadows, and contrasts between brightly lit and shadowy areas. As in *Chestnut Trees in Louveciennes*, almost all of these canvases are small to medium in size and were easily transportable, for now Pissarro frequently worked in the open air. Generally he set up his easel so that the view would include a road or a path leading away into the distance. The horizons were now lower than before, in order to lend weight to the sky or the foliage on tall trees. Finely balanced in its composition, the small, precious *Landscape near Louveciennes*, 1870 (cat. 9) is imbued with a sense of great calm and equilibrium. Pissarro had now exchanged his palette knife for a narrow, stiff brush, which makes the facture appear less dense. The individual brushstrokes vary in their length, and sometimes colours mingle into larger, opaque patches. Despite the small format the composition seems open and unconstrained, for unlike Pissarro's paintings from the 1860s, now the sky and the vegetation are created simultaneously and seem to merge with each other. More and more the heavy tectonics of earlier works are lightening and dispersing; a new style is coming to light, for which there was no name as yet. In these paintings we see the first steps towards Impressionism.

In the early days, Louveciennes seemed to be the ideal spot for Pissarro to work. Since the construction of the railway line the distance to the little town seemed that much shorter. The journey from the Gare St. Lazare in Paris only took half an hour, and in good weather hundreds of Parisians would make the trip, keen to spend a day in the country. Artists arrived, and painted the country around them; and since the picturesque motifs were soon familiar to large numbers of people, the paintings sold well, particularly since art dealers and critics alike were beginning to take note of the

burgeoning artists' colony. But already in early September 1870, as the Prussians advanced towards Paris, things became too uncertain in Louveciennes and the place emptied again. Pissarro took up an invitation from his friend Ludovic Piette and hastily moved to Montfoucault. When Pissarro and his family finally reached safety in London at the end of the year, he took the opportunity — far from his parental home – to legalise his relationship; he and Julie were joined in marriage. In London he met up with Claude Monet,[12] who was also in exile, and through Charles Daubigny made closer contact with the art dealer Paul Durand-Ruel, who was to have a decisive influence on his career. Durand-Ruel had moved his business to London and had set up 'The Society of French Artists'; in 1871 he bought two paintings from Pissarro. Pissarro worked almost exclusively in the suburb of Lower Norwood, where he had found relatively inexpensive accommodation. His visits to the city took him to the National Gallery, as much for the collection of Italian Masters from the Middle Ages as for the paintings and watercolours by William Turner.[13] Meanwhile the Royal Academy did not see fit to accept works by either Pissarro or Monet for the annual exhibition. Two works from 1871, *Near Sydenham Hill (looking towards Lower Norwood)* (cat. 10) and *The Crystal Palace, London* (cat. 11),[14] perfectly exemplify his work during his short stay in London. The second of the two portrays a particularly popular motif of the day. This gigantic structure in iron and glass, made as an exhibition hall for the Great Exhibition in 1851, had been moved from Hyde Park to the suburb of Sydenham, and was now a tourist attraction that many of the émigré artists in London depicted in their work.[15] Like Pissarro's Louveciennes pictures, this composition derives considerable depths from the broad road separating the Crystal Palace grounds from the suburban homes and gardens. One single flag sets a marked accent, reminiscent of Monet. The road itself has nothing about it of Trafalgar Square, some miles away; if anything the scene is imbued with the contemplative calm of a suburban afternoon. Pissarro

concentrated exclusively on scenes immediately around where he was living, and his London pictures show the periphery of the metropolis, as though the modern middle-class homes were enough of an indication of the urban centre close by. Aside from this, Pissarro's London pictures reveal his lively interest in the technical advances that Great Britain was making in those days; above all he was interested by the trains that passed through the station at Upper Norwood several times a day. His three *Studies of Upper Norwood, London, with All Saints Church*, all from 1871 (figs. 2–4),[16] which were amongst a dozen studies of the same view, show how intensively Pissarro worked at each individual motif. Some were drawn *in situ*, while others were copied in his studio, traced, or had individual motifs extracted. His viewpoints were thus by no means a matter of chance and each composition was carefully planned.

Near Sydenham Hill (cat. 10) was set in a suburb, which offered numerous artists from France (including Monet) a safe haven for some months. At first sight this painting has a lot in common with *Chestnut Trees in Louveciennes* (cat. 8). However, the Sydenham picture is less expressively painted, in addition it is lighter, and Pissarro had clearly paid a great deal of attention to the topography. Despite this, the view is still relatively unspectacular. The comparison shows how little notice Pissarro took of the motifs provided by the tourist attractions so near to his new surroundings. London could have provided him with countless stunning cityscapes, but instead he stayed in the country and painted the colossal Crystal Palace with the same, plain matter-of-factness as his view of somnolent Sydenham Hill.

Again political events were to affect Pissarro's place of abode and, consequently, his work too. On a visit to London in spring 1871, Julie's sister, Félice Estruc, brought the news that during the four months of Prussian occupation in Louveciennes, his house had been used as a stable. Many of his works had disappeared or been destroyed – possibly as many

Cat. 8
Chestnut Trees in Louve-
ciennes, Spring
Châtaigniers à Louveciennes,
printemps
1870
Oil on canvas, 60 x 73 cm
Stiftung Langmatt Sidney
und Jenny Brown, Baden,
Switzerland
PV 88

Cat. 9
Landscape near
Louveciennes
Paysage à Louveciennes
1870
Oil on canvas, 45.8 x 55.7 cm
Southampton City Art
Gallery, 461
PV 97

Cat. 10
Near Sydenham Hill
(looking towards Lower
Norwood)
Environs de Sydenham Hill
(avec Lower Norwood au
fond)
1871
Oil on canvas, 43.6 x 53.8 cm
Kimbell Art Museum, Fort
Worth, Texas
PV 115

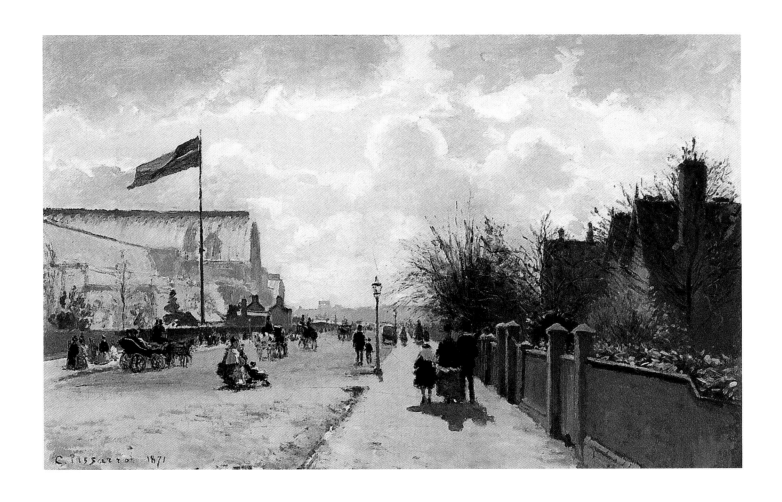

Cat. 11
The Crystal Palace, London
Le «Crystal Palace», Londres
1871
Oil on canvas, 47.2 x 73.5 cm
The Art Institute of Chicago,
Bequest of Mr. and Mrs. B. E.
Bensinger, 1972.1164
PV 109

Cat. 12
Outskirts of Louveciennes,
the Road
Environs de Louveciennes,
la route
1871
Oil on canvas, 46 x 55 cm
Collection of A. Rosengart
PV 119

Cat. 13
The Road to Louveciennes,
at the Outskirts of the Forest
La Route de Louveciennes, à
la sortie du bois
1871
Oil on canvas, 38 x 46 cm
Private collection
PV 120

Fig. 2
Camille Pissarro
Study of Upper Norwood,
London, with All Saints Church
Verso: see Fig. 3
Pencil on paper,
15.6 x 19.8 cm
Ashmolean Museum, Oxford
BL 68D r

Fig. 3
Camille Pissarro
Slight Study of All Saints
Church, Upper Norwood,
London
Recto: see Fig. 2
Pencil on paper, stained with
ink from another page,
15.6 x 19.8 cm
Ashmolean Museum, Oxford
BL 68D v

Fig. 4
Camille Pissarro
Study of Upper Norwood,
London, with All Saints Church
Pen and brown ink over pen-
cil on paper, 15.6 x 19.8 cm
Ashmolean Museum, Oxford
BL 68E r

as a thousand paintings, smaller studies and drawings – and with that almost his entire early work was lost.[7] In July 1871 he and his family returned to Louveciennes.

Amongst the few works which he made in the period immediately following his return from London is *Outskirts of Louveciennes, the Road* (cat. 12). Under the influence of studies by English artists, his own work in England, and his contact with Monet, his style now changed, even if barely perceptibly at first. He was becoming increasingly interested in natural light and its effect on colours. The tender blue of the sky in *Outskirts of Louveciennes* takes on a reddish hue towards the horizon, and bears witness not only to Pissarro's powers of observation but also to his skills as a painter. Isolated high points of colour are distributed across the picture in such a way that the composition seems perfectly self-contained without in any sense detracting from the radiant atmosphere. Somewhat similar, if rather denser in its texture, is the small painting *The Road to Louveciennes, at the Outskirts of the Forest,* 1871 (cat. 13), in which the dense vegetation at either side of the unpaved road merges smoothly into the two rows of houses. In both of these paintings, Pissarro paid particular attention to the sky and the play of the high clouds. He almost always preferred afternoon light, coming from various directions depending on the topography and the viewpoint. If one compares these works with those from five years previously, it is clear to see that he was already beginning to break away from Naturalism.

Pontoise and Montfoucault 1872–1874

In August 1872, Pissarro left Louveciennes and moved to Pontoise, where he had already lived for a time in the 1860s. Now Pissarro worked more or less without interruption for over a decade in Pontoise, and by the time he left in 1883, he had made more than three hundred paintings with scenes from the immediate vicinity of the town, as well as countless drawings, gouaches and prints. Pontoise played as integral a part in Pissarro's work and in the emergence of Impressionism,

as Ornans did for Gustave Courbet, Argenteuil for Claude Monet, Aix-en-Provence for Paul Cézanne, and Auvers for Charles Daubigny.[18] The places around Pontoise, where Pissarro set up his easel in those years, or where he threw off sketches as he passed that way, are so numerous that it is virtually impossible to quite take them all in. It seems he left nowhere out. At the same time there are certain motifs that he painted a number of times – like the road from Pontoise to Gisors or the hamlet known as L'Hermitage, which particularly fascinated him. It is interesting to note that Pissarro's extensive exploration of the geographical terrain affects the way his style develops.

The multiple greens and shades of yellow in *The Cabbage Field, Pontoise*, 1873 (cat. 14) transform the farmer's field into a shady realm caught in a strange spell. As in his earlier paintings, by reducing the colours in his palette to a few, richly graduated tones and by combining this with a clear pictorial structure, Pissarro creates a sense of melancholy stillness. *Misty Morning in Creil*, 1873 (cat. 15), one of the most unusual pictures amongst these early works, deals entirely in shades of grey, only broken up by matt accents in green, blue and orange. This picture takes up a topos beloved of Camille Corot, whose silvery grey, misty landscapes are certainly somewhere in the background here. But despite the similarity of the subject, the stylistic differences could hardly be greater. While Corot's subtle brushwork creates a fairy-tale, other-worldly aura, Pissarro's spontaneous, almost impulsive hand almost makes one feel one could reach out and touch the rugged simplicity of the agricultural landscape.

The sense of rural solitude is heightened yet further in the unusual *June Morning, View over the Hills of Pontoise*, 1873 (cat. 16). In it Pissarro addresses one of his favourite motifs: a tapering track through fields. But the view is so unspectacular that the composition almost seems to work by virtue of a negative dramaturgy. The dominance of the horizontal division between the ground and the sky – just above the half-way point of the picture – is

broken at the edges of the picture by striking, coloured accents framing the intervening expanses. Scarcely a single other picture from Pissarro's time in Pontoise is composed with such precision and concentration. With the almost abstract clarity that Pissarro achieves in this painting, he undoubtedly advances beyond the work his contemporaries were doing at the time. At the time Pissarro's contemporaries – Paul Cézanne, Claude Monet and Alfred Sisley – were living and working in the immediate neighbourhood. While the stylistic differences between them were recognisable, they were not startling. Thus the painting *Bourgeois House in L'Hermitage, Pontoise*, 1873 (cat. 17), shows the influence of Monet and Cézanne, both in its technique and in the choice of subject-matter.[19] Cézanne described Pissarro as "acharné", as a man possessed, and hugely admired the older painter's disciplined attitude to his work. Evidently the two artists often worked closely together on painting trips between Auvers and Pontoise, and it would be hard to say who in fact influenced whom. Presumably it was Pissarro who first made contact with the influential critics who then reported on the latest developments. In a letter to Théodore Duret, who had accused Monet of dilettantism, he wrote: "Are you not at all anxious that you might be mistaken about Monet's talent, which in my view is very serious and very pure, even if in rather a different sense from the one that is uppermost in your thinking? Monet's art is the result of deep study and based on observation and a whole new way of feeling."[20] The 'feeling' referred to in the French word 'sensation' was a key concept in the art of the avant-garde group around Pissarro. The fact that 'sensation' includes both the *sensual* experience and *sensational* event goes to the very heart of their shared approach to the aesthetics of what they were doing.

"We cannot refrain from observing that by following too strictly this theory, he frequently selects insignificant sites where nature itself does not present a composition, so that he produces a landscape without presenting a picture."[21] This statement, by the same critic,

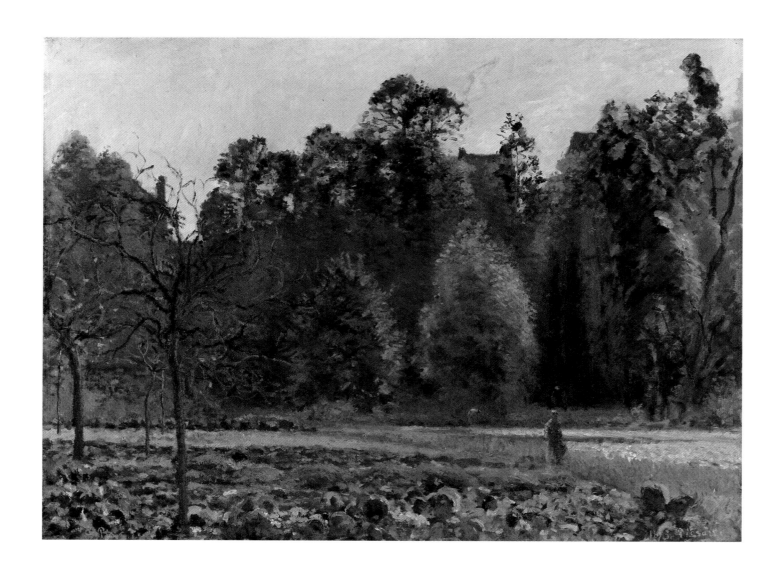

Cat. 14
The Cabbage Field, Pontoise
Le Champ de choux,
Pontoise
1873
Oil on canvas, 60 x 81 cm
Carmen Thyssen-Bornemisza
Collection
PV 230

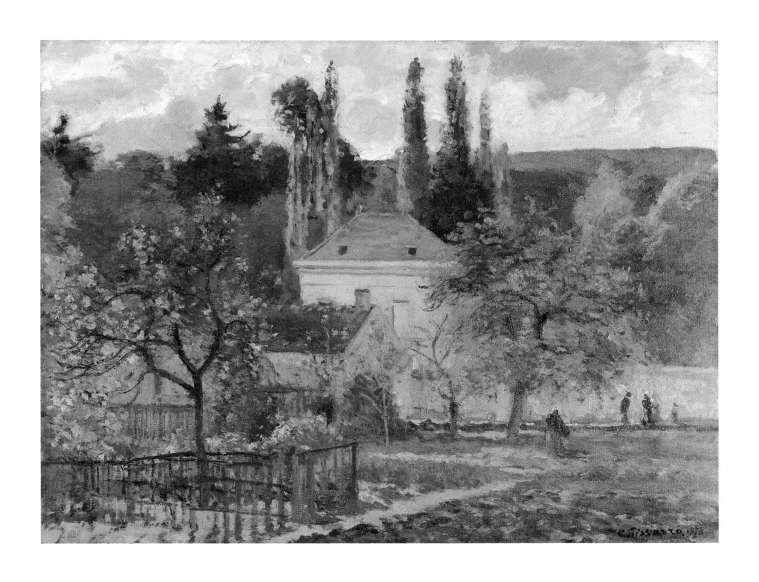

Cat. 17
Bourgeois House in
L'Hermitage, Pontoise
Maison bourgeoise à
l'Hermitage, Pontoise
1873
Oil on canvas 50.5 x 65.5 cm
Kunstmuseum Sankt Gallen,
Sturzeneggersche Gemälde-
sammlung
PV 227

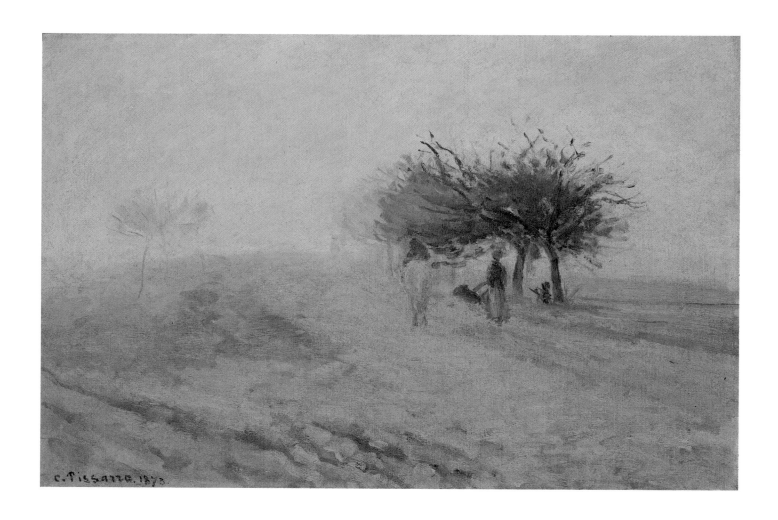

Cat. 15
Misty Morning in Creil
1873
Oil on canvas, 38 x 56.5 cm
Privately owned
Not listed in PV

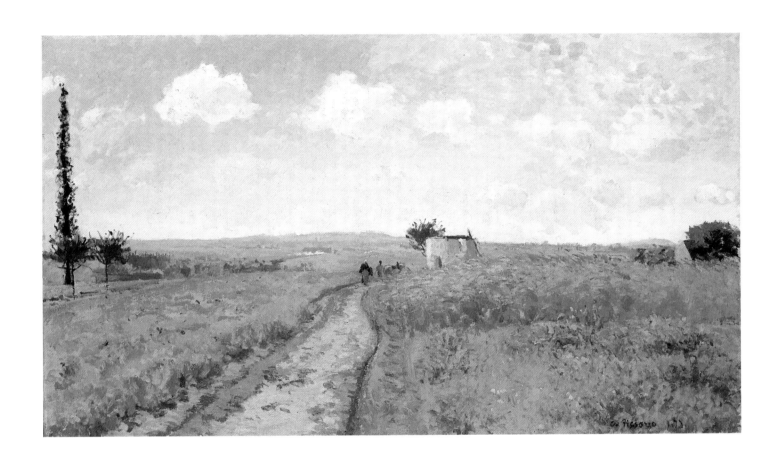

Cat. 16
June Morning, View over
the Hills of Pontoise
Une Matinée de juin, vue
prise des hauteurs de
Pontoise
1873
Oil on canvas, 54 x 91 cm
Staatliche Kunsthalle Karls-
ruhe, Inv. 2539
PV 224

Théodore Duret, and cited by John Rewald, could have been written specifically about *June Morning near Pontoise*, and in fact touches on the backdrop against which the idea of 'sensation' could turn into a battle-cry. Of course 'picture' means more than a piece of painted canvas. The term implied an artistic canon, which is precisely what Pissarro and his colleagues rejected and wanted to replace. The fact that this could only be done by creating more pictures drew Pissarro and his contemporaries into an aesthetic discourse that was soon also to have a shape and a name. The artists of the day engaged in lively debate on questions of style, as well as on the possibility of selling pictures in Paris. None of the painters could accept the official definition of 'art', which was to be seen each year in the Salon exhibitions. Thus Cézanne had been refused admission to the Académie des Beaux-Arts and Pissarro wanted to have nothing to do with the official variety of academic art training.[22]

Art dealers and art critics played an important part in all of this. The dealers in Paris – above all, Paul Durand-Ruel – were starting to take notice of Pissarro, Monet and Cézanne. So when Durand-Ruel brought out a catalogue with three hundred illustrations, including six of works by Pissarro, in early 1873, things began to look very promising. The Parisian department-store owner and banker, Ernest Hoschedé, bought three paintings, auctioned them later the same year, and made a considerable profit in the process.[23] The following year, Pissarro and his colleagues organised a remarkable "jury-free" exhibition with 165 works by thirty participants, held in a studio that had formerly belonged to the photographer Nadar, in 35, boulevard des Capucines. The critic for *Gaulois* wrote a vitriolic review of the exhibition and described the undertaking as an "exposition libre des peintres impressionistes", an allusion to the title of a painting by Monet; Louis Leroy took up the idea and gave his own review the title, 'Exposition des impressionistes'. This was the first of a total of eight Impressionist exhibitions that subsequently took place between 1874 and 1886.[24]

Now the movement had a name, and its members seemed to form into a clearly defined group. However, a glance at Pissarro's work before 1874 shows that the beginning of Impressionism did not coincide with the first Impressionist exhibition, but was an on-going process made up of a whole variety of different elements.[25] Nevertheless, many art critics reacted negatively, and Pissarro commented: "The critics tear us to pieces and reproach us with learning nothing. I go back to my work; it's better than reading [reviews] that you can't learn anything from."[26]

The Seine at Port-Marly, 1872 (cat. 18),[27] is one of the earliest examples of Pissarro's experiments with Impressionist techniques. If one compares it with river scenes from the 1860s – for instance, his *Barges on the Seine*, c. 1864 (cat. 3) – then the differences are plain to see. In the later work Pissarro does not work out individual sections in detail, but turns his attention to light reflections on the moving surface of the water. The rows of bare trees transfer the weight of the composition from the centre to the edges, and the times of day play a greater part in the depiction of the scene. Thus the earthy monochromes of the early work are shot through in the later *Seine at Port-Marly* with pastel shades, which give this powerful work the fresh tang of an autumn morning. Both in terms of subject-matter and style, this work marks the start of Pissarro's Impressionism.

Because of his own particular interests as a landscape painter, Pissarro occupied a position all of his own amongst the 'maîtres impressionistes', who otherwise formed a very close-knit group. Pissarro was interested in things like the factories along the river banks, as in the painting, *Factory at Pontoise* of 1873 (cat. 19).[28] The factory, an alcohol distillery built up in 1860 by Chalon et Cie., dominated the bank on the other side of the river from Pontoise. Pissarro always portrayed the factory buildings with smoke pouring from chimneys standing out against the sky; the same motif may be seen in an etching made in 1874. He rarely made any alterations to the site and

the buildings in his depictions of the distillery. Perhaps the most beautiful work in the series of factory views is the little painting, *The Oise on the Outskirts of Pontoise*, 1873 (cat. 20), which is clearly certainly not intended to convey any kind of photographic likeness. This is already hinted at in the title: the factory is simply another aspect of the landscape which Pissarro portrays using the same refined colours as he does for the blossoming meadow or the summer sky – and which thereby conforms as do the other elements to the precepts of Impressionist landscape art. Pissarro exercised care in choosing positions for his easel, and prepared these pictures by making conscientious studies. This is evident from his *Compositional Study of a Landscape with the Ile de Pothuis* from the same period (cat. 76), which shows the Saint-Ouen-l'Aumône factory in the background. The exaltation of industrial progress, which many other painters portrayed to considerable effect, is wholly absent from Pissarro's work. Within the context of his numerous scenes around Pontoise, these factory pictures radiate a quite particular attraction, although few critics were able to understand them during Pissarro's lifetime.

As in the paintings of the factory by the river, in *Landscape with Flooded Fields*, 1873 (cat. 21), it was the light on the water that interested Pissarro. (This picture also bears witness to Pissarro's affinity with Alfred Sisley, who made a painting of the same subject.) In contrast to his colleagues, Pissarro often preferred weather conditions without direct sunlight, with the result that at first sight the highlights seem less dramatic. Because he avoided strong local colours and primary contrasts, he achieved the subtlest of effects, and these are at times reminiscent of the subdued tones of Dutch painting in the 17th century. (Interestingly, Sisley's painting is dated 1872, the year in which the flood actually occurred. Pissarro presumably started his at the same time, but did not finish it until the following year, hence the date of 1873.)

Montfoucault

Although the main focus of this selection is on works Pissarro made in Pontoise, there was another place that also played a part in his output in the mid-1870s. That place was Montfoucault: a village approximately 150 miles west of Paris, a secluded spot set in a landscape of gentle hills, where Pissarro's long-standing friend Ludovic Piette had a good-sized property.[29] In view of his own straitened financial circumstances Pissarro decided to move to the country with his family (now five in number). In 1874 he visited Piette, and made numerous studies in Montfoucault of animals and agricultural scenes, which formed the foundation of the works on these themes that he began to produce ten years later.

In the mid-1870s – most probably during and immediately after his stay in Montfoucault – he painted a number of portraits, four of which will be discussed here. To start with, let us look once again at the portrait mentioned earlier, the *Self-Portrait* (cat. 1) from 1873, when the painter was 43 years old. Appearing older because of his flowing beard, Pissarro gazes earnestly at the viewer. Behind him two small landscape studies are pinned to the wall, creating the feeling of a studio. The artist portrays himself plainly, without adopting any airs, and the restrained colours add to the steady calm of the picture. Pissarro painted a relatively small number of portraits – they are mostly of close family members and reveal the closeness and the warmth that existed between them. The *Portrait of Jeanne Holding a Fan*, c. 1873 (cat. 22), shows his daughter seated in an interior, her head turned to the viewer as though in response to a call. The muted colours sound a distant echo of Corot's portraits from the 1850s. Yet at the same time, the appearance of the simple room and the plain, slightly untidy everyday-dress worn by Jeanne gives the picture all the charm of a very private family portrait, just as though the artist wanted to reassure himself that the child really was there, before she jumped up again and ran back outside. His particular relationship to his son Lucien comes through in a short, but exquisite series of works. *Lucien Pis-*

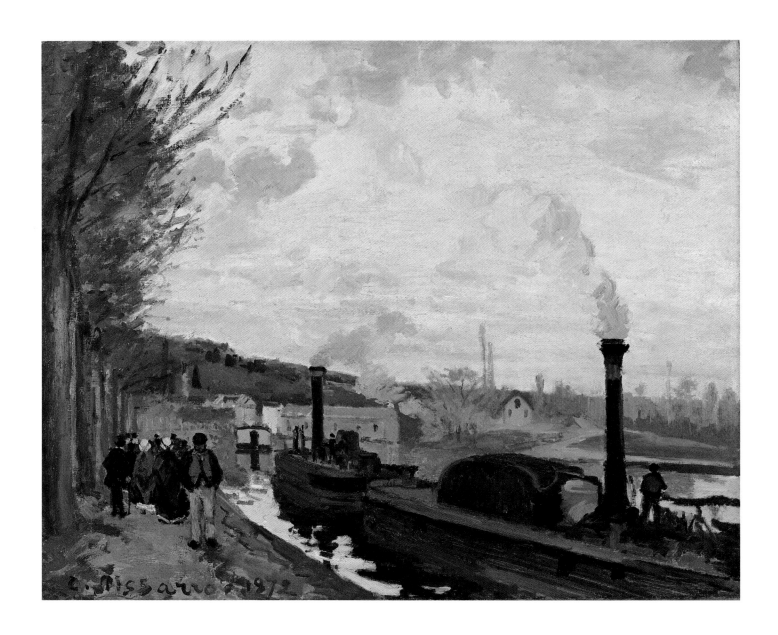

Cat. 18
The Seine at Port-Marly
La Seine à Port-Marly
1872
Oil on canvas, 46 x 55.8 cm
Staatsgalerie Stuttgart,
Inv. 2727
PV 187

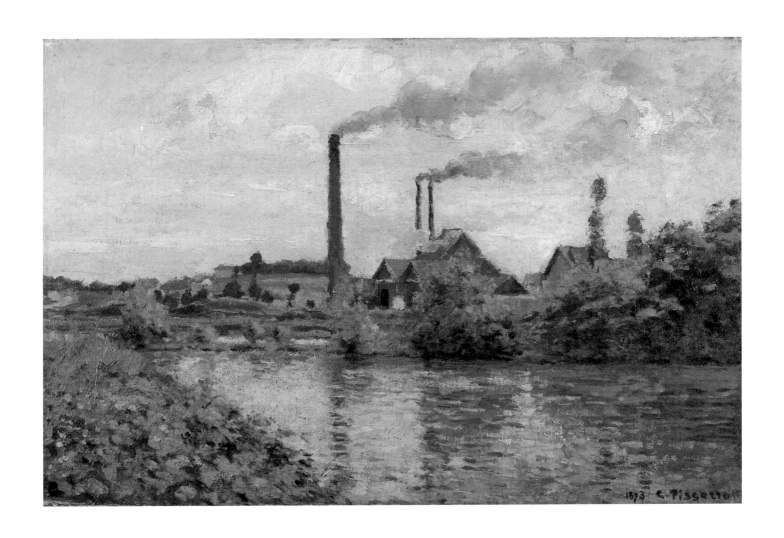

Cat. 19
The Factory at Pontoise
L'Usine à Pontoise
1873
Oil on canvas, 38 x 55 cm
The Israel Museum,
Jerusalem, Gift of the Saidye
Rosner Bronfman Estate,
Montreal, to the Canadian
Friends of the Israel
Museum, R. No. B95.1012
PV 217

Cat. 76
Compositional Study of a
Landscape with the Ile de
Pothuis and the Factory at
St. Ouen-l'Aumône
c. 1877
Black chalk on paper,
11.3 x 19.3 cm
Ashmolean Museum, Oxford
BL 100A r

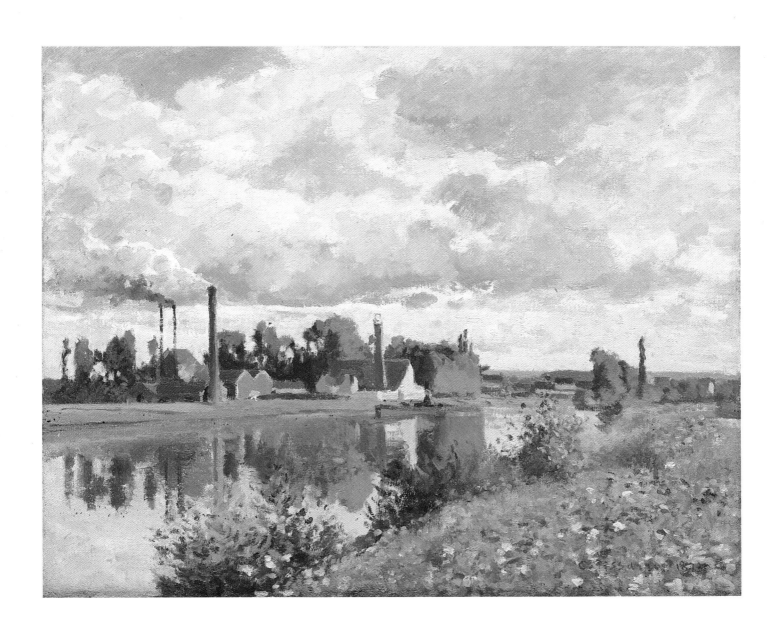

Cat. 20
The Oise on the Outskirts
of Pontoise
L'Oise aux environs de
Pontoise
1873
Oil on canvas, 45.3 x 55 cm
Sterling and Francine Clark
Art Institute, Williamstown,
Massachusetts, 1955.554
PV 218

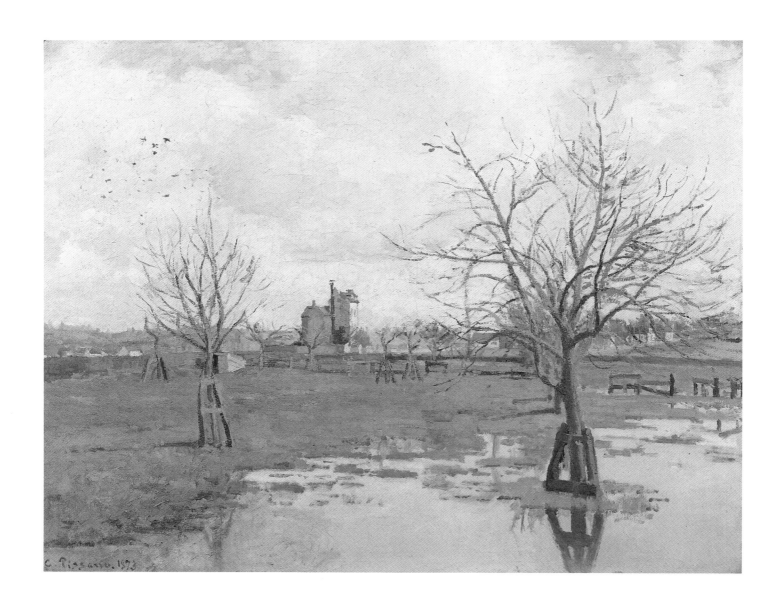

Cat. 21
Landscape with Flooded
Fields
Paysage aux champs inondés
1873
Oil on canvas, 64.9 x 81.2 cm
Wadsworth Atheneum, Hart-
ford, Connecticut, 1966.315
Not listed in PV

sarro in an Interior, c. 1875 (cat. 23), is one of Pissarro's finest portraits. Pissarro is sensitive and almost tender in his approach to his first-born son, whose talent for drawing he encouraged from early childhood onwards. Lucien later also became a painter, and over the years the two conducted an intensive, life-long dialogue about art, that has been in part preserved in hundreds of letters. Pissarro seated the boy, busily drawing a picture, in front of a large window looking out into the luscious green of the garden. The sun streams in from the left, creating lively lights and shadows on the boy's soft, red-edged jacket, while the right-hand side of the picture is dark and warm. This portrait, with its well-tempered colours, was painted quickly and confidently – without the need for major corrections – and the perspectival inexactitude of the boy's legs is simply in keeping with the rapid flow of the work as a whole. The slightly melancholic nature of the young boy is seen again in the drawing (with watercolour wash), *Half-length Portrait of Lucien Pissarro*, c. 1875 (cat. 75), which belongs to the large group of studio sketches.[30] Pissarro, who sometimes reworked his larger drawings as watercolours in subtle browns and greys, used these drawings as preparatory studies for paintings. At the same time, this technique allowed him to work faster than was possible in oils. This unfinished work, in particular, touches the viewer because of its openness and reduced means, and, in its simplicity, seems astonishingly modern.

In terms of style, a number of genre paintings should also be seen together with the above works, for instance the relatively large-format *Peasant Untangling Wool*, 1875 (cat. 24), which has similar brushwork to that in the portraits. As in the portraits, Pissarro places the main figure in the centre of the composition, and thus creates a pictorial space that is free of dramatic accents. The colours and the forms generate a harmonious union between the figure and the landscape. The activities of many of his figures convey a strong impression of contemplative withdrawal. Pissarro places them in their own world, out of the viewer's

reach, where they pursue their daily round apparently unnoticed. In *Peasant Pushing a Wheelbarrow, Maison Rondest, Pontoise*, 1874 (cat. 25),[31] the opening in the wall creates a clearly defined area within the picture, which closes protectively around the small figure. The cuboid shapes of the houses behind the woman are echoed in the square stones of the wall on the right; the ochres, grey-blue and broken white are matched in the wall further back to the left. Even the lines of the crowns of the trees, with their fresh, young leaves meeting up above the woman's head, are reflected in the rounded hummocks in the foreground, forming a sheltering oval. The intimacy of the scene derives from the carefully considered elements of its composition and the finely calculated colouration. By contrast the wintry, snow-covered fields in the painting, *L'Hermitage, Pontoise, Snow Effect*, 1874 (cat. 26) are strictly laid out according to a clear grid, and demonstrate Pissarro's interest in experimenting with geometric compositional elements. Like Alfred Sisley and Claude Monet, around the mid-1870s Pissarro produced numerous wintry landscapes, most of which were painted during his stay in Montfoucault.[32]

Pontoise 1874–1884

After the remarkable exhibition of 1874, in which Pissarro, Cézanne and Monet all participated, a number of like-minded artists came together as the 'Groupe impressionniste'. The following examples show why particular weight should be given to Pissarro's influence on the group, and why his works are regarded as having made a crucial contribution to Impressionism. Our selection includes three landscape paintings which amply demonstrate his masterly handling of the new technique: *Landscape, Bright Sunlight, Pontoise*, 1874 (cat. 27), *The Village Pathway*, 1875 (cat. 28), and *The Quarry, Pontoise*, c. 1875 (cat. 29). Pissarro applied the paint with a short, trimmed brush in strokes of varying lengths, using horizontal, flat lines for the ground, changing to irregular flecks for the foliage. In these pictures the colour green dominates in a multiplicity of

rich shades which give the summery vegetation an almost physical density. Besides this, there are blue accents in the roofs and figures, with silvery grey shadows. All three of these landscapes depict views in the immediate vicinity of Pontoise. In *The Village Pathway*, the middle-ground shows some of the houses in L'Hermitage, although Pissarro has the vegetation denser than it appears on contemporary photographs, in order to obscure a new building that had just been put up.[33] In *Landscape, Bright Sunlight, Pontoise*, he includes a genre-like image of a rider with two horses, keeping pace with each other and obviously a team – a rarity in Pissarro's work. These three compositions are all structured according to similar criteria: a sloping meadow in the foreground, a path bordered by trees leading through the middle-ground, a group of houses or a rocky outcrop in the middle-ground, and a narrow band of overcast sky.

The sequence of landscapes that Pissarro painted in Pontoise around 1875 is striking for the limited range of its themes: above all Pissarro preferred fields, paths and the edges of woods, gardens and houses on the outskirts of the town, small factories along the banks of the river. Besides these motifs the area, of course, also contained churches, châteaux, mills and farms[34] as well as picturesque views within the town itself. Pissarro does not tell any stories in his pictures, and the views he shows are so simple that they look as though they had been chosen quite randomly. Théodore Duret, a close friend of Edouard Manet's and an extremely knowledgeable connoisseur of contemporary painting, was one of the first to recognise this particular feature of Pissarro's art: "You haven't Sisley's decorative feeling, nor Monet's fanciful eye, but you have what they have not, an intimate and profound feeling for nature and a power of brush, with the result that a beautiful picture by you is something absolutely definitive. If I had a piece of advice to give to you, I should say: Don't think of Monet or of Sisley, don't pay attention to what they are doing, go on your own, your path of rural nature. You'll be going

along a new road, as far and as high as any master!"[35] Pissarro replied: "Thank you for your advice. You should know that I have been thinking about what you said for a long time now. What has hindered me for so long in directly portraying nature, is quite simply the possibility of finding models, not only to produce the picture, but also in order to devote some serious study to the subject-matter. As far as the rest is concerned, I will not hesitate to try to do that; it will be very difficult, for you should know, that one cannot always paint these pictures directly face to face with nature, that is to say outside, but only after nature. It will be quite difficult."[36] The last comments here give an indication of how Pissarro went about his work: at this period painters like Pissarro worked outside in the open air a lot, but not exclusively, and in his *Peasant Pushing a Wheelbarrow* (cat. 25) – mentioned earlier – it is noticeable that he was clearly working according to specific compositional criteria which he had defined for himself, as though he were taking a theme through a number of variations. It is tempting to conclude that these should be seen as a group of works, intended to make the paradigms of his own art visible and to introduce an impressionist 'style' into painting. An extraordinary composition in this series is *The Climbing Path, L'Hermitage, Pontoise*, 1875 (cat. 30), for the gradient gives the path up above L'Hermitage an unusual, somewhat bewildering perspective, particularly since the sun is lighting up the pale tree-trunks and the path is coloured by a lively interplay of light and shade. This picture occupies a special position amongst the Pontoise landscapes, and although it shows how easily and confidently Pissarro could deal with a conventional topos, experimenting and finding convincing solutions, *The Climbing Path* is nevertheless still the exception to the rule in his œuvre as a whole.

As we have already seen, Pissarro was no outsider. He took an active part in the development of the Impressionist movement and his works from the mid-1870s should be seen in the conjunction with works by Cézanne, Monet, Sisley and other contemporaries.

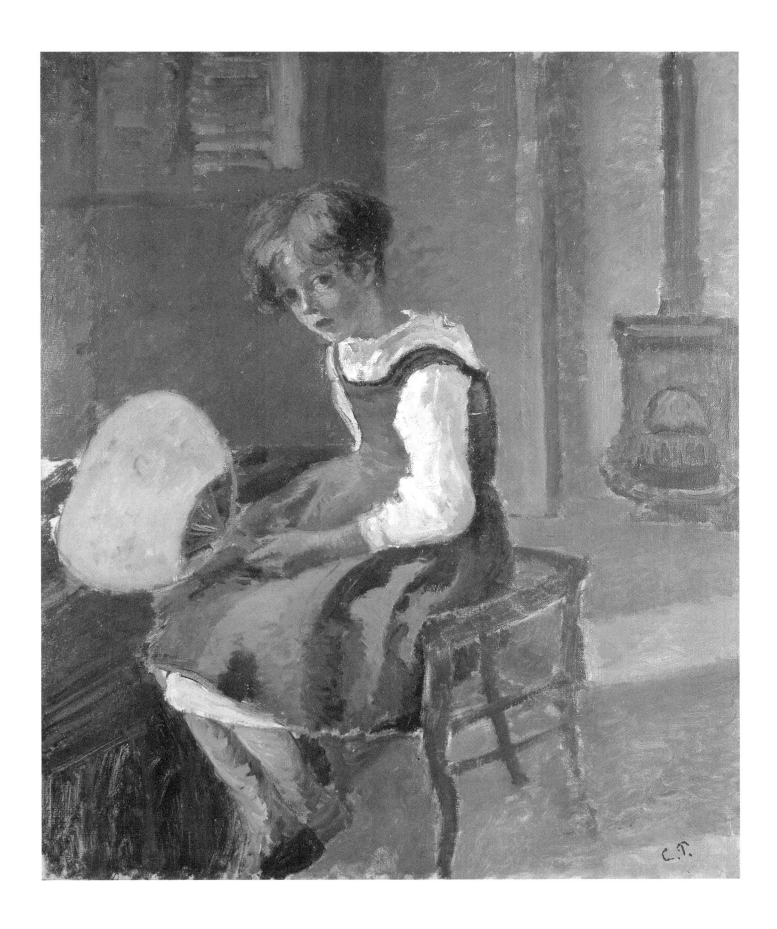

Cat. 23
Lucien Pissarro in an Interior
Lucien Pissarro dans un
intérieur
c. 1875
Oil on canvas, 65 x 54 cm
Private collection, Paris
PV 333 (as *Figure assise,
Lucien*)

Cat. 75
**Half-length Portrait of Lucien
Pissarro**
c. 1875
Watercolour over charcoal on
paper, 28.3 x 23.5 cm
Ashmolean Museum, Oxford
BL 71

Plates pp. 74 and 75

Cat. 24
Peasant Untangling Wool
Paysanne démêlant de la
laine
1875
Oil on canvas, 55 x 46 cm
Stiftung Sammlung E. G.
Bührle, Zurich
PV 270

Cat. 25
**Peasant Pushing a Wheel-
barrow, Maison Rondest,
Pontoise (Landscape near
Pontoise)**
Paysanne poussant une
brouette, Maison Rondest,
Pontoise (Paysage de
Pontoise)
1874
Oil on canvas, 65 x 51 cm
Nationalmuseum Stockholm,
NM 2086
PV 244

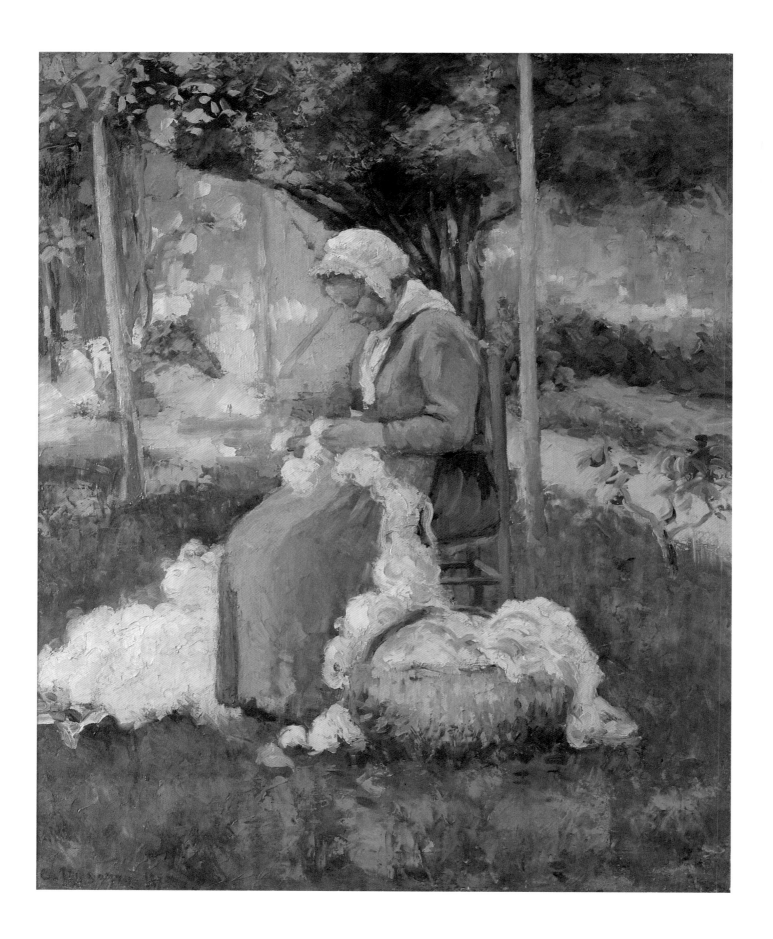

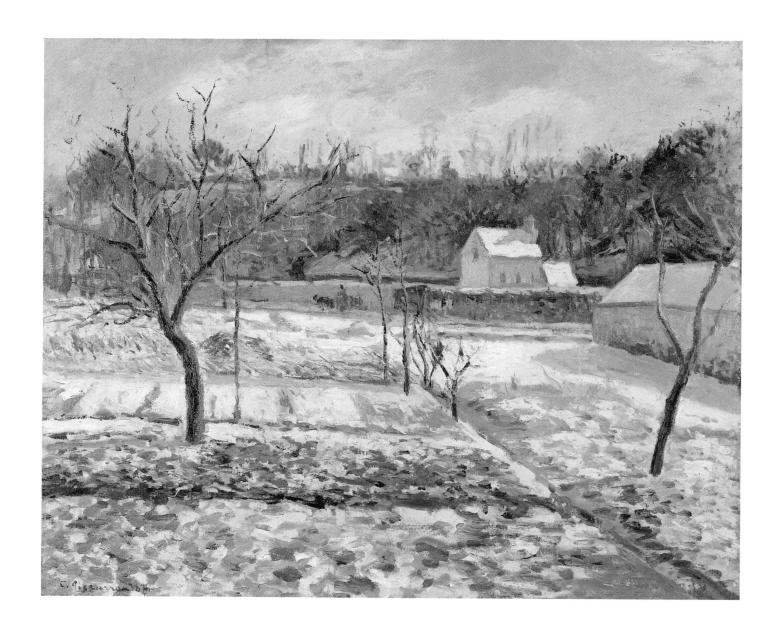

Cat. 26
L'Hermitage, Pontoise,
Snow Effect
L'Hermitage, Pontoise, effet
de neige
1874
Oil on canvas, 54 x 64.8 cm
The Fogg Art Museum, Har-
vard University, Cambridge,
Gift of Mr. and Mrs. Joseph
Pulitzer, Jr., 1953.105
PV 240

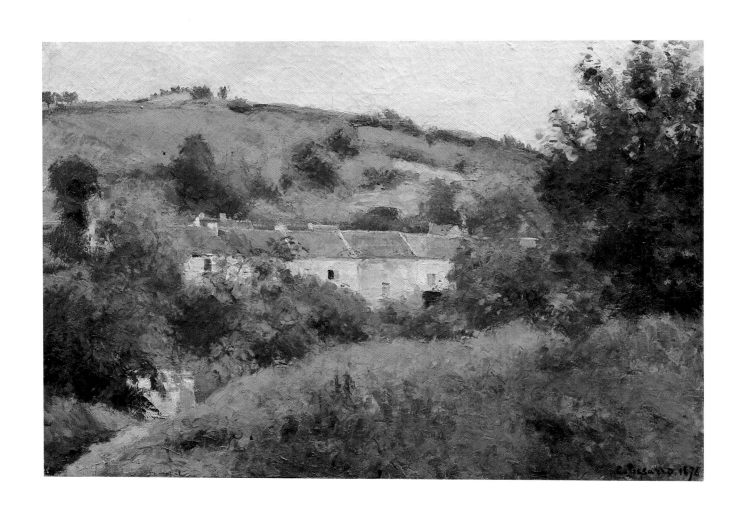

Cat. 28
The Village Pathway
Le Sentier du village
1875
Oil on canvas, 39 x 55.5 cm
Rudolf Staechelinsche Fami-
lienstiftung, Basel
PV 310

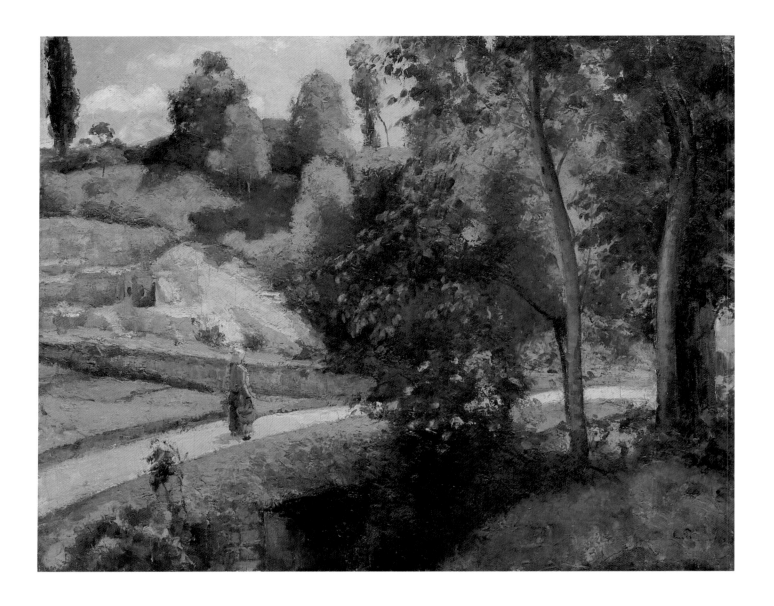

Cat. 29
The Quarry, Pontoise
La Carrière, Pontoise
c. 1875
Oil on canvas, 58.2 x 72.5 cm
Rudolf Staechelinsche
Familienstiftung, Basel
PV 251

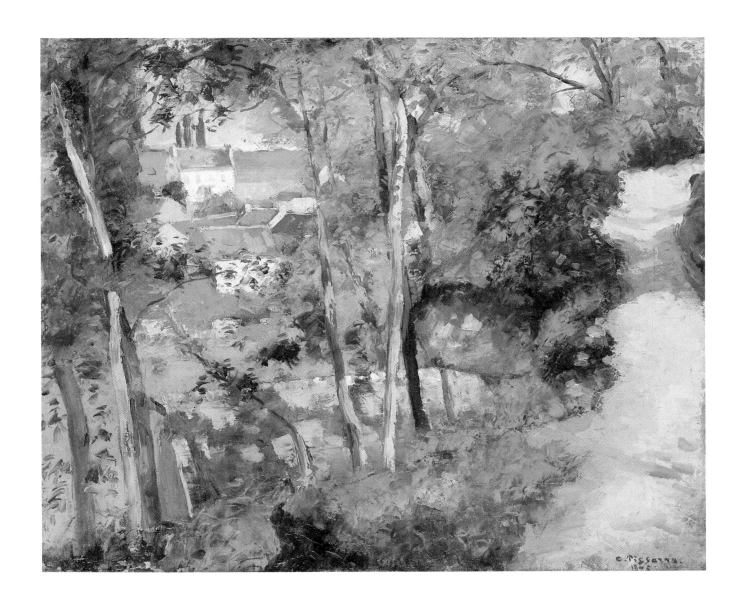

Cat. 30
The Climbing Path,
L'Hermitage, Pontoise
Le Chemin montant,
L'Hermitage, Pontoise
1875
Oil on canvas, 54 x 65 cm
The Brooklyn Museum of
Art, Gift of Dikran K.
Kelekian, 22.60
PV 308

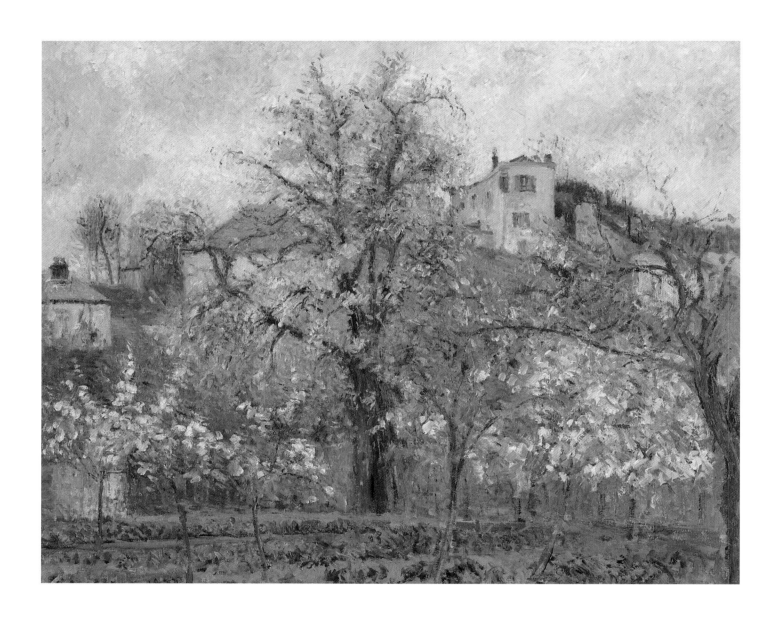

Cat. 31
Vegetable Garden and Trees
in Blossom, Spring, Pontoise
Potager et arbres en fleurs,
printemps, Pontoise
1877
Oil on canvas, 65.5 x 81 cm
Musée d'Orsay, Paris, Legats
Gustave Caillebotte, 1894,
RF 2733
PV 387

Cat. 32
Path under Trees, in Summer
Chemin sous bois, en été
1877
Oil on canvas, 81 x 65.7 cm
Musée d'Orsay, Paris, Legats
Gustave Caillebotte, RF 2731
PV 416

Cat. 33
The Pathway at Le Chou,
Pontoise
La Sente du Chou, Pontoise
1878
Oil on canvas, 50.5 x 92 cm
Musée de la Chartreuse,
Douai, 2231
PV 452

Cat. 34
Rainbow, Pontoise
L'Arc-en-ciel, Pontoise
1877
Oil on canvas, 53 x 81 cm
Kröller-Müller Museum,
Otterlo, 615-19
PV 409

implied the revolutionary abandonment of tradition. With this analysis by Zola – which other critics adopted virtually to a man – the goal was both defined and attained in one. And thus Impressionism was hit by its first crisis.

III MARKETS AND MAIDSERVANTS: NEO-IMPRESSIONISM 1880–1890

The 1880s bring fundamental changes in Pissarro's methods. He turns to Neo-Impressionism. New themes emerge.

Around 1880 the Impressionist movement was in danger of falling apart. Two reasons can be identified. On one hand, there was no common manifesto; the painters were linked by their shared exhibitions and by the responses of the critics. Meanwhile the stylistic similarities between Monet, Pissarro, Sisley and Cézanne were becoming less pronounced, and the artists were beginning to go their own separate ways. On the other hand, the art market was also in crisis. Since there was a shortage of collectors, and an abundance of painters trying to force their way into the market, there was an over-supply above all of landscape paintings, and many of the first wave of Impressionists saw their finances becoming increasingly precarious. In 1879, from 10 April until 11 May, the fourth Impressionist exhibition took place in the avenue de l'Opéra. It was entitled 'Exposition des Artistes Indépendants'. The following year the fifth Impressionist exhibition was held in the rue des Pyramides. Meanwhile Degas had accused Renoir and Monet of being "renegades" since they had not shown their work along with the "independents". When it came to the sixth exhibition in 1881 – held, like the first, in the boulevard des Capucines – Caillebotte tried to insist that it should take place without Degas, but Pissarro rejected this suggestion. In the end it took place with Degas, but without Renoir, Monet and Sisley, and the internal disputes wrangled on into the next year, which in turn meant that the penultimate exhibition in March 1882 could no

longer be regarded as a proper overview of Impressionism.[40] These external circumstances matched the inner crisis in Impressionism, which was itself reflected in a major change in Pissarro's own work.

An outstanding work from the beginning of this transitional phase in Pissarro's work is *The Wood by L'Hermitage, Pontoise*, 1879 (cat 35), which is also one of his largest canvases. He never attempted anything as large as this again, and in a certain sense it marks a turning point in his work. The unusual size suggests that it was intended for public display, but there is no evidence that it was shown in the Salon of 1879. *The Wood by L'Hermitage* has all the compositional elements of earlier works: a path leading into the middle-ground; luscious vegetation that is denser towards the outer edges of the scene; houses in the middle-ground setting a pale accent; a rise in the background and, not least, a genre motif (in this case a billy-goat and a slumbering goatherd). The finely differentiated spectrum of colours is dominated by green, with touches of blue in the sky and on the figure. The whole is a synthesis of earlier works. A glance back at *Path under Trees*, 1877 (cat. 32), *The Climbing Path* and *The Quarry* show that compact areas of colour are now breaking apart into closely juxtaposed lines, frequently changing their direction, so that, close to, they create an impression of shimmering unrest. The usual comparison with Cézanne's *château noir* paintings does not seem entirely appropriate. Admittedly, both artists were intensely preoccupied with the effect of sunlight in woods and undergrowth, yet Cézanne's *château noir* paintings were going in the direction of more secure forms, while Pissarro's forms show distinct tendencies towards disintegration.[41] If anything, there seems to be a greater affinity to Renoir's work and to paintings by Monet, whose pictures in the 1880s frequently concentrate on the infinite variety that can be found in one colour.

Eragny and Gisors 1884–1890
Pissarro left Pontoise in winter 1883. After a short stay in a hamlet by the name of Osny,

only a few miles away from Pontoise, he decided to move to Eragny, where he lived until his death in 1903, occasionally making trips elsewhere. The deciding factor behind this move was the damp climate in Pontoise during the winter months. Yet, in the background, there was also the fact that Pissarro was now less interested in landscape and was turning his attention to a whole new area: the lives of the 'peasants' working on the land. Having hitherto devoted almost all his attention to landscapes, at a stroke Pissarro started to portray the human figure – only to join the Neo-Impressionists at the end of the decade and to return to landscape art.

Soon after *The Wood by L'Hermitage* (cat. 35), Pissarro's new interest in genre took concrete form. During the 1880s he was so intensely involved in figure painting that it is hard to make the link with his landscapes. As we have already indicated, the Impressionist movement had lost a certain amount of ground due to the conflict regarding individual styles, that came to a head in 1882 in the seventh exhibition (which now also included Paul Gauguin amongst the participants).[42] The other main reason for the decline in the Impressionist movement was more pragmatic: Durand-Ruel's business was so poor in the early 1880s that he advised his artists to turn out more work that would definitely sell. Since so many landscapes were now surplus to demand, Durand-Ruel suggested to Pissarro and others that they might add genre painting to their repertoire, as well as smaller formats and fan-designs. The artists who followed his advice were quickly rewarded with success, in the sense that these kinds of pictures really did sell. For Monet and Renoir the crisis meant that they left Paris for a while, in order to seek out new themes and motifs, and to try their hand at new styles. Pissarro, however, was faced with the fact that his large family and unending financial worries prevented him from going beyond the immediate environs of Paris. Initially he stayed put in Pontoise. How he personally dealt with the crisis in Impressionism and in the art market, may be seen

from the following representative selection of works he created during the 1880s. Initially his paintings depicted one or two peasant women – working in the fields, taking care of the cattle or resting from their toils. Most of these works are relatively conventional in their subject-matter, such as *Peasants Resting*, 1881 (cat. 36), which was shown at the seventh Impressionist exhibition in 1882, *Peasant Woman and Child in the Fields, Pontoise*, 1881 (cat. 37), and *Woman with Goat*, 1881 (cat. 38). This last work, which is particularly memorable for the refinement of its greens and blues as well as for the treatment of light and shade, was amongst a number of works that Pissarro passed on to Durand-Ruel soon after their completion. The latter sold it to an American private collector in 1907. Like *Peasant Woman and Child in the Fields*, painted in the same year, *Woman with Goat* has a touch of humour about it that is also evident elsewhere in his work and which particularly suits his rural genre scenes. In his graphic output, too, there are drawings that border on caricature, such as *Cowgirl*[43] and *Woman Harvesting*.[44] This ironic undercurrent betrays a certain distance between the painter and his models plus their activities. Although Pissarro focused intensely on the reality of peasants' lives, he never adopted their ways, and when he worked the land, it was only in the extensive garden around his own house. *Le Père Melon, Lighting his Pipe*, c. 1879/80 (cat. 39), and *Young Peasant Girl Wearing a Hat*, 1881 (cat. 40), which was shown at the seventh Impressionist exhibition, are typical of Pissarro's output during the 1880s. For these works he turned to a traditional topos in portraiture: at the time the half-length portrait was a favourite amongst bourgeois clients and was correspondingly often the choice of 'academic' painters. In this portrait by Pissarro, the combination of a traditional portrait schema with genre painting and an Impressionist technique sets his subject apart from the traditions of the Academy, although not entirely preventing them from still gleaming through in the background as it were. He took the same approach to *Resting, Peasant Girl Lying on the*

Grass, Pontoise, 1882 (cat. 41), where the dominant figure of the girl stretched out full-length forms a diagonal cutting through the grass from left to right. This work has distant echoes of Millet, although the rather stronger influence of Edgar Degas is apparent in the spatial composition. The edges of the picture are 'open', as though the artist had just spontaneously captured his motif, a process that is also evident in contemporary photography. Since Pissarro did not use any long, continuous lines, but distinguished different shapes from each other by means of more tightly-packed brushstrokes and by his use of colour, the overall effect was restless yet uniform. There was now a quite different relationship between the foreground and the middleground. Unlike the depths in his many-layered landscapes, now the outlines of his figures are woven into the dense painterly texture of their surroundings, with the result that the pictures themselves are more planar and the viewer's attention is drawn to the qualities of the technique used to portray the subject.

In another group of genre pictures Pissarro shows young working girls occupied with all kinds of tasks in the home and in the market place. In *Young Woman Washing Dishes*, c. 1882 (cat. 42), a simple kitchen maid is washing stacks of crockery in the yard outside the house. Pissarro often chose the lowliest domestic servants as his subjects, and portrayed these young girls entirely absorbed in their work. To urban eyes these themes were unusual, even original, since they contrasted so markedly with apparently cultivated – but much more conventional – subjects. Rural bluntness also characterises the painting, *The Pork Butcher*, 1883 (cat. 43), and the pastel, *The Poultry Market, Gisors*, 1884 (cat. 44). *The Pork Butcher*, with her apron and sleeve-protectors, the central figure in this portrait-format composition, is bending in towards her canvas-topped stand where her wares are displayed. Since the butcher's trade meant dealing with blood, and the goods were extremely perishable, the meat-sellers in the market – usually women – were right at the bottom of the hierarchy. Pissarro, who had observed the real-life

situation with great care, and who had his niece Nini pose for the main figure, hoped his finished work would radiate a certain "naïve power". He chose his genre themes with care, as illustrations of the unspoilt nature of life in the country. In terms of its colours, *The Pork Butcher* is dominated by the white of the woman's apron and by the canvas top of a stand in the background. Besides this there are violet-greys and shades of pink, composed of very closely packed, short brushstrokes which create a dense, impasto surface. Preparatory drawings and studies for individual figures in this painting show that the artist did not just spontaneously come up with the scene, but that it was carefully and consciously composed.[45]

The critics were divided in their reactions to these genre paintings. While certain art journalists praised the direction that Pissarro had now taken, others regretted his proletarian subject-matter. Alert observers could hardly miss an affinity to Millet's art. But compared to the dry rigour of Millet's paintings Pissarro's appeared colourful and uncomplicated, even naïve, and seemed somehow inferior. Only a few critics made the effort to properly understand the apparent relationship between these two artists' output: broadly speaking, Millet's idealisations of rural life were a form of allegory while Pissarro's images were immediate, free of idealistic excess and biblical allusions.[46] Nevertheless, Pissarro respected Millet's clear compositions and admired his graphic works, above all his woodcuts of haystacks, some of which he himself owned and drew on for his own graphic works. (See Barbara Stern Shapiro on Pissarro's works on paper, elsewhere in this volume.)[47] One journalist, reviewing the seventh Impressionist exhibition, in 1882, took criticisms of Pissarro's work seriously – which at times amounted to accusations of plagiarism – and wrote: ". . . the human figure often takes on a biblical air in his work. But not any more. Pissarro has entirely detached himself from Millet's memory. He paints his country people without false grandeur, simply as he sees them.

Plates pp. 90 and 91

Cat. 36
Peasants Resting
Paysannes au repos
1881
Oil on canvas, 82 x 66 cm
The Toledo Museum of Art, Toledo, Purchased with funds from the Libbey Endowment, 1935.6
PV 542

Cat. 37
Peasant Woman and Child in the Fields, Pontoise
Paysanne et enfant dans les champs, Pontoise
1881
Oil on canvas, 41 x 27 cm
Private collection
PV 552

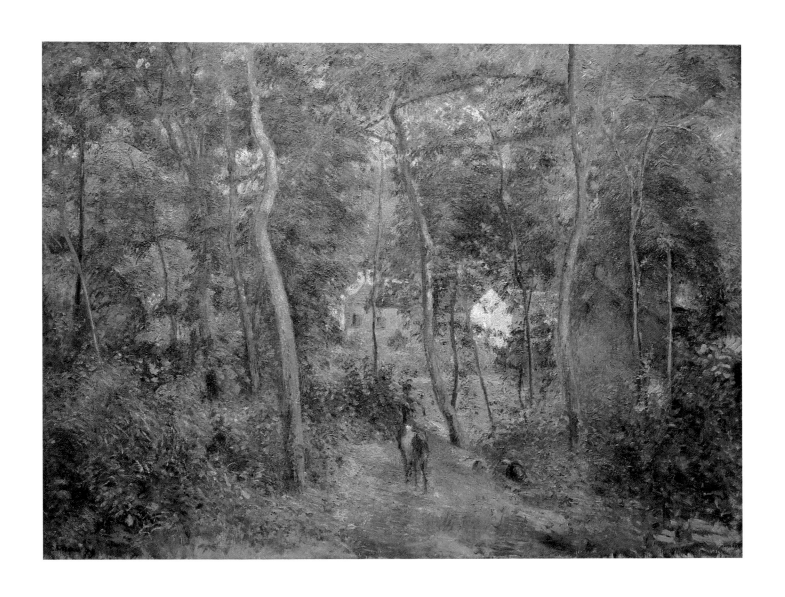

Cat. 35
The Backwoods of
L'Hermitage, Pontoise
Le Fond de L'Hermitage,
Pontoise
1879
Oil on canvas,
126.3 x 164.7 cm
The Cleveland Museum of
Art, Gift of the Hanna Fund,
51-356
PV 489

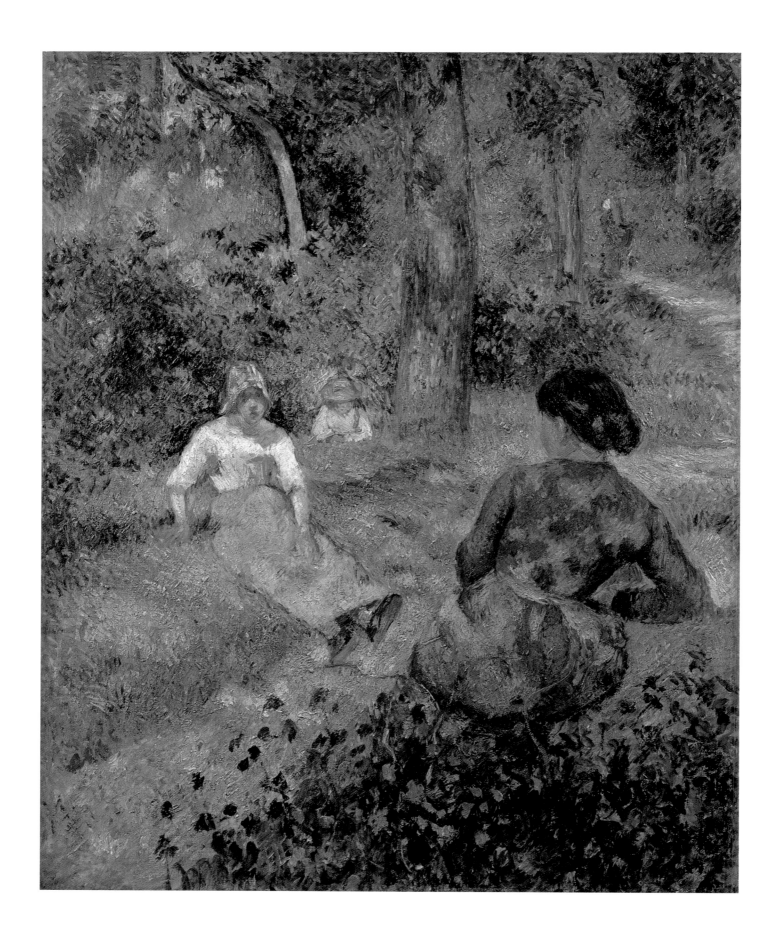

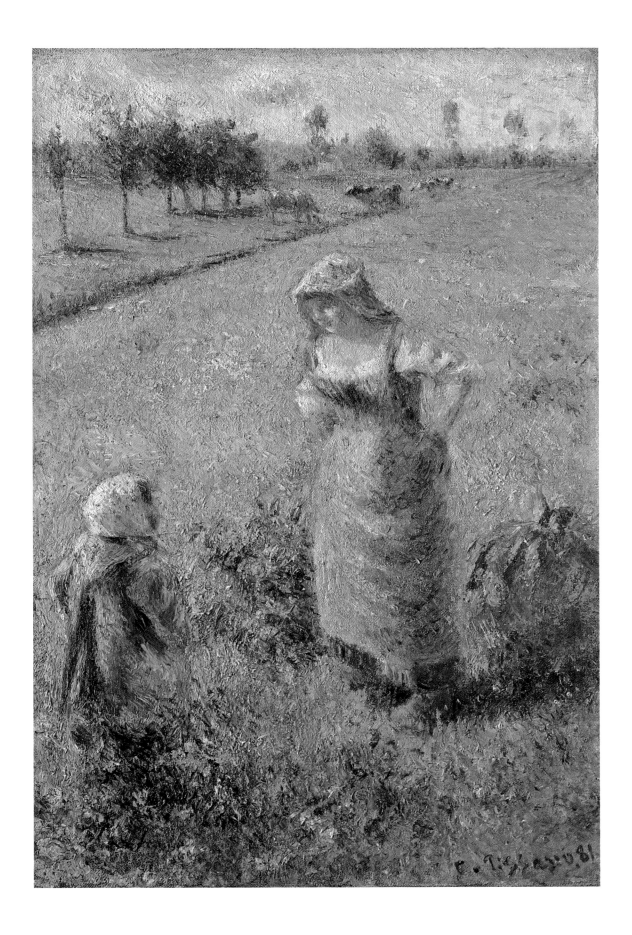

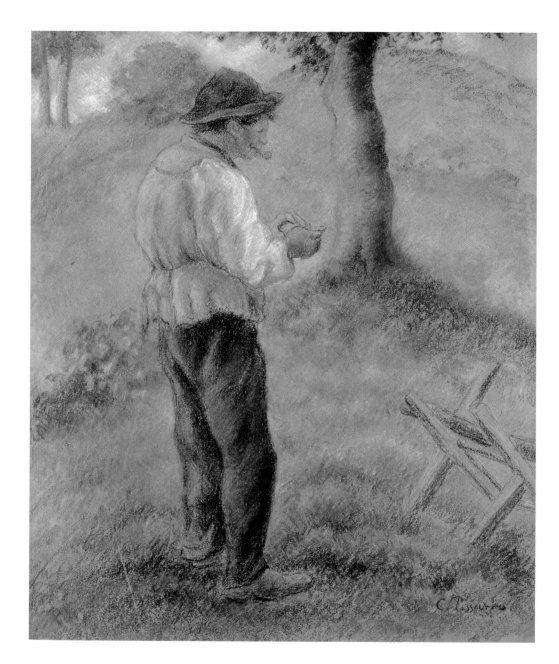

Cat. 39
Le Père Melon,
Lighting his Pipe
Le Père Melon allumant son
pipe
c. 1879/80
Pastel, 56 x 46 cm
Private collection
Not listed in PV.

Cat. 38
Woman with Goat
La Femme à la chèvre
1881
Oil on canvas, 82.6 x 74.9 cm
Private collection, New York
PV 546

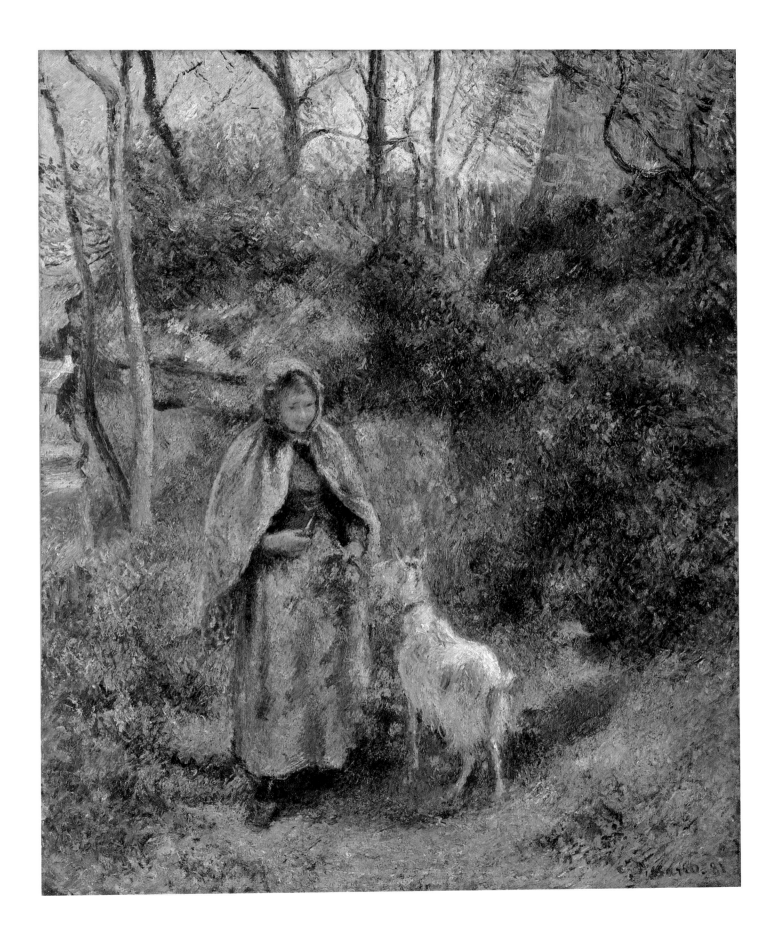

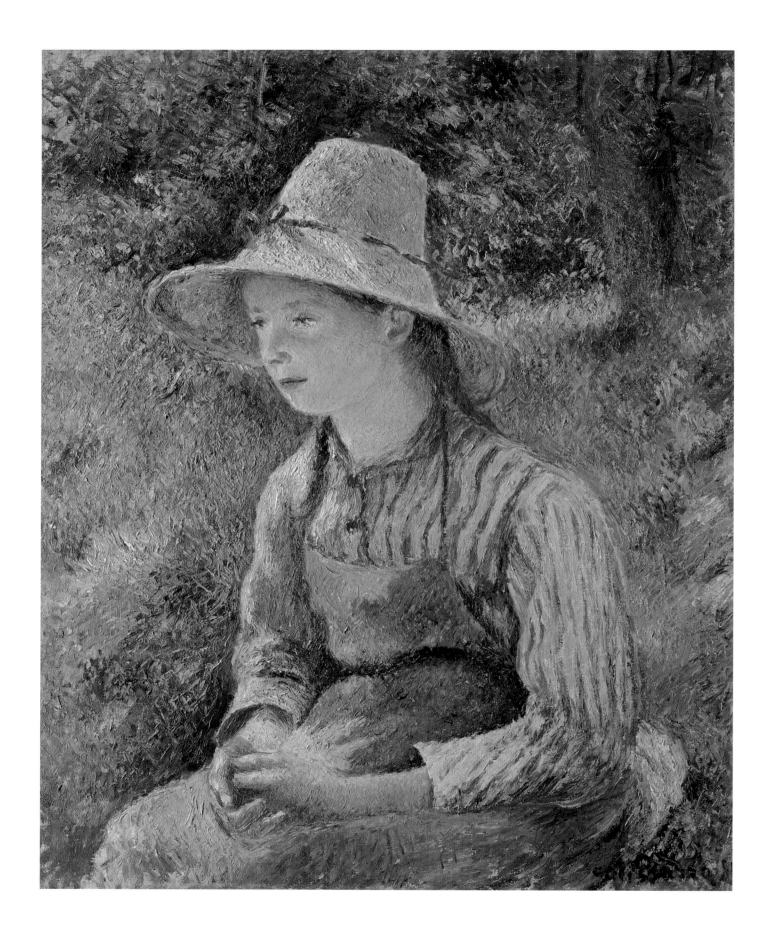

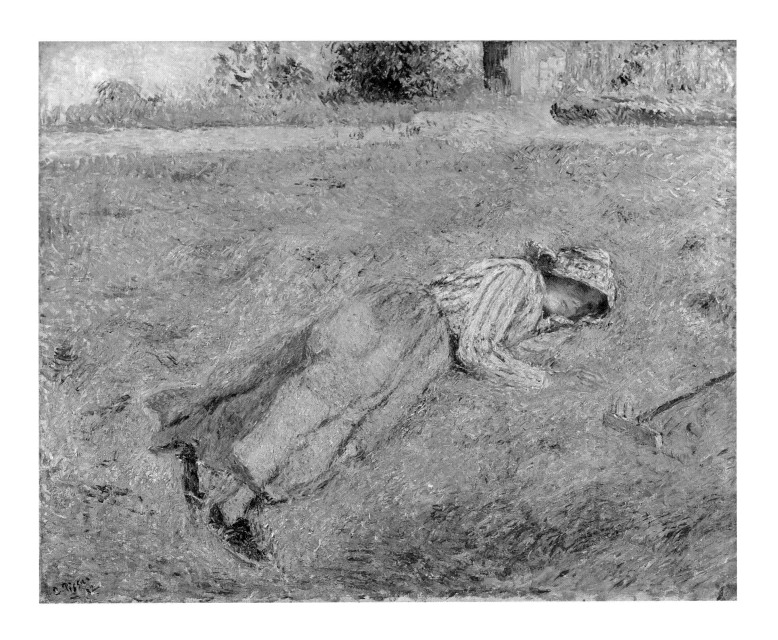

Cat. 40
Young Peasant Girl Wearing
a Hat
Jeune Paysanne au chapeau
de paille
1881
Oil on canvas, 73.4 x 59.6 cm
National Gallery of Art,
Washington, Ailsa Mellon
Bruce Collection, 1970.17.52
PV 548

Cat. 41
Resting, Peasant Girl Lying
on the Grass, Pontoise
Le Repos, paysanne couchée
dans l'herbe, Pontoise
1882
Oil on canvas, 64.5 x 78 cm
Kunsthalle Bremen,
Inv. 960-1967/8
PV 565

His delicious little girls in their red stockings, his old woman wearing a kerchief, his shepherdesses and laundresses, his peasant girls cutting hay or eating, are all true, small masterpieces."[48] Pissarro's pictures of peasants should be seen against the background of the escalating debate on Impressionism: Pissarro himself decried certain works by his academic colleagues as "romances" and saw them as an offence against art, which must be prevented, come what may.[49] The distance had never been greater between Pissarro as an exponent of modern Impressionism and successful, academic art, which – with its heavily symbolic, erotic images – was attracting an ever broader public in the 1880s. This was due on one hand to the growing reputation of Impressionism, and on the other hand to the publicly aired disagreements as to whether its followers should be adopting the same style. Against this backdrop, the simplicity of Pissarro's pictures takes on a different aspect. To be precise, the crisis of Impressionism was not a crisis of style, for since the mid-1870s the various members of the group had all developed individually, according to their own abilities and leanings. But the crisis was brought on by a process that was larger than any one individ-

ual: this was the institutionalisation that set in with the Impressionist exhibitions and which locked into position as the market for Impressionist works developed. Following the agreement by Pissarro, Monet and Renoir that there should be no exhibition in 1884, the Impressionists did not meet again until 1886. Faced with the large number of genre paintings on show in 1886, the art critics were divided in their responses. Some declared that Pissarro and his colleagues had done a great service to the realistic portrayal of the peasantry,[50] while others condemned the genre paintings as fawning to public taste. Nevertheless, Durand-Ruel's sales went up again, and there was a gradual improvement in the financial fortunes of the Pissarro family, which was now eight in number.

The gouache, *The Poultry Market, Gisors*, 1885 (cat. 44), is one of a number of market scenes that Pissarro made in Gisors, approximately ten miles south of Eragny-sur-Epte. "I think," he wrote on 1 March 1884 to Lucien in London, "you will find attractive things to paint in Gisors, subjects, moreover, which should interest the English: churches, markets, farms, stations, coachmen, shopkeepers, and the landscape itself."[51] The composition of *The Poultry Market* is based on two different scenes, that is to say, the two women in the foreground were set against the background of the gouache, *The Market in Gisors (rue Cappeville)*, of 1885.[52] Claude Monet owned a pastel of *The Poultry Market* until his death and was particularly fond of it.

That same large gouache of *The Market in Gisors*, 1885 (cat. 45) was the start of an ambitious, graphic project with the same title, which has a rather complicated history. From the originally relatively large, almost square 1885 crowd scene, in 1893 Pissarro made a portrait-format composition, with a group of four figures in the foreground. This was followed by a series of coloured designs for a woodcut, which Lucien was to make. Although the design was already transferred to a woodblock,[53] the project got stuck at this stage. In letters written during December 1894, Pissarro mentioned an etching of a design, which

Fig. 5
Camille Pissarro
Compositional Study for 'La Charcutière'
Blue watercolour over black chalk on paper,
21.5 x 16.4 cm
Ashmolean Museum, Oxford
BL 168E

he then printed in early 1895 in seven states, some coloured. Around 1890, Pissarro's working methods changed radically: while his allegiance ten years before had definitely been to Impressionist techniques, now he created his genre scenes by means of an elaborate design process, which involved him moving progressively away from his first spontaneous sketches, until he had worked out all the final details of the composition. At the same time as his working methods changed so, too, did his understanding of the status of painting within his own work. Painting still offered a means of expression, but now it was not necessarily the most important, as may be seen from *The Market in Gisors*. Interestingly enough, the creative process now evidently had no pre-defined goal, for sometimes it resulted in finished works, and sometimes it recorded mid-way stages. Similarly there was also a change in the narrative element, which again may be seen in *The Market in Gisors* in the division and separation of people of different sexes and classes. Now Pissarro seems to be handling his motifs and the composition just as freely as matters of technique – freely combining elements, albeit aware of the effect that this will have on the ultimate 'meaning' of the work. This basically formalist process is not just typical of Pissarro but may be seen throughout Impressionism in the 1880s, and bears witness to the increasingly analytical approach that artists were taking to their pictorial materials. Pissarro's late works, from the last decade of his life, are marked by this basically analytical, formalistic approach. As to whether these changes also affected his themes, it is impossible to give a definitive answer.

Let us venture here on a small excursion into his graphic works. Pissarro's œuvre includes one rather remarkable series of drawings, namely his *Turpitudes sociales*, which should not be ignored here because it is such a foreign body in the otherwise steady continuum of his artistic development (fig. 31, p. 23). If one looks at Pissarro's biography, one cannot fail to notice that he favoured certain socio-critical, anti-capitalist ideas. His market scenes were regarded by some as a pictorial mirror of his criticism of society as it was. In a monograph of his great-grandfather's work, Joachim Pissarro corrected this notion by putting the artist's political views in their proper historical context. Pissarro rejected socialism as such, because it was out of line with his own individualistic self-image as an artist. On the other hand, he also despised capitalism, which he felt was simply paving the way for a reactionary aesthetic and thus ran counter to Impressionism. At the same time, however, he saw himself as part of a subversive minority determined to grasp the new, progressive means open to them and to use these to revolutionise traditional aesthetic attitudes. In view of the fact that Pissarro's art could hardly be described as politically explosive, it seems strange that he saw himself in this light, and yet it was typical for the times. Being an "anarchist" meant occupying a position somewhat on the fringes of society and questioning social norms. Strictly speaking, in this context the adjective "anarchist" meant "avant-garde", and applied to all those who were in some sense aggressive or outspoken in their social and cultural-political attitudes. As far as Pissarro was concerned, the idea of absolute freedom from social norms could be conveyed just as effectively in an artwork as in an aesthetic manifesto. Accordingly, the very fact of putting everyday life – particularly rural everyday life – at the centre of his own artistic engagement with reality had an importance all of its own, and it was not necessary for the pictures themselves to illustrate political themes. Interestingly, there are scarcely any letters from Pissarro which discuss these matters, and which could be seen as statements in effect serving the purpose of a manifesto. He was so much a practical painter that theory (as evolved and propounded by Seurat) was never a primary aim in his art.

This brings us to the said graphic experiment in Pissarro's output. After 1890 Pissarro was equally active in the town and the country. Although he remained faithful to rural life and country landscapes throughout the decade, nonetheless, big cities – above all Paris – held a particular attraction for him. In

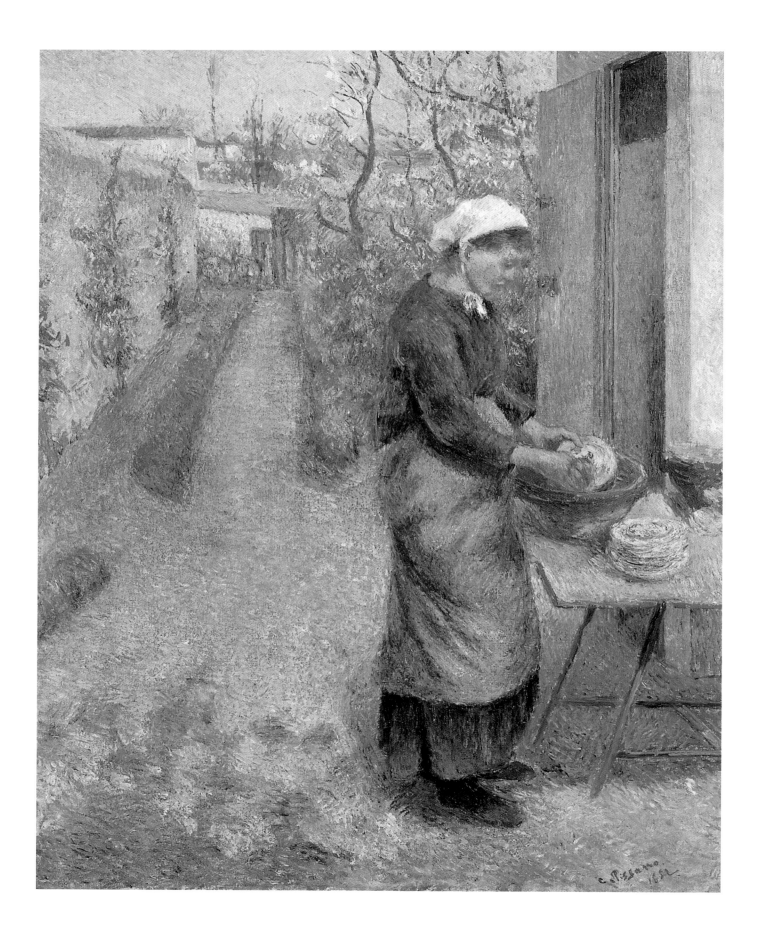

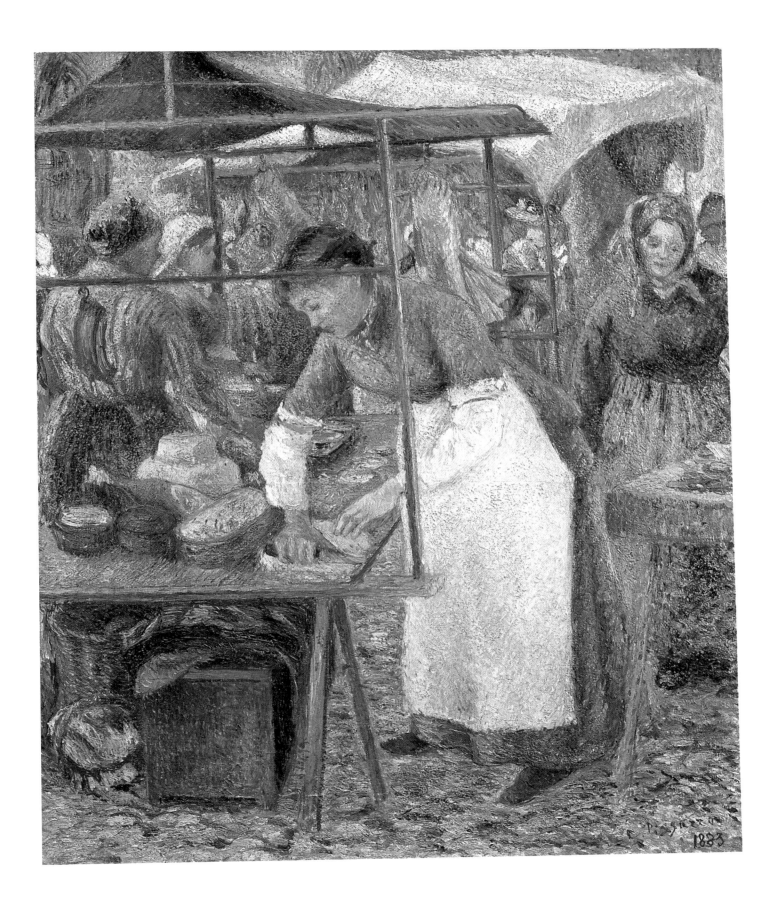

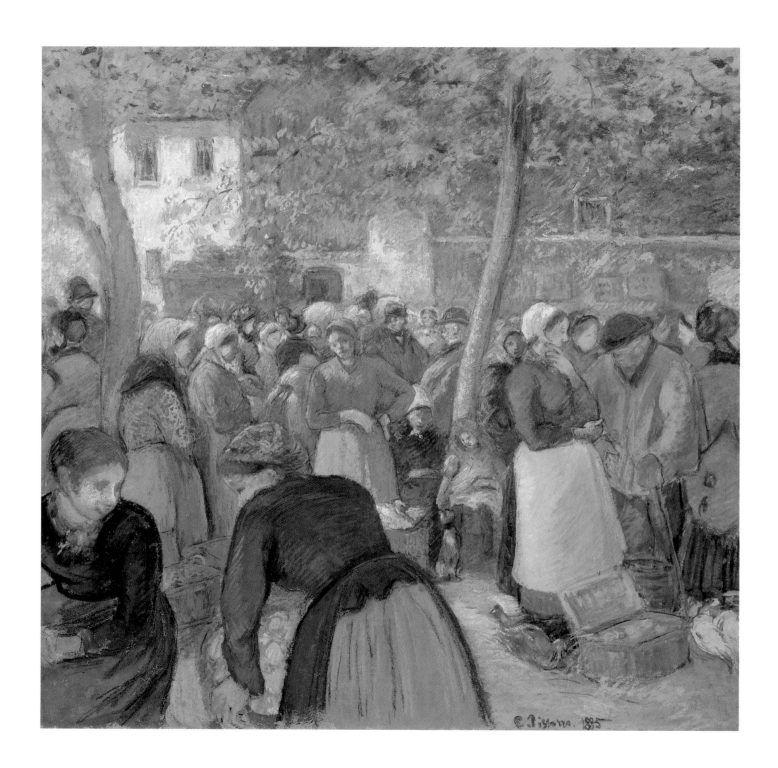

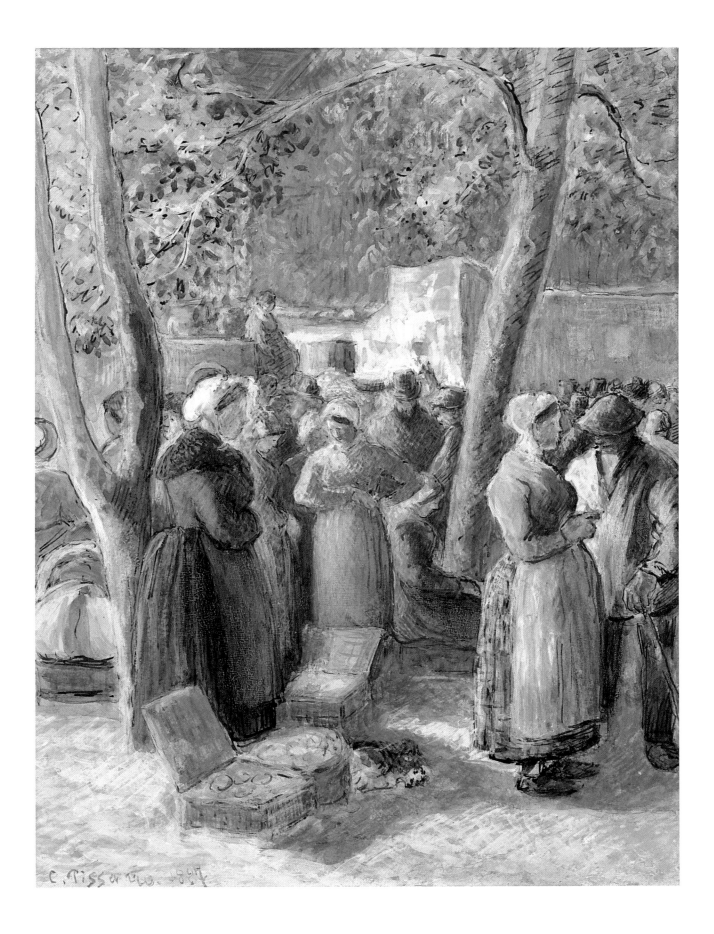

1889, he produced a series of 28 pen and ink drawings, which he put together in an album with the title *Les Turpitudes sociales* (which can scarcely be adequately translated), dating the work 1890. In the same year he became a member of the 'Club de l'art social', which had a reputation for being extremely anarchist in its thinking. Ironically, in the folio of drawings, the newest landmark in the city – the Eiffel Tower – features as a symbol of the capitalism and corruption of the Paris of the bourgeoisie. Logically the Eiffel Tower is nowhere to be seen in his cityscapes. His *Turpitudes sociales* were doubtless intended to be published and publicised as a series of prints, but this never happened. In their assessment of this series – which both in terms of quantity and quality is only a very small part of Pissarro's body of work – later generations have often overestimated the importance of these drawings and have lauded them as the essence of political implications elsewhere in his work. However, as we now turn to the last, very productive decade of Pissarro's artistic career, the significance of these critical graphic works will shift back into a proper perspective. His *Turpitudes sociales* were a discreet attempt to leave his accustomed position. Pissarro was experienced enough to know his strengths, and to draw on these, both for artistic and financial reasons. Pissarro the "anarchist" had already found his own artistic expression. Let us return for a moment to his pictures of maidservants and young working girls. Might the *Young Woman Washing Dishes* (cat. 42) not also be read as indirect criticism of social conditions? Or was it no more than a classical genre-motif aimed at a particular stratum of bourgeois collectors? It is not possible to answer these questions with any certainty. Pissarro's political thinking, described by some as "anarchist", is not as a rule reflected in his pictures, and if one also takes into account the reality of life for the rural population, then the perspective changes quite considerably. The all-pervasive political problems facing the French nation at the time were to do with a reluctance to do traditional jobs, the depopulation of the countryside, urbanisation

and industrialisation. None of these issues arises in Pissarro's art.[54] This is not intended as a reproach on our part, but the fact remains that Pissarro concentrated on the contemplative beauty of everyday rural life and – to make no bones about it – he stuck to the standard clichés. If one only looks at the artist, then his personality seems strangely contradictory; if one takes the themes of his art literally, then he would seem to be fundamentally conservative in his thinking. But if one looks at the evolution of his style and technique, then he takes up his rightful place in the ranks of the militant avant-garde as an outstanding exponent of Impressionism.

Neo-Impressionism
In Pissarro's opinion, Impressionism was already over in 1883: "Impressionism was in reality nothing other than a theory of perception, without forgetting fantasy, freedom and greatness – in a word, all the things that make art great."[55] It sounds like a nostalgic memory of the past, giving credit to the artistic methods of the time, and also pointing towards new developments. Unlike the emergence of the Impressionist style in the 1870s, in which he had played a crucial part, now younger painters were taking the concept a stage further and re-interpreting the crucial concept of "perception". This no longer referred to the direct or spontaneous representation by the artist of a natural phenomenon, for now perception was seen as a physiological and psychological process that took place between the picture and the viewer. Painters now favoured a way of painting using spots of unmixed colours, which were dotted individually over the almost white ground, creating the impression of a shimmering pictorial surface. Pissarro was clearly attracted by the painterly precision of the new method, and experimented with pen and ink on paper. In early 1885 the painter, Paul Signac, had introduced him to Georges Seurat, the driving force behind the new movement, and Pissarro was immediately taken by his compositions, with their air of cool calculation. From Gisors near Eragny he wrote to Durand-Ruel (who put on an exhibi-

tion of Impressionist works in Brussels in June 1885), telling the dealer about the changes in his work: "I have worked a great deal in Gisors. Unfortunately the changeable weather is making me ill with impatience. I was not able to finish certain most interesting and above all very difficult motifs as I would have wanted to. I am all the more downcast that I can't complete these studies because at present I am caught up in a transformation, and impatiently hoping for some kind of a result."[56]

In a letter to Durand-Ruel the following year, in November 1886, discussing notions of "theory", he describes the changes in his thinking. Now the aim was "To seek a modern synthesis of methods based on science, that in turn is based on M. E. Chevreul's theory of colour. . . . To substitute optical mixture for mixture of pigments. In other words: the breaking up of tones into their constituents. For optical mixture stirs up more intense luminosities than does mixture of pigments."[57] Critics construed this move away from Impressionism as a development of existing Impressionist techniques, and gave it the name Neo-Impressionism. Therefore it seems appropriate here to use this term for Pissarro's style in the 1880s. His relationship with Neo-Impressionism can initially be elucidated by means of some striking genre paintings from the time. Between 1888 and 1890, Pissarro produced a group of pictures showing women working in the fields, in which he employed the new technique. The fan-design, *Peasants Planting Pea-Sticks*, 1890 (cat. 46) shows a first version of the composition in landscape-format while the subsequent oil painting is in a crowded portrait-format. The gouache is executed in an Impressionist style with loose dabs of paint, and is a masterpiece of fan-design from that period. The pleasing contrast of the straight sticks and the curved figures of the women is even more pronounced in the oil painting.[58] Pissarro showed the oil painting, *Peasants Planting Pea-Sticks*, 1891 (cat. 47), the following year in Durand-Ruel's rooms, and it is one of the finest paintings of this period. The narrow view concentrates on three of the figures, whose

dance-like movements keep the composition poised somewhere between charm and strength, and introduce an almost emblematic succinctness into the scene. It is necessary to look briefly ahead at this point. In Pissarro's late works from the 1890s certain motifs come up more than once (generally views in major cities, painted in quick succession). These motifs depicting the same location can be grouped as series. The principle evident in these series, namely the concentration on one main motif, is also present in his genre paintings – and before that, had already been apparent in the landscapes from the 1870s. It is therefore not an invention of Pissarro's – particularly since other Impressionists were working in series, particularly Monet – simply a logical consequence of his development as an artist.

Although Pissarro was not at the centre of Neo-Impressionism he very much made an independent contribution to it. For whereas Monet was apparently almost entirely unmoved by Seurat's experiments, Pissarro tried out Pointillist techniques along with the Neo-Impressionists, although he did not then apply them with the same doctrinaire matter-of-factness as Seurat and Signac for instance, whose Pointillist works practically drove Emile Zola to distraction: "In the salon there is now nothing but dots, a portrait is no more than a dot; trees, houses, the continents and the oceans are nothing but dots. And now black is re-appearing, the dot is black, when it is not white. The beholder passes smoothly from the works of one painter – five or six canvases which are simply a juxtaposition of white dots – on to the works by the next painter – five or six canvases which are a juxtaposition of black dots. Black on black, white on white, oh, how original! Nothing could be more comfortable. And my consternation grows."[59] Those features that Zola had once admired – naturalness and gravitas – which he had above all seen as virtues specifically in Pissarro's work, now seemed to have become quite the opposite. The pictures by the painters who favoured the *point*, seemed cold and calculated, and nature seemed to have been

banned from them for ever more. If one looks at Pissarro's landscapes from that time, then this impression takes on a slightly different aspect. *View from my Window, Eragny*, 1888 (cat. 48), is an experimental painting, which has elements of Neo-Impressionism as well as signs of Pissarro's own Pointillist experiments. It was painted during the year following the eighth and last Impressionist exhibition, in which the main players were no longer Degas and Monet but Seurat and Signac instead. Pissarro had already started work on the picture in 1886 and had shown it the same year together with the most famous of all Pointillist works, George Seurat's monumental *Grande Jatte*, 1884/85 (now in the Art Institute, Chicago). At the time, the critic Félix Fénéon wrote about Pissarro: "With his changed way of painting, he brings to Neo-Impressionism mathematically strict analysis and the authority of his name. Now he divides his colours systematically. Sunny landscapes, white houses in blossoming orchards, wide expanses."[60] When he reworked *View from my Window* in 1888, the result was not entirely in keeping with the cool rigour of the Pointillists. The foreground with the almost rectangular red roof and the landscape divided into practically equal-depth bands give the impression that the painting is composed of a combination of countless dots of colour and short, parallel lines. This work, intended to display a completely new direction in Impressionism, provoked a very unfavourable reaction from Durand-Ruel of all people, who found it too colourful, described the view into the yard with the hens as unsuitable, and judged it to be unsellable. At the same time, there are also indisputable masterworks from this period, such as *Apple Picking at Eragny-sur-Epte*, 1888 (cat. 49), with its wealth of colours and radiant hues.[61] In contrast to the somewhat stilted compositions of the Pointillists, Pissarro manages to achieve a perfect synthesis of different styles, which in turn enhance the atmosphere and the overall optimistic mood of the painting. Thus it is overly simplistic to dismiss Pissarro's compositions as unreflected responses; on the contrary they are carefully considered advances on an already existing paradigm in art. For Pissarro, artistic progress neither simply meant negating tradition, nor did it have to bear the name of revolution.

A number of paintings from the 1870s, as we have already seen, were made up of short, curved, often directionless lines, with a relatively wide spectrum of colours within fairly small areas. In the 1880s, the lines are increasingly short and straight, very closely packed, with a noticeably narrower spectrum of colours and overall, a lighter effect. However, the picture ground is practically never visible, or gleaming through to the surface, and Pissarro never reduced his brushstrokes to the extent that they were merely dots. He viewed Pointillism as interesting but also as a passing phenomenon. On 6 September 1888 he wrote to Lucien: "I think continually of some way of painting without the dot. I hope to achieve this but I have not been able to solve the problem of dividing the pure tone without harshness. . . . How can one combine the purity and simplicity of the dot with the fullness, suppleness, liberty, spontaneity and freshness of sensation postulated by our impressionist art? This is the question which preoccupies me, for the dot is meager, lacking in body, diaphanous, more monotonous than simple, even in the Seurats, particularly in the Seurats. . ."[62]

If one compares Pissarro's Neo-Impressionist works from the 1880s with the earlier landscapes from the 1870s, one might conclude that he had turned his back on nature. These paintings give the impression of not having been made outside in the open air, and indeed, increasingly Pissarro was returning to his studio as soon as he had made his first compositional sketches and studies for individual figures out in the open. Auguste Renoir and, above all, Edgar Degas were pursuing the same path, and Pissarro commented on this method in a letter to his son, Lucien, who had just enrolled in an academic drawing class: "Only at home you must draw again from memory what you drew in class. . . . You will find it hard, but the time will come when you will be astonished at how easily you are able to

remember the forms, and strangely the studies that you will do from memory will be much stronger and more original than those done from life."[63] This move away from the Impressionist precept of capturing an impression as immediately as possible may primarily be accounted for by the new attitudes to style that were making themselves felt at the time, and which in themselves reflected a change in the dominant paradigms. For Impressionists during the 1870s, "immediacy" had been the top priority. Now the idea of "distance from nature", which came with the new techniques and wider range of subject-matter, allowed artists to create work based on studies and memory. In Pissarro's late works, to which we are now coming, both artistic methods peacefully co-exist.

Eragny 1894–1903

Pissarro produced a large proportion of his late work in Eragny – including the two works just discussed. Far away from Paris he turned once again to Impressionism. He was no doubt only too well aware that in the art market his pictures were not going to create the same kind of sensation as the works the Pointillists were making at the time. In a letter to Lucien he described himself as a patient worker, with a peasant-like, melancholic disposition: ". . . there is something uncouth and clumsy about me. People only like me when they have known me for a while – the people who are well disposed towards me must have some weakness for me. Passers-by only catch a fleeting glimpse and that is not enough – all they see is the surface."[64]

Two hours by train from Paris lay the hamlet of Eragny, about two miles north of Gisors; like Pontoise, it was an important market town in the area. In the country around Eragny numerous family-run farms divided the land up into small parcels and gave it a picturesque appearance. Harvesting machines were not financially viable, and under the pressure of competition from England and Northern France, the few small textile mills in the district went bankrupt in the 1880s. The savings to be made by living in Eragny, the attractive

countryside around him and the rail-connection to Paris[65] all delighted Pissarro: "The house is wonderful and not too dear: a thousand francs with garden and fields. It is about two hours from Paris. I found the country much more beautiful than Compiègne, although that day it was still pouring in torrents. But here comes the spring, the fields are green, outlines are delicate in the distance. Gisors is superb."[66] Here Pissarro painted a large proportion of his late works, above all landscapes and scenes in the garden of his house. As a refuge for an artist whose reputation was already established, Eragny served Pissarro rather as Giverny served Monet. But while Monet created a world in his house and garden which was soon attracting painters and art dealers alike, in Eragny the family was on its own, and Pissarro used his time there – long stretches between trips to Paris, Rouen and other towns – for tireless, uninterrupted work. Many views in paintings from that time show the surrounding fields and orchards with the hamlet of Bazincourt on a rise in the distance, or his garden. And there was no season or time of day that Pissarro did not portray, indeed he would impatiently wait for certain atmospheric changes, so that he could set up his easel in the open air and return to work with palette and brush. In letters to Lucien in London he often described weather and light conditions in minute detail, and when the seasons made it impossible for him to spend any length of time outside, he would stand inside the house and paint the scene from his window. In Eragny Pissarro once more studied nature out in the open and took up watercolour-painting again, capturing the changing times of day and the infinitely varying light.

The two paintings *Morning, Autumn, Eragny,* 1892 (cat. 50), and *Hoar Frost, Morning (Snow Effect in Eragny),* 1894 (cat. 51) still bear signs of the influence of Neo-Impressionism, which disappears entirely from Pissarro's works in the mid-1890s. These works demonstrate Pissarro's immense sensitivity in his use of colour to depict seemingly scarcely different

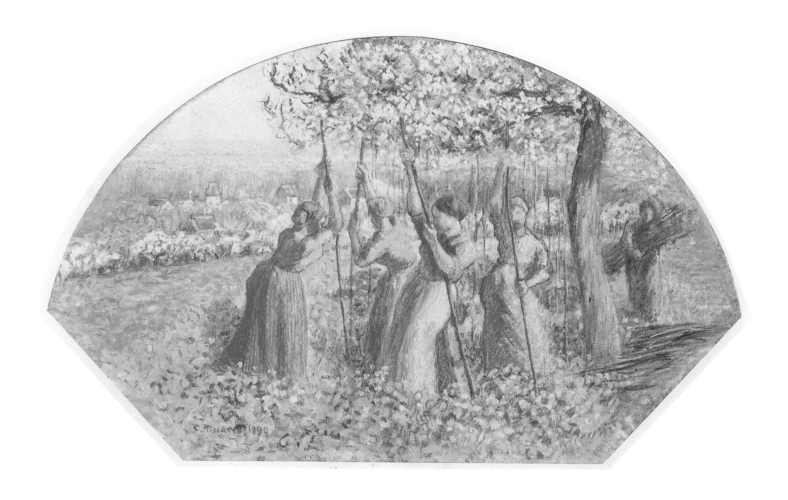

Cat. 46
Peasants Planting Pea-Sticks
Paysannes plantant des rames
1890
Gouache with traces of black
chalk on grey-brown paper,
40.7 x 64.1 cm (Fan design:
39 x 60.6 cm)
Ashmolean Museum, Oxford
BL 219, PV 1652

Cat. 47
Peasants Planting Pea-Sticks
Paysannes plantant des rames
1891
Oil on canvas, 55 x 46 cm
Private collection, on loan to
the Sheffield Galleries and
Museums Trust
PV 772

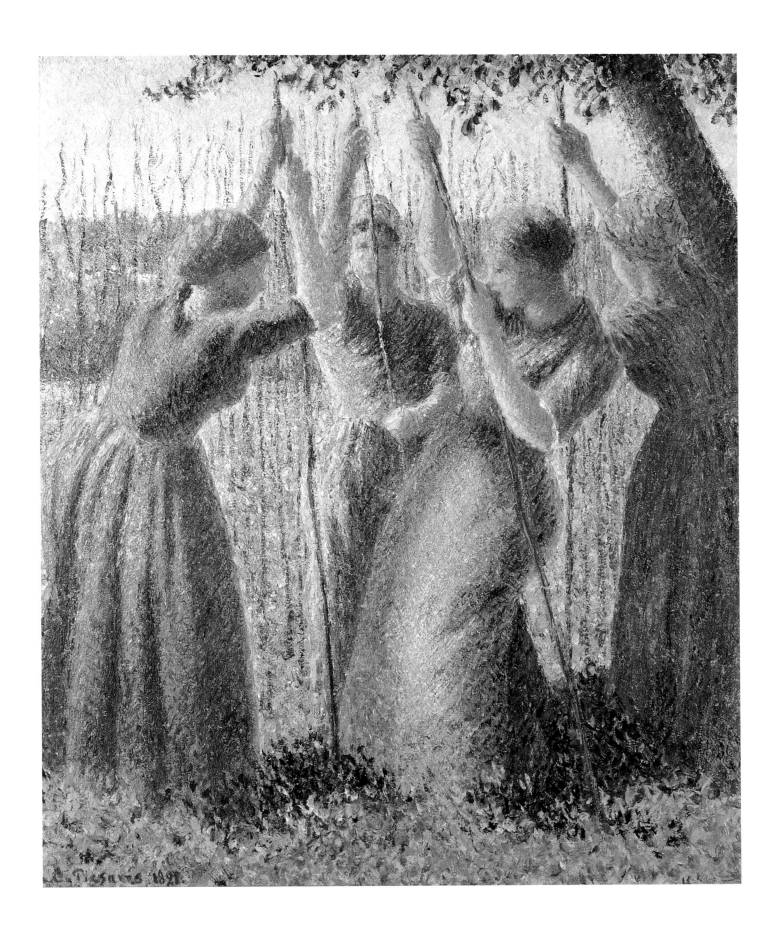

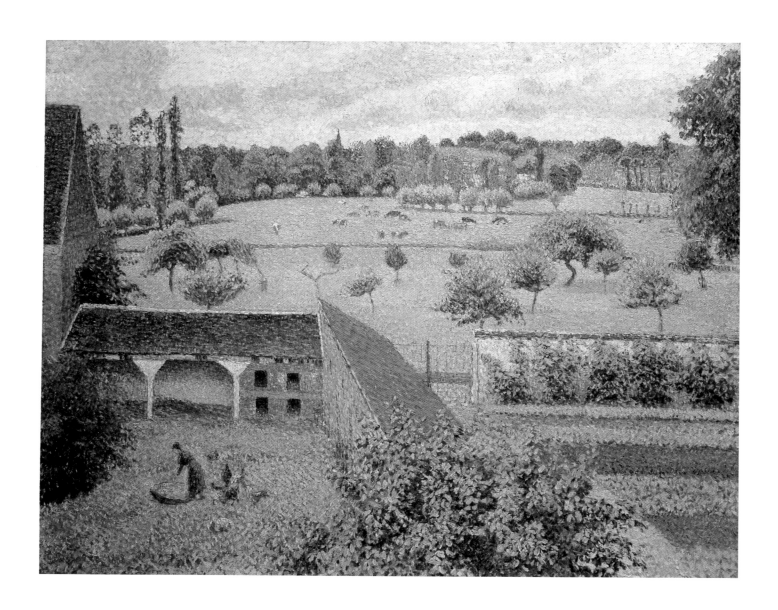

Cat. 48
View from my Window,
Eragny
Vue de ma fenêtre, Eragny
1888
Oil on canvas, 65 x 81 cm
The Ashmolean Museum,
Oxford, 334
PV 721

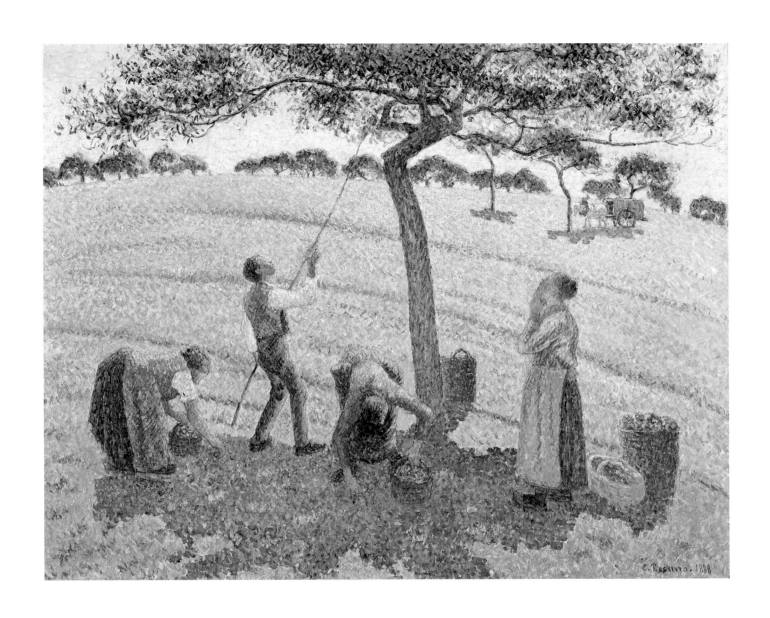

Cat. 49
Apple Picking at Eragny-
sur-Epte
La Cueillette des pommes,
Eragny-sur-Epte
1888
Oil on canvas, 60 x 73 cm
Dallas Museum of Art,
Munger Fund, 1955.17.M
PV 726

weather conditions. At this time he was particularly fascinated by the transitions between the seasons and the times of day, and his palette included endless pastel shades reminiscent of the iridescent hues of a piece of mother-of-pearl. Frequently he would return to the same spot at intervals of days or weeks, waiting eagerly for the leaves to change colour or for the first hoar frost. These pictures only reveal the depth of their quiet charm over a period of time, as though the artist wanted somehow to transfer his own, persistent observation onto the viewer. The very absence of grand sensations is typical for his late work, which has consequently often wrongly been judged inferior to contemporaneous works by other Impressionists. The late Eragny pictures have a quality all of their own, and the sum of their parts is an essential element in the Impressionist movement. In the late 1890s, due to the vicissitudes of age, Pissarro increasingly painted in the immediate vicinity of the house, or by his studio window – and, once more, he created splendidly coloured works, such as *Corner of the Garden at Eragny*, 1897 (cat. 52) and *Morning, Sun Effect, Eragny*, 1899 (cat. 53); both flooded in sunshine, they seem like companion pieces despite being painted two years apart. In the large-format painting, *The Gardener, Afternoon Sun, Eragny*, 1899 (cat. 54), which is amongst the finest of the Eragny pictures, the colours and the painterly formulation of the composition are extraordinarily rich. In the centre of the painting Pissarro ignites a small firework of green, chrome yellow, scarlet and orange, in the form of short, radial lines. This painting is one of the few late works to have a large figure in the centre of the composition, although it has to be said that there is a fine hint of irony in the way that the somewhat drowsily contemplative mood of the country garden is caught in the figure of the gardener.

In the last Eragny pictures, painted around 1900, it is particularly striking to see the looseness of the facture, as in *Steading of the Auberge Ango, Varengeville*, 1899 (cat. 55), *Vegetable Garden in Eragny, Overcast Sky, Morning*, 1901 (cat.

56), or in *Autumn in Eragny*, 1899 (cat. 57), with free rhythms that almost make them seem like late improvisations. Pissarro's mastery, his ability to playfully reveal light-effects even when the sky is cloudy or dusk is descending, is also evident in the watercolours he made at this time. Just two examples should suffice to give an impression of the several hundred he completed, namely *Sunset with Mist, Eragny* (cat. 58), in the shape of a fan-design, and *Hoar Frost* (cat. 59), both from the beginning of the last decade of Pissarro's artistic career. The tender colours are almost translucent, and their application reflects the speed with which the artist worked, outside, facing his subject. Painted at almost exactly the same time, they show how refined Pissarro was in his use of various technical means. The lengthways, rectangular brushstrokes in *Hoar Frost* are reminiscent of works by Cézanne while the generous wash and gentle daubs of paint in *Sunset* are clearly related to Monet's style. In his late works in the 1890s Pissarro fitted his mode of expression to the subject in hand, not vice versa, and thus cast aside the doctrinaire constraints of Neo-Impressionism. The landscape and nature were a challenge that he took up again and again, like a man possessed – "acharné" to use Cézanne's description. Thus Eragny was more than a secluded refuge, it was a place where Pissarro engaged intensely and creatively with the central theme of his art.

In the eyes of Parisian art critics, Pissarro's life in Eragny seemed like a complete anachronism. People accused him of "running away from things", and rumour had it that he was living in primitive conditions, like a peasant, tilling his own land and sending his wife out to milk the cows in the shed (see cat. 80–82). The tinge of scorn that may be heard in some commentaries points to a typical phenomenon of the time. The artists, above all the group around Paul Gauguin, who had settled in Pont-Aven in the 1880s, were searching for an unspoilt existence far from the madding crowd and the world of academic art. While the critics could perfectly well see through the often somewhat self-glorifying attitudes of the

young artists, they were nevertheless well-disposed towards them and supported their search for an apparently intact world. While many artists in Pont-Aven went along with this rather artificial notion of an "avant-garde at one remove", Pissarro rejected it out of hand, and distanced himself and his work from the Symbolism favoured by Gauguin and Sérusier.

IV THE BIG CITIES 1890–1900

The last decade sees Pissarro make trips from Eragny to London, Rouen, Dieppe and Paris. On his travels he paints a number of series concentrating on individual motifs, culminating in a sequence of stunning 'boulevard pictures'.

There are two main strands to Pissarro's development as an artist in the 1890s. On one hand, there are his advances in landscape painting (in Eragny). On the other hand he explored a whole new area, namely cityscapes, creating a number of substantial series and using a variety of techniques.[67] During the last decade of his life, Pissarro undertook frequent, extended journeys: London, Rouen, Dieppe and Paris were his most important destinations, and he was immensely productive in all of these.[68] Thus the Eragny pictures come from the same period as his cityscapes. The 1890s brought Pissarro recognition and pleasing financial rewards. By February 1892 at the latest – when Durand-Ruel put on a solo exhibition of his works, with 50 paintings and 21 gouaches from 1872 to 1892 – Pissarro was a celebrity. Since Durand-Ruel bought in a relatively large number of pictures as an investment and was receiving numerous enquiries from the United States, Pissarro's family was now able to live free from worry and in comfortable, bourgeois conditions.

London
London and Paris, which come at the beginning and the end of our selection were important sources of inspiration for Pissarro. Ever since his short exile in London in 1871, he had always been happy to return there. His

oldest son, Lucien, who had also decided to become an artist, moved permanently to London in 1883; father and son were engaged in a life-long dialogue about art which can still be followed in the hundreds of letters they left. Pissarro's other older sons also lived in England at various times, and two of them married English women. Pissarro made extended painting trips to London in 1890, 1892 and 1897.

Charing Cross Bridge, London, 1890 (cat. 60), like the other two examples of his London pictures, was painted during Pissarro's Pointillist-influenced, Neo-Impressionist phase. Unlike during his first, less willing stay in London in 1871, now Pissarro would paint in the centre of the city and in the capital's vast parks. *Charing Cross Bridge* is a typical example of his many landscape-format compositions with 'frontal' views of bridges; in this case the subject is the still relatively new railway bridge leading over the River Thames and on into Charing Cross Station. The picture consists of horizontal and vertical elements, and seems to have been carefully constructed, not unlike works by Signac or Seurat (a useful comparison may be made with Paul Signac's *Harbour in Portrieux*, (fig. 30, p. 22).[69] Water and sky are painted with the same short strokes, with the result that the entire surface is suspended in an optical vibrato. *Hampton Court Green, London*, 1891 (cat. 61), has a similar low horizon and vertical elements, creating a sense of tense calm rather than of busy activity. The figures in these park scenes are tiny, almost unnoticeable, and lend an air of desolation to the wide expanses of lawn before the massive one-time residence of Henry VIII, just outside the Gates of London. Things were rather livelier in *Kew Green (Kew Gardens), London*, 1892 (cat. 62), and Pissarro wrote to Durand-Ruel in either late May or early June 1892: "At the moment I am very busy in Kew Gardens, where I have found a series of wonderful motifs, which I am trying to portray to the best of my ability."[70] Pissarro's dedicated efforts were partly financially motivated since his pictures of London parks sold well, and Durand–Ruel encouraged him to do as many

Cat. 50
Morning, Autumn, Eragny
Matin, automne, Eragny
1892
Oil on canvas, 55 x 46 cm
Von der Heydt-Museum,
Wuppertal, Inv. G 1148
PV 816

Cat. 51
Hoar Frost, Morning
(Snow Effect in Eragny)
Gelée blanche, matin
(Effet de neige à Eragny)
1894
Oil on canvas, 73.5 x 92.5 cm
Musée d'Orsay, Paris, Legs du
Comte Isaac de Camondo,
RF 2014
PV 867

Cat. 52
Corner of the Garden in
Eragny
Coin de jardin à Eragny
1897
Oil on canvas, 65.5 x 81 cm
Ordrupgaard, Copenhagen
PV 1011

Cat. 53
Morning, Sun Effect, Eragny
Matin, effet de soleil, Eragny
1899
Oil on canvas, 65 x 81 cm
The Israel Museum,
Jerusalem, Bequest of Mrs.
Neville Blond, B87.110
PV 1077

Plates pp. 116 and 117

Cat. 55
The Steading of the
Auberge Ango, Varengeville
Le Clos de l'auberge Ango,
Varengeville
1899
Oil on canvas, 55 x 46 cm
Privately owned
PV 1084

Cat. 54
The Gardener, Afternoon
Sun, Eragny
Le Jardinier, soleil d'après-
midi, Eragny
1899
Oil on canvas, 92 x 65 cm
Staatsgalerie Stuttgart, on
loan from the Stuttgart
Galerieverein, Inv. GVL 107
PV 1079

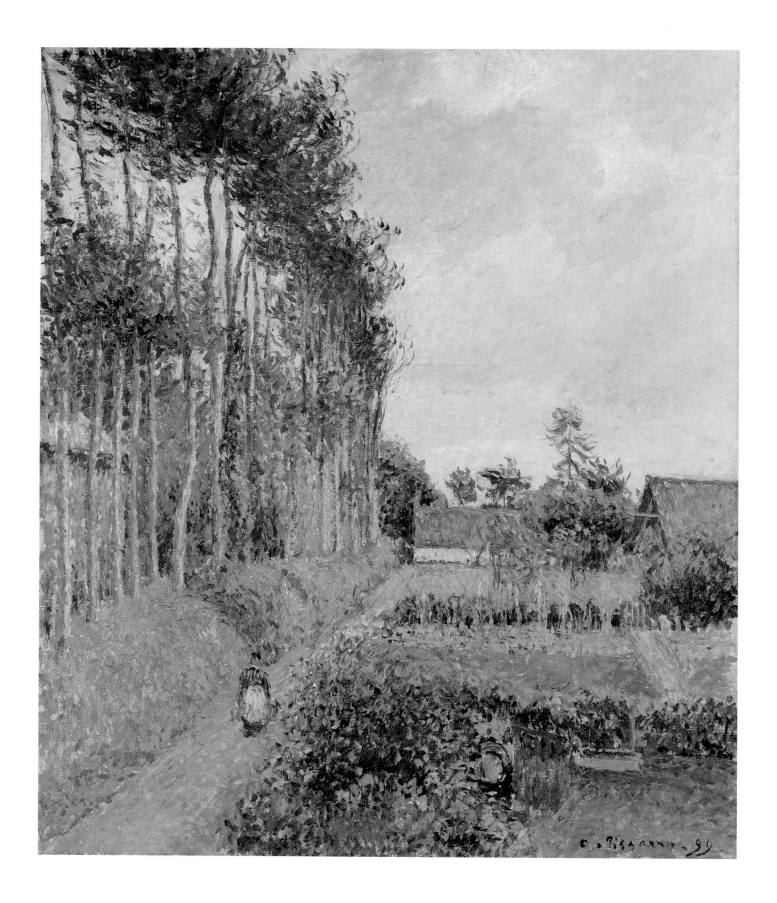

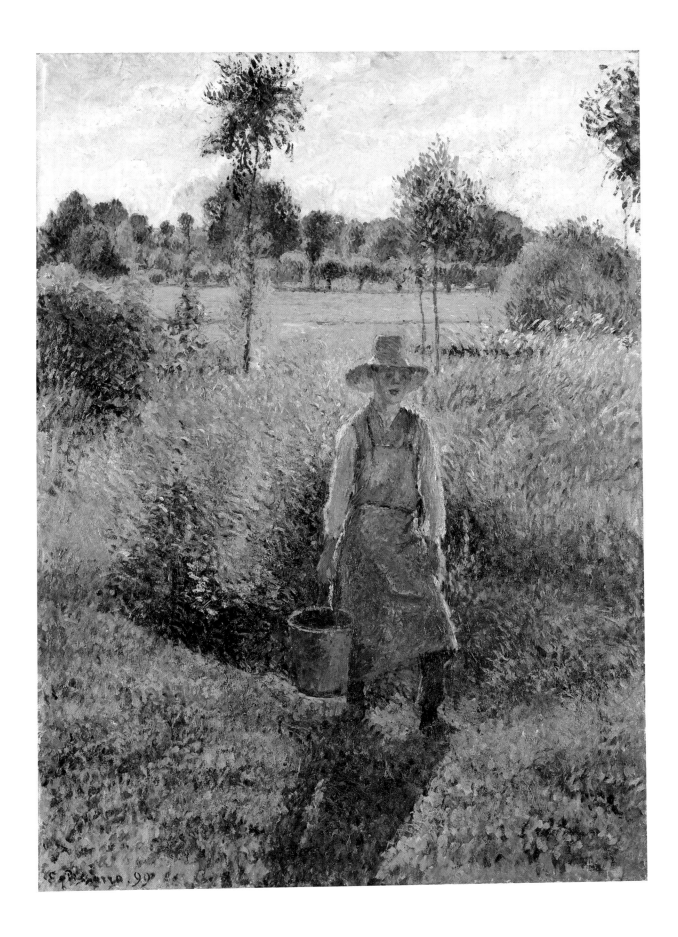

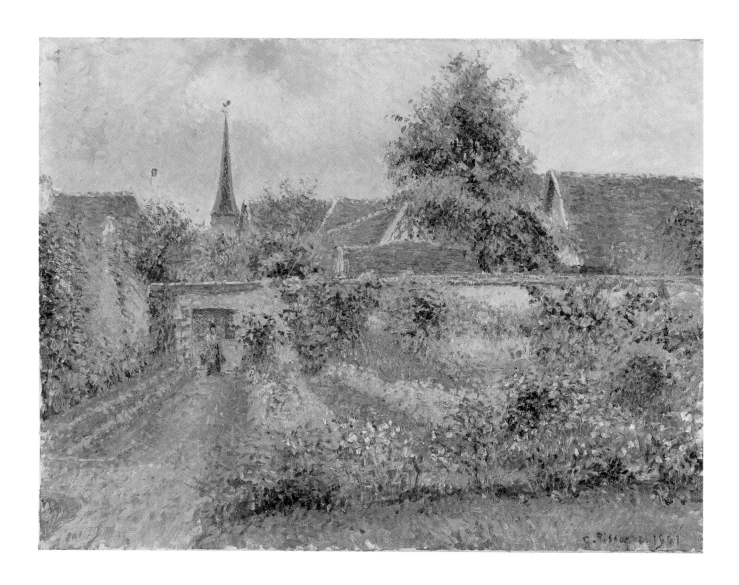

Cat. 56
Vegetable Garden in
Eragny, Overcast Sky,
Morning
Jardin potager à Eragny,
temps gris, matin
1901
Oil on canvas, 64.8 x 81.3 cm
Philadelphia Museum of Art,
Bequest of Charlotte Dor-
rance Wright, 1978-1-26
PV 1183

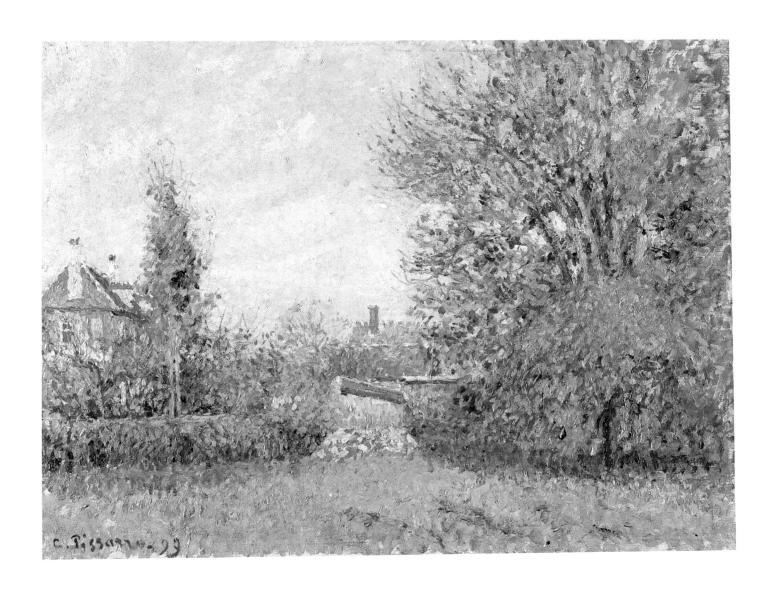

Cat. 57
Autumn in Eragny
Automne à Eragny
1899
Oil on canvas, 50 x 65 cm
Stiftung Langmatt Sidney
und Jenny Brown, Baden,
Switzerland
PV 1095

Cat. 58
Sunset with Mist, Eragny
Soleil couchant avec brouil-
lard, Eragny
1890
Watercolour with tempera on
Japanese paper, 35.1 x 54.4
cm
Ashmolean Museum, Oxford
BL 235

Gelée blanche 15 Dec 90 C. Pissarro

n°1

Cat. 59
Hoar Frost
Gelée blanche
1890
Watercolour over pencil on
paper, 20.8 x 26.2 cm
Ashmolean Museum, Oxford
BL 234

as he could. Compared to *Charing Cross Bridge*, this painting of the botanic gardens seems less contrived; the horizon is broken up by groups of trees, the main area of grass forms an irregular triangle, the figures are involved in numerous different activities, and the brushwork is more reminiscent of Impressionism than of Pointillism. The motifs and the sheer quantity of the works Pissarro painted in London led to Durand-Ruel putting on an exhibition in 1893; the paintings sold well, which encouraged Pissarro to continue with his cityscapes. An important station on his subsequent painting trips was the city of Rouen.

Rouen and Dieppe

Rouen preoccupied Pissarro for almost fifteen years starting in the mid-1880s, when he visited it at regular intervals. In 1888 he painted *The Ile Lacroix, Rouen, Mist Effect* (fig. 6): a Neo-Impressionist work, with leanings towards Pointillism — a synthesis of earlier themes and the new, one might almost say 'fashionable' technique, which involved placing different colours side by side. As far as its style goes, this painting is related to the London pictures from around 1890; however, during the next few years Pissarro's style was to change. In Rouen he found his first motifs in the old town; later on he started to portray the harbour and the bridges over the Seine, which he loved to paint with a clouded sky or when the sun was low over the horizon. After painting a number of Neo-Impressionist views of Rouen in the mid-1880s, it was in the late 1890s that Pissarro created the main body of his Rouen pictures in a "moderated style". At this time, his 'Impressionist' colleagues – first and foremost Monet – were choosing individual motifs and then painting these as series, while the younger generation, with their interest in Neo-Impressionism or Pointillism, preferred a wider range of themes. Pissarro, however, occupies a position all of his own in the 1890s in comparison to his colleagues. The younger artists good-naturedly mocked him for the apparent vagueness of his position: "I know that old man Pissarro is very busy with his Rouenneries," wrote the painter, Charles

Angrand, in November 1896 in a letter to Paul Signac.[71] What some disrespectfully regarded as an old man's whim, turns out in retrospect to be an impressive group of works comprising a total of 28 paintings, which can hold its own with any works from the time. One of the finest examples, *Rue de l'Epicerie, Rouen* (cat. 63), painted in late summer 1898, shows the cathedral in front of which the rue de L'Epicerie broadens out into the place de la Haute-Vieille-Tour (the same view that Monet and other Impressionist painters had also chosen). Pissarro's interest lay as much in the monumental medieval structure as in the busy crowds thronging the Friday market. The verticals of the cathedral's towers in the upper third of the picture are set against the horizontal lines of the bourgeois houses, and the triangular area of ground leading into the picture from the bottom edge – structured by large numbers of figures – adds striking depth to the composition, which in itself brings to mind thoughts of Pissarro's London parks. Despite the complexity of its spatial inter-relations the proportions are perfect in every detail and the colours are equally well balanced.

Another side of the city Rouen which fascinated Pissarro was the view of the Pont Boïeldieu, a monumental iron structure (completed in 1887) spanning the Seine, and which had hundreds of ships passing under it every day, usually big, placid barges. As before in *The Ile Lacroix*, Pissarro again showed his preference for motifs from the industrialized regions on the outskirts of the city along the banks of the Seine. "Just imagine," he wrote enthusiastically to Lucien, "from my window, directly opposite the new quarter, Saint-Sever, with the terrifying Gare d'Orléans, all new and gleaming, and a crowd of chimney stacks, huge big ones and little ones too with smoke pouring out. In the foreground ships and the water, left of the station is the workers' quarter which stretches right along the quay as far as the iron bridge, the Pont Boïeldieu; it is morning with sun and mist . . . it is just as beautiful as Venice."[72] The closing comment here is a mildly ironic allusion to the fashion-

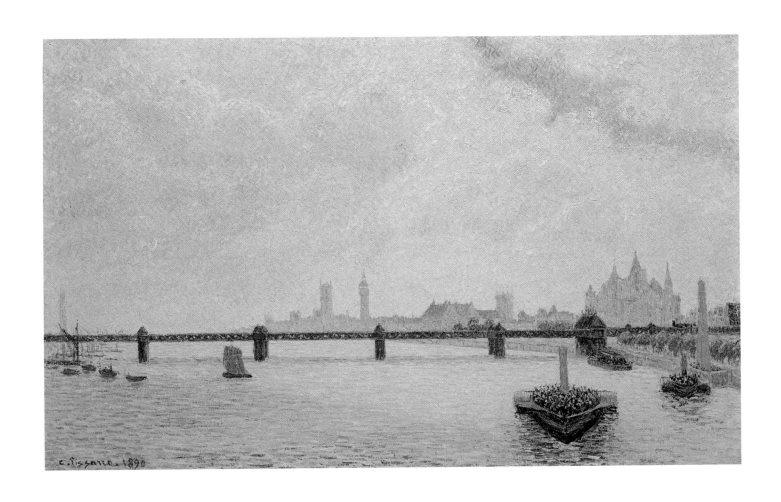

Cat. 60
Charing Cross Bridge,
London
Le Pont de Charing-Cross,
Londres
1890
Oil on canvas, 60.6 x 93.3 cm
National Gallery of Art,
Washington, Collection of
Mr. and Mrs. Paul Mellon,
1985.64.32
PV 745

Cat. 61
Hampton Court Green,
London
1891
Oil on canvas, 54.3 x 73 cm
National Gallery of Art,
Washington, Ailsa Mellon
Bruce Collection, 1970.17.53
PV 746

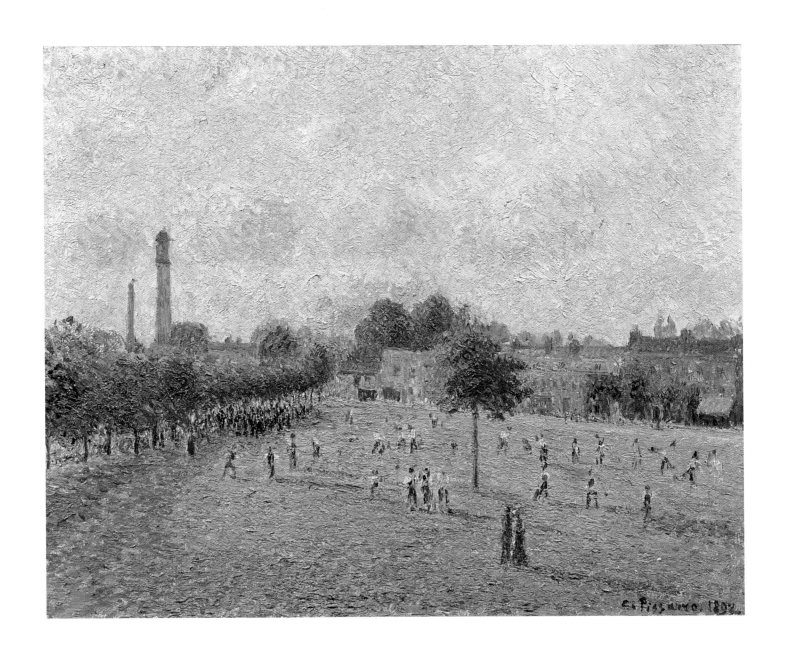

Cat. 62
Kew Green (Kew Gardens),
London
1892
Oil on canvas, 46 x 55 cm
Musée des Beaux-Arts, Lyon
(Dépot du Musée d'Orsay)
PV 799

able appeal that Venice had around the turn of the century for so many artists – Impressionists and Symbolists alike. As far as Pissarro was concerned, the city on the lagoon was entirely divorced from the reality that he found by the bustling bridges and waterways in the city of Rouen. Industry was making its own ineradicable mark on the periphery of the city, and this was of much greater interest to Pissarro than traces of ancient history. Whatever the weather he sketched out of doors, and then went back to his hotel to work on his canvases late into the night in his improvised studio. Again and again he returned to the massive iron constructions of the bridges over the Seine, painting them in the changing light, in the sun, the rain and the mist, almost always choosing a viewpoint where the bridge formed a dominant diagonal. *The Pont Boïeldieu, Rouen, Sunset, Misty Weather*, 1896 (cat. 64) is filled with superb atmospheric effects: water, mist, and clouds of smoke all mingle in the faintly reddish light of the setting sun – a modern image of industry. *The Pont Boïeldieu, Rouen, Rain Effect*, 1896 (cat. 65), is more varied in terms of colours and

motifs, and has various anecdotal allusions; nevertheless it is no tourist souvenir, it is simply about capturing a moment in the everyday life of the city.

Pissarro plays with small colour effects on vehicles, houses and advertising hoardings, which he sets like markers for the eye of the beholder as it wanders freely over the scene. The compositions with the bridge were intended by Pissarro as series, an idea that he already mentioned when he first stayed in Rouen in 1883. As he reported to Lucien, he was working on nine pictures at once: "The day after your departure I started a new painting at Le Cours-la-Reine, in the afternoon in the glow of the sun, and another in the morning . . . These two canvases are fairly well advanced, but I still need one session in fine weather without too much mist to give them a little firmness. Until now I have not been able to find the effect I want, I have even been forced to change the effect a bit, which is always dangerous. I have also an effect of fog, another, same effect from my window, the same motif in the rain, several sketches in oils, done on the quays near the boats; the next day it was impossible to go on, everything was confused, the motifs no longer existed; one has to realise them in a single session."[73]

This 'simultaneity' – the complicated process involved in working in parallel on a number of pictures – becomes a constituent element in Pissarro's late work, and 'time', which seemed to stand still in his earlier works, now becomes the determining factor in his art, referred to in his use of the word *effet*. His numerous sketches[74] did not merely serve to confirm the spatial relationships in a situation, for he also carried these out in order to 'fix' the changing weather conditions, the 'effects', the movements of clouds, trails of smoke and vehicles. Despite the somewhat conventional pictorial structure of *Sunset, Port of Rouen (Steamboats)*, 1898 (cat. 66), this is a good example of Pissarro's 'effects'. The reflections of the evening sunshine on the choppy water, boats at their moorings – contours sharpened by the evening light – smoke gathering over the river in a fine, coloured haze – not forget-

Fig. 6
Camille Pissarro
The Ile Lacroix, Rouen, Mist Effect
L'Ile Lacroix, Rouen, effet de brouillard
1888
Oil on canvas, 44 x 55 cm
Philadelphia Museum of Art, The John G. Johnson Collection
PV 719

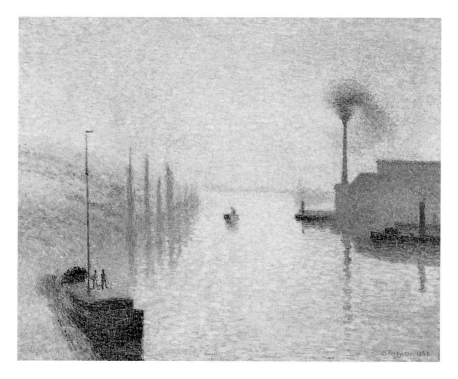

ting the sky, with hues spanning the spectrum from azure blue to orange-red – here is the seasoned colourist who adapts his style to suit his own subject.

The last extensive painting trips undertaken by Pissarro – now over seventy years of age – were to Dieppe. *The Port of Dieppe*, 1902 (cat. 67), with its contrasts of brick red and turquoise blue and its almost gestural, very free brushwork, conveys the optimistic mood that pervades many of his last works. At the same time, these works, by virtue of their many characters in walk-on parts as it were, have a narrative undertone, which add to the brittle charm of the otherwise scarcely elegant harbour views. "Well," he wrote to Lucien on 11 July 1902, "here I am in Dieppe at the Hôtel du Commerce. I have rented a room on the second floor under the arcades of the fish-market. This is my studio. I have a first-rate motif, indeed I have several." And again on 15 August: "The annual fair is on just now. Blaring music by Gounod and other great classics. I am completely unable to sleep!"[75] *The Fair, Dieppe, Sun, Afternoon*, 1901 (cat. 68) radiates the good mood of the people in the sun-soaked square; in front of the choir of the Church of Saint Jacques, at the left edge of the picture, stands the large carrousel, surrounded by roofed booths. A broad street (a late echo of earlier woodland paths), leading into the background, is filled with people, who are making way for a colourful procession. The foreground is accented by one red awning in the market; in front of it there are neatly arranged flower-stands. In these light, amicable pictures Pissarro uses an almost abbreviated style of brushwork, which breathes life into the scene through the paint and the colours. This picture too is imbued with movement which is only held in check by the distance between painter and subject. Compared with the static constructions of his Neo-Impressionist phase and the solitary figures in his early landscapes, *The Fair* reveals Pissarro's love of life, as though in these last works, he was simply celebrating the visible (non-aestheticized) world.

Paris

The extent of the late artistic achievement embodied in Pissarro's cityscapes has long been underestimated, overshadowed by Monet's great series – albeit not entirely unjustly because, amongst more than three hundred cityscapes, not all are of the same high quality. (We will come in our conclusion to the question of the misleading nature of any comparison with Monet, which in itself blurs Pissarro's own, independent position.) Pissarro painted seven series with motifs showing the city of Paris: from the Tuileries, the bridges and the quays, to the great boulevards, which bring our selection to a close.[76] The three pictures of the boulevard Montmartre give a brief but representative insight into Pissarro's technique and aims around the turn of the century.

Boulevard Montmartre, Spring, 1879 (cat. 69), was painted in a year when the Pissarro family suffered deep anxiety and loss. Lucien suffered stroke and only gradually recovered; his brother Félix (called Titi at home) contracted tuberculosis and died shortly afterwards. At the end of the year Pissarro wrote a long letter to Lucien, from whom the family had at first tried to hide Titi's death. This letter contains a remarkable passage which throws light on the link that Pissarro made between art and living: "Well, my dear Lucien, let us work, that will dress our wounds. . . . I forgot to mention that I found a room in the Grand Hôtel du Louvre with a superb view of the Avenue de l'Opéra and the corner of the Place du Palais Royal! It is very beautiful to paint! Perhaps it is not aesthetic, but I am delighted to be able to paint those Paris streets that people have come to call ugly, but which are so silvery, so luminous and vital. . . . This is completely modern!"[77] This letter, with its relish for the city and its streets, shows how seriously Pissarro took his work even at this late stage in his life. Painting was his profession, and besides public acclaim it also brought him inner satisfaction.[78] It is hardly surprising that the pictures he painted of the streets and scenes in Paris should have been particularly important to him. They have

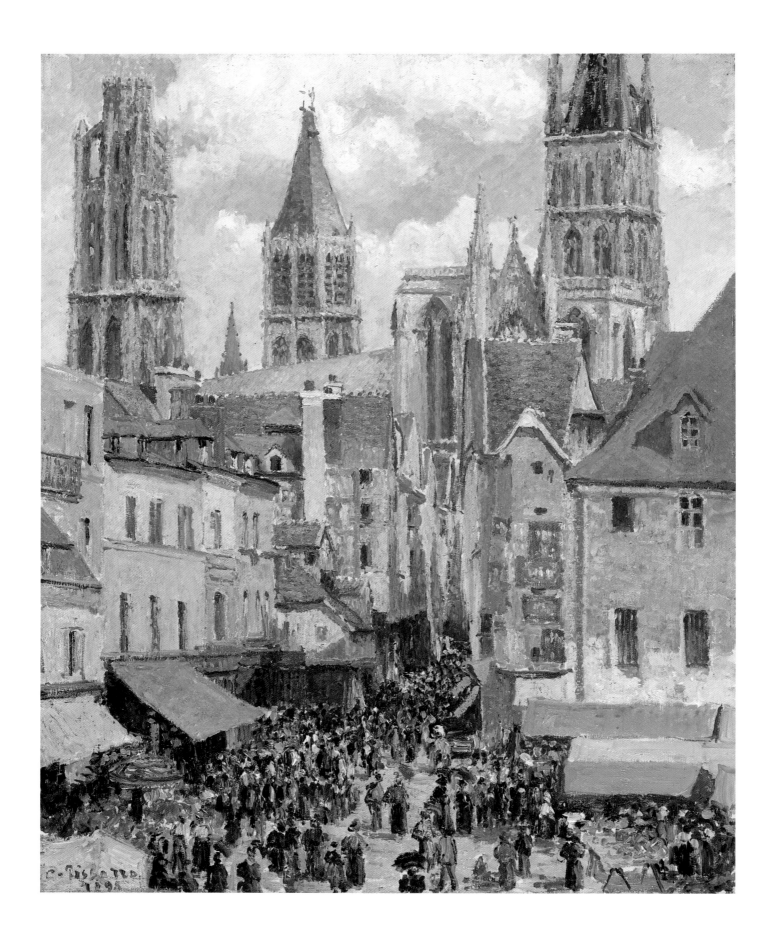

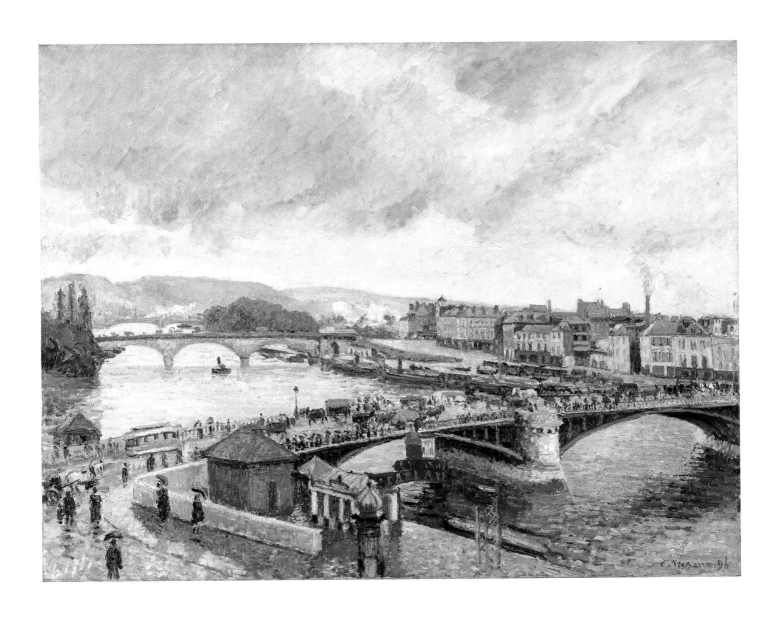

Cat. 63
The Rue de l'Epicérie in Rouen
La Rue de l'Epicérie à Rouen
1898
Oil on canvas, 81.3 x 65.1 cm
The Metropolitan Museum of Art, New York, Purchase, Mr. and Mrs. Richard J. Bernhard Gift 1960, 60.5
PV 1036

Cat. 65
The Grand Pont, Rouen, Rain Effect
Le Grand Pont, Rouen, effet de pluie
1896
Oil on canvas, 73 x 92 cm
Staatliche Kunsthalle Karlsruhe, Inv. 2488
PV 950

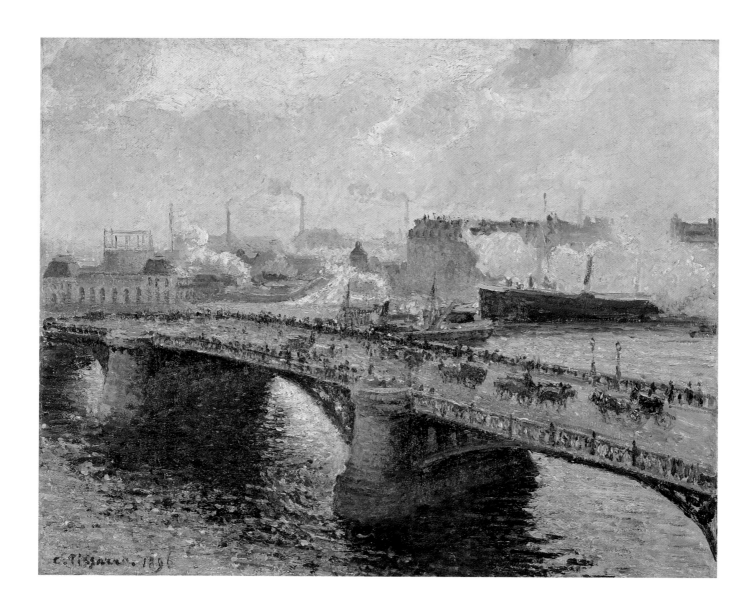

Cat. 64
The Pont Boïeldieu, Rouen,
Sunset, Misty Weather
Le Pont Boïeldieu à Rouen,
soleil couchant, temps
brumeux
1896
Oil on canvas, 54 x 65 cm
Musée d'Orsay, Paris,
RF 1983-7
PV 953

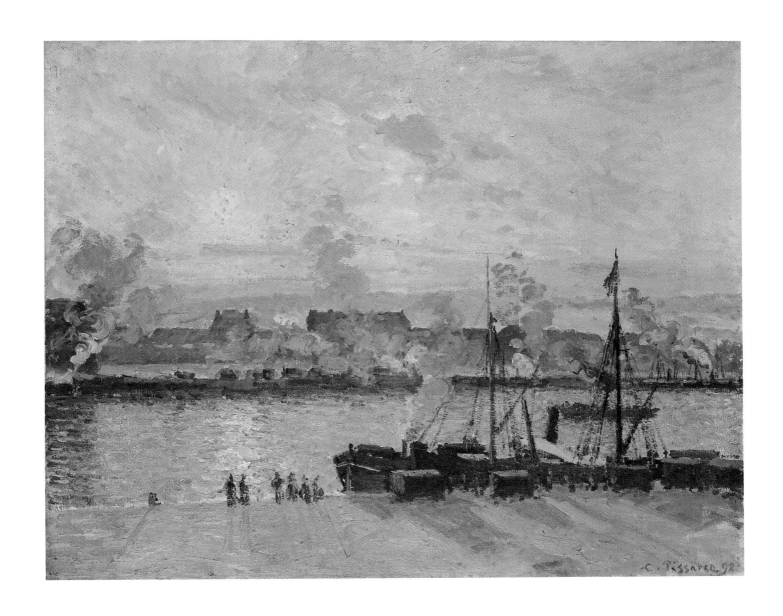

Cat. 66
Sunset, the Port at Rouen
(Smoke)
Soleil couchant, port de
Rouen (fumées)
1898
Oil on canvas, 65 x 81 cm
National Museums and
Gallery, Cardiff, 1066
PV 1039

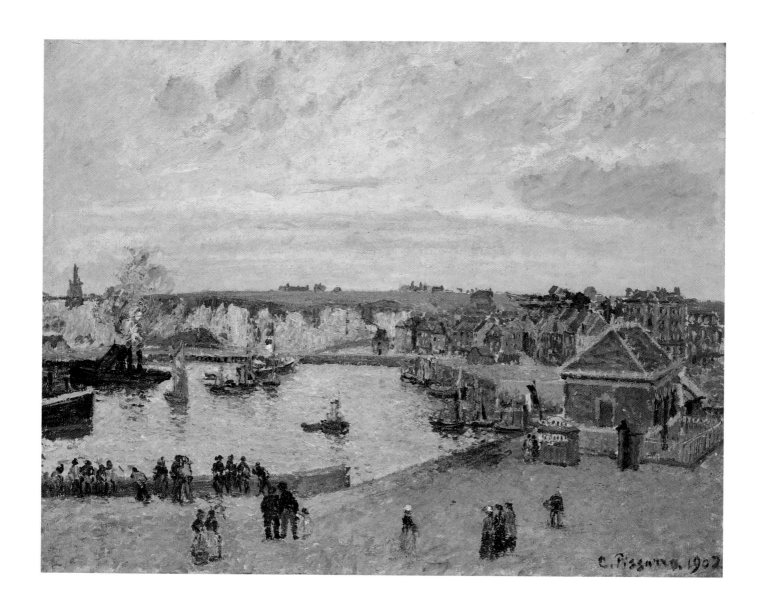

Cat. 67
The Port of Dieppe
Port de Dieppe
1902
Oil on canvas, 60 x 73 cm
Private collection
PV 1248

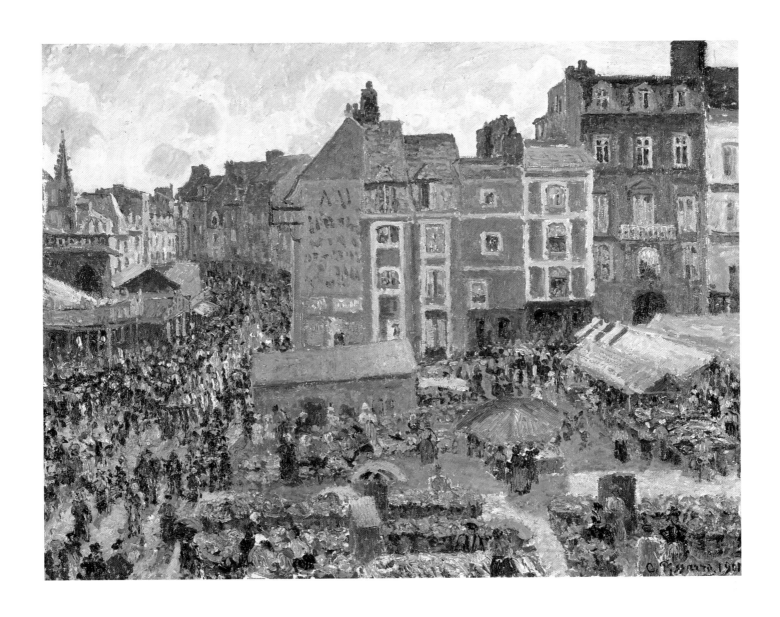

Cat. 68
The Fair at Dieppe, Sun,
Afternoon
La Foire à Dieppe, soleil,
après-midi
1901
Oil on canvas, 73.5 x 92.1 cm
Philadelphia Museum of Art,
Bequest of Lisa Norris Elkins,
1950-92-12
PV 1200

all the hallmarks of his landscape paintings: a thoroughfare leading far into the distance between houses and trees, the bustle of coaches, carts and pedestrians, and long shadows cast by the low sun somewhere to one side of the picture. *Boulevard Montmartre, Spring* was painted rapidly and even sketchily in some places; the colours range through all the finest nuances of green, rust-brown, putty and grey, just like the bridges and the harbour scenes. The larger-than-life city in its never-ending coming and going was just as 'modern' as the industrial sites on its outskirts. The most astonishing of the boulevard pictures, the (undated) *Boulevard Montmartre, Night Effect* (cat. 70) must have been painted at around the same time. It shows a night-time scene, in heavy rain. Thousands of reflections from artificial lights blur solid shapes to the point of unrecognisability. The cold gleam of the gaslamps on the wet street contrasts with the warm glow of the light streaming out into the street from the restaurants – which in turn seems to absorb the passers-by into a golden shimmer. The boulevard becomes the epitome of the metropolis as a living organism.

"I have a number of things going on," Pissarro wrote on 5 March 1897 from the Hôtel de Russie, "At Shrove-Tuesday I painted the boulevards with the crowd and the march of the Boeuf-Gras, with effects of sun on the serpentines and the trees, the crowd in the shadow."[79] *Shrove Tuesday, Sunset, Boulevard Montmartre*, 1897 (cat. 71) really requires no further comment. For a moment Pissarro overstepped the limits of his composition, as though its precepts were subsumed in the very act of painting itself: the dissolution of the firm pictorial structure into associative trails of colour seems to have only one purpose: not to capture movement but to make it visible, as in a still from a film. Pissarro's boulevard pictures are painted with modern eyes. The artist was at the end of his own creative life, but not at the end of an epoch.

The old man at the window up above the boulevard was not some lonely, other-worldly artist (cat. 72). Pissarro's boulevard pictures embody both the essence of his art and the dilemma that this brought with it, for they are not only the logical consequence of his output hitherto; they are more than a destination, they are a possibility. And this is the fundamental difference between Pissarro and Monet. While Monet created colourist masterpieces of an experimental character, carefully selecting them and grouping them for each exhibition; the thing uppermost in Pissarro's mind was the minutely precise observation of atmospheric changes that came with the passing of the seasons and the times of day. If one separates his cityscapes and series from the rest of his work, then compared to Monet's bold tableaux they look like the products of a highly-skilled craftsman. But perhaps the most important difference may be seen in one single motif: when Pissarro painted movement, he painted people and coaches and carts, that is to say, movement as it is in the visible world. Maybe Monet's late works attain a higher level of abstraction, but that does not mean that they were more "modern" in their day than Pissarro's. The latter's approach to the world is direct – sometimes borne aloft by naïve excess – and ranges from his initial love of all things visible to his ultimate love of all things changeable and changing. Against this background, Pissarro's art may be seen as an inner journey where the traveller availed himself of all the latest advances in technique and style. Pissarro was neither an intellectual nor a theoretician, setting his sights determinedly on the 'great abstract' and sinking into a haze of colour. Throughout his life he kept his gaze fixed firmly on the world.

On one of his last painting trips he once said to a journalist: "I only see flecks. When I start a picture, the first thing that I try to establish is the harmony. Between this sky and this ground and this water there is, of necessity, a tonal relationship, and that is the great difficulty in painting. . . . The great problem that has to be solved, is the matter of relating everything in the picture, even the smallest details, to the overall harmony, that is to say, making everything sound harmoniously together."[80] This sentence clearly applies to his late work and at the same time touches on the

heart of his development as an artist: At the end of his life, his mature view of the world leads to the "harmony" behind any earlier idealisation and stylisation. In the 1880s his contact with Neo-Impressionism and Pointillism had led him to a greater degree of refinement in his own technique. During the 1870s, when Impressionism was just emerging, he and others had developed the new style according to the principles of Naturalism. In his œuvre Pissarro possibly created a greater range of Impressionist expression than any other artist at the same time as achieving the highest level of differentiation in his artistic means. His art reflected on the work of his role-models, Courbet, Corot, Millet and Daubigny; it engaged in dialogue with that of his fellow-travellers, Monet, Degas and Cézanne; and it influenced Sisley, van Gogh and Gauguin. And yet, when all's said and done, while Pissarro was infinitely responsive and giving, ultimately his art was entirely his own.

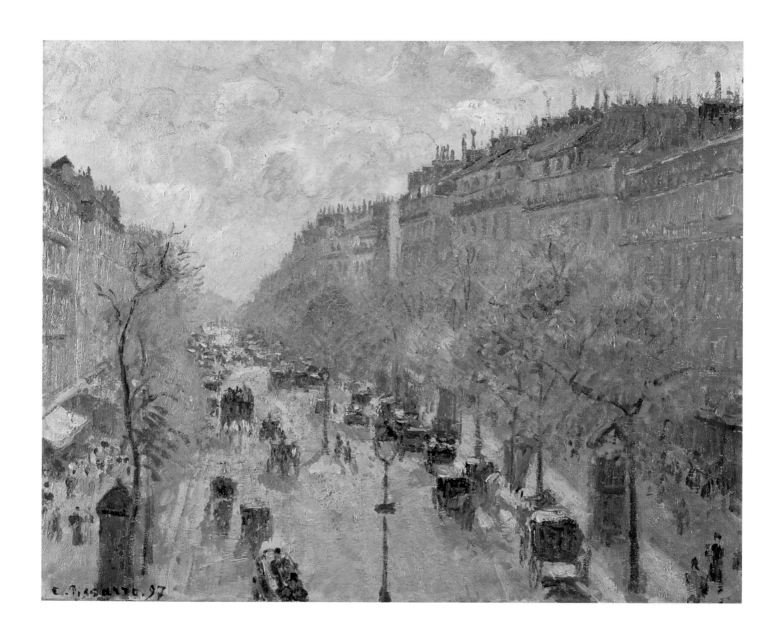

Cat. 69
Boulevard Montmartre,
Spring
Boulevard Montmartre,
printemps
1897
Oil on canvas, 35 x 45 cm
Stiftung Langmatt Sidney
und Jenny Brown, Baden,
Switzerland
PV 998

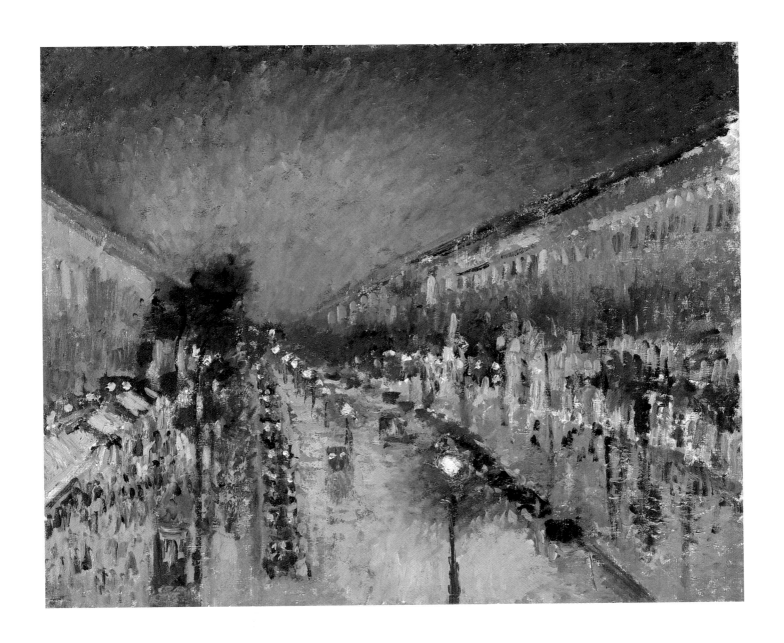

Cat. 70
Boulevard Montmartre,
Night Effect,
Boulevard Montmartre, effet
de nuit
No date
Verso: Boulevard des Italiens,
Night
Oil on canvas, 54 x 65 cm
National Gallery, London
PV 994

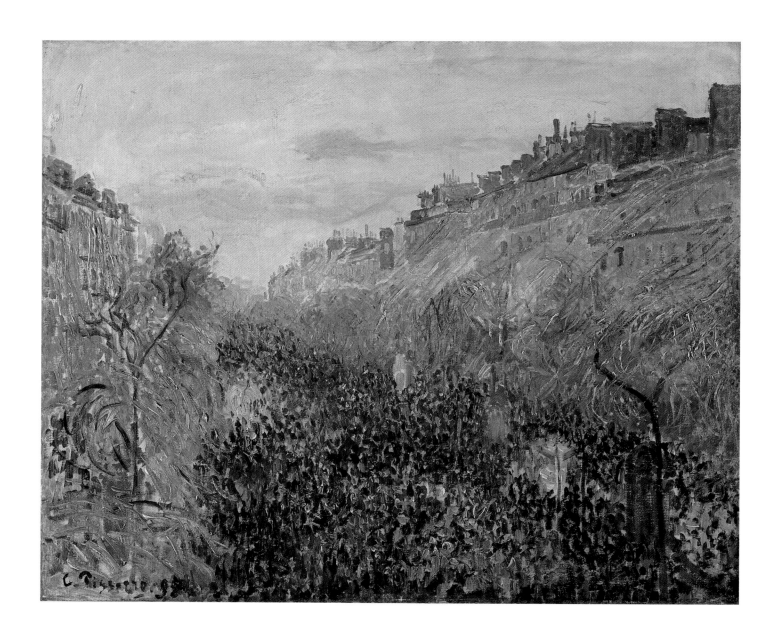

Cat. 71
Shrove Tuesday, Sunset,
Boulevard Montmartre
Mardi gras, soleil couchant,
Boulevard Montmartre
1897
Oil on canvas, 54 x 65 cm
Kunstmuseum Winterthur
PV 997

Cat. 72
Self-Portrait
Portrait de l'artiste, par lui-
même
1903
Oil on canvas, 41 x 33 cm
Tate Gallery, London, 4592
PV 1316

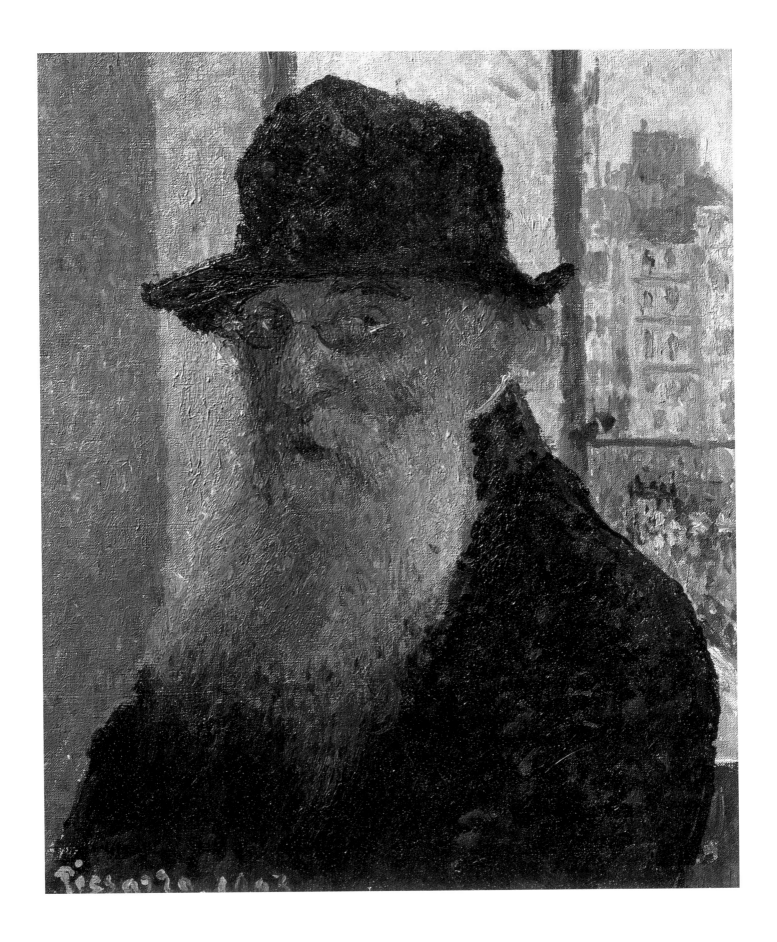

Notes

1 He was referred to as "Moses", for instance, by Louis-Edmond Duranty (in: *L'Artiste,* no. L, Februar 1880, p. 142); as "Bon Dieu" by Cézanne (in: *Conversations au Cézanne,* ed. by P. M. Doran, Paris 1978, p. 59); as "Père Eternel" [Eternal Father] by Thadée Nathanson (in an essay with the title 'L'Apôtre Pissarro' [Pissarro the Apostle], see *Peints à leur tour,* Paris 1948, p. 59; cf. exh. cat. Paris 1981, p. 91).

2 Fritz Melbye (Helsingør 1928–1896 Shanghai), Danish painter of maritime scenes, who mainly exhibited in Copenhagen and at times lived in both New York and China.

3 *L'Hermitage à Pontoise,* 1867 (PV 56), Cologne, Wallraf-Richartz-Museum, and *Les coteux de l'Hermitage,* c. 1867/68 (PV 58), New York, The Solomon R. Guggenheim Museum, Collection Justin K. Thannhauser, as well as another painting in private ownership (PV 61).

4 It may be that this is the painting listed as no. 72 in the Impressionist exhibition of 1881; it is mentioned on a list which Pissarro sent that same year to Durand-Ruel.

5 Pissarro returned to this composition once again in 1875, when he was in contact with Cézanne.

6 Zola 1959, pp. 128f.

7 Zola 1959, p. 127.

8 Gustave Courbet (Ornans 1819–1877 La-Tour-de-Peilz by Vevey), self-taught, had caused a stir during the World Exhibition of 1855 by putting on a controversial exhibition entitled 'Le Réalisme' in his own pavilion. Because of his socialist views, from 1873 onwards he lived in exile in Switzerland. During the 1850s Jean-Baptiste-Camille Corot (Paris 1796–1875 Paris) painted seemingly unspectacular motifs, including factories, and in his portraits never in any way bowed to middle-class taste.

9 Zola 1959, p. 127.

10 Inscription on works which he submitted to the Salons of 1864 and 1865; Pissarro 1993, p. 41.

11 It is not possible here to go into the extent of Pissarro's connection with the Barbizon School. There is documentary evidence that in 1860 he painted in Fontainebleau with Renoir and Sisley.

12 Claude Monet (Paris 1840–1926 Giverny); Wolf Eiermann discusses the relationship between Monet and Pissarro in his biography of the artist.

13 See John Russell, in: exh. cat. London 1968, pp. 7–13.

14 This picture is in a fragile condition and could therefore not be lent for this exhibition.

15 Charles-François Daubigny (Paris 1817–1878 Auvers-sur-Oise) painted this motif in 1866.

16 19.8 x 15.6 cm, Oxford, Ashmolean Museum, B/L 68D verso and recto; B/L 68E recto.

17 Bailly-Herzberg, Corr., vol. I, 1980, pp. 69f.

18 Brettell 1990, pp. 2ff.; Richard Brettell's dissertation (1977) on Pissarro and Pontoise was published in a revised version in 1990, and is probably the most extensive account of this.

19 A useful comparison may be made with Claude Monet, *Houses in Argenteuil,* c. 1873 (fig. 14, p. 12), and Paul Cézanne, *L'Hermitage, Pontoise,* c. 1875 (fig. 21, p. 17); see the biography of Pissarro by Wolf Eiermann.

20 Quoted in Graber 1943, p. 32.

21 Quoted in Rewald 1963, p. 74; Rewald also points out that it was only later that Théodore Duret came to a deeper understanding of Pissarro's work.

22 See *Gespräche mit Cézanne,* ed. by Michael Doran, Zurich 1982, p. 168.

23 These paintings fetched between 270 and 350 francs, an *Avenue of Trees near Pontoise* even made 700 francs, which was something of a sensation; see Graber 1943, pp. 35–38.

24 Wolf Eiermann discusses the relationships between the artists in detail in his biography of Pissarro.

25 Five of Pissarro's Pontoise landscapes were on show, but not a single one was sold.

26 Rewald 1982, p. 219.

27 In a private collection in Switzerland there is a similar painting to the one in the Staatsgalerie; cf. exh. cat. Birmingham 1990, no. 20.

28 See Brettell 1990, pp. 77ff.

29 Ludovic Piette (Niort 1826–1877 Paris), pupil of Thomas Couture, painter and lithographer. Christophe Duvivier, whom we should like to thank once more, honoured Piette with an exhibition catalogue; Musée Tavet-Delacour, Pontoise 1997/98.

30 This fund of works is in the Ashmolean Museum in Oxford and consists of nearly three hundred drawings, watercolours and gouaches.

31 There is a preparatory drawing in the Ashmolean Museum, Oxford (Brettell/Lloyd 1980, no. 85A recto). Jean-Baptiste Rondest (1832–1907), whose house was in L'Hermitage, was a spice dealer and owned works by Cézanne, Guillaumin and Pissarro, which he presumably took in exchange for goods delivered (see Paul Gachet, *Le Docteur Gachet et Murer,* Paris 1956, p. 59; backed up by friendly help from Christophe Duvivier, Pontoise).

32 There is a compilation of so-called "effets de neige" in: exh. cat. *Impressionists in Winter,* The Phillips Collection et al., Washington 1998.

33 Rudolf Staechelin's acquisition papers give the location as "La route près Auvers"; see Hans-Joachim Müller, *Die Sammlung Rudolf Staechelin,* Basel 1990, p. 64.

34 For the very few exceptions see Brettell 1990, pp. 5off.

35 Quoted in Rewald 1963, p. 94.

36 Bailly-Herzberg, Corr., vol. I, 1980, pp. 87f.; in the original: "[...] que ces tableaux ne peuvent se faire toujours sur nature, c'est-à-dire, dehors [...]".

37 Zola 1959, p. 196.

38 For a comparison with Paul Cézanne's *L'Hermitage, Pontoise,* 1877 (fig. 21, p. 17), see Wolf Eiermann's biography of Pissarro.

39 Zola 1959, p. 226.

40 The most important link between Pissarro and Degas is their shared interest in printed works on paper. For more on this see the essay by Barbara Stern Shapiro.

41 See exh. cat. Paris 1981, p. 115.

42 For more on Pissarro's relationship to Gauguin and to Symbolism see Thomson 1982, pp. 14ff.; for a discussion of Symbolism in Pissarro's own work see also Shiff 1992.

43 Original title *La Vachère*, charcoal, 16.1 x 13.5 cm, Oxford, Ashmolean Museum, B/L 130.

44 Original title *Study of a Female Peasant Picking Beans*, grey/brown wash over pencil, 14.9 x 19.1 cm, Oxford, Ashmolean Museum, B/L 221.

45 *Compositional Study for 'La Charcutière'*, blue watercolour over black chalk, 21.5 x 16.4 cm, Oxford, Ashmolean Museum, B/L 168E.

46 See Thomson 1990, p. 51.

47 Particularly striking is the similarity between Millet's image of a man sowing seed and a pastel by Pissarro (see exh. cat. Birmingham 1990, nos 53–55); van Gogh also took up the same theme.

48 Quoted in Charles S. Moffet, in: exh. cat. *The New Painting: Impressionism 1874–1886*, Fine Arts Museums of San Francisco, Seattle and Geneva 1986, p. 408. The comment is by the critic Joris-Karl Huysmans.

49 Pissarro 1993, p. 161.

50 See Joris-Karl Huysmans, 'Chronique d'Art. L'Exposition Internationale de la Rue de Sèze', in: *Révue indépendante*, Nouvel Série, III, 8, June 1887, pp. 345–355.

51 Quoted in Pissarro 1963, p. 52.

52 PV 690, 1401. In 1887 Pissarro returned to this subject once again (PV 1413).

53 The original is in the Whitworth Art Gallery, Manchester.

54 See Richard Thomson, in: exh. cat. Birmingham 1990, pp. 58, 69.

55 Bailly-Herzberg, Corr., vol. I, 1980, p. 178.

56 Quoted in Graber 1943, pp. 77f.

57 Quoted in Pissarro 1943, p. 64.

58 In the early 1900s one critic even referred to an "epidemic of fans"; see *Gazette des Beaux-Arts*, vol. 12, 1880, p. 368.

59 Zola 1959, p. 267.

60 Quoted in Graber 1943, p. 80.

61 For more on its forerunners and Pissarro's preparatory drawings see exh. cat. Paris 1981, no. 68. The catalogue entry fittingly reads: "La palette est chaude et la toile vibre positivement sous la chaleur . . . "

62 Pissarro 1943, pp. 131–132. Pissarro made some experimental paintings which at least come close to doctrinaire Pointillism (e.g. PV 694, PV 719, PV 723).

63 Bailly-Herzberg, Corr., vol. I, 1980, p. 218.

64 Bailly-Herzberg, Corr., vol. I, 1980, p. 252.

65 Letter no. 222 of 30 July 1888 to Lucien, in: Bailly-Herzberg, Corr., Bd. I, 1980, p. 291.

66 Letter to Lucien, quoted in Pissarro 1943, p. 58.

67 See Joachim Pissarro, »Pissarro's Series – Conception, Realisation and Interpretation«, in: exh. cat. Dallas 1993, pp. XXXVII-LIII.

68 In 1993 Richard Brettell and Joachim Pissarro put on an exhibition on this theme in the Dallas Museum of Art. See also the relevant chapter in Dagmar E. Kronenberger, *Die Kathedrale als Serienmotiv* (diss.), Frankfurt am Main 1996, pp. 137–175.

69 Paul Signac's estate contained a number of works by his colleague Pissarro (PV 531, PV 723, PV 1258, PV 1552) from different stages in his life.

70 Graber 1943, p. 95.

71 F. Lespinasse (ed.), *Charles Angrand. Correspondances, 1883–1926*, Rouen 1988, p. 75. Charles Angrand (1854–1926), painter and graphic artist was influenced by the Impressionists and the Neo-Impressionists

72 Letter of 11 November 1896, in: Rewald 1950, p. 419.

73 Letter to Lucien of 19 October 1883, Rouen, quoted in Pissarro 1943, p. 42.

74 For instance the *Study of the Port of Rouen* (cat. 83), which Barbara Stern Shapiro discusses in her essay.

75 Quoted in Pissarro 1943, p. 349.

76 See Stevens 1992, pp. 278f.

77 Pissarro 1943, pp. 315f.

78 Joachim Pissarro goes interestingly into the cultural politics during Pissarro's time in Paris in his essay 'Paris: The Avenue de l'Opéra. Painting and Politics', in: exh. cat. Dallas 1993, pp. 79–84. In it he discusses the Dreyfus Affair which was unfolding just then.

79 Quoted in Pissarro 1963, pp. 211f.

80 Quoted in Graber 1943, p. 106.

Camille Pissarro
Cowgirl
La Vachère
Pencil and charcoal on paper, 16.1 x 13.5 cm
Ashmolean Museum, Oxford
BL 130

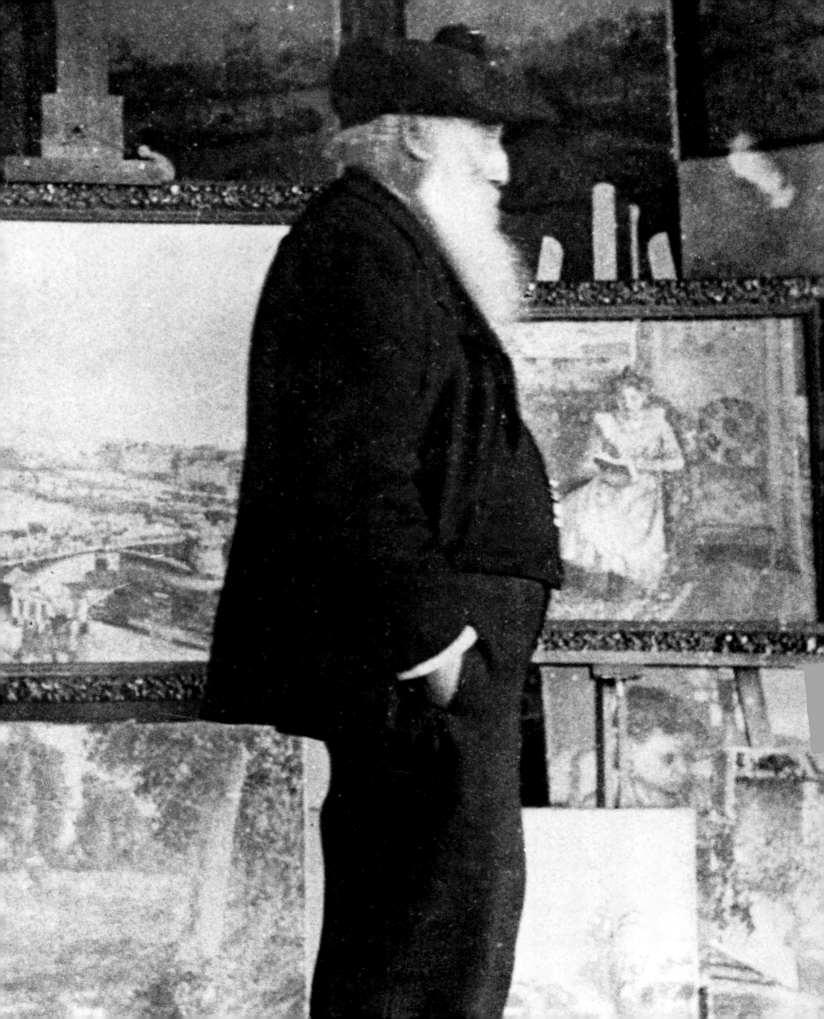

"It is only by drawing often, drawing every-thing, drawing incessantly, that one fine day, you discover to your surprise that you have rendered something in its true character."[1]

"What a pity there is no demand for my prints. I find this work as interesting as painting, which everybody does, and there are so few who achieve something in printmaking."[2]

The paintings of Camille Pissarro can hardly be studied without a considerable under-standing of the corpus of his drawings and an appreciation of his many inventive prints. When one realizes that Pissarro's drawing out-put may have amounted to more than a thou-sand sheets and his prints add up to some two hundred examples in multiple impressions, not to mention pastels, watercolors, mono-types, and fan designs, it is difficult to imag-ine that the artist could be properly examined without taking into account this extraordinary production of works on paper. There are drawings sheets that document every decade of Pissarro's working life and many prints that illustrate his various stylistic campaigns. In relationship to his Impressionist colleagues, Pissarro's graphic œuvre far exceeds that of Manet, Sisley, Cézanne, Renoir, and Monet; only a comparison with Degas seems possible. Certainly the superabundance of Pissarro's drawings denies the premise that all Impres-sionist painting was spontaneous and lacked a preliminary and underlying process – indeed Pissarro relied upon an impressive repertoire of visual information that enabled him to cre-ate his landscape, urban, and figural composi-tions. Moreover, his numerous etchings and lithographs provided another significant source upon which he drew to create new pictures.

The earliest drawings were made before Pissarro left St. Thomas for France, and they have a distinct charm and high level of obser-vation (cat. 73, 74). He used pencil, pen, and wash to illustrate the surroundings of his birthplace in St. Thomas. On reaching France, Pissarro practiced in the manner of the popular Barbizon artists, most notably Corot, Daubigny, and Rousseau. His first etch-ings such as *At the Water's Edge*, 1863 (cat. 85) take precedence stylistically and technically in his printed work. The silver tonality and the arcadian rustic setting are reminiscent of Corot's photographic experiments with clichés-verre, and this etching (as well as a variant in reverse) could well have been accepted as the artist's submissions to the Société des Aquafortistes founded in 1861 by the publisher, Alfred Cadart and the printer, Auguste Delâtre. The Society embraced the production of original etchings in a linear style, and although Pissarro was a member in 1863, he did not design a print expressly for the Society's albums. Nevertheless, his early prints reveal a sureness of etching and print-ing procedures that launched Pissarro on a career of fidelity to and ability with the devel-opment of a subject and an expert knowledge of technical processes. Both his drawings and prints of this period demonstrate the artist's dependence on recording motifs observed near his home and in his rural surroundings. By the 1870s these drawing sheets were con-tained in, or were taken from, sketchbooks; many of which have now been re-assembled by technique and dating. Richard Brettell and Christopher Lloyd, the authors of this colla-tion, are convinced that in the case of Pis-sarro's drawings, "economy of means and con-ciseness of style are their principal virtues."[3] The drawings themselves, executed in black

Cat. 73
View of a Military Fortress
c. 1851
Brown wash over pencil
on paper, 36.2 x 54.3 cm
Ashmolean Museum, Oxford
BL 7

Cat. 74
Wooded Landscape on
Saint Thomas
c. 1854
Pencil on paper,
34.5 x 27.7 cm
Ashmolean Museum, Oxford
BL 34

Cat. 85
At the Water's Edge
Au Bord de l'eau
c. 1863
Black and white etching on
paper, 28.4 x 21.4 cm
Bibliothèque Nationale,
Paris, P 191080,
DC 419 Pissarro
D 2

Cat. 87
Paul Cézanne
1874
Etching on paper,
27 x 21,4 cm
Bibliothèque Nationale,
Paris, P 191090,
DC 419 Pissarro
D 13

1874 Pissarro

Cat. 86
Portrait of Lucien Pissarro
Portrait de Lucien Pissarro
1874
Lithograph on transfer
paper, 24 x 30.2 cm
Museum of Fine Arts, Boston,
Fund in Memory of Stephen
Bullard
D 128

chalk, pastel, and watercolor, range from appealing landscape scenes to large-scale figure studies. Within the print medium, a remarkable etched portrait of Paul Cézanne, dated 1874 (cat. 87), is the most powerful representation of Pissarro's expertise. Concurrently, he also tried his hand at lithography, producing twelve prints, most in unique examples and a few in up to four impressions. These were sensitive crayon drawings, notably including his *Portrait of Lucien,* 1874 (cat. 86), a fine rendition of the artist's eldest son. In addition there were delicately realized rural scenes (fig. 1) and airy sketches, seemingly executed in pen and ink. The dozen lithographs of this year were drawn on paper and transferred to a stone or a prepared zinc plate. Despite their "Impressionist" brightness and realism, Pissarro abandoned lithography for twenty years. At the same time, his sheets of drawings reveal a greater interest in the study of the human figure, and differ from early periods in that they are explorations in their own right rather than specifically related to paintings or prints. In general, the drawing studies of 1873 to 1880 reveal an indebtedness to Jean-François Millet, who was not personally known to Pissarro (he called him the "Great Millet") but whose methods held a fascination for him.

The artist's most profound surge of print-making began in the spring of 1879 when he was invited to work with Edgar Degas to launch a journal of original prints, *Le Jour et la nuit.* At the close of the successful fourth Impressionist exhibition, discussions were underway for a serious project, and by the fall, the artists gathered together by Degas – mainly Mary Cassatt and Pissarro, with Félix Bracquemond as artistic adviser – began an intense period of making prints.[4] Pissarro, who lived in the outlying village of Pontoise, was dedicated to these activities, and in realizing his contributions to the journal, he acquired a brilliant new set of skills. He became proficient in working with both copper and zinc plates, and some thirty impressions from about twenty plates were printed with or by Degas. It is interesting to note,

however, that no group of drawings by Pissarro can make precise connections with the etchings of this period. In fact, the print that the artist intended as his contribution to the journal, *Wooded Landscape, L'Hermitage, Pontoise,* used a painting as its prototype (fig. 2). This important softground etching went through six states or stages of development (cat. 88, 89) in which Pissarro scraped and polished the plate, and added layers of aquatint and drypoint lines that mimicked the heavily textured brushstrokes of the painting. The resulting state changes exemplified the Impressionist aesthetic whereby a series of equivalent views of the same motif was established on one plate. The finished matrix, that investigates the full potential of the medium, was given to a professional printer who made an edition of fifty on oriental paper; the artist exhibited four states in a frame at the fifth Impressionist exhibition in 1880.

The closest collaboration between Degas and Pissarro is seen in the outstanding example of the Impressionist print: *Twilight with Haystacks* of 1879 (fig. 3). Produced by a professional printer in a small edition in black and white, it conveys an extraordinary implication of

Fig. 1
Camille Pissarro
Two Women with a Haycart
Femmes portant du foin sur une civière
1874
Lithograph on transfer paper, 21.5 x 29.2 cm
New York Public Library
D 134

Fig. 2
Camille Pissarro
Wooded Landscape, L'Hermitage,
Pontoise, Detail
Paysage sous bois,
L'Hermitage, Pontoise
1878
Oil on canvas,
46.5 x 56 cm
The Nelson-Atkins Museum,
Kansas City

Cat. 88
Wooded Landscape, L'Her-
mitage, Pontoise
Paysage sous bois,
L'Hermitage, Pontoise
1879
Softground etching, aquatint,
and drypoint, 1st state,
22 x 27 cm
Museum of Fine Arts, Boston,
Lee M. Friedman Fund, 1971
D 16

Cat. 89
Wooded Landscape,
L'Hermitage, Pontoise
Paysage sous bois,
L'Hermitage, Pontoise
1879
Softground etching, aquatint,
and drypoint, 6th state,
22 x 27 cm
Museum of Fine Arts, Boston,
Katherine E. Bullard Fund in
Memory of Francis Bullard,
Prints and Drawings Cura-
tor's Discretionary Fund,
Anonymous Gifts, and Gift of
Cornelius C. Vermeule III,
1973
D 16

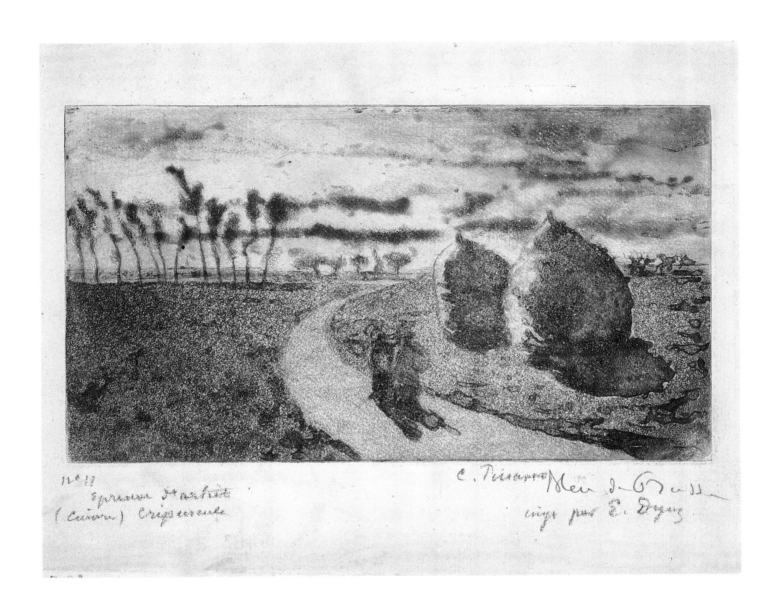

Fig. 3
Camille Pissarro
Twilight with Haystacks
Crépuscule avec meules
1879
Aquatint with etching, 3rd
state, printed in black,
11.5 x 18 cm
Museum of Fine Arts, Boston
D 23

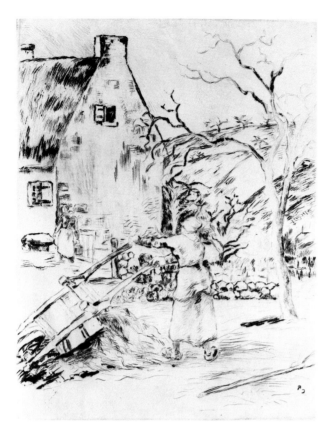

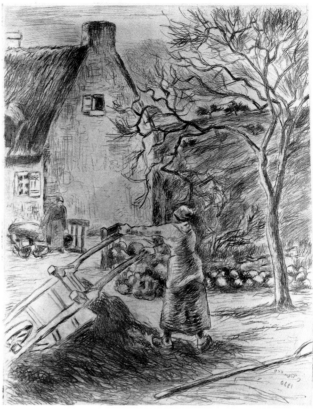

Fig. 4
Camille Pissarro
Woman Emptying a Wheelbarrow
Femme vidant une brouette
1878
Drypoint, 2nd state, 31.9 x 23 cm
Ashmolean Museum, Oxford
D 31

Fig. 5
Camille Pissarro
Woman Emptying a Wheelbarrow
Femme vidant une brouette
1880
Drypoint and manière grise,
5th state, 31.9 x 23 cm
Library of Congress,
Washington DC
D 31

Fig. 6
Camille Pissarro
Woman Emptying a Wheelbarrow
Femme vidant une brouette
1880
Drypoint and aquatint, 12th
state, 31.9 x 23 cm
Sterling and Francine Clark
Institute, Williamstown, Mass.
D 31

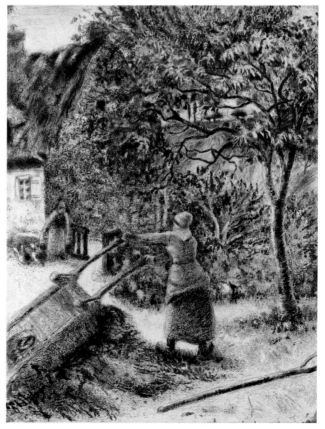

color and light. With the unusual intervention of Degas as printer, there are impressions in various colors – brown, red, blue – that have an intensity of hue found in many of Pissarro's paintings. One example in brown (Bibliothèque Nationale) was printed on the verso of a wedding invitation dated "Paris, 17 juin 1879" signifying when Degas and Pissarro began their enterprise.

Pissarro even reworked a plate that had been printed and exhibited several years earlier. An impression of the third state of *Woman Emptying a Wheelbarrow* was shown in London in 1878, but Pissarro took the copper to Degas's studio where he extensively reworked the image, even scratching the date "1880" in the fifth state. Using abrasive materials such as sand paper and metal brushes, he produced impressions in gray tones, two of which bear the notation: "manière grise." In the last states, Pissarro completely altered the plate by building up aquatint tones to simulate a verdant summer foliage. The change in the season and the definition of space, as well as the relationship of the working figure to the landscape creates in the final state, a "printed painting" (figs. 4–6).

After this highly productive and inventive campaign of making prints with Degas that culminated in the fifth Impressionist exhibition in 1880, where examples of their work were displayed, (a completed journal never did appear), Pissarro spent the next two decades of his life using the graphic medium and printmaking techniques to study and/or to enhance his diverse artistic designs. Pissarro returned from the heady atmosphere of Degas's active printmaking workshop to his rural setting in Pontoise, ready to pursue other directions. It is noteworthy that Degas owned more than thirty impressions of prints by Pissarro dating from 1879–1882, part of the more than three hundred prints by various contemporaries that were sold at the memorable auctions after Degas's death. In 1891, Degas notified Pissarro that he had found some of the artist's lost plates verifying their collaboration, which pleased the rural artist very much.

The prints of these years were triumphs of printmaking, characterized by the use of unconventional means to attain inventive and artistic images. The slavish reproduction of paintings was rejected with the intention of fashioning painterly images or "impressions." Changes and manipulations were accomplished on a single plate, and each impression that was printed revealed these transformations but essentially maintained the original concept. This could not be achieved in paintings where succeeding layers of paint obscure the last corrections and alterations with only the final image as the end result. Pissarro's unique use of pen or pencil annotations that recorded state changes on each printed sheet gave equal weight to all impressions. Not only do these various "states" form an inseparable ensemble but they have a direct relationship to Pissarro's paintings series in the 1890s.[5]

Studies of Pissarro's work after his association with Degas easily conclude that the artist did not embrace any single direction and style but cultivated a diversity of manner and media. In the early 1880s he turned his attention to drawing large figural studies, devoid of background settings, that often served as staffage for his agrarian paintings (see, for example, fig. 7). Many of these drawings were made with black chalk or charcoal and heightened with colored chalks, pastels or water-colors. The few small etchings or drypoint prints of his rural surroundings testify to Pissarro's lean printmaking attempts during this period.

In October 1883 he made his first extended visit to Rouen, initiating a fascination with the city that manifested itself in a considerable output of paintings, drawings, and prints. Pissarro was enthralled with the traditionalism of Rouen as well as with its modern working ports; a number of works reflect his affection for the fast disappearing historic streets. He began with some hesitancy, mindful of the early lithographs commissioned by the State to record the antiquities of France, until he found his own vision. Some of these prints were executed after his return to Pontoise (fig. 8, cat. 83, 92).[6]

Fig. 7
Camille Pissarro
Study of a Peasant
Etude de paysanne
1881/82
Black chalk, charcoal,
pastel and gouache,
34. 8 x 53.7 cm
Ashmolean Museum, Oxford
BL 125

Fig. 8
Camille Pissarro
Rue du Gros-Horloge, à Rouen
1883/84
Etching and aquatint,
3rd state, 19.2 x 14.7 cm
Ashmolean Museum, Oxford
D 54

Both etchings amply describe the various aspects of the city that seduced Pissarro. He was also well aware of the spectacular views of Rouen from the outlying hillside villages; in fact, Pissarro, Monet, and the dealer Durand-Ruel visited one such site in October 1883. A group of etchings from this working excursion was exhibited in July 1888 at the Etching Club in Amsterdam and a *Série de Rouen*, some fourteen etchings from the same period, were sent to his son, Lucien, in England in 1891. In April 1884, Pissarro moved to Eragny on the river Epte, a town further away from Paris than Pontoise but near Gisors, a flourishing farmers' market that would occupy Pissarro's visual interest for many years. The multi-figured market scenes became a fruitful source for five oil paintings, a number of drawings, gouaches, and several prints culminating in an elaborate colored etching that went through a complicated preparatory process.[7] The etching *Market in Gisors, rue Cappeville* seems to have originated with an oil painting of 1885, then eight years later progressed through two horizontal drawings: one in a private collection is black chalk, watercolor and gouache on pale brown paper; another, a tracing based on this drawing, is in the Ashmolean Museum, Oxford composed in pen and India ink over charcoal and pencil on tracing paper. A handsome third drawing (fig. 9) was designed vertically with black crayon, black and brown ink and wash with white heightening on buff tracing paper. Pissarro settled on this example with only a slight adjustment to its horizon line and in 1893 he transferred it to a wooden block.

Although Pissarro gave directions through extensive letter writing to Lucien (who now lived in England) for cutting the block, the task was never performed. In early 1895, Pissarro sent Lucien an impression of a colored etching of a market subject; at the time he had his own small press, and was experimenting with multiple printings from four plates on a single sheet in order to achieve an image printed in color. The etching went through seven states of development including an example heightened with crayons before a small edition in color was completed (cat. 94): one impression of the second state in the Musée du Louvre, Paris, is printed in black with an overall blue wash.
Pissarro, who was enthusiastic about the drypoint and aquatints in color that Mary Cassatt had created and exhibited at Galerie Durand-Ruel in 1891, took a different route to making such prints. His five etchings in color were laboriously printed by himself in Eragny, and his hope of making a series with Cassatt of "market scenes and peasants in the fields" with a professional printer and good equipment was eventually abandoned.[8]

Pissarro's enduring interest in printed color manifested itself in other ways, most notably by a cycle of prints entitled *Les Travaux des champs* (fig. 10, cat. 95, 97), a series of woodcuts on which he and Lucien collaborated irregularly from 1886 to 1903. Pissarro drew the images, and Lucien was expected to transfer them to woodblocks for printing. Although the project may be perceived as a father supporting and encouraging his son to become a notable printmaker, it was more likely a truly collaborative enterprise in which the craftsmanlike skills of two artists were joined. Described by Lucien and Camille Pissarro as their Manga (a folio of sketches well known in Japanese art), the project's first series was placed in the dealer's hands in 1895, nearly a decade after their initial discussions. The execution of the prints is documented in the Ashmolean Museum, Oxford,[9] by some fifty watercolors and drawings, tracings, pieces of celluloid with the design indented, annotated proofs, and numerous letters between father and son, that describe the progression of illustrations dealing with aspects of country life according to the changing seasons. Of the six prints in the first portfolio, three were printed in blue-green or olive-green ink, including a sheet called *Etudes, travaux des champs,* a possible title page that most closely resembles Hokusai's *Manga.* Another woodcut was printed in ocher and blue ink, and the last two, *Femmes faisant de l'herbe* (cat. 95, 97), and *Les sarcleuses* (cat. 96) were developed from five and six blocks, with all the color areas contained and offset by pronounced black outlines. These multicolored prints are reminiscent of the "cloisonniste" principles embraced by Gauguin rather than the "Japonisme" effects perfected by Mary Cassatt. Along with his color etchings, Pissarro captured in these woodcuts the same shimmering effects he achieved in his paintings. Nearly ten years earlier, Camille had persuaded his son to learn the skill of cutting blocks to illustrate children's books and journals. Lucien freely admitted that "my first experiments were with plates drawn for me by my father."[10] Although he did not find a pub-

lisher, Lucien did manage to show another portfolio – initial and tentative – at the eighth and last Impressionist exhibition in 1886; these color woodcuts revealed the artist's interest in a new vocabulary for the decorative arts. The opening of an exhibition of Millet's works at the Ecole des Beaux-Arts on 9 May 1887 reaffirmed the validity of Camille and Lucien's project of *Les Travaux.* In 1855 an album of drawings by Millet had appeared that were cut into wood and entitled *Les Travaux des champs.*

Pissarro's etchings and a number of lithographs recorded his trips to Rouen and Paris as well as visits to neighboring market places and small fairs. In frequent visits to Paris, he worked with his lithographer, Tailliardat, and wrote extensively to Lucien about the various results. In April 1894, Pissarro indicated, "I have done a whole series of printed [lithographic] drawings in a romantic style: *Bathers,* plenty of them, in all sorts of poses, in all sorts of paradises." (fig. 11)[11] He painted the image in lithographic ink onto the zinc plate, then modeled the figures with diluted washes. Pissarro commented earlier in 1894 that since

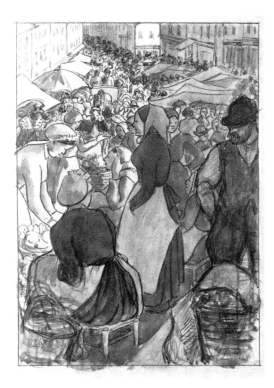

Fig. 9
Camille Pissarro
Market in Gisors, rue Cappeville
Marché de Gisors
(rue Cappeville)
c. 1893/94
Black chalk, pen and ink,
gray and brown washes
heightened with white,
19.6 x 13.7 cm
Ashmolean Museum, Oxford
BL 299

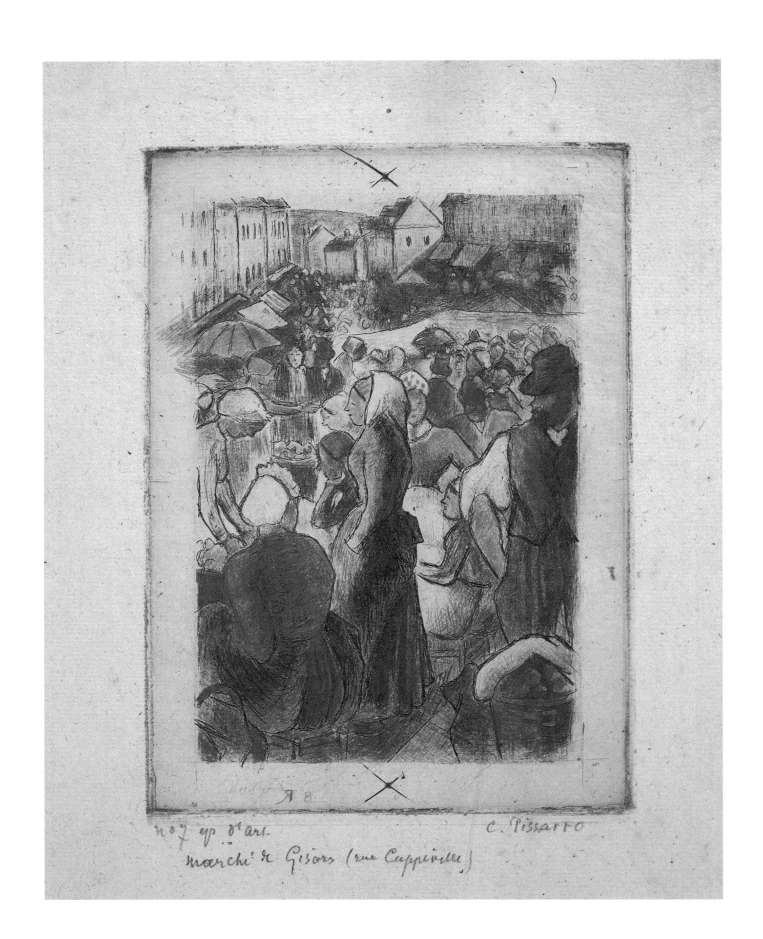

n° 7 ep d'art. C. Pissarro

marché de Gisors (rue Cappeville)

he had a press, he was free to make many *Bathers* at home. Although it is generally accepted that the "series of printed drawings" are lithographs, it is possible that some of these pictures were monotypes. Only one monotype is dated and it corresponds to the work that Pissarro was doing: "when the weather is very uncertain for poor painting; I am content to work indoors."[12]

In April 1895 he wrote: "I have a large lithograph on stone in process, a market (fig. 12). I am working on it here in Paris. I messed it up with wash, scratched it, rubbed it with sandpaper; I do not know what will come of it . . . I should have done some *Bathers*."[13]

Four years earlier, on 25 April 1891, Pissarro mentioned to Lucien that Degas was making some lithographs – it is "rather an important deal."[14] One can readily propose that Pissarro was thinking of Degas's striking bather where he had focused on the back of a model who presents a monumental stature (fig. 13). In a similar manner, Pissarro forces the viewer to look around and beyond the back of the stolid figure. Degas, in turn, had recently seen Mary Cassatt's exhibition of color prints and was probably inspired by her image of a woman, seen from the back, performing her toilette.

Lest one believes that Pissarro's printmaking activities evolved in a direct line of new techniques and methodology, one has only to consider two important portraits in his œuvre: *Grandmother (Light Effect),* 1889/91 (fig. 14) and *Camille Pissarro, Self-Portrait,* 1890–91 (cat. 93). The tight network of parallel and crosshatched lines and the tonal inking in both etchings are reminiscent of the chiaroscure of Rembrandt; the overall effect reveals a dedicated response to the past. Pissarro added some touches of aquatint to the plate to enrich his mother's portrait but this may have been done after her death. Unlike Rembrandt, who etched self-portraits of widely varying expressions that offer a profound self-examination, this powerful image of the gentle artist, who was well-known for his patriarchal countenance, is the only printed self-portrait that he made. Using a thin zinc plate (now in the collection of the Cabinet d'Estampes, Bibliothèque Nationale, Paris), Pissarro managed to realize some twenty impressions of varying tonal intensities. The prints were made for friends and family, although today impressions can be found in many major public collections. There is a tenebrist drawing in the style of Seurat that relates to the portrait etching of the artist's mother; no drawing seems to exist that precedes the powerful etched self-portrait.

Encouraged by his dealer, Paul Durand-Ruel, to think in terms of series (just as Monet had done before him), Pissarro's late urban works preoccupied the artist for at least the last decade of his life. Between 1893 and 1903 he produced more than 300 paintings, the same number of drawings (some on tracing paper, probably used for transfer), and a group of prints that described four cities: Paris, Rouen, Dieppe or Le Havre. Pissarro launched his painting series in Paris during 1892 and 1893, and after an especially pleasurable and productive visit to Rouen in 1883, he returned to the city in 1896 for the second of his three extended trips there. A number of etchings and lithographs but very few drawings record the quays and historic, fast disappearing

Cat. 80
Study of a Male Peasant
Seen from the Back Leaning
on a Spade
c. 1899
Pen and indian ink on paper,
11.1 x 5.5 cm
Ashmolean Museum, Oxford
BL 268 A

Cat. 81
Study of a Female Peasant
Carrying a Bucket
c. 1899
Pen and indian ink on paper,
11.1 x 5.5 cm
Ashmolean Museum, Oxford
BL 268 B

Cat. 82
Study of a Male Peasant
Carrying a Pitchfork in
Conversation with a Seated
Female Peasant Set in a
Landscape
c. 1899
Pen and indian ink over
pencil on paper,
8.9 x 15.4 cm
Ashmolean Museum, Oxford
BL 269

Plates pp. 164 and 165

Cat. 95
Femmes faisant de l'herbe
(Series: *Travaux des champs*)
1893–1895
Woodcut printed in black
with watercolor, annotations
in margin, 21.2 x 17.8 cm
Ashmolean Museum, Oxford
BL 328

Cat. 97
Femmes faisant de l'herbe
(Series: *Travaux des champs*)
1893–1895
Woodcut printed in color
from six blocks by Lucien
Pissarro, 26.5 x 19 cm (sheet)
Museum of Fine Arts, Boston,
Gift of Robert P. Bass, 1982

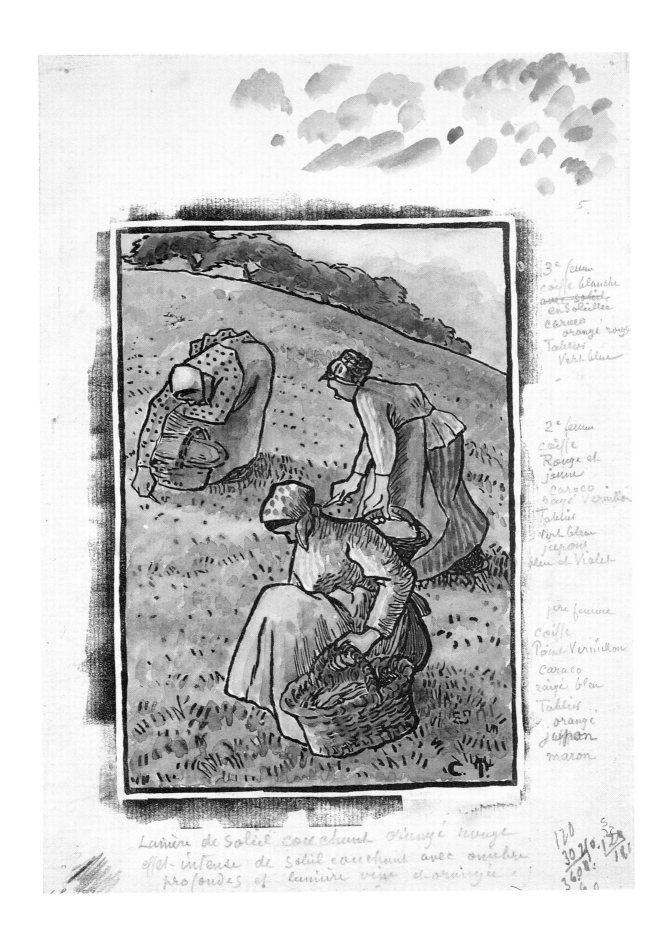

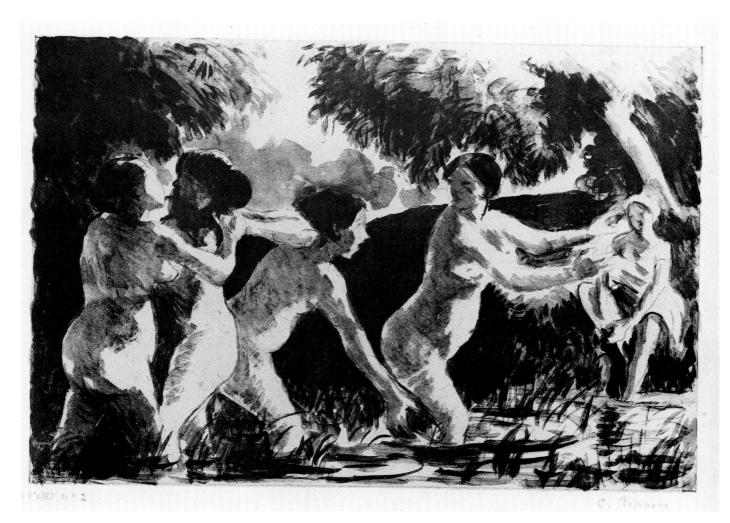

Fig. 11
Camille Pissarro
Wrestling Bathers
Baigneuses luttant
1894
Lithograph on zinc,
18 x 26.3 cm
Museum of Fine Arts, Boston
D 160

Fig. 13
Edgar Degas
Woman Drying Herself After a Bath
c. 1889
Pastel on tracing paper,
121 x 101 cm
Staatsgalerie Stuttgart,
Graphische Sammlung,
Inv. C 59/912

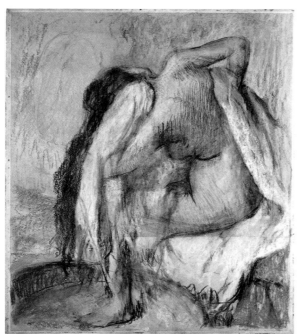

streets of Rouen. Even fewer works on paper depict the scenes of Paris when Pissarro was working on his series paintings from various hotel and apartment rooms overlooking the gardens and urban streets; a significant example of a printed view, however, is the lithograph of the *Place du Havre, Paris* (fig. 15), where Pissarro focused on the crowded omnibus and the horses pulling it forward. The many pedestrians surrounding the popular conveyance are relegated to silhouettes. From his earliest years, Camille Pissarro used pen, pencil, watercolor, charcoal and chalk, and pastel to record on paper his visions of men and women who labored in the nearby pastoral landscapes, the active market scenes, and the energetic and complex urban views. He was probably the most prolific draughtsman among the Impressionist artists. His observations of people and nature culminated in a great number of splendid paintings that were built upon a scaffold of figures and images conceived as preparatory sketches or as major finished drawings.

Of all his colleagues, Pissarro was the only artist to explore in the print medium the tenets of Impressionism: an abiding interest in nature and light, the changing seasons, as well as the energy of urban views. There is no typical Pissarro print: on a single plate he would create inventive transformations, experimenting with different effects. Pissarro's interest in making prints was enduring and he employed a variety of technical solutions to create etchings, lithographs, and monotypes of great originality, conveying his unerring observations of rural and urban life. In his paintings, Pissarro produced brilliant effects of light; in his prints, however, the concept of a "black and white impressionism" originated with Pissarro.

With Degas as an influential guide, Pissarro expanded his talent and techniques for printmaking, eventually pushing on alone to record and to create with a powerful constancy. With Pissarro, the opposition between unique drawings and multiple impressions of prints disappeared; all media were fields to be explored and conquered. Even the manuscript annotations on individual etchings, lithographs, drawing sheets, and study impressions reinforce the recognition of an overarching originality that Pissarro, alone among the Impressionist artists, encompassed in his brilliant works on paper.[15]

Fig. 12
Camille Pissarro
Market in Pontoise
Marché de Pontoise
1895
Lithographie auf Stein
National Gallery of Art,
Washington, D. C.

Fig. 14
Camille Pissarro
Grandmother, (Light Effect)
Grand'mère
(effet de lumière)
1889–1891
Etching and aquatint,
7th state, 17.1 x 25.3 cm
Museum of Fine Arts, Boston
D 80

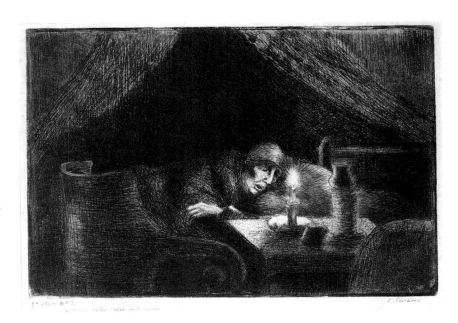

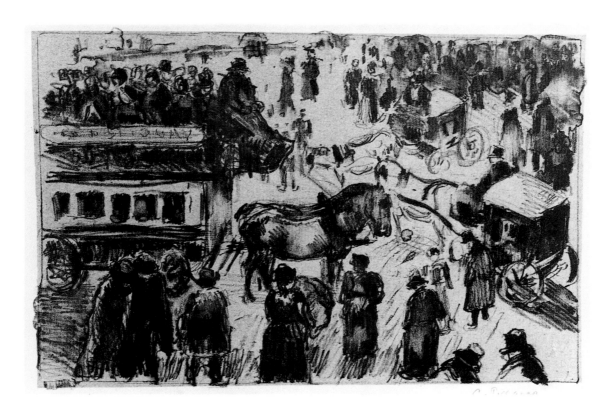

Fig. 15
Camille Pissarro
Place du Havre, Paris
1897
Lithograph on zinc,
2nd state, 14 x 21 cm
Ashmolean Museum, Oxford

Plate p. 169

Cat. 93
Camille Pissarro,
Self-Portrait
Camille Pissarro, par lui-
même
c. 1890
Etching on paper, 2nd state,
18.5 x 17.7 cm (plate)
Kunstantiquariat Laube,
Zurich
D 90

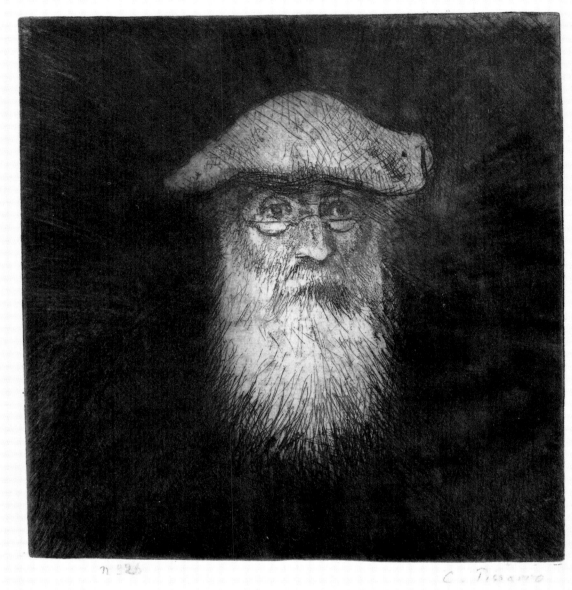

n°25 C. Pissarro

Portrait a. C. P.

Notes

1 Bailly-Herzberg, Corr., vol. I, 1980, p. 212.

2 Bailly-Herzberg, Corr., vol. IV, 1989, p. 55.

3 See Brettell/Lloyd, 1980.

4 Barbara Stern Shapiro, 'A Printmaking Encounter', in: exh. cat. *The Private Collection of Edgar Degas*, The Metropolitan Museum of Art, New York: 1997, pp. 235–245.

5 See exh. cat. Dallas 1993, p. XI, where Richard R. Brettell and Joachim Pissarro refer to Michel Melot, 'La practique de l'artiste: Pissarro graveur en 1880', in: *Histoire et Critique des Arts*, June 1977, p. 17.

6 See Lloyd, pp. 75–93.

7 Richard Thomson, 'The Image of the Market: Exchange between Country and Town', in: exh. cat. Birmingham 1990, pp. 66–77.

8 See Nancy Mowll Mathews and Barbara Stern Shapiro, 'Mary Cassatt's Color Prints and Contemporary French Printmaking', in: exh. cat. *Mary Cassatt: The Color Prints*, Williams College Museum of Art, Williamstown, Mass. 1989, pp. 78–79.

9 Brettell/Lloyd, 1980, pp. 66–75.

10 Michel Melot, *The Impressionist Print*, New Haven and London 1996, p. 192.

11 Bailly-Herzberg, Corr., vol. III, 1988, p. 445.

12 Exh. cat. *The Painterly Print: Monotypes from the Seventeenth to the Twentieth Century*, with Colta Ives, David Kiehl, Sue Welsh Reed, and Barbara Stern Shapiro, The Metropolitan Museum of Art, New York 1980, p. 126.

13 Bailly-Herzberg, Corr., vol. IV, 1989, p. 55.

14 Bailly-Herzberg, Corr., vol. III, 1988, p. 68.

15 This author and Michel Melot have mutually embraced the theory of uniqueness and originality in Pissarro's distinctive prints including his monotypes. See Melot's discussion in *The Impressionist Print*, partic. p. 162.

"... a solitary lover of the truth"

In 1868 Emile Zola devoted the third of his Salon Reviews to the 'Naturalists', and in it he concentrated to such an extent on Camille Pissarro, that his readers must have had the impression that this painter was certainly the most important in this school of painting as Zola defined it.[1] At the same time, however, Zola cast a shadow over his own enthusiasm for Pissarro by his frequent expressions of regret that this painter – now past his first youth – would most probably never receive broad public acclaim, precisely because of his leading role and self-sufficiency. With hindsight, it seems that this assessment by Zola was just as prophetic with regard to Pissarro's reception as it was intentional with regard to the image that Zola – still young and striving for recognition – wanted to create for himself. No doubt the 28 year-old was above all interested in clarifying his own position, as it were exemplifying his views through the work of Pissarro (who was ten years his senior) and thus claiming the latter for the newly invented Naturalism. By portraying Pissarro in this light, Zola was subtly able to assume the role of advocate, championing Pissarro's work; this in itself allowed him to take a somewhat superior stance which he could hardly have adopted with regard to Edouard Manet, who was already much more widely admired and better known. From Pissarro's point of view, however, precisely this attitude taken by Zola, the critic, became an irritant that was to last all his life; apart from anything else, it vividly revealed the persistent quandary faced by critics writing about one of their own contemporaries: lacking the historical distance to see the œuvre in its proper context, they frequently preferred to express their own views and thoughts rather than attempting to empathise with the position of the artist under discussion.

In this early text Zola was already focusing on the truth of the picture in a Naturalistic sense, looking at the authenticity of the representation compared to the person or thing represented – in other words, Nature; he defended a degree of rawness, coarseness, greyness, even ugliness that entered unannounced into the picture, without make-up as it were: not according to the painter's plans but just as he found it in the moment when he took out his brushes. This openness led to a new painterly directness – where surfaces were not smoothed out nor sharp edges rounded off – and was at the root of much of the scorn that greeted the Impressionists; thus Zola's own sleight of hand, at this early stage, was to look at this new style and to praise precisely those features which were later to be so widely dismissed. The result was that Pissarro took on admirable qualities in the eyes of those who understood something about Naturalism, but not in the eyes of ordinary art-lovers, who did not appreciate being spoken to so directly. Thus this strikingly "authentic" painter was to remain for ever more "a solitary lover of the truth", when all the time it was Zola who wanted to be seen as such.

This review by Zola largely established the categories that were subsequently used by art critics, particularly with regard to Pissarro's work, both in a positive and a negative sense; it also sketched in the first outlines of the image that Pissarro's contemporaries and colleagues were to have of him. And so it was, that for almost twenty years, well into the 1880s, no-one took any notice of the fact that the few short sentences which constitute Zola's actual remarks on Pissarro's works (and, with that, by implication on the subject

of Impressionism in general) say much more than might at first sight appear to be the case. After all, one of the most important points Zola is making is that this is painting in its true essence, in other words, these are the first signs of impending Modernism, and specifically Pissarro was one of those involved in its making, always completely serious in his intentions, despite many changes along the way in his own working methods. It was not only in view of his chosen subjects or the naturalism of his treatment of them that he could be regarded as a "lover of the truth", but, in a higher sense, it was because of the sheer truth of his art, for his concern above all was directness and immediacy in his painting. Zola made a clear distinction between the reprehensible painter-poets who thronged the Salons (using every means known to them to pamper the public's eyes) and the rough, serious hand of the worker (telling the unadorned truth), that is to say, of the real painter that he saw in Pissarro – and while Zola's purpose was to honour the painter and his work for its Naturalism, he nevertheless also opened the way for all kinds of rejection and clichéd notions.

The critics of the day can hardly be blamed for not realising that Pissarro was not alone, and was perhaps not even a leading exponent of Naturalism. What is, however, rather more surprising is that for a long time the very fact of these revolutionary developments in painting was not registered at all. It was only with the emergence of Symbolism along with the continued progress of Impressionism and Pointillism, that gradually a small number of writers managed to convince their readers of the insights and new ways of looking at art for which the seed had already been sown in Zola's early Salon Reviews. In light of this, it is perhaps no coincidence that – as has often been pointed out – after his early showing as an art critic, for many years Zola was only sporadically active in this field, and concentrated on his own literary output.
The strange indecision critics displayed towards Pissarro's works and career as an artist –

which still coloured the tributes by Joris-Karl Huysmans, Félix Fénéon and Octave Mirbeau, who all by and large picked up where Zola had left off – provides an intriguing body of material for a case study of the beginnings of Modernism and how it was perceived.

Zola discussed two paintings by Pissarro in his article: *L'Hermitage*, c. 1867, and *The 'Côte du Jallais', Pontoise*, 1867 (cat. 6). In his comments on the first he praised the naturalness of the colours and the breadth of the horizon which gradually "opens up the landscape" to the viewer. The painting does not recount some tidy anecdote, whose fine depiction and moral message the viewer could delight in, rather the viewer finds him or herself in immediate contact with the landscape – the picture draws the viewer into its own world. The landscape in the second painting, *The 'Côte du Jallais'*, struck Zola as particularly modern and contemporary because of the way that the soberly portrayed scenery bore traces of human habitation. In the clarity of its structure and in the evenness of the technique – which displays the artist's masterly understanding of Impressionism as it was developing at the time – this work from 1867 may be regarded as Pissarro's first Impressionist painting. Already at this stage, a year after *The 'Côte du Jallais'* was created, Zola's succinct characterisation (albeit reflecting the criteria of the Realistic-Naturalistic school), took away the ground from under all future critics of its plain, unadorned style of landscape painting. His focus on the technical execution in both paintings (which is enough to cancel out the vacuum created by the virtually complete absence of any subject) is in stark contrast to the then prevalent differentiation and evaluation of pictures in Salon reviews according to themes and modes of representation.

And it was Pissarro's motifs, rather than his technique, which led the critics to their first conclusions about his work, although Zola's praise for its rawness and unspoilt air did play an important part in their coming up with certain criteria. Naïve and close to the peas-

antry, a "landscape man" who portrays the homely patch and its inhabitants without prettification in a "rustic" manner – these were the supposed attributes that were to accompany Pissarro through all the changes he later underwent, and which are still linked to his name in art-historical texts today.[2] Two examples may suffice here: in 1866, two years before Zola's article, Jean Rousseau discussed Pissarro's painting. He, too, sensed the powerful artistic personality that was behind the everyday motifs, which he felt were justified by their direct contact with the "vulgarity" of the times.[3] This "realistic" attitude in Pissarro's work also struck Armand Silvestre a few years later, who similarly viewed Pissarro as the most naïve of the Impressionists, and with this remark, provided the last attribute that was to cling to him ever after.[4]

Zola's emphasis on the faithfulness of Pissarro's depiction of Nature – as a painterly representation rather than a slavish imitation – was taken up as early as 1870 by Théodore Duret, long-standing friend and historiographer of the Impressionists. Furthermore, in a letter of 1873, Duret vouched for the artist's talent for representing the rural countryside.[5] In all of this it was easy to almost entirely overlook the fact that Pissarro's paintings were simultaneously also documenting the infiltration of the industrial age into the landscape, as in *Factory at Pontoise* of 1873 (cat. 19).

Other critics concentrated on the painterly and motivic aspects of Pissarro's paintings. Philippe Burty, for one, maintained with grotesque insistence that, in his paintings, Pissarro really should have devoted more attention to the tree-trunks – and this from a critic who, in fact, could be counted amongst those who did not just dismiss the Impressionists out of hand as inept and unartistic,[6] but who were trying to come to a balanced conclusion about a movement that was undoubtedly gaining in influence and importance.[7] Another of the critics in this circle was Jules Castagnary, although he was less interested in a painter's style or technique than in his

themes, expecting these to have a suitably academic aura.[8] While this meant that initially he could hardly do justice to the real innovations of Impressionism, nevertheless he was soon crediting Pissarro, for instance, with considerable skills as a painter – as he did in his 1874 review of the first great *Exposition des Indépendants* in the photographer Nadar's rooms. Yet in the same breath – even in the same sentence – Castagnary also regretted Pissarro's "deplorable leaning towards meadows and fields" and his unabashed "depiction of all kinds of homely greens and vegetables."[9] Virtually no mention in these reviews of Pissarro's pathos-free (Impressionist) realism, of his painterly approach as a value in its own right, as in *Cabbage Field, Pontoise* of 1873 (cat. 14). Years later Pissarro still had to deal with barbs of this kind, which sometimes even went to the extent of Jules Moréas's biting scorn in 1886: Moréas took the cliché of the 'peasant' to extremes and introduced the artist as "Pissarro, Camille, Impressionist vegetable-farmer, cabbage-specialist."[10]

After 1874, the actual birth-date of Impressionism, public recognition of Pissarro's work increased noticeably, even if the criticisms of the new painters which had already been voiced continued to lead to vehement attacks and widespread rejection. The artists themselves – loosely connected through friendship, common aims, and (by and large) their exclusion from the official Salon – formed into a group: a recognisable movement which now also had a name of its own. The heightened public profile of this movement – due as much to its conservative critics as to the champions of the new style – led to numerous publications and regular pitched verbal battles, not to mention caricatures that were often highly insulting.

The best known amongst these was the satirical dialogue published in *Charivari* in 1874 by Louis Leroy, which is often claimed to have been the first place where the name 'Impressionists' was explicitly used.[11] In 1876 Albert Wolff published a scathing review in *Le Figaro* in which he accused Pissarro, amongst others,

of completely disregarding the colours and forms of the natural appearance of things.[12] His stinging comparisons and abrasive dismissal take up precisely the aspect which Zola regarded as particularly typical for the emerging school of Impressionism: the faithful transposition into pictorial form of a natural, optical phenomenon.

More interesting (specifically in the case of Pissarro) than these attacks – which today seem amusing rather than anything else – are the attempts of champions and disapproving critics alike to match the established attributes and explanations with what they could in fact see in the pictures. For each of the countless descriptions of Pissarro that art critics have come up with, there is almost always an opposite view, and this – in contrast to Pissarro's own comments on various points – speaks volumes of the difficulties that critics have with any new style of painting. Before the arrival of Fénéon, most critics – despite Zola's best attempts – neither managed to break out of established thought patterns and their limits, nor (consequently) out of the given limits of criticism either. Thus they were in effect not free to recognise what was truly new, the very being of Impressionist painting; at any rate it was not acknowledged as such. Instead, Pissarro's paintings were alternately described as realistic and close to Nature or as unconvincing and false, either they appeared naïve and authentic or presumptuous and vulgar; the scenes either looked like melancholic, unmediated responses or like carefully calculated compositions. For all his steadiness and constancy, Pissarro's adoption of Pointillism meant that he was fickle, faddish and weak. But the persistent ground bass to all of this was the rural unspoiltness of the "veteran" of Impressionism, and, over time, repeated biblical allusions to "Moses" and "Abraham" had a not entirely positive effect on his image – not only amongst critics but also amongst his colleagues.[13] At the same time, there was at least a tendency to banish him from the avant-garde into the realms of grandfatherly harmlessness, relegating him to the second ranks of Impressionism. Pissarro was to suffer the consequences of this throughout his life, not only in his own self-image as an artist but, primarily, in financial terms: the fact that his sales-returns were never entirely gratifying was clearly due in part to public opinion of his work and person – a problem that Zola had recognised very early on.

While critics were still struggling to find a categorisation for the new style, at least Jean-François Millet provided a ready point of comparison for Pissarro's rural motifs.[14] This comparison, which Pissarro always resisted with varying degrees of surly displeasure,[15] demonstrates clearly how little motif-oriented critics understood of the potential of a style of painting that was so completely different from the instructive or emotive, occasionally illustrative, decorative art of the Salon artists. Even George Rivière, writing in the journal *L'Impressioniste* which came out in four issues in 1877, could not throw off this critical commonplace, although he did credit Pissarro with having gone further than Millet. However, this observation did not prevent Rivière from comparing the melancholic solemnity of Pissarro's landscapes with the epic breadth of Victor Hugo's 1869 cycle, *Les Misérables*, and ultimately even concluding that these paintings were imbued with their own "rural religiosity".[16] In 1876, Edmond Duranty, in his programmatic text, 'La Nouvelle Peinture', launched a major attack on the Salon as a spectacle and on Salon painting in general: his aim was to proclaim the newly-won freedoms of realistic painting, but even he – in his review three years later of the fourth Impressionists' exhibition – once again pointed out close links between Millet and Pissarro's work.[17]

In his Salon Review of 1881 Joris-Karl Huysmans, like other critics, still perceived an affinity between Pissarro's figures and Millet's peasants, but by the following year he had revised that opinion, for now he concluded that Pissarro had completely broken away from any lingering reminiscences of Millet, and

had come to his own individual, direct, true concept of Nature.[19] In his eulogy to one of Pissarro's depictions of the *Pathway at Le Chou* (cat. 33), painted in the late 1870s, Huysmans particularly lauded the strong, lively colours employed by Pissarro, whose whole technique set him so clearly apart from the "paysagistes" of the Salon. The last sentence of this review is especially striking. In it Huysmans describes how, in close up, the thick layers of individual colours stand proud of the canvas and greet the eye individually and bizarrely, whereas, seen from a distance the overall effect truly recreates Nature: the eddying air, the endless skies, the water evaporating, the radiant sun and the steaming, fermenting earth – in short – living, breathing Nature in all its totality fills Pissarro's paintings.[19] In fact, what Huysmans is describing here is simply the effect of our own optical response to the colours. Nevertheless, with the writer himself tending slowly but surely towards a Symbolist approach, his comments on Pissarro's work are overall not wholly enthusiastic. As we know from Pissarro's letters, his initial, guarded optimism in response to Huysman's occasional favourable comments was not to last. Soon Pissarro – anarchic and anti-Catholic – had no choice but to roundly reject the aesthetic opinions of his critic, even before the latter had finally sunk deep into the misty depths of *fin de siècle* Catholicism laced with Symbolism.[20]

It was in part Mirbeau who was responsible for rescuing Pissarro from the strait-jacket of the widespread critical view of him as the naïve, uncouth painter of peasants with connections to the religious, moralistic images of Millet. In his foreword to the retrospective of 1904, Mirbeau broadly repeated the line of argument that he had put forward in 1892 in an article for *Le Figaro*. In his view, Pissarro's choice of subject matter was not determined by the desire to articulate sentimental or dramatic anecdotes, but rather it was the logical consequence of a painterly process which was aiming at the most faithful representation of reality as it existed around him.[21] This marked a major shift towards a modern interpretation

of Pissarro's paintings, which also helped to shed a completely new light on the changes that took place within the painter's own body of work. However, Mirbeau's comments – for all the affirmative power of his prose – never went beyond that to the point of elucidating any more specifically Pissarro's painterly and theoretical calculations on the subject of representation within the picture. Mirbeau was generally satisfied with simply decrying the hopeless misjudgements by others who insisted on regarding Pissarro's paintings as leaden, rustic and a little lacking in intelligence.[22]

In the end, the decisive move towards examining the art-historical relevance of Pissarro's work in the light of contemporary pictorial representation, and hence towards seeing it as ground-breaking for Modernism, was left up to a critic who was, of all critics, the most serious yet euphoric in his writings on the "scientific reforms" of Neo-Impressionism, and who himself was later to experience the real beginnings of Modernism in the early years of the 20th century. That critic was Félix Fénéon.

Fénéon was outspoken in his enthusiasm when Pissarro turned his attention to the Pointillist experiments being carried out by Seurat and Signac; for like the painters themselves, Fénéon recognised this as the beginning of a new kind of modern, scientific painting. Thus he viewed the epoch of Impressionism as a thing of the past, and he made this abundantly clear by describing the new school as Neo-Impressionism. It must therefore have been all the more surprising for Fénéon when, a few years later, Pissarro turned away from this modern style that he had defended with such verve. Nevertheless – like Mirbeau – Fénéon understood that the key to the evolution of painting in general, and particularly to that of Pissarro, lay in the way that artists responded to external demands for a 'naturalistic' style of painting and the relationship of this notion to the actual aspirations of the painters themselves. In 'La Nouvelle Peinture', Duranty, with theo-

ries of realistic representation in mind, had emphasised that – because of the honesty of its direct, uninterpreted style of portrayal – Impressionist painting was in a position to incorporate into the picture the countless different ways in which the world can be perceived, which in itself is the one, i.e., empirical reality of human existence. However, since these paintings by definition represented the sense-impressions of individual painters, each picture was also the momentary, individualised impression as experienced by one individual. If the viewer, looking at an Impressionist painting, could be aware of this, then he would be capable of recognising the significance of a painterly "memory" of this kind for the edification of his own senses.[23] Duranty's views were a melting pot of all kinds of problematic statements regarding what painters were doing, and as we have already seen, these sentiments did not go unchallenged. In 1878, for instance, Théodore Duret came to the conclusion in his pamphlet about Impressionist painters that it was specifically the immutable aspects of Nature that Pissarro captured and displayed by means of his simplifying mode of representation.[24] And it was Pissarro's seemingly cursory treatment of landscapes, things and creatures in his paintings, that was always highlighted in the few commentaries that focused in their argument on Pissarro's painterly technique. Admittedly this purely technical observation is particularly inconclusive. Thus it was equally possible to describe the scenes in Pissarro's paintings either as arbitrary and hence realistic (or dilettante, as Castagnary would have it) or as carefully chosen and composed, and hence idealistic. As early as 1876, writing in an exhibition review, Alexandre Pothey remarked that Pissarro's apparently random landscape scenes were, on the contrary, consciously through-composed[25] and indeed, this does seem to approximate most closely to the truth, if one bears in mind Pissarro's interest in Pointillism in the mid-1880s as a scientifically justifiable mode of composition. So what kind of truth was Pissarro really searching for?

In 1886, Fénéon's review of the eighth Impressionist exhibition marked the beginning of his critical writings on the Neo-Impressionists, who now included Pissarro besides Signac and Seurat; first of all, however, the critic made sure his remarks had suitable historical backing by outlining the technical evolution of painting since the 1850s. Seeing the emphasis shifting from the subject to its representation, Fénéon observed that the Impressionists – unlike the academic painters with their artificial, mixed colours – were using complementary, light colours, and thus, by means of their admittedly largely intuitive separation of colours, had reclaimed light and colour as constitutive elements in painting. In his view, Pointillism, by contrast, was based on a considered, scientific separation of colours; he then, in the same article, goes in minute detail into the theory behind Pointillism. Fénéon added weight to the claims of art criticism to be almost equally scientific by including an annexe to the article precisely chronicling Impressionist exhibitions to date.[26]

Subsequently Fénéon underpinned his thesis and his argument by repeatedly referring to the determination and consistency with which the Pointillists were now no longer reliant on chance brushstrokes and fortuitous colour effects – that is to say, no longer merely improvising in the attempt to convey some particular impression. In all of this, Pissarro was increasingly cast in the role of one who had both pre-empted and perfected the style, standing as guarantor for the necessity of the transition from "old" Impressionism to Neo-Impressionism. According to Fénéon, Pissarro himself – by adopting the new technique into his own work – had increased his own expressive power and, by virtue of his successful implementation of the technique in its most perfect form, acquired in Fénéon's eyes the status of a completely new painter, whose progress was characterised by consistency rather than contradiction, as some would have it.[27] Pissarro only reluctantly agreed to read Fénéon's article before it went to print; and when he did so, he repeatedly pointed

out the ground-breaking role that Seurat had played in the evolution of the new style of painting.[28]

At any rate, Fénéon concentrated specifically on the new technique and its potential for representation, which meant that any discussion of the subject-matter of a picture was only of secondary interest. In this respect, he was probably closest to Pissarro. Nevertheless, looking back later, he had to admit that his ideas about the way that painting would progress scarcely corresponded to the way things had in fact gone. Pissarro turned his back on Pointillism when he found that it would not let him achieve what was in his mind. The man "searching for clarity and light", as Fénéon had called him in 1889, now (in the critic's estimation) seemed to be falling back into the old ways of the "Tachistes" and was busily constructing pictures out of a "hopeless tangle of blotches".[29]

However, Fénéon's dismay at Pissarro's change of heart did not last long. In 1892 he devoted perhaps his best article to Pissarro, on the occasion of the exhibition in the Galerie Durand-Ruel.[30] Having recounted the course of the various phases of Pissarro's career as an artist, and having discussed a number of pictures, Fénéon ends his text with two impassioned sentences which in effect incorporate Pissarro's work, at a stroke, into Symbolism. The year after Gauguin had set sail for Tahiti, Fénéon discovered in Pissarro's paintings "Symbolist" ornament and the unstudied power of Primitivism. However, whereas the Primitivism in the paintings of the Symbolists (and Gauguin's in particular) was loaded with import "behind the picture", the Primitivist tendencies observed in Pissarro's paintings were there for the purpose of actually simplifying and clarifying the pictorial space. This can be seen very clearly in *View from my Window, Eragny* of 1888 (cat. 48). Together with the "flat" bands of the pictorial perspective, the Pointillist technique in this picture creates the effect of an inventory of the artist's circumstances, which is so unforced that the plain account of each item, of

each leaf – with almost naïve honesty – brings to mind thoughts of the paintings of Henri Rousseau.[31] Above all, Fénéon saw in Pissarro a "master of forms" who was able to evoke an "eternally light atmosphere" in his paintings. Fénéon's subsequent comments go on to discuss Pissarro's Symbolist tendencies: in his view Pissarro was now not only able to draw on his extensive observation of Nature, but also, without even trying to, evoked extremes of symbolic expressivity in his compositions. In his closing remarks, the critic then drew a parallel between the colours and gestures in the painting, *Peasants Planting Pea-Sticks* (cat. 47), and the rhythms in Botticelli's *Prima Vera*. No doubt Fénéon slightly overshot the mark with these comments, nevertheless he was not the only critic to pursue this route in the attempt to arrive at a new interpretation not just of Pissarro's works and of Impressionism as a whole, but of its younger exponents in particular.

Albert Aurier held the view that the Impressionists were primarily concerned with transferring "tout court" onto the canvas the material existence of things as they appear in the world, and the distinction that he consequently made between idealist Symbolists and realist Symbolists[32] was effectively undermined by Mirbeau (as previously mentioned). When Mirbeau looked at Pissarro's pictures he found parallels and harmonies that set the latter's rural scenes far apart from the moralising depictions in Millet's works. Pissarro, according to Mirbeau, had a much greater understanding of how to translate the inner harmony of the physical world into the harmony of painting, thus – to continue Mirbeau's line of thought – expressing 'anarchist', utopian notions by means of painting. Mirbeau cloaked his views in a style that was as poetic as it was evocative, in effect giving the reader a sound picture of the rhythmic harmonies in the works concerned.[33] Pissarro's own opinion of critical constructs of this kind, may perhaps be deduced from a letter to his son Lucien in which he comments on this same article by Aurier. Pissarro's own

anti-Symbolist attitude and positively 'materialistic' approach are all too clear: "According to him [Aurier], it is literally not necessary to draw or to paint in order to make art, all you need is a few ideas conveyed by a few lines! True enough, it seems to me too this is all there is to art, only you do actually have to draw these few lines. There also has to be a certain harmony in order to put over one's ideas – consequently it is good to have feelings, for these lead to ideas. This gentleman seems to take us for dunderheads."[34]

Despite Pissarro's clear refusal to have his work claimed by proto-Symbolist theorists, nevertheless these interpretations – particularly Mirbeau and Fénéon's – do display an eye for Pissarro's intentions as a painter, which was very rare in the stream of disparaging comment since Zola's early reviews. Pissarro's search for a way of translating immediate sensations of light and colour into painting as faithfully as possible, without having to fall back on the improvisatory techniques of early Impressionism or the painstaking – even rather sterile – methods of Pointillism (which in themselves hindered any spontaneity), led to his "passages", as his contemporaries called the transitions between contrasting pure colours. Fénéon repeatedly asked Pissarro about this new facture, which emerged in Pissarro's work in the early 1890s. The artist himself, however, was hesitant in his responses to questions of this kind because he found his own results not entirely satisfying[35]; he was still striving to find a technical equivalent to his ideas as an artist, and it seemed that now he might perhaps have found it. Meanwhile, in a letter to Henry van de Velde in 1896, he specifically explained the fact that he had abandoned the scientifically-based practice of colour-separation by citing the danger of rigidity which threatened anyone using this technique.[36] As late as 1899 Signac, in his history of Neo-Impressionism, commented on this change in Pissarro's style, saying that the one-time Pointillist had never completely adopted the technique of using complementary contrasts, only ever skimming on its surface.[37] By now Pissarro was painting

life in the streets of Paris and the light-effects at different times of day in Eragny, and had arrived at his late style, which fluctuated between the early, impasto surfaces of High Impressionism and the colour-separations of Divisionism.

If one looks at Pissarro's motifs, it is perhaps possible after all to establish the relationship between his output and the art criticism of the day. His rural scenes, his landscapes and city scenes – created at a particular moment in time with the intention of transposing a momentary mood into painting – all convey a particular sense of time. Pissarro is interested in the moment, when things stand still: the moment that marks the transition between two stages like the juxtaposed flecks of colour on the canvas. At the same time the scene inside the frame is hardly a matter of chance: the painter has too clearly pondered over tonal values, light and shade, planes and accents. The images of rural life which constantly emerge in his work right from the outset – and which were regarded as his trademark – strikingly often depict figures 'on the way' to somewhere or taking a break, soaking up the peace of the light and colour of the atmosphere around them. Ever since *The 'Côte du Jallais', Pontoise* of 1867 (cat. 6), there had been a steady flow of through-composed works with motifs in layers or bands, which adopted a more or less literal attitude to the notion of the viewer's standpoint when it came to structuring the composition of the picture. Seen frontally, the bands are arranged strictly one behind the other, when seen from above they are arranged on top of each other, as in many of his garden scenes and also in the city scenes in London and Paris.

Art critics at the time did indeed often enough recognise these elements for what they were, but never saw them in their own right; instead they tried to fit them into the profile of painting as it was then, or at least to find some connection between the two. However, there is in fact nothing truly innovative about Pissarro's choice of subject or

the specific features of his technique, rather it is his striving to create a picture which the viewer can experience as a direct expression of moods and impressions – without the artist having to resort to a story, to symbolism, or a moral. The material act of painting as the recreation of a passing sensation by reproducing the specific relationship of colour and light in that moment – without a 'subject' – is the truly modern aspect of his paintings, as in all Impressionist works. In a conversation a few months before his death, he was very clear about his search for this in his painting: "I only see flecks. When I start a picture, the first thing that I try to establish is the harmony. Between this sky and this ground and this water there is, of necessity, a tonal relationship, and that is the great difficulty in painting. . . . The great problem that has to be solved, is the matter of relating everything in the picture, even the smallest details, to the overall harmony, that is to say, making everything sound harmoniously together."[38] The existential essence of Pissarro's painting is embodied, as it were, in his *passages*, which in itself explains why his critics, in their texts, so rarely equalled his achievements. His work stands between Manet and the emerging Modernism of the Symbolists and the Fauves, helping to implement the move, instigated by Manet, from the tableau ('willing' a particular image and using easel painting to achieve it) to peinture, where the image – still – is the means of expression of the painting.[39] People were only too glad to see Pissarro as an artist whose work was significant in late 19th century painting for acting as a bridge, forming a link between the different trends in the last third of the century. The changes in his own work and his influence on artists of his own and the following generation, on Cézanne, Signac, and Gauguin, made him almost seem like a seismographer registering the tremors in the art of his day as well as in the thinking of other artists. In his role as the father-figure and Nestor of the whole Impressionist movement, he provided a suitable foil for the jubilant discoveries of the younger generation. However, the suggestion one occasionally comes across that Pissarro was not just a mirror but also the motor behind these developments[40] is contradicted by the frequent, obvious bewilderment of contemporary critics, who clung to the clichés they knew, and who found it difficult to see beyond Pissarro's undeniable allegiance to Impressionism (as an integral part of his own development), and were consequently unable to distinguish what characterised his work in particular, and what his specific contribution to the school of Impressionism had been. Instead, even well-meaning critics tended to take the status quo of Pissarro's development at any one time, and rather than regarding this as a stage in an emerging body of work, they would use it to bolster their own theories and ideas – witness Zola, Duranty and Fénéon.

Circumstances do not allow us here to go into the extent to which Pissarro's images of rural life are indeed imbued with the anarchist notions of a social utopia.[41] Certainly there is an element of anarchic socialism in the modernity of Pissarro's painting, with its landscapes and images of rural and urban everyday life represented in unpretentious, 'mood paintings' capturing the moment, the Here and Now, and consequently, affirming existence itself – and no more than that: an anarchic socialism that demands a fair and just world-order in our life on Earth and the realisation of this world-order under the banner of a general sense of harmony. Nevertheless, these were considerations that had, if anything, only a secondary influence on the painterly process in Pissarro's work. He was preoccupied with painting itself, the relationship of a plane to a point, of colour and light as the expression of a sensation or feeling. It is tempting to see this notion of painting in the various stages of his work as the touch-paper for the ultimate explosion of the representation of 'realistic' colour and form in Expressionism and Cubism, without necessarily also having to acclaim him as the actual pioneer of a still dormant pictorial Modernism – although he certainly did play a part in that.

Guillaume Apollinaire, a great admirer of Fénéon's, and, like him, an astute protagonist (both as an art critic and an author) of the avant-garde of the day, saw this and wrote about it. In one of his reviews of the 1914 Salon des Indépendants he put it as follows: "There are two main directions, one branches off from Picasso's Cubism, the other from André Derain's Cubism, both have their roots in Cézanne. That, I believe, is the most succinct and simplest description one could give of modern art, although one does also have to take into account the influence of folk art, of Couture's studio, *le douanier* Rousseau, Seurat and Impressionism (particularly Pissarro), and even the theories of the Futurists."[42]

Notes

1 Emile Zola, 'Salon de 1868. Mon Salon', in: *L'Evénement illustré*, 19 May 1868, reprinted in: Emile Zola, *Salons*, recueillis, annotés et présentés par F. J. W. Hemmings et Robert J. Niess, Geneva and Paris, 1959, pp. 119–146.

2 Richard Brettell, 'Camille Pissarro: A Revision', in: exh. cat. Paris 1981, pp. 13–37, here pp. 21, 27.

3 Jean Rousseau, 'Le Salon de 1866', in: L'Univers illustré, 14 July 1866, quoted in: Lionello Venturi, *Les Archives de l'impressionnisme*, 2 vols, Paris and New York 1939, vol. 2, p. 281; Jacques Lethève, *Impressionnistes et symbolistes devant la presse*, Paris 1959, p. 35.

4 Armand Silvestre, 'Préface', in: *Recueil d'estampes*, Galerie Durand-Ruel, Paris 1873, quoted in: Lionello Venturi (as note 3), vol. 2, p. 284.

5 Quoted in: Graber 1943, pp. 26, 33.

6 On his varied reception before 1874, see above all John Rewald, The History of Impressionism, 4th edn, London 1973, partic. pp. 271–308.

7 Anonymous (Philippe Burty), 'Exposition de la société anonyme des artistes', in: *La République Française*, 25 April 1874, quoted in: Lionello Venturi (as note 3), vol. 2, p. 289; also in exh. cat. *Centenaire de l'impressionnisme*, Grand Palais, Paris 1974, pp. 261f.

8 Jacques Lethève (as note 3), pp. 47f.

9 Jules Castagnary, 'L'Exposition du boulevard des Capucines. Les impressionnistes', in: *Le Siècle*, 29 April 1874, quoted in: *Centenaire de l'impressionnisme* (as note 7), pp. 264f.

10 Anonymous, *Petit Bottin des lettres et des arts 1886*, p. 109, quoted in: Françoise Cachin, 'Pissarro regardé', in: exh. cat. Paris 1981, pp. 37–57, here p. 49, with more examples.

11 Louis Leroy, 'L'Exposition des impressionnistes', in: *Le Charivari*, 25 April 1874; reprinted (amongst others) in: Centenaire de l'impressionnisme (as note 7), pp. 259–261.

12 Albert Wolff, 'Le Calendrier parisien', in: *Le Figaro*, 3 April 1876, quoted in: Jacques Lethève (as note 3), pp. 76f.

13 Graber 1943, pp. 64f.; Françoise Cachin, 'Pissarro regardé', in: exh. cat. Paris 1981, pp. 37–57, here p. 52.

14 On the reception of the portrayal of peasantry see Neil McWilliam, 'Le Paysan au salon: Critique d'art et construction d'une classe sous le Second Empire', in: Jean-Paul Bouillon (ed.), *La Critique d'art en France 1850–1900* (Actes du colloque de Clermont-Ferrand 1987), Saint-Etienne 1989, pp. 81–94; Robert Herbert, 'City Versus Country: the Rural Image in French Painting from Millet to Gauguin', in: *Artforum*, 8, 1970, pp. 44–55.

15 Cf. for instance. Pissarro 1993, pp. 146f.

16 Georges Rivière, 'L'Exposition des impressionnistes', in: L'Impressionniste, 2, 14 April 1877, pp. 1–7, quoted in: Lionello Venturi (as note 3), vol. 2, pp. 317f.

17 Edmond Duranty, 'La quatrième exposition faite par un groupe d'artistes indépendants', in: *Chronique des arts et de la curiosité*, 19 April 1879, quoted in: idem, *La nouvelle peinture. A propos du groupe d'artistes qui expose dans les Galeries Durand-Ruel*, Paris 1876, ed. by Marcel Guérin, Paris 1946, pp. 57–59, here p. 58.

18 Joris-Karl Huysmans, 'L'Exposition des Indépendants en 1881', in: Joris-Karl Huysmans, *L'Art moderne*, Paris 1883, quoted in: Joris-Karl Huysmans, *L'Art moderne/Certains*, ed. by Hubert Juin, Paris 1975, pp. 212, 235.

19 Joris-Karl Huysmans (as note 18), p. 211.

20 Letters to Lucien on 9 May 1883 and on 30 September 1896, cf. for instance: Pissarro 1963, p. 21.

21 Octave Mirbeau, 'Camille Pissarro', in: *Catalogue des Œuvres de Camille Pissarro*, exposées chez Durand-Ruel du 7 au 30 avril 1904, quoted in: *Octave Mirbeau, Combats esthétiques*, ed. by Pierre Michel and Jean-François Nivet, vol. 2, 1893–1914, Paris 1993, pp. 346–351.

22 As in his article on Claude Monet in *L'Humanité*, 8 May 1904, quoted in: *Octave Mirbeau* (as note 21), pp. 352–356, here pp. 352f.

23 Edmond Duranty (as note 17), partic. pp. 33, 46.

24 Théodore Duret, *Les Peintres impressionnistes*, Paris 1878; again in: Théodore Duret, *Critique d'avant-garde*, Paris 1885, pp. 75–80, quoted in: Graber 1943, p. 50.

25 Alexandre Pothey, 'Expositions', in: *La Presse*, 31 March 1876, quoted in: Lionello Venturi (as note 3), vol. 2, p. 303.

26 Félix Fénéon, 'VIIIe Exposition impressionniste', in: *La Vogue*, 13. Juni 1886, pp. 261–275, quoted in: Félix Fénéon, *Œuvres plus que complètes*, ed. by Joan U. Halperin, vol. 1: *Chroniques d'art*, Geneva and Paris 1970, pp. 35–38.

27 Félix Fénéon, 'Le Néo-impressionnisme', in: *L'art moderne de Bruxelles*, 15 April 1888; idem, 'Quelques impressionnistes', in: *La Cravache*, 2 June 1888, quoted in: Félix Fénéon, *Œuvres plus que complètes* (as note 26), pp. 82, 127.

28 Félix Fénéon, *Œuvres plus que complètes* (as note 26), p. 54, note 1.

29 Anonymous (Félix Fénéon), 'Exposition Pissarro', in: *L'Art moderne de Bruxelles*, 20 January 1889; idem, 'Autre groupe impressionniste', in: *La Cravache*, 6 July 1889; idem, 'Tableaux', in: *La Vogue*, September 1889, quoted in: Félix Fénéon, *Œuvres plus que complètes* (as note 26), pp. 137f., 157, 166f.

30 Félix Fénéon, 'Exposition Camille Pissarro', in: *L'Art moderne de Bruxelles*, 14 February 1892, quoted in: Félix Fénéon, *Œuvres plus que complètes* (as note 26), p. 209.

31 Cf. Martha Ward, Pissarro, *Neo-Impressionism, and the Spaces of the Avant-Garde*, Chicago und London 1996, pp. 64–73.

32 Albert Aurier, 'Le Symbolisme en peinture: Paul Gauguin', in: *Mercure de France*, 3, 1891, quoted in: Gudrun Inboden, *Mallarmé und Gauguin. Absolute Kunst als Utopie*, Stuttgart 1978, p. 141, note 12.

33 These comments draw extensively on the study by Richard Shiff, 'To Move the Eyes: Impressionism, Symbolism and Well-Being, c. 1891', in: Richard Hobbs (ed.), *Impressions of French Modernity*, Manchester und New York 1998, pp. 190–210, here partic. pp. 193, 201f.

34 Letter of 20 April 1891 to Lucien, quoted in: Pissarro 1963, p. 97.

35 Letter of 20 February 1889 to Lucien, quoted in: Pissarro 1963, p. 82.

36 Quoted in: Graber 1943, pp. 101f.

37 Paul Signac, *D'Eugène Delacroix au néo-impressionnisme*, ed. by Françoise Cachin, Paris 1964, p. 95.

38 Quoted in: Graber 1943, p. 106.

39 Cf. Gudrun Inboden (as note 32), Stuttgart 1978, pp. 96–101.

40 Cf. John Rewald, 'Foreword', in: exh. cat. Paris 1981, pp. 9–12.

41 For more detail see Thomson 1990.

42 Guillaume Apollinaire, 'Le Salon des Indépendants', in: *L'Intransigeant*, 2 March 1914, quoted in: Hajo Düchting (ed.), *Apollinaire zur Kunst. Texte und Kritiken 1905–1918*, Cologne 1989, p. 226.

CATALOGUE OF WORKS Manuela Ganz

Abbreviations

PV
Ludovic-Rodo Pissarro and Lionello Venturi, *Camille Pissarro. Son art – son œuvre*, 2 vols, Paris 1939.

BL
Richard R. Brettell and Christopher Lloyd, *Catalogue of Drawings by Camille Pissarro in the Ashmolean Museum*, Oxford and New York 1980.

D
Lloys Delteil, *Le Peintre-Graveur illustré. Pissarro, Sisley, Renoir*, vol. 17, Paris 1923.

Each catalogue entry lists the provenance of the work, the most important exhibitions where it was shown, and relevant literature. The titles of solo exhibitions of Camille Pissarro's work are not given. The relevant literature comprises publications before 1939 and after 1980. For publications between 1939 and 1980 please consult the extensive details given in the catalogue for the retrospective *Camille Pissarro 1830–1903* in London, Boston and Paris, 1980/81 (Exh. Cat. Paris 1981).

Camille Pissarro
Five Studies of Cats
Grey and brown ink over pencil on paper,
11.5 x 19.5 cm
Privately owned

PAINTINGS

Cat. 1
C. Pissarro, Self-Portrait
Portrait de C. Pissarro
1873
Oil on canvas, 55 x 46.7 cm
Signed and dated lower left:
"C. Pissarro. 1873"
Musée d'Orsay, Paris, Gift of Paul-Emile Pissarro, RF 2837
PV 200

PROVENANCE: Camille Pissarro Collection. – Paul-Emile Pissarro Collection. – Paul-Emile Pissarro donated the painting in 1930, retaining the right of usufruct. – Since 1947 in the Musée du Louvre.
EXHIBITIONS: London, Leicester Galleries, 1920, cat. 56. – Paris, Orangerie, 1930, cat. 19. – Paris, Bernheim-Jeune, *Cent ans de portraits français 1800–1900*, 1934, not numbered. – Paris, Galerie de l'Elysée, 1936, cat. 4. – Paris, Galerie André Seligmann, *Portraits français de 1400–1900*, 1936, cat. 138. – London, Thomas Agnew and Sons, 1937, cat. 3. – Dieppe, Musée des Beaux-Arts, 1955, no catalogue. – Limoges, Musée Municipal, *De l'impressionnisme à nos jours*, 1956, cat. 21. – Lisbon, Fundação Calouste Gulbenkian, *Un seculo de pintura francesa 1850–1950*, 1965, cat. 112. – Leningrad, Hermitage; Moscow, Pushkin Museum, *Peintures impressionnistes des musées français*, 1970/71. – Madrid, Museo de Arte Contemporaneo, *Los impresionistas franceses*, 1971, cat. 56. – Paris, Palais de Tokyo, Musée d'Art et d'Essai, *Autoportrait de peintres*, 1978, not numbered. – Paris, Grand Palais, 1981, cat. 24.
LITERATURE: Exh. Cat. Paris 1981, cat. 24, p. 91. – Lloyd 1981, ill. p. 36. – M. McQuillan, *Portraitmalerei der französischen Impressionisten*, Rosenheim 1986, p. 82, illus. – Musée d'Orsay, *Meisterwerke der Impressionisten und Post-Impressionisten*, Stuttgart 1988,

p. 54, illus. – Pissarro 1993, ill. 326. – Leymarie 1998, pp. 30f.

Cat. 2
Two Women, Chatting by the Sea, Saint Thomas
Deux Femmes causant au bord de la mer, Saint-Thomas
1856
Oil on canvas, 28 x 41 cm
Signed and dated lower left:
"C. Pizarro. 1856"
National Gallery of Art, Washington, Collection of Mr. and Mrs. Paul Mellon, 1985.64.30
PV 5

PROVENANCE: Collection of Director Gunnar A. Saddin, Dragor, Denmark.
LITERATURE: Lloyd 1981, pp. 18f., illus. – Pissarro 1993, ill. 34.

Cat. 3
Barges on the Seine
Péniches sur la Seine
c. 1864
Oil on canvas, 46 x 72 cm
Signed lower left: "C. Pissarro"
Musée Camille Pissarro, Pontoise, p. 1980.3
Not listed in PV.

PROVENANCE: Acquired in 1979.
EXHIBITIONS: Pontoise, Musée Pissarro, *Camille Pissarro & Pontoise*, 1980, cat. 81. – Tokyo, Musée National d'Art Occidental, *L'Angelus de Millet. Tendance du réalisme en France 1848–1870*, 1982, cat. 19. – Pontoise, Musée Pissarro, *Camille Pissarro et son fils Lucien*, 1982/83, cat. 1. – Pontoise, Musée Pissarro, *Les Bords de l'eau dans la peinture*, 1986, cat. 48. – Birmingham, City Museum and Art Gallery, 1990, cat. 4. – Tokyo, Tobu Museum of Art, *The Birth of Impressionism*, 1996, cat. 128. – Tokyo, Isetan Museum of Art, *Camille Pissarro and the Pissarro Family*, 1998, cat. 19.

Cat. 4
A Square in La Roche-Guyon
Une Place à La Roche-Guyon
c. 1867
Oil on canvas, 50 x 61 cm
Signed lower right: "C. P."
Staatliche Museen zu Berlin – Preußischer Kulturbesitz, Nationalgalerie, Inv. 75–61
PV 49

PROVENANCE: Camille Pissarro Collection. – Collection of Mme. Vve. Pissarro. – Armand Dorville Collection, Paris. – Tooth, London. – Acquired in 1961.
EXHIBITIONS: Paris, Orangerie, 1930, cat. 5. – Paris, Marcel Bernheim, 1936, cat. 4. – London, Tooth, *Recent Acquisitions*, 1946, cat. 2. – Berlin, Orangerie Schloß Charlottenburg, *Die Ile de France und ihre Maler*, 1963, cat. 10. – Paris, Grand Palais, 1981, cat. 7. – Jerusalem, The Israel Museum, 1994, cat. 25.
LITERATURE: C. Kunstler, 'Camille Pissarro', in: *La Renaissance*, XI, December 1928, pp. 503f., illus. – Pissarro 1928, cat. 47. – Exh. Cat. Paris 1981, cat. 7, p. 74. – Lloyd 1981, p. 63, illus. – Lloyd 1985a, pp. 38f., ill. 5. – Campbell 1992, p. 313, illus.

Cat. 5
The House of Père Gallien, Pontoise
La Maison du Père Gallien, Pontoise
1866
Oil on canvas, 40 x 55 cm
Signed and dated lower left: "C. Pissarro. 1866"
Ipswich Borough Council Museums and Galleries
PV 48

PROVENANCE: Cabruja Collection. – Lucien Pissarro, London. – Private collection, Scotland.
EXHIBITIONS: London, Marlborough Fine Art Ltd., 1955, cat. 1. – Birmingham, City Museum and Art Gallery, 1990, cat. 4. – Jerusalem, The Israel Museum, 1994, cat. 23.
LITERATURE: B. Denvir, *Impressionism: The Painters and their Paintings*, London 1991, pp. 141f., illus.

Cat. 6
The 'Côte du Jallais', Pontoise
La Côte du Jallais, Pontoise
1867
Oil on canvas, 87 x 114.9 cm

Signed and dated lower right: "C. Pissarro/1867."
The Metropolitan Museum of Art, New York, Bequest of William Church Osborn, 1951, 51.30.2
PV 55

PROVENANCE: Durand-Ruel, Paris. – Heinemann Gallery, New York, 1927. – William H. Holston, New York, 1929. – Collection of William Church Osborn, New York.
EXHIBITIONS: Paris, Palais des Champs-Elysées, *Salon de 1868*, 1868, cat. 2015. – Paris, Galerie Manzi & Joyant, 1914, cat. 5. – Chicago, The Art Institute, *A Century of Progress*, 1934, cat. 260. – New York, The Metropolitan Museum of Art, *French Painting from David to Toulouse-Lautrec*, 1941, cat. 96. – New York, Wildenstein, 1945, cat. 2. – Toledo, Museum of Art; Toronto, Art Gallery, *The Spirit of Modern France*, 1946/47, cat. 46. – New York, The Metropolitan Museum of Art, *Masterpieces of Fifty Centuries*, 1970, cat. 37. – Paris, Grand Palais; New York, The Metropolitan Museum of Art, *Centenaire de l'impressionnisme*, 1974/75, cat. 33. – Paris, Grand Palais, 1981, cat. 9.
LITERATURE: J.-A. Castagnary, 'Salon de 1868, V', in: *Le Siècle*, May/June 1868. – E. Zola, 'Mon Salon. III, Les naturalistes. V, Les paysagistes', in: *L'Evénement illustré*, May/June 1868. – O. Redon, 'Le Salon de 1868', in: *La Gironde*, July 1868. – M. Hamel, 'Camille Pissarro: exposition rétrospective de ses œuvres', in: *Les Arts*, March 1914, p. 26. – Exh. Cat. Paris 1981, cat. 9, pp. 75f. – Lloyd 1981, pp. 31f., illus. – Lloyd 1985a, pp. 40f., ill. 8. – Brettell 1990, p. 104, ill. 95. – Thomson 1990, p. 26, ill. 24. – Lloyd 1992, pp. 285f., ill. 6. – C. Lloyd, 'Marly-le-Roi et Sèvres 1875–1880', in: Exh. Cat. *Alfred Sisley*, Royal Academy of Arts, London, 1992, p. 168. – Pissarro 1993, ill. 44. – White 1996, pp. 112f., 115, illus. – Leymarie 1998, p. 25, ill. 12.

Cat. 7
The Maidservant
La Bonne
1867
Oil on canvas, 93.6 x 73.7 cm
Signed lower right: "C. P."
The Chrysler Museum of Art, Norfolk, Virginia, Gift of Walter P. Chrysler, Jr.
PV 53

EXHIBITIONS: Paris, Orangerie, 1930, cat. 23. – Basel, Kunsthalle, *Impressionisten – Claude Monet, Camille Pissarro, Alfred Sisley*, 1949, cat. 69. – Raleigh, North Carolina Museum of Art; Birmingham, Museum of Art, *French Paintings from the Chrysler Museum*, 1986/87, cat. 33.
LITERATURE: C. Kunstler, *Camille Pissarro*, Paris 1930. – Brettell 1990, p. 212, note. 16. – The Chrysler Museum, *Handbook of the European and American Collection*, Norfolk, Virginia, 1991, p. 121, ill. 96. – Pissarro 1993, ill. 4.

Cat. 8
Chestnut Trees at Louveciennes, Spring
Châtaigniers à Louveciennes, printemps
1870
Oil on canvas, 60 x 73 cm
Signed and dated lower left: "C. Pissarro. 1870"
Stiftung Langmatt Sidney und Jenny Brown, Baden, Switzerland
PV 88

PROVENANCE: Dr. George Viau. – Sidney W. Brown, Baden, Switzerland. – Acquired in 1910.
EXHIBITIONS: Paris, Durand-Ruel, *Exposition de tableaux de Monet, Pissarro, Renoir et Sisley*, 1899, cat. 38. – Paris, Durand-Ruel, 1904, cat. 4. – Stuttgart, Königliches Museum der bildenden Künste, *Große Kunstausstellung*, 1913, cat. 327. – Paris, Galerie de la Gazette des Beaux-Arts, *La Peinture française du XIX^e siècle en Suisse*, 1938, cat. 71 A.
LITERATURE: Duret 1906. – T. Duret, *Die Impressionisten*, Berlin 1923. – F. Fels, 'La Retour à Lancelot. Impressionnistes', in: *A.B.C. Magazine d'Art*, Paris 1925, ill. 2.

Cat. 9
Landscape near Louveciennes
Paysage à Louveciennes
1870
Oil on canvas, 45.8 x 55.7 cm
Signed and dated lower left: "C. Pissarro 1870"
Southampton City Art Gallery, 461
PV 97

PROVENANCE: Alexander Bonin Collection, Paris. – Mme. Catia Granoff, Paris. – Acquired in 1936 for £470.
EXHIBITIONS: Paris, Manzi & Joyant, 1914,

cat. 7. – Paris, Galerie d'Elysée, 1936, cat. 1. – Exeter, Royal Academy of Arts, Albert Memorial Museum, *Contemporary Paintings from the Southampton Art Gallery*, 1953, cat. 33. – Worthing, Art Gallery, *Modern Paintings from Southampton Art Gallery*, 1957, cat. 27. – Wales, Arts Council, *How Impressionism Began*, 1960, cat. 30. – Newcastle upon Tyne, Laing Art Gallery, *French Paintings from Southampton Art Gallery*, 1985. – Birmingham, City Museum and Art Gallery, 1990, cat. 7.
LITERATURE: Tabarant 1924, p. 17, ill. 8. – Southampton Art Gallery, *Illustrated Inventory of Paintings, Drawings and Sculptures*, 1980, p. 65. – C. Wright, *Renaissance to Impressionism, Masterpieces from Southampton City Art Gallery*, London 1998, p. 110, ill. 71.

Cat. 10
Near Sydenham Hill
(looking towards Lower Norwood)
Environs de Sydenham Hill
(avec Lower Norwood au fond)
1871
Oil on canvas, 43.6 x 53.8 cm
Signed lower left: "C. Pissarro"
Kimbell Art Museum, Fort Worth, Texas
PV 115

EXHIBITION: Manchester, New Hampshire, The Currier Gallery of Art, *The Rise of Landscape Painting in France*, 1991, cat. 99.
LITERATURE: Reid 1977, p. 261, illus. – Lloyd 1981, ill. p. 49. – Lloyd 1986, p. 63. – Brettell 1990, pp. 65f., illus. – Pissarro 1993, ill. 85.

Cat. 11
The Crystal Palace, London
Le «Crystal Palace», Londres
1871
Oil on canvas, 47.2 x 73.5 cm
Signed and dated lower left:
"C. Pissarro 1871"
The Art Institute of Chicago, Bequest of Mr. and Mrs. B. E. Bensinger, 1972.1164
PV 109

PROVENANCE: Durand-Ruel, Paris. – Durand-Ruel, New York. – Henry J. Fisher Collection. – Collection of Mr. and Mrs. B. E. Bensinger, Chicago.
EXHIBITIONS: Paris, Durand-Ruel, 1894, cat. 6. – New York, Durand-Ruel, *Exhibition*

of Paintings by Degas, Renoir, Monet, Pissarro and Sisley prior to 1880, 1931, cat. 3. – New York, Union League, *Exhibition of Paintings by the Master Impressionists*, 1932, cat. 13. – New York, Durand-Ruel, 1933, cat. 2. – New York, Durand-Ruel, *Exhibition by the Master Impressionists*, 1934, cat. 19. – New York, Durand-Ruel, *Exhibition of French Paintings from 1810 to 1880*, 1938, cat. 4. – New York, Durand-Ruel, *Monet, Pissarro, Sisley before 1890*, 1938, cat. 11. – Los Angeles Museum, *The Development of Impressionism*, 1940, cat. 50. – Detroit, Institute of Arts, *The Age of Impressionism and Realism*, 1940, cat. 32. – New York, Knoedler, *Paintings of London*, 1940, cat. 21. – New York, Durand-Ruel, 1941, cat. 7. – New York, Durand-Ruel, *Exhibition Celebrating One Hundred and Fortieth Birthday*, 1943, cat. 15. – London, Hayward Gallery, *The Impressionists in London*, 1973, cat. 33, Detroit, Institute of Arts, *The Arts and Crafts in Detroit: The Movement, the Society, the School*, 1977, cat. 27. – Paris, Grand Palais, 1981, cat. 15.
LITERATURE: L. Cardon, 'Camille Pissarro', in: *L'Evénement*, Paris 1894. – A. Alexandre, *L'Art à Paris*, Paris 1894. – Tabarant 1924, ill. 10. – Exh. Cat. Paris 1981, cat. 15, p. 82. – Lloyd 1981, ill. p. 48. – Exh. Cat. *Alfred Sisley*, Royal Academy of Arts, London, 1992, p. 138. – Pissarro 1993, ill. 88. – Ward 1995, pp. 251f., ill. 11.10. – Leymarie 1998, pp. 28f., ill. 18.

Cat. 12
Outskirts of Louveciennes, the Road
Environs de Louveciennes, la route
1871
Oil on canvas, 46 x 55 cm
Signed and dated lower left:
"C. Pissarro. 1871"
A. Rosengart Collection
PV 119

EXHIBITION: Bern, Kunstmuseum, 1957, cat. 15.
LITERATURE: Pissarro 1993, ill. 56.

Cat. 13
The Road to Louveciennes, at the Outskirts of the Forest
La Route de Louveciennes, à la sortie du bois
1871
Oil on canvas, 38 x 46 cm
Signed and dated lower left:

"C. Pissarro. 1871"
Private collection
PV 120

PROVENANCE: PV: "Collection L.-B., 1918."
EXHIBITIONS: Jerusalem, The Israel Museum, 1994, cat. 36. – Ferrara, Palazzo dei Diamanti, 1998, cat. 12.

Cat. 14
The Cabbage Field, Pontoise
Le Champ de choux, Pontoise
1873
Oil on canvas, 60 x 81 cm
Signed and dated lower right:
"1873. Pissarro", signed left: "C. Pissarro"
Carmen Thyssen-Bornemisza Collection
PV 230

PROVENANCE: Dr. Peter Nathan, Zurich. – Sotheby's, London, 1994. – Thyssen-Bornemisza Collection. – Collection of Carmen Thyssen-Bornemisza.
EXHIBITIONS: Paris, Durand Ruel, 1910, cat. 51. – Bern, Kunstmuseum, 1957, cat. 31. – Madrid, Thyssen-Bornemisza Museum, *From Canaletto to Kandinsky. Masterworks from the Carmen Thyssen-Bornemisza Collection*, 1996, cat. 58.
LITERATURE: Lloyd 1986, p. 96.

Cat. 15
Misty Morning in Creil
1873
Oil on canvas, 38 x 56.5 cm
Signed and dated lower left:
"C. Pissarro. 1873"
Privately owned
Not listed in PV.

PROVENANCE: Marianne and Dr. Walter Feilchenfeldt, Zurich.
EXHIBITION: London, Marlborough Fine Art Ltd., 1955, cat. 5. – London, Marlborough Fine Art Ltd., 1968, cat. 5. – Birmingham, City Museum and Art Gallery, 1990, cat. 13.

Cat. 16
June Morning, View over the Hills of Pontoise
Une Matinée de juin, vue prise des hauteurs de Pontoise
1873
Oil on canvas, 54 x 91 cm

Signed and dated lower right:
"C. Pissarro. 1873."
Staatliche Kunsthalle Karlsruhe, Inv. 2539
PV 224

PROVENANCE: Drake del Castillo, Paris. – J.
C. W. Sawbridge-Erle-Drax. – Mrs. Derek
Fitzgerald. – A. Tooth Collection, London.
– Sotheby's, London, 1965. – Dr. Walter
Feilchenfeldt, Zurich. – Acquired in 1966.
EXHIBITIONS: Paris, Boulevard des
Capucines bei Nadar, *Première exposition des
peintres impressionnistes*, 1874, cat. 140. –
London, Royal Academy of Arts, *Landscape
in French Art*, 1949/50, cat. 249.
LITERATURE: J.-A. Castagnary, 'L'Exposition
du boulevard des Capucines – les impres-
sionnistes', in: *Le Siècle*, 1874. – L. Venturi,
Les Archives de l'impressionnisme, vol. II, Paris
1939. – Rewald 1963, p. 28. – *Jahrbuch der
Staatlichen Kunstsammlungen Baden-Württem-
berg*, vol. IV, 1967, p. 136, illus. – *Ausgewählte
Werke der Staatlichen Kunsthalle Karlsruhe.
150 Gemälde vom Mittelalter bis zur Gegenwart*,
Karlsruhe 1988, p. 258, illus.

Cat. 17
Bourgeois House in L'Hermitage, Pontoise
Maison bourgeoise à l'Hermitage, Pontoise
1873
Oil on canvas 50.5 x 65.5 cm
Signed and dated lower right:
"C. Pissarro. 1873"
Kunstmuseum Sankt Gallen,
Sturzeneggersche Gemäldesammlung
PV 227

PROVENANCE: Durand-Ruel, Paris. – Natio-
nalgalerie, Berlin, 1897 (forcibly removed
in 1936). – Eduard Sturzenegger. – Bequest
to the Kunstmuseum St. Gallen.
EXHIBITIONS: Dresden, *Internationale Kunst-
ausstellung*, 1897, cat. 48. – Paris, Galerie de
la Gazette des Beaux-Arts, *La Peinture
française du XIXᵉ siècle en Suisse*, 1938, cat.
73. – Amsterdam, Stedelijk Museum, *Un
Siècle de peinture française*, 1938, cat. 191. –
Basel, Kunsthalle, *Impressionisten. Monet, Pis-
sarro, Sisley*, 1949, cat. 75. – Paris, Durand-
Ruel, 1956, cat. 22. – Bern, Kunstmuseum,
1957, cat. 30. – Paris, Petit-Palais, *De Géri-
cault à Matisse: Chefs d'œuvre français des col-
lections suisses*, 1959, cat. 107. – Wolfsburg,
Stadthalle, *Französische Malerei von Delacroix
bis Picasso*, 1961, cat. 117. – Berlin,
Orangerie Schloß Charlottenburg, *Die Ile de*

France und ihre Maler, 1963, cat. 16. – Paris,
Grand Palais, 1981, cat. 33. – Cologne,
*Landschaft im Licht. Impressionistische Malerei
in Europa und Amerika 1860–1910*, 1990,
cat. 142.
LITERATURE: W. Weisbach, *Impressionismus:
ein Problem der Malerei in der Antike und
Neuzeit*, vol. II, Berlin 1911, p. 143, illus. –
Exh. Cat. Paris 1981, cat. 33, pp. 98f. –
Kunstmuseum Sankt Gallen, *Catalog der
Sammlung*, Sankt Gallen 1987, p. 6, 140. –
B. Paul, *Hugo von Tschudi und die moderne
französische Kunst*, Mainz 1993, p. 94, 349,
ill. 39. – J. G. Prinz v. Hohenzollern and P.-
K. Schuster (eds), *Manet bis van Gogh –
Hugo von Tschudi und der Kampf um die Mod-
erne*, Munich and New York 1996, p. 104,
ill. 31.

Cat. 18
The Seine at Port-Marly
La Seine à Port-Marly
1872
Oil on canvas, 46 x 55.8 cm
Signed and dated: "C. Pissarro. 1872"
Staatsgalerie Stuttgart, Inv. 2727
PV 187

PROVENANCE: Dr. Paul Gachet, Auvers. –
Wildenstein, New York. – Marlborough Fine
Art Ltd., London. – Acquired in 1965.
EXHIBITIONS: New York, Wildenstein, 1945,
cat. 54. – Houston, Museum of Fine Arts,
1954, cat. 34. – Birmingham, City Museum
and Art Gallery, 1990, cat. 11. – Washing-
ton, The Phillips Collection, *Impressionists
on the Seine: A Celebration of Renoir's "Lun-
cheon of the Boating Party"*, 1996/97, cat. 11.
– Atlanta, High Museum of Art. – Seattle
Art Museum; Denver Art Museum, *Impres-
sionism: Paintings Collected by European Muse-
ums*, 1999, cat. 41.
LITERATURE: *Catalogue de la collection Paul
Gachet*, cat. 8 (unpublished manuscript,
Bibliothèque Nationale Paris). – *Jahrbuch
der Staatlichen Kunstsammlungen Baden-
Württemberg*, vol. III, 1966, p. 253, illus.
– *La Chronique des arts. Supplément à la
Gazette des Beaux-Arts*, Paris 1966, p. 20,
ill. 82. – Staatsgalerie Stuttgart, *Malerei und
Plastik des 19. Jahrhunderts*, Stuttgart 1982,
p. 113, ill. 2727. – Brettell 1990, p. 216,
note. 50. – B. Denvir, *Impressionism, The
Painters and the Paintings*, London 1991,
p. 258, ill. 276.

Cat. 19
The Factory at Pontoise
L'Usine à Pontoise
1873
Oil on canvas, 38 x 55 cm
Dated lower right: "1873"
The Israel Museum, Jerusalem, Gift of the
Saidye Rosner Bronfman Estate, Montreal,
to the Canadian Friends of the Israel
Museum, R. No. B95.1012
PV 217

PROVENANCE: Collection of Mme. Louise
Gillou, Paris. – Bronfman Foundation,
Montreal. – Gift to The Israel Museum,
Jerusalem.
EXHIBITIONS: Jerusalem, The Israel
Museum, 1994, cat. 44. – Jerusalem, The
Israel Museum, *Permanent Exhibition Floers-
heimer Pavilion*.
LITERATURE: Brettell 1990, pp. 81f., ill. 74.

Cat. 20
The Oise on the Outskirts of Pontoise
L'Oise aux environs de Pontoise
1873
Oil on canvas, 45.3 x 55 cm
Signed and dated lower right:
"C. Pissarro. 1873"
Sterling and Francine Clark Art Institute,
Williamstown, Massachusetts, 1955.554
PV 218

PROVENANCE: E. Garçin, Paris. – Durand-
Ruel, New York, 1943. – Collection of R. S.
Clark. – Clark Art Institute, 1955.
EXHIBITIONS: Paris, Marcel Bernheim, 1936,
cat. 14. – New York, Durand-Ruel, *Exhibition
Celebrating One Hundred and Fortieth Anniver-
sary*, 1943, cat. 16. – Paris, Grand Palais,
1981, cat. 30 (exhibited in Boston).
LITERATURE: Exh. Cat. Paris 1981, cat. 30,
p. 95. – Lloyd 1986, pp. 26f., 46. – Brettell
1990, pp. 81–86, illus. – Leymarie 1998,
p. 32, illus.

Cat. 21
Landscape with Flooded Fields
Paysage aux champs inondés
1873
Oil on canvas, 64.9 x 81.2 cm
Signed and dated lower left: "C. Pissarro 1873"
Wadsworth Atheneum, Hartford, Connecti-
cut, 1966.315
Not listed in PV.

PROVENANCE: Possibly bought by Durand-Ruel from the artist in 1881 as *Prairie inondée* and sold to Ernest May in 1882. – Collection of Ernest May, Paris. – Woolworth, 1890. – Harry K. Taylor. – Acquired in 1966 from the estate of Harry K. Taylor.
EXHIBITION: Paris, Grand Palais, 1981, cat. 23.
LITERATURE: Exh. Cat. Paris 1981, cat. 23, p. 90.

Cat. 22
Portrait of Jeanne Holding a Fan
Portrait de Jeanne, tenant un éventail
c. 1873
Oil on canvas, 56.1 x 46.6 cm
Signed lower right: "C. P."
Ashmolean Museum, Oxford
PV 232

PROVENANCE: Lucien Pissarro, London. – Collection of Esther Pissarro. – Ashmolean Museum, Oxford, 1950.
EXHIBITIONS: Paris, Manzi & Joyant, 1914, cat. 69. – London, Tate Gallery, 1931, cat. 35. – London, O'Hana Gallery, *Three Generations of Pissarros 1830–1954*, 1954, cat. 1. – Paris, Grand Palais, 1981, cat. 34 (exhibited in London and Paris as *Portrait de Minette tenant un éventail*).
LITERATURE: Exh. Cat. Paris 1981, cat. 34, p. 99. – Pissarro 1993, ill. 343.

Cat. 23
Lucien Pissarro in an Interior
Lucien Pissarro dans un intérieur
c. 1875
Oil on canvas, 65 x 54 cm
Signed lower right: "C. P."
Private collection, Paris
PV 333 (as *Figure assise, Lucien*)

PROVENANCE: Lucien Pissarro, London. – John Bensusan-Butt.
EXHIBITIONS: London, Tate Gallery, 1931, cat. 7. – Basel, Kunsthalle, *Impressionisten. Monet, Pissarro, Sisley. Vorläufer und Zeitgenossen*, 1949, cat. 13.

Cat. 24
Peasant Untangling Wool
Paysanne démêlant de la laine
1875
Oil on canvas, 55 x 46 cm
Signed and dated lower left:
"C. Pissarro. 1875"

Stiftung Sammlung E. G. Bührle Collection, Zurich
PV 270

PROVENANCE: Galerie F. G. Fehse, Basel. – Bernheim-Jeune Collection, Paris. – Jean-Baptiste Faure. – A. Gildemeister, Hochkamp. – Art market, New York. – Acquired in 1954 from a Swiss art dealer.
EXHIBITIONS: Paris, Durand-Ruel, 1904, cat. 21 (as *La Cardeuse*). – Winterthur, Kunstmuseum, *Europäische Meister 1790–1910*, 1955, cat. 158. – Zurich, Kunsthaus, *Sammlung E. G. Bührle*, 1958, cat. 320. – Munich, Haus der Kunst, *Hauptwerke der Sammlung Emil Georg Bührle – Zürich*, 1958/59, cat. 124.
LITERATURE: Lloyd 1981, ill. p. 76. – Pissarro 1993, ill. 147.

Cat. 25
Peasant Pushing a Wheelbarrow, Maison Rondest, Pontoise (Landscape near Pontoise)
Paysanne poussant une brouette, Maison Rondest, Pontoise (Paysage de Pontoise)
1874
Oil on canvas, 65 x 51 cm
Signed and dated lower left:
"C. Pissarro 1874"
National Museum Stockholm, NM 2086
PV 244

PROVENANCE: Collection of Henri Rouart, Paris. – Collection of Hugo Perls, Berlin. – Since 1918 in the National Museum Stockholm.
EXHIBITION: Paris, Grand Palais, 1981, cat. 36.
LITERATURE: Exh. Cat. Paris 1981, cat. 36, p. 101. – Lloyd 1981, ill. p. 61. – Brettell 1990, pp. 172–174, ill. 151. – Pissarro 1993, ill. 139.

Cat. 26
L'Hermitage, Pontoise, Snow Effect
L'Hermitage, Pontoise, effet de neige
1874
Oil on canvas, 54 x 64.8 cm
Signed and dated lower left:
"C. Pissarro. 1874"
The Fogg Art Museum, Harvard University, Cambridge, Gift of Mr. and Mrs. Joseph Pulitzer, Jr., 1953.105
PV 240

PROVENANCE: Mr. and Mrs. Joseph Pulitzer, Jr., 1951. – Gift to The Fogg Art Museum, 1953.
EXHIBITIONS: St. Louis, City Art Museum, *St. Louis Collects*, 1952. – New York, Knoedler, *Modern Painting, Drawing and Sculpture Collected by Louise and Joseph Pulitzer, Jr.* – Cambridge, The Fogg Art Museum, 1957, cat. 59. – New York, Wildenstein, 1965, cat. 24. – Cambridge, The Fogg Art Museum, *Masterpaintings from the Fogg Collection*, 1977.
LITERATURE: T. Duret, *L'Histoire des peintres impressionnistes*, Paris 1923, illus. – E. P. Bowron, *European Paintings before 1900 in the Fogg Art Museum*, Harvard University Art Museum, Cambridge, 1990, p. 124, ill. 336.

Cat. 27
Landscape, Bright Sunlight, Pontoise
Paysage, plein soleil, Pontoise
1874
Oil on canvas, 52.3 x 81.5 cm
Signed and dated: "C. Pissarro. 1874"
Museum of Fine Arts, Boston, Collection of Juliana Cheney Edwards, 25.114
PV 255

PROVENANCE: Collection of Jean-Baptiste Faure (cat. 87 as *En plein soleil*).
LITERATURE: Brettell 1990, p. 174, ill. 149.

Cat. 28
The Village Pathway
Le Sentier du village
1875
Oil on canvas, 39 x 55.5 cm
Signed and dated lower right:
"C. Pissarro. 1875"
Rudolf Staechelinsche Familienstiftung, Basel
PV 310

PROVENANCE: Acquired in 1917 in Geneva.
EXHIBITIONS: London, New Burlington Galleries, *Exhibition of Masters of French Nineteenth Century Painting*, 1936, cat. 56. – Basel, Kunstmuseum, *Sammlung Rudolf Staechelin – Gedächtnisausstellung zum 10. Todesjahr des Sammlers*, 1956, cat. 13. – Paris, Musée National d'Art Moderne, *Fondation Rodolphe Staechelin de Corot à Picasso*, 1964, cat. 10. – Basel, Galerie Beyeler, *Impressionnistes*, 1967, cat. 23. – Paris, Grand Palais, 1981, cat. 42.

LITERATURE: Exh. Cat. Paris 1981, cat. 42, p. 107. – Brettell 1990, pp. 106f., ill. 97.

Cat. 29
The Quarry, Pontoise
La Carrière, Pontoise
c. 1875
Oil on canvas, 58.2 x 72.5 cm
Signed lower left: "C. P."
Rudolf Staechelinsche Familienstiftung, Basel
PV 251

PROVENANCE: Acquired from Mario Arbibi in 1920 by Rudolf Staechelin, Munich.
EXHIBITIONS: London, Stafford Gallery, 1911, cat. 12. – Bern, Kunsthalle, *Französische Meister des 19. Jahrhunderts und van Gogh*, 1934, cat. 83. – Amsterdam, Stedelijk Museum, *Honderd Jaar fransche Kunst*, 1938, cat. 92. – Basel, Kunstmuseum, *Sammlung Rudolf Staechelin – Gedächtnisausstellung zum 10. Todesjahr des Sammlers*, 1956, cat. 12. – Bern, Kunstmuseum, 1957, cat. 35. – Paris, Musée Nationale d'Art Moderne, *Fondation Rodolphe Staechelin de Corot à Picasso*, 1964, cat. 12. – Basel, Galerie Beyeler, *Impressionnistes*, 1967, cat. 22. – Paris, Grand Palais, 1981, cat. 39.
LITERATURE: Exh. Cat. Paris 1981, cat. 39, p. 104. – Lloyd 1981, p. 71, illus. – Brettell 1990, p. 52, ill. 50.

Cat. 30
The Climbing Path, L'Hermitage, Pontoise
Le Chemin montant, L'Hermitage, Pontoise
1875
Oil on canvas, 54 x 65 cm
Signed and dated lower right: "C. Pissarro / 1875"
The Brooklyn Museum of Art, Gift of Dikran K. Kelekian, 22.60
PV 308

PROVENANCE: Collection of Georges de Bellio, Paris. – Collection of Donop de Monchy, Paris (Mme. Donop de Monchy, daughter of de Bellio). – Paul Rosenberg, Paris. – Collection of Dikran Khan Kelekian, Paris and New York.
EXHIBITIONS: New York, Brooklyn Museum, *Paintings by Contemporary English and French Painters*, 1922/23, cat. 181. – Chicago, The Art Institute, *A Century of Progress*, 1934, cat. 258. – New York, Brooklyn Museum, *Leaders from the American Impressionism*, 1937,

cat. 15. – New York, Wildenstein, 1945, cat. 13. – Montreal, Museum of Fine Arts, *Manet to Matisse*, 1949, cat. 28. – Richmond, Virginia, Museum of Fine Arts, *Paintings by the Impressionists and the Post-Impressionists*, 1950. – Palm Beach, Florida, *Society of the Four Arts*, 1960, cat. 7. – New York, Wildenstein, 1965, cat. 30. – New York, Wildenstein, *Paris–New York: A Continuing Romance*, 1977, cat. 77. – Paris, Grand Palais, 1981, cat. 41. – Los Angeles, County Museum of Art; The Art Institute of Chicago; Paris, Grand Palais, *A Day in the Country: Impressionism and the French Landscape*, 1984/85, cat. 66.
LITERATURE: Exh. Cat. Paris 1981, cat. 41, pp. 106f. – Lloyd 1981, p. 71, illus. – Brettell 1990, p. 168.

Cat. 31
Vegetable Garden and Trees in Blossom, Spring, Pontoise
Potager et arbres en fleurs, printemps, Pontoise
1877
Oil on canvas, 65.5 x 81 cm
Signed and dated lower left: "C. Pissarro. 1877"
Musée d'Orsay, Paris, Legats Gustave Caillebotte, 1894, RF 2733
PV 387

PROVENANCE: Caillebotte Collection. – Bequest to the Musée du Louvre, 1894.
EXHIBITIONS: Paris, Avenue de l'Opéra, *4ᵉ Exposition des peintres impressionnistes*, 1879, cat. 183 (as *Printemps, pruniers en fleurs, appartenant à M. G. C.*). – Paris, Orangerie, 1930, cat. 37. – Los Angeles, County Museum of Art; The Art Institute of Chicago; Paris, Grand Palais, *A Day in the Country: Impressionism and the French Landscape*, 1984/85, cat. 98.
LITERATURE: G. Bazin, *Die Impressionisten im Louvre*, Heidelberg 1958, p. 178, illus. – L. Reidemeister, *Auf den Spuren der Maler der Ile de France*, Berlin 1963, pp. 66f. – Rewald 1963, pp. 106f. – Rosensaft 1974, p. 53, ill. 4. – Lloyd 1981, p. 79, illus. – Brettell 1990, pp. 92, 183f., ill. 159. – Pissarro 1993, ill. 112. – White 1996, pp. 130f., illus.

Cat. 32
Path under Trees, in Summer
Chemin sous bois, en été
1877

Oil on canvas, 81 x 65.7 cm
Signed and dated lower right: "C. Pissarro. 1877"
Musée d'Orsay, Paris, Legats Gustave Caillebotte RF 2731
PV 416

EXHIBITIONS: Paris, Avenue de l'Opéra, *4ᵉ Exposition des peintres impressionnistes*, 1879, cat. 169. – Memphis, Dixon Gallery and Gardens, 1977. – Ferrara, Palazzo dei Diamanti, 1998, cat. 24.
LITERATURE: H. Adhémar and A. Dayez-Distel, *Musée du Jeu de Paume*, Paris 1979, pp. 89, 167. – C. Moffett, *The New Paintings: Impressionism 1874–1886*, San Francisco 1986, p. 288, ill. 83. – Brettell 1990, p. 184.

Cat. 33
The Pathway at Le Chou, Pontoise
La Sente du Chou, Pontoise
1878
Oil on canvas, 50.5 x 92 cm
Signed and dated lower right: "C. Pissarro. 1878"
Musée de la Chartreuse, Douai, 2231
PV 452

PROVENANCE: Collection of Mme. Pissarro. – Galerie Georges Petit, 1928. – Collection of Pierre Malric. – Acquired in 1931.
EXHIBITIONS: Paris, Boulevard des Capucines, *6ᵉ Exposition des peintres impressionnistes*, 1881, cat. 63 (as *La Sente du Chou en mars. Appartient à M. J. P.*). – Paris, Durand-Ruel, 1892, cat. 10. – Paris, Durand-Ruel, 1904, cat. 48. – Bremen, Kunsthalle, *Große Kunstausstellung*, 1910, cat. 264. – London, Stafford Gallery, 1911, cat. 29. – Paris, Manzi & Joyant, 1914, cat. 22, London, Leicester Gallery, 1920, cat. 72. – Paris, Nunès et Fiquet, 1921, cat. 1. – Paris, Galerie André Weil, 1950, cat. 18. – Dieppe, Musée des Beaux Arts, 1955, no catalogue. – Tourcoing, Musée, *Portraits et Paysages du 19ᵉ siècle*, 1955, not numbered. – Basel, Kunstmuseum, *Sammlung Rudolf Staechelin. Gedächtnisausstellung zum 10. Todesjahr des Sammlers*, 1956, cat. 14. – Paris, Durand-Ruel, 1956, cat. 33. – Paris, Galerie Heim, *Chefs d'œuvres du Musée de Douai*, 1956, cat. 25. – Douai, Musée de la Chartreuse, *Henri Duhem et ses amis impressionnistes*, 1963, no catalogue. – Paris, Grand Palais, 1981, cat. 48 (exhibited in London and Paris). – Recklinghausen, Ruhrfestspiele, *Wer hat

dich du schöner Wald, 1984, cat. 116. – Douai, Musée de la Chartreuse, *Le Paysage français au 19e siècle*, 1987, cat. 27. – Ibaraki, Fukushima and Kyoto, *Monet et ses amis*, 1988, cat. 51. – Jerusalem, The Israel Museum, 1994, cat. 56. – Ferrara, Palazzo dei Diamanti, 1998, cat. 28.
LITERATURE: E. Cardon, 'Chose d'art: l'exposition des artistes indépendants', in: *Le Soleil*, April 1881. – Gonzague-Privat, 'L'Exposition des artistes indépendants', in: *L'Evénement*, April 1881. – A. Silvestre, 'Le Monde des Arts', in: *La Vie Moderne*, April 1881, p. 151. – C. Saunier, 'L'Art Nouveau: I. Camille Pissarro', in: *La Revue Indépendante*, 1892, p. 34. – M. Hamel, 'Camille Pissarro: exposition rétrospective de ses œuvres', in: *Les Arts*, 1914, p. 28, illus. – Lecomte 1922, p. 68, illus. – Pissarro 1928, cat. 35. – Exh. Cat. Paris 1981, cat. 48, p. 113. – Lloyd 1981, p. 79, illus. – Lloyd 1986, p. 46, ill. 28. – C. Moffett, *The New Paintings: Impressionism 1874–1886*, San Francisco 1986, p. 346, ill. 13. – Brettell 1990, p. 86, ill. 78. – Pissarro 1993, ill. 120. – P. H. Feist, *La Peinture impressionniste*, Cologne 1996, p. 174.

Cat. 34
Rainbow, Pontoise
L'Arc-en-ciel, Pontoise
1877
Oil on canvas, 53 x 81 cm
Signed and dated lower left:
"C. Pissarro. 1877"
Kröller-Müller Museum, Otterlo, 615-19
PV 409

PROVENANCE: Hoschedé, Paris. – Jean-Baptiste Faure, Paris. – Georges Bernheim, Paris, 1919.
EXHIBITIONS: Paris, Rue Le Peletier, *3e Exposition des peintres impressionnistes*, 1877, cat. 171 (as *La Plaine d'Epluches*). – Paris, Durand-Ruel, 1904, cat. 44. – Rotterdam, Museum Boijmans Van Beuningen, 1935, cat. 46. – Arnheim, Gemeente Museum, 1936, cat. 51. – Amsterdam, Stedelijk Museum, *Meesterwerken van 1800 tot Heden*, 1946. – Paris, Institut Néerlandais, *Les Amis de Van Gogh*, 1960, cat. 60.
LITERATURE: *Paintings of the Rijksmuseum Kröller-Müller*, Otterlo 1969, p. 216, ill. 44. – C. Moffett, *The New Paintings: Impressionism 1874–1886*, San Francisco 1986, p. 232, ill. 59. – Thomson 1990, p. 37, ill. 38.

Cat. 35
The Backwoods of L'Hermitage, Pontoise
Le Fond de L'Hermitage, Pontoise
1879
Oil on canvas, 126.3 x 164.7 cm
Signed and dated lower left:
"C. Pissarro. 1879"
The Cleveland Museum of Art, Gift of the Hanna Fund, 51-356
PV 489

PROVENANCE: Pissarro Family. – Acquired from the Pissarro Family in 1913 for 20,000 francs by Bernheim-Jeune, Paris. – Bernheim-Jeune Collection, Luzern, 1917. – Anonymous sale (Hôtel Drouot, Paris, 20 June 1935, for 23,100 francs). – Collection of C. Comiot, Paris. – Hector Brame et César de Haucke, Paris. – Acquired in 1951.
EXHIBITIONS: Paris, Avenue de l'Opéra, *4e Exposition des peintres impressionnistes*, 1879, cat. 168 (as *Lisière d'un bois*) or cat. 173 (as *Sous bois en été*). – Paris, Durand-Ruel, 1928, cat. 30. – Paris, Orangerie, 1930, cat. 35. – Paris, Marcel Bernheim, 1936, cat. 32. – Paris, Orangerie, *De David à Toulouse-Lautrec. Chef d'œuvres des collections américaines*, 1955, cat. 45. – Paris, Grand Palais, 1981, cat. 52.
LITERATURE: Exh. Cat. Paris 1981, cat. 52, p. 115. – Lloyd 1981, p. 81, illus. – C. Moffett, *The New Paintings: Impressionism 1874–1886*, San Francisco 1986, p. 287, ill. 82. – Brettell 1990, pp. 134f., ill. 124. – Pissarro 1993, ill. 138.

Cat. 36
Peasants Resting
Paysannes au repos
1881
Oil on canvas, 82 x 66 cm
Signed and dated lower right:
"C. Pissarro. 81"
The Toledo Museum of Art, Toledo, Purchased with funds from the Libbey Endowment, Gift of Edwards Drummond Libbey, 1935.6
PV 542

PROVENANCE: Paul Durand-Ruel, Paris
EXHIBITIONS: Paris, Salon du Panorama de Reichshoffen, *7e Exposition des artistes indépendants*, 1882, cat. 104. – Paris, Durand-Ruel, 1921, cat. 30. – New York, Wildenstein, 1945, cat. 19. – Boston, Museum of Fine Arts, *Barbizon Revisited*,

1962, cat. 110. – Bordeaux, Musée des Beaux-Arts, *La Peinture française: collections américaines*, 1966, cat. 172. – Michigan, Museum of Art, *The crisis of Impressionism 1878–1882*, 1980, cat. 40.
LITERATURE: O. Wittmann, *European Paintings*, The Toledo Museum of Art, Toledo 1976, p. 128, ill. 250. – Lloyd 1981, ill. p. 93. – C. Moffett, *The New Paintings: Impressionism 1874–1886*, San Francisco 1986, p. 407, ill. 125 (as *Etude de figure en plein air, effet de soleil*). – Pissarro 1993, ill. 162.

Cat. 37
Peasant Woman and Child in the Fields, Pontoise
Paysanne et enfant dans les champs, Pontoise
1881
Oil on canvas, 41 x 27 cm
Signed and dated lower right:
"C. Pissarro. 81"
Private collection
PV 552

PROVENANCE: Durand-Ruel, Paris. – Sam Salz, New York, c. 1943. – Maurice Sachoux, New York, 1943.
EXHIBITION: Paris, Durand-Ruel, 1910, cat. 6.
LITERATURE: G. H. Stephens, 'Camille Pissarro, Impressionist', in: *Brush and Pencil*, March 1904, no. 6.

Cat. 38
Woman with Goat
La Femme à la chèvre
1881
Oil on canvas, 82.6 x 74.9 cm
Signed and dated lower right:
"C. Pissarro. 81"
Private collection, New York
PV 546

PROVENANCE: Durand-Ruel. – Ryerson, 1891. – Durand-Ruel, New York, 1902. – Hugo Reisinger, New York, 1907. – Mrs. H. O. Havemeyer, New York, 1916.
EXHIBITIONS: Paris, Salon du Panorama de Reichshoffen, *7e Exposition des artistes indépendants*, 1882, cat. 120 (as *La Gardeuse de chèvres*). – New York, The Metropolitan Museum of Art, *Splendid Legacy: The Havemeyer Collection*, 1993, cat. 429.

LITERATURE: *H. O. Havemeyer Collection: Catalogue of Paintings, Prints, Sculpture and Objects of Art*, Portland, Maine, 1931, p. 424. – Pissarro 1993, ill. 204.

Cat. 39
Le Père Melon, Lighting his Pipe
Le Père Melon allumant son pipe
c. 1879/80
Pastel, 56 x 46 cm
Private collection
Not listed in PV.

Cf. *Le Père Melon sciant du bois, Pontoise*, 1879, Oil on canvas, PV 499. – *Le Père Melon au repos*, c. 1979, Oil on canvas, PV 498.

Cat. 40
Young Peasant Girl Wearing a Hat
Jeune Paysanne au chapeau de paille
1881
Oil on canvas, 73.4 x 59.6 cm
Signed and dated lower right:
"C. Pissarro 81"
National Gallery of Art, Washington, Collection of Ailsa Mellon Bruce, 1970.17.52
PV 548

PROVENANCE: Durand-Ruel, Paris. – Collection of Mme. A. Aude, Paris. – Collection of Mme. R. de Brecey, Paris. – Durand-Ruel, Paris. – Sam Salz, New York, 1963. – Collection of Ailsa Mellon Bruce, New York, 1963. – National Gallery of Art, Washington, 1970.
EXHIBITIONS: Paris, Salon du Panorama de Reichshoffen, *7ᵉ Exposition des artistes indépendants*, 1882, cat. 118. – London, Dowdeswell and Dowdeswell, 1883, no catalogue. – Paris, Durand-Ruel, 1904, cat. 67 (as *Paysanne assise*). – Paris, Durand-Ruel, 1910, cat. 17 (as *Paysanne au repos*). – Paris, Durand-Ruel, 1921, cat. 2. – Paris, Durand-Ruel, 1928, cat. 35. – Paris, Durand-Ruel, *Quelques œuvres de Manet à Van Gogh*, 1932, cat. 34. – Paris, Durand-Ruel, 1956, cat. 43. – Bern, Kunstmuseum, 1957, cat. 58. – Paris, Durand-Ruel, 1962, cat. 18. – New York, Knoedler, *Impressionist Treasures*, 1966, cat. 25. – Washington, National Gallery of Art, *French Paintings from the Collection of Mr. and Mrs. Paul Mellon Bruce*, 1966, cat. 69. – Paris, Grand Palais, 1981, cat. 54. – Munich, Neue Pinakothek, *Französische Impressionisten und ihre Wegbereiter*, 1990, cat. 41.

LITERATURE: A. Silvestre, 'Le Monde des arts', in: *La Vie moderne*, 1882, p. 151. – W. Kirchbach, 'Pissarro und Raffaelli, zwei Impressionisten', in: *Die Kunst unserer Zeit*, XV, 1904, p. 127. – H. Stephens, 'Camille Pissarro: Impressionist', in: *Brush and Pencil*, XIII, 1904, p. 417. – F. Fels, 'Pissarro', in: *A.B.C. Magazine of Art*, 1927, p. 229, illus. – Exh. Cat. Paris 1981, cat. 54, p. 117. – Lloyd 1981, p. 96, illus. – C. Moffett, *The New Paintings: Impressionism 1874–1886*, San Francisco 1986, p. 410, ill. 128. – Leymarie 1998, pp. 98f., illus.

Cat. 41
Resting, Peasant Girl Lying on the Grass, Pontoise
Le Repos, paysanne couchée dans l'herbe, Pontoise
1882
Oil on canvas, 64.5 x 78 cm
Signed and dated lower left:
"C. Pissarro/82"
Kunsthalle Bremen, Inv. 960-1967/8
PV 565

PROVENANCE: Van Wisselinghe, Amsterdam. – Collection of Dr. Hugo Oelze, Amsterdam. – Acquired in 1967/68.
EXHIBITIONS: Amsterdam, Van Wisselinghe, *La Peinture française du XIXᵉ et XXᵉ siècle*, 1931, cat. 40. – Bremen, Kunsthalle, *Paula Modersohn-Becker*, 1976, cat. 420. – Bremen, Kunsthalle, *Zurück zur Natur: Die Künstlerkolonie von Barbizon*, 1977/78, cat. 426. – Paris, Grand Palais, 1981, cat. 56.
LITERATURE: F. Fagus, 'Petite gazette d'art: Camille Pissarro', in: *La Revue Blanche*, XVIII, 1899, p. 546. – G. Gerkens and U. Heiderich, *Catalog der Gemälde des 19. und 20. Jahrhunderts in der Kunsthalle Bremen*, Bremen 1973, p. 268. – Exh. Cat. Paris 1981, cat. 56, p. 118. – Brettell 1990, pp. 134f., ill. 124. – Pissarro 1993, ill. 168.

Cat. 42
Young Woman Washing Dishes
La Laveuse de vaisselle
c. 1882
Oil on canvas, 85 x 65.7 cm
Signed and dated lower right:
"C. Pissarro/1882"
The Syndics of the Fitzwilliam Museum, Cambridge, England, PD.53-1947
PV 579

PROVENANCE: Durand-Ruel, Paris (acquired in 1882 from the artist for 2,500 francs). – Averkieff Collection, London, 1938. – René Gimpel, Paris. – Acquired in 1947 from Spencer George Perceval Fund, with support from the National Art-Collections Fund.
EXHIBITIONS: London, Gimpel Fils, *Five Centuries of French Painting*, 1946, cat. 46. – Paris, Grand Palais, 1981, cat. 59. – Jerusalem, The Israel Museum, 1994, cat. 65.
LITERATURE: Fitzwilliam Museum Cambridge, *Catalogue of Paintings*, vol. I, 1960, p. 188, ill. 100 (as *Garden at Pontoise*). – Exh. Cat. Paris 1981, cat. 59, p. 121. – Lloyd 1981, ill. p. 91. – Pissarro 1993, ill. 191.

Cat. 43
The Pork Butcher
La Charcutière
1883
Oil on canvas, 66 x 54 cm
Signed and dated lower right:
"C. Pissarro 1883"
Tate Gallery, London, 724
PV 615

PROVENANCE: Lucien Pissarro, London. – Bequest in The National Gallery, London, 1949 (Transferred to the Tate Gallery in 1950).
EXHIBITIONS: London, Stafford Gallery, 1911, cat. 20. – London, Doré Galleries, *Post-Impressionist and Futurist Exhibition*, 1913, cat. 4. – London, Leicester Galleries, 1920, cat. 71. – Paris, Orangerie, 1930, cat. 63. – London, Tate Gallery, 1931, cat. 5. – London, Stafford Gallery, *Constable, Bonington, C. Pissarro*, 1939, cat. 19. – Paris, Grand Palais, 1981, cat. 60. – Birmingham, City Museum and Art Gallery, 1990, cat. 32. – Jerusalem, The Israel Museum, 1994, cat. 68.
LITERATURE: E. Jaques, 'Exposition de M. Pissarro', in: *L'Intransigeant*, 1883. – C. Kunstler, *Camille Pissarro*, Paris 1930, p. 236, ill. I. – Exh. Cat. Paris 1981, cat. 60, p. 122. – Lloyd 1981, p. 90, illus. – B. Denvir, *Impressionism: The Painters and their Paintings*, London 1991, p. 300, illus. – Pissarro 1993, ill. 235.

Cat. 44
The Poultry Market, Gisors
Le Marché de volaille, Gisors
1885
Gouache and pastel on paper, mounted on canvas, 82.2 x 82.2 cm

Signed and dated lower right:
"C. Pissarro 1885"
Museum of Fine Arts, Boston, Bequest of
John T. Spaulding, 48.588
PV 1400

Cf. *Le Marché de Gisors (rue Cappeville)*, 1885,
Oil on canvas, PV 690. – *Le Marché de Gisors
(rue Cappeville)*, 1885, Watercolour/gouache,
PV 1401.

PROVENANCE: Claude Monet, Giverny. –
Michel Monet, Giverny. – Wildenstein,
New York. – John T. Spaulding, Boston.
EXHIBITIONS: Paris, Durand-Ruel, 1904,
cat. 157. – Paris, Goupil-Boussod & Valadon,
1910, cat. 17. – Paris, Orangerie, 1930,
cat. 36. – Boston, Museum of Fine Arts,
The Collection of John Spaulding, 1870–1948,
1948, cat. 65. – New York, The Metropoli-
tan Museum of Art, *100 Paintings from the
Boston Museum of Fine Arts*, 1970, cat. 59. –
Paris, Grand Palais, 1981, cat. 61 B.
LITERATURE: Boston, Museum of Fine Arts,
100 Paintings from the Boston Museum, 1970,
p. 89, illus. – Exh. Cat. Paris 1981, cat. 61
B, p. 123. – Lloyd 1986, p. 109, ill. 55. –
Pissarro 1993, ill. 236.

Cat. 45
The Market in Gisors
Le Marché de Gisors
1887
Gouache on paper, 31 x 24 cm
Signed and dated lower left: "C. Pissarro 1887"
Columbus Museum of Art, Ohio, Gift of
Howard D. and Babette L. Sirak, Founders
of the Campaign for Enduring Excellence
and the Derby Fund
PV 1413

EXHIBITION: Paris, Durand-Ruel, 1904,
cat. 159. – Paris, Durand-Ruel, 1910,
cat. 84, Paris, Durand-Ruel, 1928, cat. 121.
– Paris, Orangerie, 1930, cat. 23.
LITERATURE: Pissarro 1993, ill. 237.

Cat. 46
Peasants Planting Pea-Sticks
Paysannes plantant des rames
1890
Gouache with traces of black chalk on
grey-brown paper, 40.7 x 64.1 cm
(Fan design: 39 x 60.6 cm)
Signed and dated lower left in red gouache:

"C. Pissarro 1890"
Ashmolean Museum, Oxford
BL 219, PV 1652

Cf. *Paysanne plantant des rames*, 1891, Oil on
canvas, PV 772.

PROVENANCE: Collection of Lucien Pissarro,
London. – Bequeathed to the Ashmolean
Museum by Esther Pissarro, 1950.
EXHIBITIONS: Birmingham Museum, 1931,
cat. 33. – Gloucester, *Peintures modernes fran-
çaises*, 1936, cat. 22. – London, Royal Acad-
emy of Arts, *Landscape in French Art
1400–1900*, 1950, cat. 558. – London,
O'Hana, 1956, cat. 73. – London, Royal
Academy of Arts, *Impressionism: Its Masters,
its Precursors, and its Influence in Britain*,
1974, cat. 92. – London, Morley Gallery;
Nottingham, University Art Gallery; East-
bourne, Towner Art Gallery, 1977/78,
cat. 28. – Tokyo, Sunshine Museum, 1979,
cat. II-36. – Paris, Grand Palais, 1981,
cat. 212. – Birmingham, City Museum and
Art Gallery, 1990, cat. 53.
LITERATURE: M. Gerstein, *Impressionist and
Post-Impressionist Fans*, Harvard University
1978, pp. 217 ff., ill. 66. – Exh. Cat. Paris
1981, cat. 212, p. 237.

Cat. 47
Peasants Planting Pea-Sticks
Paysannes plantant des rames
1891
Oil on canvas, 55 x 46 cm
Signed and dated lower left: "C. Pissarro.
1891"
Private collection, on loan to the Sheffield
Galleries and Museums Trust
PV 772

PROVENANCE: Claude Monet. – Michel
Monet, Giverny.
EXHIBITIONS: Paris, Durand-Ruel, 1892, cat.
41. – Paris, Durand-Ruel, 1904, cat. 83. – Pa-
ris, Orangerie, 1930, cat. 80. – Birmingham,
City Museum and Art Gallery, 1990, cat. 57.
– Jerusalem, The Israel Museum, cat. 86.
LITERATURE: Lloyd 1986, p. 29. – Shiff 1992,
pp. 307f., ill. 1.

Cat. 48
View from my Window, Eragny
Vue de ma fenêtre, Eragny
1888

Oil on canvas, 65 x 81 cm
Signed and dated lower left: "C. Pissarro.
1888"
The Ashmolean Museum, Oxford, 334
PV 721

PROVENANCE: Lucien Pissarro, London. –
Collection of Esther Pissarro. – Ashmolean
Museum, Oxford 1950.
EXHIBITIONS: Paris, Durand-Ruel, 1889,
cat. 224. – Paris, Manzi & Joyant, 1914,
cat. 17. – Paris, Orangerie, 1930, cat. 73. –
London, Tate Gallery, 1931, cat. 6. – Lon-
don, Royal Academy, *Landscape in French Art
1550–1900*, 1950, cat. 272. – Amsterdam,
Stedelijk Museum. – Otterlo, Rijksmuseum
Kröller-Müller, *Van Goghs grote tijdgenoten*,
1953, cat. 45. – London, O'Hana Gallery,
1954, cat. 11. – New York, The Solomon R.
Guggenheim Museum, *Neo-Impressionism*,
1968, cat. 53. – London, Royal Academy,
*Impressionism: Its Masters, its Precursors, and
its Influence in Britain*, 1974, cat. 91. – Lon-
don, Royal Academy, *Post-Impressionism.
Cross-Currents in European Paintings*, 1979/80,
cat. 153. – Paris, Grand Palais, 1981,
cat. 65. – Birmingham, City Museum and
Art Gallery, 1990, cat. 39.
LITERATURE: Exh. Cat. Paris 1981, cat. 65,
p. 128. C. Moffett, *The New Paintings: Impres-
sionism 1874–1886*, San Francisco 1986,
p. 461, ill. 148. – Ward 1995, p. 73, ill. 3.7.

Cat. 49
Apple Picking at Eragny-sur-Epte
La Cueillette des pommes, Eragny-sur-Epte
1888
Oil on canvas, 60 x 73 cm
Signed and dated lower right:
"C. Pissarro. 1888"
Dallas Museum of Art, Munger Fund,
1955.17.M
PV 726

PROVENANCE: Goupil-Boussod & Valadon,
Paris (purchased from the artist in 1888 for
300 francs). – Victor Desfossés, Paris (pur-
chased in 1889 for 400 francs). – Durand-
Ruel, Paris (purchased in 1899 for 1,000
francs). – Thannhäuser, Berlin. – Dr. Max
Emden, Hamburg. – Max Epstein, Chicago.
EXHIBITIONS: Brussels, Musée Moderne, *La
VI Exposition des XX*, 1889, cat. 5. – Paris,
Goupil-Boussod & Valadon, 1890, cat. 6. –
Houston, Museum of Fine Arts, *From Gau-
guin to Gorky in Cullinan Hall*, 1960, cat. 55a.

– New York, Wildenstein, 1965, cat. 50. – New York, The Solomon R. Guggenheim Museum, *Neo-Impressionism*, 1968, cat. 52. – Dallas, Museum of Fine Arts, *Seventy-Five Years of Art in Dallas*, 1978. – Paris, Grand Palais, 1981, cat. 68. – Tokyo, Musée National d'Art Occidental, *Exposition du Pointillisme*, 1985, cat. 42.
LITERATURE: F. Fénéon, 'Exposition Pissarro', in: *L'Art Moderne*, 1889, reprinted in: F. Fénéon, *Œuvres plus que complètes*, ed. by J. U. Halperin, vol. 1, Geneva and Paris 1970, pp. 137f. – O. Maus, 'Le Salon des XX à Bruxelles', in: *La Cravache*, 1889. – H. Le Roux, *L'Exposition C. Pissarro*, in: *Le Temps*, 1890. – J. Antoine, 'Exposition C. Pissarro', in: *Art et Critique*, II, 1890, p. 194. – G.-A. Aurier, 'Camille Pissarro', in: *La Revue Indépendante*, 1890, p. 512. – G.-A. Aurier, 'Beaux-Arts: expositions de février–mars', in: *Le Mercure de France*, I, 1890, p. 143. – Meier-Graefe 1907, p. 166. – Exh. Cat. Paris 1981, cat. 68, p. 130. – Lloyd 1986, pp. 8f., ill. 7. – Brettell 1993, p. xxii, ill. 12. – Ward 1995, p. 179, ill. 8.7.

Cat. 50
Morning, Autumn, Eragny
Matin, automne, Eragny
1892
Oil on canvas, 55 x 46 cm
Signed and dated lower left:
"C. Pissarro. 1892"
Von der Heydt-Museum, Wuppertal,
Inv. G 1148
PV 816

PROVENANCE: Durand-Ruel, Paris. – Galerie Nierendorf, Berlin. – Baron Eduard von der Heydt, Ascona, Switzerland. – Bequeathed to the Von der Heydt-Museum, Wuppertal, 1964.
EXHIBITIONS: Paris, Durand-Ruel, 1893, cat. 14. – Paris, Durand-Ruel, 1910, cat. 47. – Brussels, Palais des Beaux-Arts, *L'Impressionnisme*, 1935, cat. 61.
LITERATURE: *Gemälde des 19. und 20. Jahrhunderts*, Von der Heydt-Museum, Wuppertal 1996, p. 131, ill. 210.

Cat. 51
Hoar Frost, Morning (Snow Effect in Eragny)
Gelée blanche, matin (Effet de neige à Eragny)
1894

Oil on canvas, 73.5 x 92.5 cm
Signed and dated lower left: "C. Pissarro. 94"
Musée d'Orsay, Paris, Legs du Comte Isaac de Camondo, RF 2014
PV 867

PROVENANCE: Collection of Isaac Camondo.
EXHIBITIONS: Paris, Galerie Eugène Blot, 1907, cat. 11. – Paris, Orangerie, 1930, cat. 84.
LITERATURE: The Phillips Collection, *Impressionists in Winter: Effet de neige*, Washington 1998, p. 164.

Cat. 52
Corner of the Garden in Eragny
Coin de jardin à Eragny
1897
Oil on canvas, 65.5 x 81 cm
Signed and dated lower left: "C. Pissarro. 97"
Ordrupgaard, Copenhagen
PV 1011

PROVENANCE: Conseiller d'Etat Wilhelm Hansen, Copenhagen.

Cat. 53
Morning, Sun Effect, Eragny
Matin, effet de soleil, Eragny
1899
Oil on canvas, 65 x 81 cm
Signed and dated lower left:
"C. Pissarro. 99"
The Israel Museum, Jerusalem, Bequest of Mrs. Neville Blond, B 87.110
PV 1077

PROVENANCE: Neville Blond, London, O. B. E., London, to British Friends of the Art Museum of Israel.
EXHIBITIONS: Paris, Durand-Ruel, 1901, cat. 22. – Paris, Durand-Ruel, 1910, cat. 27. – London, Matthiesen Gallery, 1950, cat. 28. – Jerusalem, The Israel Museum, 1994, cat. 106. – Ferrara, Palazzo dei Diamanti, 1998, cat. 43, Jerusalem, The Israel Museum, *Permanent Exhibition Floersheimer Pavilion*.

Cat. 54
The Gardener, Afternoon Sun, Eragny
Le Jardinier, soleil d'après-midi, Eragny
1899
Oil on canvas, 92 x 65 cm
Signed and dated lower left: "C. Pissarro. 99"
Staatsgalerie Stuttgart, on loan from the

Stuttgart Galerieverein, Inv. GVL 107
PV 1079

PROVENANCE: Durand-Ruel Collection, Paris. – Acquired in 1901 by the Staatsgalerie Stuttgart. – 1937 forcibly exchanged. – Galerie Haberstock, Berlin. – Wildenstein, Paris. – Collection of Andrès E. T. Sperry, Buenos Aires and Auribeau sur Siagne, Cannes. – Re-acquired in 1962 with the help of the Daimler-Benz AG and the Robert Bosch GmbH.
EXHIBITIONS: Paris, Durand-Ruel, 1901, cat. 23. – Stuttgart, Königliches Museum der bildenden Künste, *Französische Kunstwerke*, 1901, cat. 204. – Düsseldorf, Städtische Kunsthalle, *Vom Licht zur Farbe. Nachimpressionistische Malerei zwischen 1886 und 1912*, 1977, cat. 91.
LITERATURE: J. C. Holl, *Après l'impressionnisme*, Paris 1910. – *Jahrbuch der Staatlichen Kunstsammlungen Baden-Württemberg*, vol. I, 1964, p. 78. – Lloyd 1981, ill. p. 115. – Staatsgalerie Stuttgart, *Malerei und Plastik des 19. Jahrhunderts*, 1982, p. 115, illus. – Pissarro 1993, ill. 199.

Cat. 55
The Steading of the Auberge Ango, Varengeville
Le Clos de l'auberge Ango, Varengeville
1899
Oil on canvas, 55 x 46 cm
Signed and dated lower right: "C. Pissarro. 99"
Privately owned
PV 1084

PROVENANCE: Mosseri Collection, Paris.
EXHIBITION: London, Royal Academy of Arts, *Von Manet bis Gauguin: Meisterwerke aus Schweizer Privatsammlungen*, 1995, cat. 52.

Cat. 56
Vegetable Garden in Eragny, Overcast Sky, Morning
Jardin potager à Eragny, temps gris, matin
1901
Oil on canvas, 64.8 x 81.3 cm
Signed and dated lower right:
"C. Pissarro. 1901"
Philadelphia Museum of Art, Bequest of Charlotte Dorrance Wright, 1978-1-26
PV 1183

EXHIBITION: Paris, Orangerie, 1930, cat. 115.

Cat. 57
Autumn in Eragny
Automne à Eragny
1899
Oil on canvas, 50 x 65 cm
Signed and dated lower left: "C. Pissarro. 99"
Stiftung Langmatt Sidney und Jenny Brown, Baden, Switzerland
PV 1095

Cat. 58
Sunset with Mist, Eragny
Soleil couchant avec brouillard, Eragny
1890
Watercolour with tempera on Japanese paper, 35.1 x 54.4 cm
Signed and dated lower left in blue: "C. Pissarro. 1890"
Damaged and stained by damp in the upper half
Ashmolean Museum, Oxford
BL 235

Cat. 59
Hoar Frost
Gelée blanche
1890
Watercolour over pencil on paper, 20.8 x 26.2 cm
Signed and dated lower left: "19 Dec. 90 C. Pissarro", inscribed lower left: "Gelée blanche"
Ashmolean Museum, Oxford
BL 234

PROVENANCE: Bequeathed to the Ashmolean Museum by F. Hindley Smith, 1939.
EXHIBITIONS: London, The Royal Academy, *Impressionism: Its Masters, its Precursors, and its Influence in Britain*, 1974, cat. 93. – London, Morley Gallery; Nottingham, University Art Gallery; Eastbourne, Towner Art Gallery, 1977/78, cat. 41. – London, JPL Fine Arts, 1978, cat. 34. – Paris, Grand Palais, 1981, cat. 139. – Birmingham, City Museum and Art Gallery, 1990, cat. 51.
Literature: Exh. Cat. Paris 1981, cat. 139, p. 183.

Cat. 60
Charing Cross Bridge, London
Le Pont de Charing-Cross, Londres
1890
Oil on canvas, 60.6 x 93.3 cm

Signed and dated lower left: "C. Pissarro. 1890"
National Gallery of Art, Washington, Collection of Mr. and Mrs. Paul Mellon 1985.64.32
PV 745

PROVENANCE: Goupil-Boussod & Valadon, Paris (purchased from the artist in 1890 for 650 francs). – Elkins Collection, New York (purchased in 1891 for 3,380 francs). – Durand-Ruel, Paris. – Collection of Paul Harth, Paris. – Rosenberg, Paris. – Bignou, Paris. – Lefevre, London. – Collection of Carruth William Cargill, London, 1963.
EXHIBITIONS: Paris, Durand-Ruel, 1892, cat. 45, Paris, Orangerie, 1930, cat. 78. – New York, Bignou, *Nineteenth Century French Paintings*, 1940, cat. 8. – Washington, National Gallery of Art, *French Paintings from the Collection of Mr. and Mrs. Paul Mellon and Mrs. Mellon Bruce*, 1966, cat. 32. – Paris, Grand Palais, 1981, cat. 70.
LITERATURE: Exh. Cat. Paris 1981, cat. 70, p. 132. – Pissarro 1993, ill. 287.

Cat. 61
Hampton Court Green, London
1891
Oil on canvas, 54.3 x 73 cm
Signed and dated lower left: "C. Pissarro. 1891"
National Gallery of Art, Washington, Collection of Ailsa Mellon Bruce 1970.17.53
PV 746

EXHIBITIONS: Washington, National Gallery of Art, *French Paintings of the Collection of Mr. and Mrs. Paul Mellon and Mrs. Mellon Bruce*, 1966, cat. 33. – London, Hayward Gallery, *The Impressionists in London*, 1973, pp. 16, 27, 53, 77. – Munich, Neue Pinakothek, *Französische Impressionisten und ihre Wegbereiter*, 1990, cat. 42. – Jerusalem, The Israel Museum, 1994, cat. 97.
LITERATURE: Pissarro 1993, ill. 289.

Cat. 62
Kew Green (Kew Gardens), London
1892
Oil on canvas, 46 x 55 cm
Signed and dated lower right: "C. Pissarro. 1892."
Musée des Beaux-Arts, Lyon (Dépot du Musée d'Orsay)
PV 799

EXHIBITIONS: London, Marlborough Fine Art Ltd., 1955, cat. 18. – Bern, Kunstmuseum, 1957, cat. 86.
LITERATURE: Pissarro 1993, ill. 290.

Cat. 63
The Rue de l'Epicérie in Rouen
La Rue de l'Epicérie à Rouen
1898
Oil on canvas, 81.3 x 65.1 cm
Signed and dated lower left: "C. Pissarro/1898"
The Metropolitan Museum of Art, New York, Purchase, Mr. and Mrs. Richard J. Bernhard Gift 1960, 60.5
PV 1036

PROVENANCE: Collection of Louis Bernard, Paris. – Collection of Maurice Leclanché, Paris. – Collection of Auguste Savard, Paris, until 1939/40. – Collection of Roger Varenne, Geneva, 1939/40–1960
EXHIBITIONS: Bern, Kunstmuseum, 1957, cat. 98. – Paris, Petit-Palais, *De Géricault à Matisse: chefs d'œuvre français des collections suisses*, 1959, cat. 110. – New York, Wildenstein, 1965, cat. 68. – New York, Knoedler, *Impressionist Treasures*, 1966, cat. 24. – Boston, Museum of Fine Arts, *Masterpieces of Painting in the Metropolitan Museum of Art*, 1970, cat. 85. – Tokyo, National Museum of Western Art; Kyoto, Municipal Museum, *Treasured Masterpieces of the Metropolitan Museum of Art*, 1972, cat. 101. – Leningrad, Hermitage; Moscow, Pushkin Museum, *100 Paintings of the Metropolitan Museum of Art*, 1975, cat. 69. – Paris, Grand Palais, 1981, cat. 81 (exhibited in Boston).
LITERATURE: C. Mauclair, 'Les Artistes secondaires de l'impressionnisme', in: *L'Impressionnisme, son histoire, son esthétique, ses maîtres*, Paris 1904, ill. p. 161. – F. Fels, 'Le Retour à Lancelot. Impressionnistes', in: *A.B.C. Magazine d'Art*, 1925, ill. p. 25. – Exh. Cat. Paris 1981, cat. 81, p. 144. – Bailly-Herzberg 1981, p. 59. – Lloyd 1981, ill. p. 129. – Lloyd 1986, p. 86, ill. 45.

Cat. 64
The Pont Boïeldieu, Rouen, Sunset, Misty Weather
Le Pont Boïeldieu à Rouen, soleil couchant, temps brumeux
1896
Oil on canvas, 54 x 65 cm

Signed and dated lower left:
"C. Pissarro. 96."
Musée d'Orsay, Paris, RF 1983-7
PV 953

PROVENANCE: Collection of the Durand-Ruel Family, Paris. – Musée d'Orsay, 1983.
EXHIBITIONS: Paris, Durand-Ruel, 1896, cat. 9. – Paris, Durand-Ruel, *Tableaux de Monet, Pissarro, Renoir et Sisley*, 1899, cat. 61. – London, Grafton Gallery, *A Selection from the Pictures by Boudin, Cézanne, Degas, Manet, Monet, Morisot, Pissarro, Renoir, Sisley*, 1905, cat. 201. – Paris, Durand-Ruel, *Tableaux et gouaches de Camille Pissarro*, 1910, cat. 18. – Paris, Durand-Ruel, 1928, cat. 72. – Paris, Durand-Ruel, *Les Amis des enfants*, 1932, cat. 35. – Paris, Musée d'Orsay, *Les Arts et la civilisation industrielle 1850–1914*, 1984/85. – Dallas, Museum of Art, 1993, cat. 3. – Ferrara, Palazzo dei Diamanti, 1998, cat. 46.
LITERATURE: 'Museos grandes del mundo: el impresionismo', in: *El Mundo*, Madrid, March 1941, p. 267. – I. Compin and A. Roquebert, *Catalogue sommaire illustré des peintures de Musée du Louvre et du Musée d'Orsay*, vol. IV, Paris 1986, p. 139, illus. – R. Rosenblum, *Les Peintures du Musée d'Orsay*, Paris 1989, p. 318, illus.

Cat. 65
The Grand Pont, Rouen, Rain Effect
Le Grand Pont, Rouen, effet de pluie
1896
Oil on canvas, 73 x 92 cm
Signed and dated lower right:
"C. Pisarro. 98"
Staatliche Kunsthalle Karlsruhe, Inv. 2488
PV 950

PROVENANCE: Collection of Dr. Francesco Llobet, Buenos-Aires. – Acquired in 1963 on the Swiss art market.
EXHIBITIONS: Paris, Durand-Ruel, 1904, cat. 95. – Paris, Eugène Blot, 1907, cat. 13. – Bremen, Kunsthalle, *Internationale Kunstausstellung*, 1910, cat. 262. – Paris, Manzi & Jouant, 1914, cat. 14. – Buenos-Aires, *Premier Salon de la Société des Arts de Buenos-Aires*, 1924, cat. 7. – Buenos-Aires, *Amis des Arts*, 1932, cat. 44. – Munich, Bayerische Staatsgemäldesammlungen, Neue Pinakothek, *Französische Malerei des 19. Jahrhunderts von David bis Cézanne*, 1964/65, cat. 206. – Minneapolis, The Minneapolis Institute of Arts, *The Past Rediscovered: French Painting 1800–1900*, 1969, cat. 64.
LITERATURE: C. Mauclair, *Une belle collection argentine des maîtres français du XIXᵉ siècle*, Paris 1931. – *La Chronique des arts. Supplément à la Gazette des Beaux-Arts*, 1164, February 1964, p. 24, ill. 79. – *Jahrbuch der Staatlichen Kunstsammlungen Baden-Württemberg*, vol. I, 1964, pp. 31 ff. – Staatliche Kunsthalle Karlsruhe, *Catalog Neuere Meister*, 1971, pp. 185f.

Cat. 66
Sunset, the Port at Rouen (Smoke)
Soleil couchant, port de Rouen (fumées)
1898
Oil on canvas, 65 x 81 cm
Signed and dated lower right: "C. Pissarro."
National Museums and Gallery, Cardiff, 1066
PV 1039

PROVENANCE: Leicester Galleries, London. – Margaret Davies, 1920. – Montgomeryshire, Gregynog Hall, Collection of Margaret Davies. – Bequeathed to the National Museum of Wales, 1963.
EXHIBITIONS: Paris, Manzi & Joyant, 1914, cat. 32. – London, Leicester Galleries, 1920, cat. 90. – London, Wildenstein, *Paintings from the Davies Collection*, 1979, cat. 19. – Paris, Musée Marmottan, *Chefs d'œuvres impressionnistes du Musée National du pays de Galles*, 1979, cat. 16. – Swansea, *Festival Exhibition 'Ship – Shape 1880–1980'*, 1980, cat. 2. – Paris, Grand Palais, 1981, cat. 83. – Sogo, Museum of Art, *Masterpieces from the National Museum of Wales*, 1986, cat. 45. – Birmingham, City Museum and Art Gallery, 1990, cat. 82 (exhibited in Glasgow). – Dallas, Museum of Art, 1993, cat. 25 (exhibited in London).
LITERATURE: M. Hamel, 'Camille Pissarro. Exposition rétrospective de ses œuvres', in: *Les Arts*, March 1914, p. 31. – Anonymous, 'Camille Pissarro: Memorial Exhibition, Leicester Galleries', in: *The London Mercury*, II, July 1920, p. 352. – J. Ingamells, *The Davies Collection of French Art*, Cardiff 1967, pp. 62f., ill. 27. – Y. Brayer, 'Chefs d'œuvre impressionnistes de la collection Davies', in: *L'Œil*, June 1979, p. 28. – Exh. Cat. Paris 1981, cat. 83, p. 145. – Lloyd 1981, p. 128. – B. Denvir, *Impressionism: The Painters and their Paintings*, London 1991, p. 339, ill. 330.

Cat. 67
The Port of Dieppe
Port de Dieppe
1902
Oil on canvas, 60 x 73 cm
Signed and dated lower right:
"C. Pissarro. 1902"
Private collection
PV 1248

PROVENANCE: Elie Mousseri, Paris. – Private collection, Switzerland. – Anonymous sale (Sotheby's, London, 30 June 1992, no. 14 A). – Private collection.
EXHIBITION: Dallas, Museum of Art, 1993, cat. 139.

Cat. 68
The Fair at Dieppe, Sun, Afternoon
La Foire à Dieppe, soleil, après-midi
1901
Oil on canvas, 73.5 x 92.1 cm
Signed and dated lower right:
"C. Pissarro. 1901"
Philadelphia Museum of Art, Bequest of Lisa Norris Elkins, 1950-92-12
PV 1200

PROVENANCE: Durand-Ruel, Paris (purchased from the artist in 1901). – Bernheim-Jeune Collection, Paris, 1902. – Van de Velde Collection, Le Havre. – Duncan Phillips Memorial Gallery, Washington. – Collection of Gaston Lévy, Paris. – Paul Rosenberg, Paris. – Collection of J. Hessel, Paris. – Collection of H. S. Southam, Ottawa. – French Art Galleries and Knoedler, New York, 1944. – Mr. and Mrs. William M. Elkins, Philadelphia, 1944. – Bequeathed to the Philadelphia Museum of Art.
EXHIBITIONS: Paris, Bernheim-Jeune, 1902, cat. 4. – Paris, Orangerie, 1930, cat. 111. – London, Agnew and Sons, 1937, cat. 26. – Zurich, Galerie Aktuargus, *Pissarro, Renoir, Sisley, Guillaumin*, 1938, cat. 1, Philadelphia, Museum of Art, *Masterpieces of Philadelphia Private Collections*, 1947, Catalogue published in: *The Philadelphia Museum Bulletin*, xiii, 1947, p. 84. – Paris, Grand Palais, 1981, cat. 88. – Brighton, Museum and Art Gallery, *The Dieppe Connection: The Town and its Artists from Turner to Braque*, 1992, cat. 55. – Dallas, Museum of Art, 1993, cat. 134.
LITERATURE: A. Fontainas, 'Art moderne: expositions [...] Monet et Pissarro [...]', in:

Le Mercure de France, XLVIII, April 1902, pp. 246f. – D. Phillips, *A Collection in the Making*, Washington and New York 1926, p. 33, illus. – L. Venturi, *Les Archives de l'impressionnisme*, vol. II, Paris 1939, pp. 48f., ill. 74–76. – Exh. Cat. Paris 1981, cat. 88, p. 150. – Lloyd 1981, ill. p. 130.

Cat. 69
Boulevard Montmartre, Spring
Boulevard Montmartre, printemps
1897
Oil on canvas, 35 x 45 cm
Signed and dated lower left:
"C. Pissarro. 97"
Stiftung Langmatt Sidney und Jenny
Brown, Baden, Switzerland
PV 998

PROVENANCE: Acquired in 1910 by Sidney Brown from Dr. Viau.
EXHIBITION: Paris, Durand-Ruel, 1898, cat. 24.
LITERATURE: Coe 1954, p. 107, ill. 7.

Cat. 70
Boulevard Montmartre, Night Effect
Boulevard Montmartre, effet de nuit
Verso: *Boulevard des Italiens, nuit*
Oil on canvas, 54 x 65 cm
National Gallery, London
PV 994

PROVENANCE: Lucien Pissarro, London. – The French Gallery, London. – Trustees of the Courtauld Fund. – Tate Gallery, London, 1925 (Transferred to the National Gallery, London in 1950).
EXHIBITIONS: London, The French Gallery, *123rd Exhibition*, 1925, cat. 2. – London, Tate Gallery, 1931, cat. 17. – London, Tate Gallery, *Samuel Courtauld Memorial Exhibition*, 1948, cat. 53. – Dallas, Museum of Art, 1993, cat. 50.
LITERATURE: D. Cooper, in: *The Burlington Magazine*, XCVI, 1954, p. 121. – Lloyd 1986, p. 100. – Bailly-Herzberg 1992, p. 50.

Cat. 71
Shrove Tuesday, Sunset, Boulevard Montmartre
Mardi gras, soleil couchant, Boulevard Montmartre
1897
Oil on canvas, 54 x 65 cm

Signed and dated lower left:
"C. Pissarro. 97"
Kunstmuseum Winterthur
PV 997

PROVENANCE: Durand-Ruel, Paris. – Mme. Granoff, Paris, 1938. – Mr. Tanner, 1939. – Mr. Tanner and Mr. Schwarzkopf. – Acquired in 1947.
EXHIBITIONS: Paris, Galerie de l'Elysée, 1936, cat. 8. – Bern, Kunstmuseum, 1957, cat. 95. – Bremen, Kunsthalle, *Die Stadt: Bild–Gestalt–Vision*, 1974, cat. 127. – Dallas, Museum of Art, 1993, cat. 55 (exhibited in Dallas and Philadelphia).
LITERATURE: W. Hausenstein, *Hauptwerke des Kunstmuseums Winterthur*, Winterthur 1949, pp. 73–76. – F. Novotny, *Die großen französischen Impressionisten – Ihre Vorläufer und ihre Nachfolger*, Vienna 1952, p. 51, ill. 15. – J. O'Brian, *Degas to Matisse: The Maurice Wertheim Collection*, New York, Cambridge, 1988, pp. 98–100.

Cat. 72
Self-Portrait
Portrait de l'artiste, par lui-même
1903
Oil on canvas, 41 x 33 cm
Signed and dated lower left:
"C. Pissarro. 1903"
Tate Gallery, London 4592, presented by Lucien Pissarro, the artist's son, 1931
PV 1316

PROVENANCE: Collection of Camille Pissarro. – Collection of Mme. Vve. Pissarro, Eragny. – Lucien Pissarro, London.
EXHIBITIONS: Paris, Durand-Ruel, 1904, cat. 130. – London, Leicester Galleries, 1920, cat. 84. – London, Tate Gallery, *List of Loans at the Opening Exhibition of the Modern Foreign Gallery*, 1926, p. 6. – Paris, Orangerie, 1930, cat. 117. – London, Tate Gallery, 1931, cat. 23, Paris, Durand-Ruel, 1956, cat. 111. – Bern, Kunstmuseum, 1957, cat. 120. – London, Marlborough Gallery, 1968, cat. 32. – Paris, Grand Palais, 1981, cat. 93 (exhibited in London). – Dallas, Museum of Art, 1993, cat. 154. – Jerusalem, The Israel Museum, 1994, cat. 129. – Ferrara, Palazzo dei Diamanti, 1998, cat. 58.
LITERATURE: M. Hamel, 'Camille Pissarro: exposition rétrospective de ses œuvres', in: *Les Arts*, March 1914, pp. 31f. – G. Kahn, 'La Rétrospective de Pissarro', in: *Mercure de*

France, CCXVIII, March 1930, p. 699. – Exh. Cat. Paris 1981, cat. 93, p. 154. – Lloyd 1981, ill. p. 141. – Lloyd 1986, pp. 11–13, ill. 11. – Bailly-Herzberg 1992, p. 124. – Pissarro 1993, ill. 340.

DRAWINGS, WATERCOLOURS, PRINTS

Cat. 73
The Christian-Fort in Charlotte Amalie, Saint Thomas
View of a Military Fortress
c. 1851
Brown wash over pencil on paper, 36.2 x 54.3 cm
Somewhat damaged by damp
Ashmolean Museum, Oxford
BL 7

PROVENANCE: Collection of Lucien Pissarro, London. – Bequeathed to the Ashmolean Museum by Esther Pissarro, 1950.

Cat. 74
Wooded Landscape on Saint Thomas
c. 1854
Pencil on paper, 34.5 x 27.7 cm
Signed lower left: "C. P.",
Inscribed in pencil lower left: "St. Thomas"
Ashmolean Museum, Oxford
BL 34

PROVENANCE: Collection of Lucien Pissarro, London. – Bequeathed to the Ashmolean Museum by Esther Pissarro, 1950.

Cat. 75
Half-length Portrait of Lucien Pissarro
c. 1875
Watercolour over charcoal on paper, 28.3 x 23.5 cm
Ashmolean Museum, Oxford
BL 71

PROVENANCE: Collection of Lucien Pissarro, London. – Bequeathed to the Ashmolean Museum by Esther Pissarro, 1950.
EXHIBITION: London, Morley Gallery; Nottingham, University of Art; Eastbourne, Towner Art Gallery, 1977/78, cat. 1.

Cat. 76
Compositional study of a Landscape with the Ile de Pothuis and the Factory at St. Ouen-l'Aumône
c. 1877
Verso: *Brief Study of a Landscape at Pontoise*
Black chalk on paper, 11.3 x 19.3 cm
Signed lower right: "C. P."
Ashmolean Museum, Oxford
BL 100A r

PROVENANCE: Collection of Lucien Pissarro, London. – Bequeathed to the Ashmolean Museum by Esther Pissarro, 1950.

Cat. 77
Compositional Study of a Landscape with the Factory at St. Ouen-l'Aumône
c. 1877
Pen and dark ink over pencil with grey wash on paper, 11.3 x 19.3 cm
Signed lower right: "C. P.", Inscribed in pen upper right: "Pontoise à Mery"
Ashmolean Museum, Oxford
BL 100 B

PROVENANCE: Collection of Lucien Pissarro, London. – Bequeathed to the Ashmolean Museum by Esther Pissarro, 1950.

Cat. 78
Nearly Whole-length Study of a Female Peasant
c. 1880
Black chalk on pink paper, 46.2 x 27.6 cm
Signed lower right: "C. P.",
Numbered in blue chalk upper left: "14 A"
Ashmolean Museum, Oxford
BL 106

Preparatory study for: *La Cueillette des pois*, 1880, Oil on canvas, PV 519.

PROVENANCE: Collection of Lucien Pissarro, London. – Bequeathed to the Ashmolean Museum by Esther Pissarro, 1950.

Cat. 79
Study of the Artist's Mother with her Maid
La Mère de l'artiste et sa servante
Charcoal on paper, 28.4 x 21.9 cm
Signed lower left: "C. P.",

Inscribed in pencil lower left by a later hand: "Grand-mère et sa bonne", Verso numbered in blue chalk in upper left corner: "275"
Ashmolean Museum, Oxford
BL 152

PROVENANCE: Collection of Lucien Pissarro, London. – Bequeathed to the Ashmolean Museum by Esther Pissarro, 1950.
EXHIBITION: Paris, Grand Palais, 1981, cat. 115.
LITERATURE: Exh. Cat. Paris 1981, cat. 115, p. 170.

Cat. 80
Study of a Male Peasant Seen from the Back Leaning on a Spade
c. 1899
Pen and indian ink on paper, 11.1 x 5.5 cm
Signed lower right: "C. P."
Ashmolean Museum, Oxford
BL 268 A

PROVENANCE: Collection of Lucien Pissarro, London. – Bequeathed to the Ashmolean Museum by Esther Pissarro, 1950.
EXHIBITION: London, Morley Gallery; Nottingham, University of Art; Eastbourne, Towner Art Gallery, 1977/78, cat. 36.

Cat. 81
Study of a Female Peasant Carrying a Bucket
c. 1899
Pen and indian ink on paper, 11.1 x 5.5 cm
Ashmolean Museum, Oxford
BL 268 B

PROVENANCE: Collection of Lucien Pissarro, London. – Bequeathed to the Ashmolean Museum by Esther Pissarro, 1950.
EXHIBITION: London, Morley Gallery; Nottingham, University of Art; Eastbourne, Towner Art Gallery, 1977/78, cat. 35.

Cat. 82
Study of a Male Peasant Carrying a Pitchfork in Conversation with a Seated Female Peasant Set in a Landscape
c. 1899
Pen and indian ink over pencil on paper, 8.9 x 15.4 cm
Signed lower right: "C. P."
Ashmolean Museum, Oxford
BL 269

PROVENANCE: Collection of Lucien Pissarro, London. – Bequeathed to the Ashmolean Museum by Esther Pissarro, 1950.
EXHIBITION: London, Morley Gallery; Nottingham, University of Art; Eastbourne, Towner Art Gallery, 1977/78, cat. 34.

Cat. 83
Study of the Port at Rouen
Le Port de Rouen
c. 1885
Pen and indian ink with grey wash over pencil, 11.8 x 15 cm
Signed lower right: "C. P."
Ashmolean Museum, Oxford
BL 283

Preparatory study for: *Le Port près la douane, à Rouen*, 1883, Etching, D 43.

PROVENANCE: Collection of Lucien Pissarro, London. – Bequeathed to the Ashmolean Museum by Esther Pissarro, 1950.
EXHIBITION: London, Morley Gallery; Nottingham, University of Art; Eastbourne, Towner Art Gallery, 1977/78, cat. 1.

Cat. 84 (no. fig.)
Hackney Carriage Stand
c. 1895
Watercolour and chalk on paper, 12.8 x 17.4 cm
Signed lower right: "C. P."
Staatsgalerie Stuttgart, Inv. C 59/904.

LITERATURE: Staatsgalerie Stuttgart, *Die Zeichnungen und Aquarelle des 19. Jahrhunderts in der Graphischen Sammlung der Staatsgalerie Stuttgart*, Stuttgart 1976, p. 154, cat. 1132.

Cat. 85
At the Water's Edge ("to my friend Gachet")
Au Bord de l'eau ("à mon ami Gachet")
c. 1863
Black and white etching on paper, 28.4 x 21.4 cm
Bibliothèque Nationale, Paris, P 191080, DC 419 Pissarro
D 2

Cat. 86
Portrait von Lucien Pissarro
Portrait de Lucien Pissarro
1874
Lithograph, 24 x 30.2 cm
Signed and dated on the stone, lower right:
"C. Pissarro/1874",
Marked in graphite, upper right: "Portrait
de Lucien"
Museum of Fine Arts, Boston, Fund in
Memory of Stephen Bullard
D 128

LITERATURE: Leymarie/Melot 1971, cat. 132.

Cat. 87
Paul Cézanne
1874
Etching on paper, 27 x 21.4 cm
Bibliothèque Nationale, Paris, P 191090,
DC 419 Pissarro
D 13

LITERATURE: Leymarie/Melot 1971, cat. 13. –
Rittmann 1991, pp. 31f., ill. 16. – White
1996, p. 145, illus.

Cat. 88
**Wooded Landscape, L'Hermitage,
Pontoise**
Paysage sous bois, L'Hermitage, Pontoise
1879
Softground etching, aquatint and drypoint
on paper, 22 x 27 cm
Verso red stamp: "Atelier Ed. Degas"
Museum of Fine Arts, Boston, Lee M. Fried-
man Fund, 1971
D 16, 1st state

PROVENANCE: Collection of Edgar Degas,
Paris. – Collection of C. Comiot, Paris. –
Collection of M. Guérin, Paris. – Collection
of D. David-Weill.
EXHIBITION: Paris, Grand Palais, 1981, cat. 156.
LITERATURE: Exh. Cat. Paris 1981, cat. 156,
p. 201. – Rittmann 1991, p. 76, ill. 39.

Cat. 89
**Wooded Landscape, L'Hermitage,
Pontoise**
Paysage sous bois, L'Hermitage, Pontoise
1879
Softground etching, aquatint and drypoint
on paper, 22 x 27 cm

Signed lower right with graphite:
"C. Pissarro"
Museum of Fine Arts, Boston, Katherine E.
Bullard Fund in Memory of Francis Bullard,
Prints and Drawings Curator's Discretionary
Fund, Anonymous Gifts, and Gift of Cor-
nelius C. Vermeule III, 1973
D 16, 6th state

EXHIBITION: Paris, Grand Palais, 1981, cat. 161.
LITERATURE: Leymarie/Melot 1971, cat. 16
(as '5th and last state'). – Exh. Cat. Paris
1981, cat. 161, p. 202. – Shiff 1992, p. 299.

Cat. 90
Twilight with Haystacks (no. 8)
Crépuscule avec meules (no. 8)
1879
Aquatint, blue, on paper, black and white
print, 11.5 x 18 cm
Bibliothèque Nationale, Paris, P 191104,
DC 419 Pissarro
D 23, 3rd state.

LITERATURE: Leymarie/Melot 1971, cat. 22.

Cat. 91
Rain Effect (no. 4, artist's proof)
Effet de pluie (no. 4, épreuve d'artiste)
1879
Zincograph on paper, 15.9 x 21.3 cm
Bibliothèque Nationale, Paris, P 191109,
DC 419 Pissarro
D 24, 6th state

LITERATURE: Leymarie/Melot 1971, cat. 23. –
Lloyd 1986, p. 128, ill. 60.

Cat. 92
The Cours Boïeldieu in Rouen
Cours Boïeldieu à Rouen
1884
Etching on paper, 14.9 x 19.4 cm (plate),
27 x 37 cm (sheet)
Marked in graphite: "1er état no. 1/(Port
de Rouen (St. Sever) biffé) cuivre (avec
femme à gauche)/Cours Boieldieu à
Rouen"
Museum of Fine Arts, Boston, Bequest of
Lee M. Friedman, 1958
D 46, 1st state

PROVENANCE: Collection of Lee M. Fried-
man, Boston.

EXHIBITIONS: Boston, Museum of Fine Arts,
Camille Pissarro: The Impressionist Printmaker,
1973, cat. 29. – Paris, Grand Palais, 1981,
cat. 179.
LITERATURE: Exh. Cat. Paris 1981, cat. 179,
p. 214.

Cat. 93
Self-portrait of Camille Pissarro
Camille Pissarro, par lui-même
c. 1890
Etching on paper, 18.5 x 17.7 cm (plate)
Kunstantiquariat Laube, Zurich
D 90, 2nd state

LITERATURE: Leymarie/Melot 1971, cat. 89. –
Exh. Cat. Vevey 1998, cat. 85, pp. 106f.

Cat. 94
Market in Gisors, rue Cappeville
Marché de Gisors, rue Cappeville
1894/95
Etching, four-colour print on paper,
20 x 14 cm (plate), 26.5 x 21.0 cm (sheet)
Signed lower right: "C. Pissarro",
Inscribed in pencil: "No 7 ep. d'art/Marché
de Gisors (rue Cappeville)"
Museum of Fine Arts, Boston, Katherine E.
Bullard Fund in memory of Francis Bullard,
1959
D 112, 7th state

PROVENANCE: Collection of Orovida Pis-
sarro, London.
EXHIBITIONS: Boston, Museum of Fine Arts,
Camille Pissarro: The Impressionist Printmaker,
1973, cat. 37. – Paris, Grand Palais, 1981,
cat. 189.
LITERATURE: Leymarie/Melot 1971, cat. 112.
– Exh. Cat. Paris 1981, cat. 189, p. 219.

Cat. 95
Femmes faisant de l'herbe
(Series: *Travaux des champs*)
1893–1895
Coloured woodcut on paper, 26.5 x 19 cm
(sheet)
Signed on the block, lower right: "C. P."
Museum of Fine Arts, Boston, Gift of
Robert P. Bass, 1982

Cat. 96 (no fig.)
Les Sarcleuses
(Series: *Travaux des champs*)
1893–1895
Coloured woodcut on paper, 28 x 20.5 cm
(sheet)
Signed on the block, lower left: "C. P."
Museum of Fine Arts, Boston, Gift of
Robert P. Bass, 1982

Cat. 97
Femmes faisant de l'herbe
(Series: *Travaux des champs*)
c. 1894
Coloured woodcut on paper, 21.2 x 17.8 cm
Enumerations in pen and ink lower right
corner, signed lower right: "C. P."
Ashmolean Museum, Oxford
BL 328

PROVENANCE: Collection of Lucien Pis-
sarro, London. – Bequeathed to the Ash-
molean Museum by Esther Pissarro, 1950.
EXHIBITIONS: Birmingham, City Museum
and Art Gallery, 1990, cat. 60.

BIBLIOGRAPHY

This bibliography includes monographs, exhibition catalogues, articles and essays on Camille Pissarro. General literature and literature on Impressionism which deals in any length with aspects of Pissarro's art is also listed here.
Publications are arranged alphabetically according to authors. Exhibition catalogues, marked as "Exh. Cat.", are also listed alphabetically according to the location of the exhibition. Catalogue essays are listed under the name of the author plus details of the relevant catalogue.

Adler 1978
Kathleen Adler, *Camille Pissarro: A Biography*, London 1978.

Adler 1986
Kathleen Adler, 'Camille Pissarro: City and Country in the 1890s', in: Lloyd 1986, pp. 99–116.

Adler 1992
Kathleen Adler, 'Objets de Luxe or Propaganda? – Camille Pissarro's Fans', in: *Apollo*, 136, 1992, pp. 301–305.

Bailly-Herzberg 1975
Janine Bailly-Herzberg, 'Essai de reconstitution grâce à une correspondance inédite du peintre Pissarro du magasin que le fameux marchand Samuel Bing ouvrit en 1895 en Paris pour lancer l'Art nouveau', in: *Connaissance des arts*, September 1975, pp. 72–81.

Bailly-Herzberg, Corr.
Janine Bailly-Herzberg (ed.), *Correspondance de Camille Pissarro*, 5 vols, Paris and Pontoise 1980–1991.

Bailly-Herzberg 1981
Janine Bailly-Herzberg, 'Camille Pissarro et Rouen', in: *L'Œil*, 312/313, July/August 1981, pp. 54–59.

Bailly-Herzberg 1985
Janine Bailly-Herzberg (ed.), *Mon cher Pissarro. Lettres de Ludovic Piette á Camille Pissarro*, Paris 1985.

Bailly-Herzberg 1992
Janine Bailly-Herzberg, *Pissarro et Paris*, Paris 1992.

Bailly-Herzberg 1998
Janine Bailly-Herzberg, 'Cronologia e immagini', in: exh. cat. Ferrara 1998, pp. 199–246.

Barr 1951
Alfred H. Barr, 'Matisse: Conversation with Pissarro', in: Alfred H. Barr, *Matisse: His Art and his Public*, New York 1951.

Bates 1952
H. E. Bates, 'French Painters: Pissarro and Sisley', in: *Apollo*, 55, 1952, pp. 176–180.

Benisovich/Dallett 1966
Michael N. Benisovich and James Dallett, 'Camille Pissarro and Fritz Melbye in Venezuela', in: *Apollo*, 82, July 1966, pp. 44–47.

BL
See Brettell/Lloyd 1980.

Boulton 1966
Alfredo Boulton, *Camille Pissarro en Venezuela*, Caracas 1966, English: New York 1966.

Bouret 1998
Claude Bouret, 'Camille Pissarro incisore', in: exh. cat. Ferrara 1998, pp. 113–196.

Brettell 1990
Richard R. Brettell, *Pissarro et Pontoise. Un Peintre et son paysage*, Pontoise 1990, English: New Haven and London 1990.

Brettell 1992
Richard R. Brettell, 'Pissarro in Louveciennes: An Inscription and Three Paintings', in: *Apollo*, 136, 1992, pp. 315–319.

Brettell 1993
Richard R. Brettell, 'Camille Pissarro and Urban View Painting: An Introduction', in: exh. cat. Dallas 1993, pp. XV–XXXV.

Brettell 1996
Richard R. Brettell, 'Camille Pissarro and St. Thomas', in: exh. cat. Saint Thomas 1996.

Brettell 1998
Richard R. Brettell, 'Peintres-graveurs: Degas, Pissarro ou la genèse d'une tradition moderniste', in: exh. cat. Vevey 1998, pp. 7–11.

Brettell/Lloyd 1980
Richard R. Brettell and Christopher Lloyd, *Catalogue of Drawings by Camille Pissarro in the Ashmolean Museum*, Oxford and New York 1980.

Brown 1950
Richard F. Brown, 'The Impressionist Technique: Pissarro's Optical Mixture', in: *Magazine of Art*, XLIII, January 1950, pp. 114–121.

Cailac 1932
Jean Cailac, 'The Prints of Camille Pissarro: A Supplement to the Catalogue by Lloys Delteil', in: *The Print Collector's Quarterly*, 19, January 1932, pp. 74–86.

Campbell 1992
Christopher B. Campbell, 'Pissarro and the Palette Knife: Two Pictures from 1867', in: *Apollo*, 136, 1992, pp. 311–314.

Cate 1992
Phillip Dennis Cate, 'La Renaissance de l'eau-forte en couleur en France', in: exh. cat. New Brunswick 1992, pp. 25–110.

Champa 1973
Kermit Champa, 'Pissarro: The Progress of Realism', in: *Studies in Early Impressionism,* New Haven, London 1973, pp. 67–69.

Coe 1954
Ralph T. Coe, 'Camille Pissarro in Paris. A Study of his Later Development', in: *Gazette des Beaux-Arts,* XLIII, February 1954, pp. 92–118.

Clutton-Brock 1955
Alan Clutton-Brock, in: exh. cat. London 1955.

D
See Delteil 1923.

Delteil 1923
Lloys Delteil, *Le Peintre-graveur illustré. Pissarro, Sisley, Renoir,* vol. 17, Paris 1923.

Duhem 1903
Henri Duhem, 'Camille Pissarro, Souvenirs', in: *Le Beffroni,* December 1903, reprinted in: Henri Duhem, *Impressions d'art contemporain,* Paris 1913, pp. 187–194.

Duret 1878
Théodore Duret, *Les Peintres impressionnistes,* Paris 1878.

Duret 1904
Théodore Duret, 'Camille Pissarro', in: *Gazette des Beaux-Arts,* 31, 1 May 1904, pp. 395–405.

Duret 1906
Théodore Duret, *Histoire des peintres impressionnistes,* Paris 1906.

Duret 1920
Théodore Duret, *Die Impressionisten,* 4th edn, Berlin 1920.

Elias 1914
Julius Elias, *Camille Pissarro,* Berlin 1914.

Erickson 1992
Kristen I. Erickson, 'A Continuing Collection: Recent Acquisitions by the Pissarro Archive in Oxford', in: *Apollo,* 136, 1992, pp. 325–327.

Exh. Cat. Basel 1949
Impressionisten – Claude Monet, Camille Pissarro, Alfred Sisley, Vorläufer und Zeitgenossen, Kunsthalle Basel, Basel 1949.

Exh. Cat. Birmingham 1990
Camille Pissarro. Impressionism: Landscape and Rural Labour, ed. by Richard Thomson, City Museum and Art Gallery, Birmingham; The Burrell Collection, Glasgow, London 1990.

Exh. Cat. Bremen 1990
Camille Pissarro. Radierungen, Lithographien, Monotypien aus deutschen und österreichischen Sammlungen, ed. by Anne Röver, Kunsthalle Bremen, Kupferstichkabinett, Bremen 1990.

Exh. Cat. Dallas 1993
The Impressionist and the City. Pissarro's Series Paintings, ed. by Mary Anne Stevens, ed. by Richard R. Brettell and Joachim Pissarro, Museum of Art, Dallas; Museum of Art, Philadelphia; Royal Academy of Arts, London, New Haven 1993.

Exh. Cat. Ferrara 1998
Camille Pissarro, ed. by Janine Bailly-Herzberg, Claude Bouret and Jean Leymarie, Palazzo dei Diamanti, Ferrara, Ferrara 1998.

Exh. Cat. Jerusalem 1994
Camille Pissarro: Impressionist Innovator, ed. by Joachim Pissarro and Stefanie Rachum, The Israel Museum, Jerusalem, Jerusalem 1994.

Exh. Cat. London 1950
Camille Pissarro, Matthieson Gallery, London, London 1950.

Exh. Cat. London 1954
Three Generations of Pissarros, 1830–1954, Foreword by John Rewald, O'Hana Gallery, London, London 1954.

Exh. Cat. London 1955
Camille Pissarro, Alfred Sisley, ed. by Alan Clutton-Brock, Marlborough Fine Art Ltd., London, London 1955.

Exh. Cat. London 1968
Pissarro in England, ed. by John Russel, Marlborough Fine Art Ltd., London, London 1968.

Exh. Cat. New Brunswick 1992
De Pissarro à Picasso. L'Eau-forte en couleur en France, ed. by Phillip Dennis Cate and Marianne Grivel, Jane Voorhes Zimmerli Art Museum, New Brunswick, 1992; Museum Vincent van Gogh, Amsterdam, 1993; Bibliothèque Nationale, Paris, 1993, Paris 1992.

Exh. Cat. New York 1968
Pissarro in Venezuela, ed. by Stanton L. Catlin and Phyllis Freeman, Center for Inter-American Relations, Art Gallery, New York, New York 1968.

Exh. Cat. Paris 1930
Centenaire de la naissance de Camille Pissarro, Introduction by Adolphe Tabarant and Raymond Rey, Musée de l'Orangerie, Paris, Paris 1930.

Exh. Cat. Paris 1981
Pissarro 1830–1903, Hayward Gallery, London, 1980; Grand Palais, Paris, 1981; Museum of Fine Arts, Boston, 1981, Paris 1981.

Exh. Cat. Pontoise 1980
Pissarro et Pontoise, Musée Pissarro, Pontoise, Pontoise 1980.

Exh. Cat. Salzburg 1984
Camille Pissarro 1830–1903. Aquarelle, Pastelle, Zeichnungen, Galerie Salis, Salzburg, Salzburg 1984.

Exh. Cat. Saint Thomas 1996
Camille Pissarro in the Caribbean, 1850–55: Drawings from the Collection at Olana, ed. by Richard R. Brettell and Karen Zukowski, Lilienfeldhouse, Saint Thomas, 1996; Jewish Museum, New York, 1997, Saint Thomas 1996.

Exh. Cat. Tokyo 1984
Camille Pissarro, Isetan Museum of Art, Tokyo; Fukuoka Art Museum; Kyoto Municipal Museum of Art, Tokyo 1984.

Exh. Cat. Vevey 1998
Degas & Pissarro. Alchimie d'une rencontre, ed. by Richard R. Brettell, Nicole Minder and Eric Gillis, Musée Jenisch, Vevey, 1998; Musée de Québec, 1999; The Israel Museum, Jerusalem, 1999, Vevey 1998.

Feist 1961
Peter H. Feist, 'Der sanftmütige Anarchist: Camille Pissarro als Maler und Kunstkritiker', in: *Bildende Kunst,* 5, 1961, pp. 307–313.

Fern 1960
Alan Fern, *The Wood Engravings of Lucien Pissarro,* Phil. Diss., University of Chicago, 1960.

Gachet 1957
Paul Gachet, *Lettres impressionnistes à Dr. Gachet et à Murer,* Paris 1957.

Geffroy 1890
Gustave Geffroy, 'Camille Pissarro', in: exh. cat. Galerie Boussod et Valadon, Paris 1890, reprinted in: *La Vie artistique,* 1st series, Paris 1892, pp. 38–46.

Gillis 1998
Eric Gillis, 'Degas et Pissarro: les tirages posthumes', in: exh. cat. Vevey 1998, pp. 149–157.

Graber 1943
Hans Graber, *Camille Pissarro, Alfred Sisley, Claude Monet,* Basel 1943.

Grivel 1992
Marianne Grivel, 'La Diffusion de l'eau-forte en couleur à Paris 1870–1914', in: exh. cat. New Brunswick 1992, pp. 111–177.

Herbert 1960
Robert L. Herbert and Eugenia W. Herbert, 'Artists and Anarchism: Unpublished Letters of Pissarro, Signac and Others', in: *The Burlington Magazine,* 102, November 1960, pp. 473–482, December 1960, pp. 517–522.

Hind 1908
Arthur Maygen Hind, 'Camille Pissarros Graphische Arbeiten', in: *Die Graphischen Künste,* vol. 31, Vienna 1908, pp. 34–38.

House 1978
John House, 'New Material on Monet and Pissarro in London 1870–71', in: *The Burlington Magazine,* 120, October 1978, pp. 636–642.

House 1986
John House, 'Camille Pissarro's Seated Peasant Woman: The Rhetoric of Inexpressiveness', in: *Essays in Honor of Paul Mellon,* ed. by John Wilmerding, Washington, D. C., 1986, pp. 154–171.

Huggler 1957
Max Huggler, 'Pissarros Städtebilder', in: *Die Kunst,* 55, 1957, pp. 361–364.

Isaacson 1992
Joel Isaacson, 'Pissarro's Doubt. Plein-Air Painting and the Abiding Questions', in: *Apollo,* 136, 1992, pp. 320–324.

Jedlicka 1950
Gotthard Jedlicka, *Pissarro,* Bern 1950.

Joets 1946
Jules Joets, 'Lettres inédites de Pissarro à Claude Monet', in: *L'Amour de l'art,* XXVI, 1946, pp. 59–65.

Joets 1947
Jules Joets, 'Camille Pissarro et la période inconnue de St. Thomas et de Caracas', in: *L'Amour de l'art,* XXVII, 1947, pp. 91–96.

Koenig 1927
Leo Koenig, *Camille Pissarro,* Paris 1927.

Kopplin 1981
Monika Kopplin, *Das Fächerblatt von Manet bis Kokoschka. Europäische Traditionen und japanische Einflüsse,* Diss., Cologne 1981.

Kropotkin 1887
Pjotr Kropotkin, *Anarchist Communism. Its Basis and Principles,* London 1887.

Kropotkin 1899
Pjotr Kropotkin, *Fields, Factories and Workshops,* London 1899.

Kunstler 1967
Charles Kunstler, *Pissarro: villes et campagnes,* Lausanne and Paris 1967, English: New York undated [1967].

Lantow 1998
Bent Lantow, 'Pissarro contre la A 104', in: *Revue bimistrielle vivre en Val d'Oise,* 50, June/July/August 1998, pp. 22–29.

Lecomte 1890
Georges Lecomte, 'Camille Pissarro', in: *Les Hommes d'aujourd'hui,* 8, 366, Paris 1890.

Lecomte 1892
Georges Lecomte, 'Foreword', in: exh. cat. Galerie Durand-Ruel, Paris 1892.

Lecomte 1922
Georges Lecomte, *Camille Pissarro,* Paris 1922.

Lecomte/Kunstler 1930
Georges Lecomte and Charles Kunstler, 'Un Centenaire: un fondateur de l'impressionnisme, Camille Pissarro. Lettres inédites de Camille Pissarro à Octave Mirbeau (1891–92) et à Lucien Pissarro (1898–1899)', in: *La Revue de l'art ancien et moderne,* LVII, March 1930, pp. 157–172.

Leymarie 1998
Jean Leymarie, 'Camille Pissarro', in: exh. cat. Ferrara 1998, pp. 17–111.

Leymarie/Melot 1971
Jean Leymarie and Michel Melot, *Les Gravures des impressionnistes: Manet, Pissarro, Renoir, Cézanne, Sisley. Œuvre complet,* Paris 1971.

Lilley 1987
E. D. Lilley, 'Zola and Pissarro: A Coincidence', in: *The Burlington Magazine,* 129, January 1987, pp. 24f.

Lloyd 1975
Christopher Lloyd, 'Camille Pissarro and Hans Holbein the Younger', in: *The Burlington Magazine,* 117, November 1975, pp. 722–726.

Lloyd 1980
Christopher Lloyd, 'Camille Pissarro and Japonisme', in: *Japonisme in Art: International Symposium,* Tokyo 1980, pp. 173–188.

Lloyd 1981
Christopher Lloyd, *Camille Pissarro,* Geneva and London 1981.

Lloyd 1982
Christopher Lloyd, 'Camille Pissarro at Princeton', in: *Record of the Art Museum, Princeton University,* 41, 1, 1982, pp. 16–32.

Lloyd 1985
Christopher Lloyd, 'The Market Scene of Camille Pissarro', in: *Art Bulletin of Victoria,* 25, 1985, pp. 16–32.

Lloyd 1985a
Christopher Lloyd, 'Reflections on La Roche-Guyon and the Impressionists', in: *Gazette des Beaux-Arts,* 6, cv, 1985, pp. 37–44.

Lloyd 1986
Christopher Lloyd (ed.), *Studies on Camille Pissarro,* London and New York 1986.

Lloyd 1992
Christopher Lloyd, 'Paul Cézanne, Pupil of Pissarro: An Artistic Friendship', in: *Apollo,* 136, 1992, pp. 284–290.

Lloyd/Pissarro 1997
Christopher Lloyd and Joachim Pissarro, 'Camille Pissarro: A Case Study in Impressionist Drawing', in: *On Paper,* 2, 2, November/Dezember 1997, pp. 24–28.

Meadmore 1962
William Sutton Meadmore, *Lucien Pissarro. Un Cœur simple,* London 1962.

Meier-Graefe 1904
Julius Meier-Graefe, 'Camille Pissarro', in: *Kunst und Künstler,* 2, 12, September 1904, pp. 475–488, reprinted in: Meier-Graefe 1907, pp. 153–172.

Meier-Graefe 1907
Julius Meier-Graefe, *Impressionisten: Guys, Manet, van Gogh, Pissarro, Cézanne,* Munich 1907.

Melot 1977
Michel Melot, 'La Pratique d'un artiste: Pissarro graveur en 1880', in: *Histoire et critique des arts,* II, June 1977, pp. 14–38.

Minder 1998
Nicole Minder, 'Degas et Pissarro, alchimie d'une rencontre', in: exh. cat. Vevey 1998, pp. 13–30.

Mirbeau 1892
Octave Mirbeau, 'Camille Pissarro', in: *Le Figaro,* 1 February 1892, reprinted in: Octave Mirbeau, *Des Artistes, première série,* Paris 1922, pp. 145–153.

Mirbeau 1990
Octave Mirbeau, *Correspondance avec Camille Pissarro,* Thesson 1990.

Natanson 1950
Thadée Natanson, *Pissarro,* Lausanne 1950.

Nicolson 1946
B. Nicolson, 'The Anarchism of Pissarro', in: *The Arts,* 2, 1946, pp. 43–51.

Paulsson 1959
Thomas Paulsson, 'From Rousseau to Pissarro', in: *Idea and Form,* Stockholm 1959, pp. 204–208.

Pica 1907
Vittorio Pica, 'Camille Pissarro, Alfred Sisley', in: *Emporium,* 26, 1907, pp. 165–178.

Pissarro 1922
Ludovic-Rodo Pissarro, 'The Etched and Lithographed Work of Camille Pissarro', in: *The Print Collector's Quarterly,* 9, October 1922, pp. 275–301.

Pissarro 1928
Catalogue des œuvres de Camille Pissarro composant la Collection Camille Pissarro, vol. 4, Paris, 3 December 1928 (Sales catalogue issued by the Galerie Georges Petit, Paris, from the estate of Julie Pissarro).

Pissarro 1943
Camille Pissarro. Letters to his Son Lucien, ed. with the assistance of Lucien Pissarro by John Rewald, New York 1943.

Pissarro 1963
Camille Pissarro, *Briefe,* ed. by Fritz Erpel, Berlin 1963.

Pissarro 1984
Julie Pissarro, *Quatorze lettres,* Pontoise 1984.

Pissarro 1992
Joachim Pissarro, 'Book Reviews. Reading Pissarro', in: *Apollo,* 136, 1992, p. 339.

Pissarro 1993
Joachim Pissarro, *Camille Pissarro,* Munich 1993.

Pissarro 1993a
Joachim Pissarro, 'Pissarro's Series: Conception, Realisation and Interpretation', in: exh. cat. Dallas 1993, pp. XXXVII–LII.

Pollock 1996
Griselda Pollock, 'Don't Take the Pissarro, but Take the Monet and Run! Or, Memoirs of a Not so Dutiful Daughter', in: Fred Orton and Griselda Pollock, *Avant-Gardes and Partisans Reviewed,* Manchester and New York 1996, pp. 125–140.

PV
Ludovic-Rodo Pissarro and Lionello Venturi, *Camille Pissarro. Son art – son œuvre,* 2 vols, Paris 1939.

Rachum 1994
Stephanie Rachum, 'Chronology', in: exh. cat. Jerusalem 1994, pp. 41–55.

Reff 1967
Theodore Reff, 'Pissarro's Portrait of Cézanne', in: *The Burlington Magazine,* 109, November 1967, pp. 627–633.

Reid 1977
Sir Martin Reid, 'Camille Pissarro: Three Paintings of London of 1871. What do they Represent?', in: *The Burlington Magazine,* 119, April 1977, pp. 253–261.

Rewald 1943
See Pissarro 1943.

Rewald 1950
John Rewald, *Camille Pissarro. Lettres à son fils presentées, avec l'assistance de Lucien Pissarro, par John Rewald,* Paris 1950.

Rewald 1963
John Rewald, *Camille Pissarro,* New York 1963.

Rewald 1964
John Rewald, 'Camille Pissarro in Venezuela', in: exh. cat. Hammer Galleries, New York 1964, pp. 5–29.

Rewald 1992
John Rewald, 'Pissarro's Paris and his France: The Camera Compares', in: *Apollo,* 136, 1992, pp. 291–294.

Rittmann 1991
Annegret Rittmann, *Die Druckgraphik Camille Pissarros,* Diss., Frankfurt am Main 1991.

Röver 1990
Anne Röver, 'Pissarro Prints in Bremen. Some Discoveries', in: *The Print Quarterly,* VII, 4, 1990, pp. 436–443.

Röver 1990a
See exh. cat. Bremen 1990.

Rosensaft 1974
Jean B. Rosensaft, 'Le Néo-impression-nisme de Camille Pissarro', in: *L'Œil*, 223, February 1974, pp. 52–57.

Russell 1968
John Russell, 'Pissarro: The White Knight of Impressionism', in: exh. cat. London 1968, pp. 7–13.

Schirrmeister 1982
Anne Schirrmeister, *Camille Pissarro*, New York 1982.

Shapiro 1971
Barbara Stern Shapiro, 'Four Intaglio Prints by Camille Pissarro', in: *Boston Museum Bulletin*, 69, 357, 1971, pp. 131–141.

Shapiro 1973
Barbara Stern Shapiro, in: exh. cat. *Camille Pissarro: The Impressionist Printmaker*, Museum of Fine Arts, Boston 1973.

Shapiro 1992
Barbara Stern Shapiro, 'Pissarro as Print-maker. Some Questions and Answers', in: *Apollo*, 136, 1992, pp. 295–300.

Shapiro/Melot 1975
Barbara Shapiro and Michel Melot, 'Les Monotypes de Camille Pissarro', in: *Nouvelles de l'estampe*, 19, 1975, pp. 16–23.

Shiff 1984
Richard Shiff, 'Review Article' (critical over-view of the latest publications on Pissarro), in: *The Art Bulletin*, LXVI, 4, December 1984, pp. 681–690.

Shiff 1992
Richard Shiff, 'The Work of Painting. Camille Pissarro and Symbolism', in: *Apollo*, 136, 1992, pp. 307–310.

Shikes/Harper 1980
Ralph E. Shikes and Paula Harper, *Pissarro: His Life and Work*, New York and London 1980.

Smith 1995
Paul Smith, *Impressionismus*, Cologne 1995.

Stevens 1992
Maryanne Stevens, 'The Urban Impression-ist – Pissarro's Cityscapes: Series and Serial-ism', in: *Apollo*, 136, 1992, pp. 278–283.

Sweet 1960
F. A. Sweet, 'Pissarro's "Young Woman Mending"', in: *The Art Institute of Chicago Quarterly*, 54, 2, April 1960, pp. 17–19.

Tabarant 1924
Adolphe Tabarant, *Pissarro*, Paris 1924, English: New York and London 1925.

Thomson 1981
Richard Thomson, 'Pissarro and the Fig-ure', in: *The Connoisseur*, 207, July 1981, pp. 187–190.

Thomson 1982
Belinda Thomson, 'Camille Pissarro and Symbolism: Some Thoughts Prompted by the Recent Discovery of an Annotated Arti-cle', in: *The Burlington Magazine*, 124, Janu-ary 1982, pp. 14–23.

Thomson 1982a
Richard Thomson, 'Camille Pissarro, "Turpitudes Sociales" and the Universal Exhibition of 1889', in: *Arts Magazine*, 56, 8, April 1982, pp. 82–88.

Thomson 1990
See exh. cat. Birmingham 1990.

Thorold 1978
Anne Thorold, 'The Pissarro Collection in the Ashmolean Museum, Oxford', in: *Burlington Magazine*, 120, October 1978, pp. 642–645.

Thorold 1992
Anne Thorold, 'Learning from Pissarro. The Artist as Teacher', in: *Apollo*, 136, 1992, pp. 330–333.

Thorold 1993
Anne Thorold (ed.), *The Letters of Lucien to Camille Pissarro*, Cambridge University 1993.

Thorold/Erickson 1993
Anne Thorold and Kristen I. Erickson, *The Pissarro Collection in the Ashmolean Museum*, Oxford 1993.

Urbanelli 1994
Lora Urbanelli, *The Wood Engravings of Lucien Pissarro and a Bibliographical List of Eragny Books*, Cambridge 1994.

Ward 1995
Martha Ward, *Pissarro: Neo-impressionism, and the Spaces of the Avant-Garde*, Chicago and London 1995.

White 1996
Barbara Ehrlich White, *Impressionists side by side: their friendships, rivalries, and artistic exchanges*, New York 1996.

Zafran 1997
Eric M. Zafran, 'It is Necessary to Draw: Pissarro's Unknown Drawings of St. Thomas and Venezuela', in: *Drawing*, 19, 1, 1997, pp. 1–6.

Zola 1959
Emile Zola, *Salons*, receullis, annotés et presentés par F. J. W. Hemmings et Robert J. Niess, Paris 1959.

Zukowski 1996
Karen Zukowski, 'The Paul-Melbey-Church Connection', in: exh. cat. Saint Thomas 1996.

PHOTO CREDITS

Catalogue to accompany the exhibition
Camille Pissarro
at the Staatsgalerie Stuttgart from
11 December 1999 to 1 May 2000

Catalogue and Exhibition
Christoph Becker,
with essays by Wolf Eiermann, Manuela
Ganz, Ralph Melcher and Barbara Stern
Shapiro

Translations (Christoph Becker, Manuela
Ganz, Wolf Eiermann, Ralph Melcher)
Fiona Elliott

Copy Editor
Fiona Elliott

Design
Christine Müller

Typesetting
Weyhing digital, Ostfildern-Ruit

Set in
New Baskerville and Futura Regular

Reproductions
Repromayer, Reutlingen

Production
Dr. Cantz'sche Druckerei, Ostfildern-Ruit

© 1999 Staatsgalerie Stuttgart,
Hatje Cantz Verlag, Ostfildern-Ruit,
the authors and the photographers

Published by
Hatje Cantz Verlag
Senefelderstraße 12
D-73760 Ostfildern-Ruit
T. 0049-(0)711-44050
F. 0049-(0)711-4405220
Internet: www.hatjecantz.de

Distribution in the US
DAP, Distributed Art Publishers
155 Avenue of the Americas, Second Floor
New York, NY 10013
T. 001-212-6271999
F. 001-212-6279484

ISBN 3-7757-0861-8
Printed in Germany
Front cover illustration
Camille Pissarro, *The Gardener, Afternoon
Sun, Eragny,* 1899, Detail (Cat. 54), Staats-
galerie Stuttgart, on Loan from the
Stuttgarter Galerieverein

Back cover illustration
Camille Pissarro, *Peasants Planting Pea-Sticks,*
1891 (Cat. 47), private collection, on loan
to Sheffield Galleries and Museums Trust

Front endpaper illustration
Julie and Camille Pissarro at the wash-house
in Eragny-sur-Epte, Archives Les Amis de
Camille Pissarro, Musée de Pontoise

Frontispiece
Camille Pissarro, 1880, Archives Les Amis
de Camille Pissarro, Musée de Pontoise

Illustration preceding the essay by Wolf
Eiermann
Camille Pissarro with his daughter Jeanne
in his studio in Pont Neuf, c. 1901, Pissarro
Family Archive, Paris

Illustration preceding the essay by
Christoph Becker
Camille Pissarro with his mobile studio in
Eragny-sur-Epte, Archives Les Amis de
Camille Pissarro, Musée de Pontoise

Illustration preceding the essay by Barbara
Stern Shapiro
Camille Pissarro in his studio in Eragny-sur-
Epte, c. 1900, Pissarro Family Archive, Paris

Illustration preceding the essay by Ralph
Melcher
Camille Pissarro in Gauchotracht, Pissarro
Family Archive, Paris

Back endpaper illustration
Camille Pissarro together with Julie,
Paul-Emile and Jeanne, Archives Les Amis
de Camille Pissarro, Musée de Pontoise

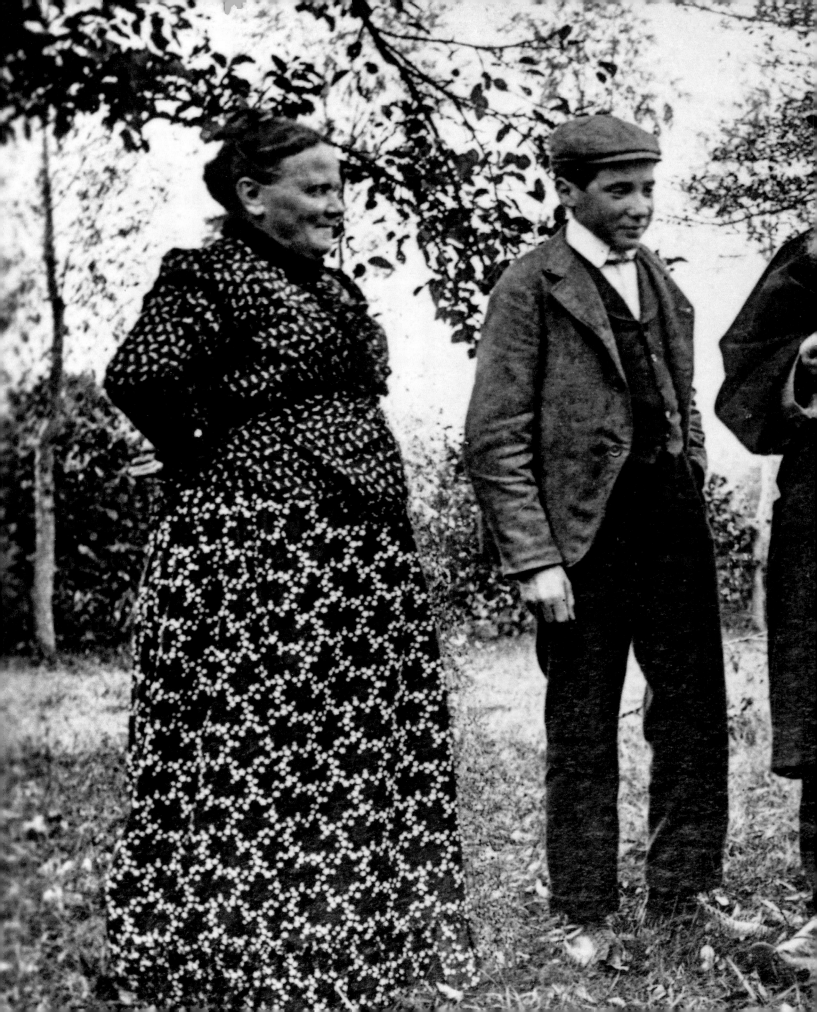